Vicereines of Ireland

Vicereines of Ireland

Portraits of Forgotten Women

Edited by Myles Campbell

First published in 2021 by
Irish Academic Press
10 George's Street
Newbridge
Co. Kildare
Ireland
www.iap.ie

Designer: Jurga Rakauskaitė-Larkin

9781788551335 (Cloth)
9781788551342 (PDF)

Typeset in Calluna 10/14

A CIP catalogue record for this book is available from the British Library.

Irish Academic Press is a member of Publishing Ireland.

Cover/Jacket front: Unknown artist, *The Right Hon. The Countess of Buckinghamshire* (detail), 1778. Reproduced courtesy of the National Library of Ireland (Fig. 00.06).

Endpapers: Aušra Lazauskienė, *Vicereine's Marble*, 2021. Courtesy of the Office of Public Works, Dublin Castle.

Frontispiece: Michael Dahl, *Lady Mary Somerset, Duchess of Ormond* (detail), c.1695–6. © National Trust Images/James Dobson (Cat. 03).

p. xi: Thomas Gainsborough, *Caroline Hobart, Countess of Buckinghamshire* (detail), 1784. © National Trust Images/John Hammond (Cat. 10).

pp. xiv–xv: J.S. Templeton, from a drawing by Elizabeth, Countess of Hardwicke, *Court of Oberon, Act I* (detail), 1831. Image from Digital Collections, The Library of Trinity College, Dublin (Cat. 17).

p. xxi: Sir Joshua Reynolds, *The Temple Family* (detail), c.1780–2. © National Gallery of Ireland (Fig. 03.04).

p. 292: Robert French (photographed by), Vice-regal Lodge, Dublin [now Áras an Uachtaráin], c.1865–1914. Reproduced courtesy of the National Library of Ireland.

IRISH ACADEMIC PRESS

DUBLIN CASTLE

OPW
Oifig na
nOibreacha Poiblí
Office of Public Works

Contents

Introduction
The Side Gallery of History

The Role of the Vicereine of Ireland

Myles Campbell

I

One
'The Goverment of the Familie'

The First Duchess of Ormonde's Understanding of the Role of Vicereine

Naomi McAreavey

18

Foreword

It is with the deepest pleasure and an unbounded sense of admiration that, on behalf of the Office of Public Works (OPW), I offer these few words of praise to Dr Myles Campbell and his expert colleagues for delivering to us this important publication. In keeping with the OPW's ongoing series of Dublin Castle exhibitions and publications, including our *Chapel Royal* of 2015, *Making Majesty* of 2017 and *Splendour and Scandal* of 2020, this extraordinarily detailed research has revealed an aspect of our history, and most particularly of our women's history, that has heretofore been largely unknown.

This research forms part of the OPW's commitment to the people of Ireland, and to our very many visitors from overseas, to present an objective assessment of the political, social and economic conditions that have prevailed since the Castle's foundation – as a major defensive work on the orders of King John of England in 1204 – more than 800 years ago. The main subject of our recent explorations has been the period running from the late seventeenth century up to the present day. A rich trove of State and personal papers, newspaper reports, contemporary histories and literature, as well as visual material, including portraits, prints, drawings, sculpture and, more recently, photographs, has allowed for a thorough analysis not only of viceregal pomp and ceremony, but also of the personal and intimate opinions and experiences of those who have occupied the posts of viceroy and vicereine, the latter of which is the particular focus of this current investigation.

Through the essays and catalogue entries contained in these pages, the opportunities and challenges experienced by the vicereine are eloquently and eruditely examined. Each writer has chosen an aspect of a vicereine's life to illuminate how these women coped with their roles as wife, mother, friend, benefactor, mediator, hostess, fashion icon and, most formally, female representative of the ruling monarch. A rich history of charitable public works is revealed, detailing the strenuous efforts made by some to alleviate crushing poverty and to eradicate rampant disease. Also made known are various vicereines' diplomatic efforts, through less formal social channels, to bridge cultural and religious divides, while also documented are the individual extremes, at one end, of social isolation, and at the other end, of popular adulation and respect, if not expressions of outright love from a grateful populace.

Future exhibitions will treat of our transition from the period of British rule to the post-independence era of freedom and self-determination. They will examine how Dublin Castle has acted as the stage from which our young Republic has presented itself to the world, both as the place of inauguration of our duly elected male and female presidents and as the place of our official welcome, at the heart of the European Union, to our fellow European citizens and to our guests from around the world.

In the meantime, I congratulate our team at Dublin Castle and express my thanks to our Director of National Historic Properties, Rosemary Collier, under whose leadership this important project has been realized. This insightful publication and its associated exhibition serve to underscore the importance of casting an objective and critical eye over our history, allowing its untold stories to emerge and to educate us as to how the journey taken has led to where we have now arrived.

John McMahon
Commissioner
Office of Public Works

Preface

It is with frustration and delight that the reader turns the final page of this important volume – frustration that the lives of the women it profiles have been hidden for so long and delight that the identities and legacies of these women can now be recognized and acknowledged. The absence, until now, of a detailed study of the lives of the vicereines of Ireland highlights the ease with which the contributions of women have been erased, omitted and forgotten in an historically male-dominated world. It also raises the question that if the lives of such high-ranking women can be swept aside, how many more lives of other, less visible women likewise remain forgotten? Dr Myles Campbell and the eminent circle of writers he has assembled in the making of this book share a common interest in filling this gaping lacuna. Their curiosity about the lives of the vicereines results in a series of chapters that fizzle with details of fascinating, in the main inspiring, and often enterprising women.

The physical absence of portraits or objects associated with the vicereines in public places has meant that their contributions have been all the more easily forgotten. In what feels like a milestone moment, Myles has also curated a landmark exhibition at Dublin Castle, which is supported by thirty-three richly researched catalogue entries in this book. At Dublin Castle, we believe that sharing new research into pre- and post-independence Ireland with visitors is a crucial part of our work. The realization of *Vicereines* has extended the reach of many peers in the ecosystem that is the interpretation of historic places. It is enormously enriching for us to widen our web of cultural collaborators and we hope that this project can, in turn, inspire our museum and heritage colleagues nationally and internationally. I offer my sincere thanks to all our Dublin Castle colleagues who have supported making *Vicereines* a reality. Jurga Rakauskaite-Larkin is to be congratulated for the artistic sensibility she has brought to the design of this beautiful book, which adds immensely to its readability and appeal. For his curious mind, his scholarship and as a much valued colleague I wish to acknowledge, thank and congratulate Myles Campbell on completing this major project. As with so many good ideas, it now seems very strange that the absence of the vicereines of Ireland was accepted without question for so long.

Mary Heffernan
General Manager
Dublin Castle

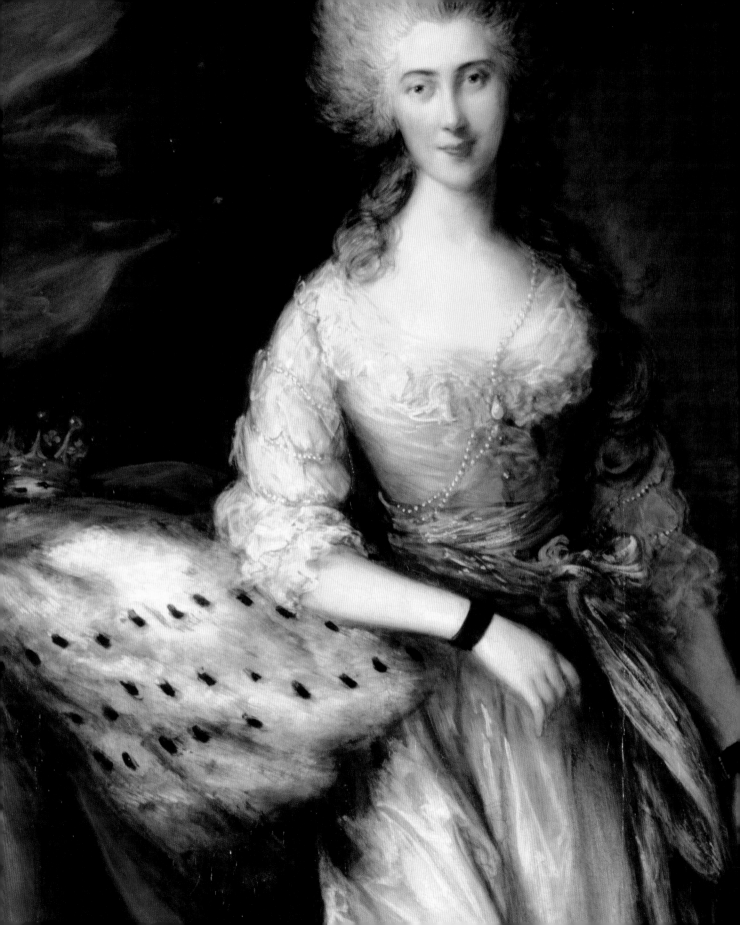

Contributors

Dr Myles Campbell is Research and Interpretation Officer for the Office of Public Works (OPW) at Dublin Castle. He received his doctorate in architectural history from Trinity College Dublin in 2014 and has taught art and architectural history at University College Dublin, the National University of Ireland Maynooth and Trinity College Dublin. He was co-editor, in 2017, of *Making Majesty: The Throne Room at Dublin Castle, A Cultural History* (Irish Academic Press), research for which earned him the George B. Clarke Prize. His most recent publications include contributions to the *Irish Arts Review* and *Country Life*, and his research for *Vicereines of Ireland* has been supported by the Paul Mellon Centre for Studies in British Art. He has curated several exhibitions at Dublin Castle, the latest of which accompanies this publication.

Dr Naomi McAreavey is a lecturer in Renaissance literature in the School of English, Drama and Film at University College Dublin where she specializes in women's writing in early modern Ireland. She is the editor of *The Letters of the First Duchess of Ormonde* (forthcoming, Arizona Center for Medieval and Renaissance Studies/Renaissance English Text Society). She co-edited, with Julie A. Eckerle, *Women's Life Writing and Early Modern Ireland* (University of Nebraska Press, 2019), and with Fionnuala Dillane and Emilie Pine, *The Body in Pain in Irish Literature and Culture* (Palgrave, 2016).

Dr Janice Morris holds a degree in French from the University of Durham and gained an MA in country house art, history and literature from the University of Leicester in 2012. She has recently been awarded a PhD for a thesis entitled 'An Elite Female Philanthropist in Late Eighteenth-Century England: Mary, Marchioness of Buckingham and the Refugees of the French Revolution', also at the University of Leicester. Her research interests include the progress of Catholic toleration in England during the French Revolution and the Revolutionary and Napoleonic Wars, refugee reception, bi-confessional marriage, elite female strategy within the family and the wider community, industrialization, poverty and philanthropy.

Dr Frances Nolan is currently writing a monograph entitled *'The Cat's Paw': Catholic and Jacobite Irish Women, 1685–1718*, which is the result of research undertaken during her time as an Irish Research Council Postdoctoral Fellow at the National University of Ireland Maynooth (2018–20). She is a former National Library of Ireland/Irish Committee of Historical Studies Research Student (2016–17) and Irish Research Council Postgraduate Scholar (2012–15). She was awarded her PhD from University College Dublin in 2016 for her research on women and property in the Williamite confiscation in Ireland. Dr Nolan has completed an academic biography of Frances Talbot, Countess and Jacobite Duchess of Tyrconnell, which has been accepted for publication by Boydell & Brewer. She has also published articles in *The Historical Journal* and *Irish Historical Studies*. Her article in the latter won the Women's History Association of Ireland/I.H.S. publication prize in 2017.

Dr Éimear O'Connor is an art historian, curator, lecturer and arts consultant. She has published books, chapters, articles and reviews on Irish art in Ireland, England, America and France, and has lectured on Irish art in cultural institutions and universities at home and abroad. The predominant concerns in her research are the complex national and international contexts pertaining to the visual construction of Irish identity in the late nineteenth and twentieth centuries. Her most recent book, *Art, Ireland and the Irish Diaspora. Chicago, Dublin, New York 1893–1939: Culture, Connections and Controversies* was published by Irish Academic Press in 2020. O'Connor is an honorary member of the Royal Hibernian Academy of Art in Dublin. She has recently been appointed to the role of Resident Director of the Tyrone Guthrie Centre at Annaghmakerrig, County Monaghan.

Dr Neil Watt currently works for the National Trust and throughout his career, has cared for three significant Irish country houses and their collections. His PhD thesis, completed at Queen's University Belfast in 2014, is entitled 'Women of the Big House Families of Ireland and Marriage, 1860–1920'. As co-curator of the National Trust and National Portrait Gallery's *Women and Power* exhibition at Mount Stewart in 2018, he was able to bring his passion for women's history to life. Dedicated to increased inclusivity at one of Ireland's greatest heritage assets, he firmly believes that these special places should be accessible to all. True to his word, he is as comfortable researching hidden histories as he is greeting visitors dressed as his alter ego 'Delicia'.

Dr Rachel Wilson obtained her PhD in history from Queen's University Belfast in 2013. She has worked as a research fellow at the University of Leeds and a lecturer in early modern history at Cardiff University, where she is now an Honorary Research Fellow. Her first book, *Elite Women in Ascendancy Ireland, 1690–1745: Imitation and Innovation*, was published by Boydell & Brewer in 2015. She has a long-standing interest in the Lord Lieutenancy of Ireland and is also the author of several articles on the country's viceroys and vicereines. She was interviewed on her research in 2019 by the Northern Irish television channel NVTV for the *History Now* show.

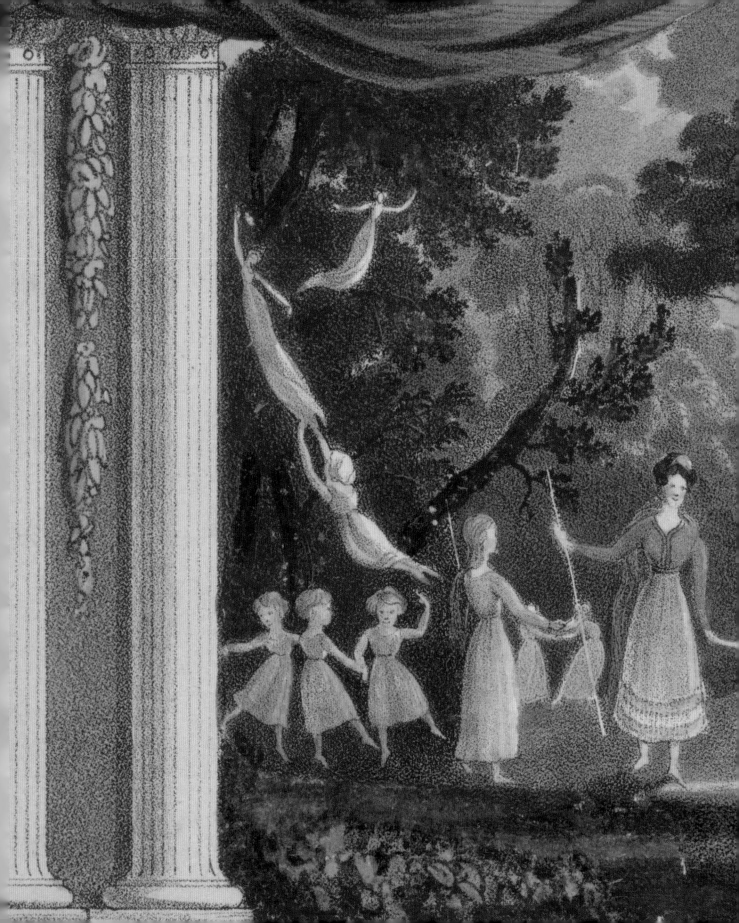

Acknowledgements

On 3 December 1990, Mary Robinson delivered her inaugural address as President of Ireland in St Patrick's Hall at Dublin Castle. 'As a woman,' she declared, 'I want women who have felt themselves outside history to be written back into history'. Watching the footage of that address some twenty-seven years later, as I prepared an exhibition to mark the history of presidential inaugurations at Dublin Castle, I was struck by the immediate but perhaps overlooked relevance of Mary Robinson's remarks to the surroundings in which they were made. There, it occurred to me, on that same spot in St Patrick's Hall where our first woman president had risen to address the nation, successive women had also stood over the centuries, but in a supporting role, and in silence, as the consorts of the viceroys of Ireland. Three years on, this book and its associated exhibition at Dublin Castle have come into being and I would like to acknowledge the powerful words of Mary Robinson, which inspired this effort towards writing the vicereines back into history.

This project could not have been realized without the support of my employer, the Office of Public Works (OPW), and I am immensely grateful to its Chairman, Maurice Buckley, its Commissioner for Heritage, John McMahon and its Director of National Historic Properties, Rosemary Collier. Their leadership sustains the research, conservation and interpretation work that enables us to tell new stories in old places for our visitors from Ireland and around the world.

The new stories told by the contributors to this book are the result of extraordinary amounts of research, thought and careful crafting. I express my warmest thanks and congratulations to Naomi McAreavey, Frances Nolan, Janice Morris, Rachel Wilson, Neil Watt and Éimear O'Connor for the insight, skill and hard work that turned ideas into words and created pen portraits every bit as vivid as the paintings featured in this book. Above all, I thank them for their infectious enthusiasm and belief in the value and meaning of what we were working towards.

There would be no book without its associated exhibition and there would be no exhibition without artworks, the majority of which have come to Dublin Castle on loan from museums, cultural institutions and historic houses across Ireland, the United Kingdom and the United States of America. I owe a very great debt of gratitude to the exceptionally generous lenders to this exhibition, and to the curators, registrars, image managers and staff who have worked tirelessly with them and on their behalf. I would like to offer my sincere thanks to the Duke of

Northumberland, Clare Baxter, Lisa Little and Eve Reverchon at Alnwick Castle; Earl Spencer, Annie Kemkaran-Smith, Antonia Brodie, India Parish and Sarah Harvey at Althorp House; the Duke of Abercorn at Barons Court House; the Duke of Rutland, Harvey Proctor and Sarah Brinsley-Sheridan at Belvoir Castle; the Duke of Devonshire, Kate Brindley, Ciara Gallagher, Charles Noble, Martha Marriott and Anna Batchelor at Chatsworth House; Charles Stopford Sackville and Bruce Bailey at Drayton House; Mary Clark at Dublin City Council; Luke Syson, David Packer, Henrietta Ward and Lynda Clark at the Fitzwilliam Museum, University of Cambridge; the Duke of Richmond and Gordon, James Peill, Catherine Miles and Amanda Sharp at Goodwood House; Henry Guest; Her Majesty Queen Elizabeth II; Christina Nielsen, Susan Coletta, Caroline Currin, Michele Ahern and Ming Aguilar at the Huntington Library, Art Museum, and Botanical Gardens; the Marquis and Marchioness of Normanby, Claire Clarke and Karen Nightingale at Mulgrave Castle; Sean Rainbird, Brendan Rooney, Caroline Clarke, Raffaella Lanino, Lynn McGrane, Marie McFeely and Brendan Maher at the National Gallery of Ireland; Sandra Collins, Katarzyna Kamieniecka, Mary Broderick, James Harte, Berni Metcalfe and Christopher Swift at the National Library of Ireland; Hilary McGrady, Phoebe Meiklejohn-McLaughlin, Susan Paisley, Frances Bailey, Fernanda Torrente and Chris Rowlin at the National Trust; Philip Long, Jennifer Melville, Bill Duff, Vikki Duncan, Susanna Hillhouse, Marcin Klimek and Lauren Jackson at the National Trust for Scotland; Rebecca Salter and Edwina Mulvany at the Royal Academy of Arts; Tim Knox, Sally Goodsir and Rufus Bird at the Royal Collection Trust; Lydia Ferguson, Laura Shanahan, Jennifer Doyle, Sharon Sutton and Estelle Gittins at Trinity College Dublin; and the trustees and board members who generously approved my requests to borrow the artworks in their care.

The safety, legibility and appeal of the artworks in the exhibition has been greatly enhanced in many cases by the meticulous conservation work that has been carried out behind the scenes over many months. I would like to thank each and every one of the conservators and technicians who devoted their time and skill to assessing and preparing the works for display, especially Simon Bobak, Siobhán Conyngham, Owen Davison, Louise O'Connor at the National Library of Ireland, Diana Roberts, and Susie Bioletti and Clodagh Neligan at Trinity College Dublin. A special note of thanks is reserved for the Duke of Abercorn and the Hunting-

ton Museum for their particularly generous support for the conservation work. For their highly professional and careful packing, moving and installation of the artworks, I thank the entire team at Irish Art Services, led by Joe Murphy, and the teams at Constantine Fine Art and Masterpiece International.

The task of capturing the character of the artworks for readers of this book fell to several talented photographers. Many of the artworks featured in this volume had never before been professionally photographed and I would like to thank all the photographers involved, especially James Dobson, John Roan and Scott Wicking.

The research for this book has been funded and facilitated by a variety of institutions and individuals. For financial support, I would like to acknowledge the generous assistance of the Paul Mellon Centre for Studies in British Art, which provided vital travel funding, and the Irish Research Council. I am also indebted to Christine Casey for her backing during the preparation of funding applications and for her many years of mentorship. For access to archival collections and permission to reproduce and publish from them, I offer particular thanks to the Duke of Northumberland and Christopher Hunwick at Alnwick Castle; the Duke of Rutland and Peter Foden at Belvoir Castle; Corranne Wheeler at Cambridgeshire Archives; Bridget Thomas and Liz Newman at Flintshire Record Office; the late Marquess of Aberdeen and Temair, and Marge Pocknell, at Haddo House; the Marquis and Marchioness of Normanby, and Claire Clark, at Mulgrave Castle; Alex Ward at the National Museum of Ireland; Julie Crocker at the Royal Archives, Windsor Castle; Natasha Serne at the Royal Dublin Society; and the many patient and helpful custodians of archival material at the Bodleian Library, the British Library, the Huntington Library, the National Archives of Ireland, the National Archives of the United Kingdom, the National Library of Ireland and the Public Record Office of Northern Ireland. Thanks are also due to Kate Ballenger, Tabitha Barber, Raymond Bolger, Harriet Bridgeman, Peter Crooks, Jane Fenlon, Ivor Guest, Gareth Hughes, Nancy Hurrell, Nicola Kelly, Paula Lalor, Conor Lucey, Philip McEvansoneya, Victoria Poklewski Koziell, Crispin Powell, Christopher Ridgway, James Rothwell, William Roulston, Ciarán Wallace, Patricia Wrafter and, most particularly, Nigel Aston, for providing helpful directions towards source material and artworks.

In addition to the archival source material and images kindly provided by lenders and lending institutions, additional images for this book were sourced from collections far and near. Guiding this process with matchless skills in the arts of co-ordination, organization and gentle persuasion was Sarah Maguire, to whom I offer my deep and abiding thanks.

The raw material gathered and prepared for this project has been transformed into book form through a dynamic partnership between the OPW and Irish Academic Press. It has been a pleasure and a privilege to work with Conor Graham, Patrick O'Donoghue and Maeve Convery at Irish Academic Press to bring this book into being. I cannot thank them enough for their commitment to the highest standards, their attention to the finest details and their endurance of the longest phone calls as it gradually took shape. For the great care they took with the

manuscript as it progressed through rounds of copy edits, corrections and proof reading, I am also very grateful to Heidi Houlihan and Guy Holland.

The importance of evoking the elegant world in which the vicereines moved, but through a complementary aesthetic lens that reflected our own time and place, was recognized from the outset by our very talented project designer, my OPW colleague Jurga Rakauskaitė-Larkin. This book and its associated exhibition are testaments to the uncompromising pursuit of originality and beauty in design that I admire so much in her work. Thank you, my friend.

For her beautiful marbled endpapers inspired by a notebook found among a vicereine's papers, thanks and appreciation also go to Aušra Lazauskienė.

At Dublin Castle, I am fortunate to work with people who share a true passion for preserving, researching and interpreting one of Ireland's most important historic properties and its precious collections. Their support, enthusiasm and constant hard work has helped to make this project possible. First and foremost, I would like to thank our Keeper of Collections, Dave Hartley, who remained utterly unfazed when tasked with co-ordinating the logistics of a major exhibition during his first week in the role. Since day one, he has been a master of customs paperwork, delivery schedules and condition reports, and I thank him for his expertise and good humour. I would also like to thank William Derham, who so kindly and blithely read and annotated an entire early draft of the manuscript, and Emily Ternent, who completed an internship at Dublin Castle and carried out valuable preliminary research in the early days of this project. I am also very grateful to Fergal Martin, Hugh Bonar, Nuala Canny, Dave Cummins, Darren Lennox, Willie Doyle, Antoinette Robinson, Angela Cassidy, Anthony Hayes and the Castle's dedicated teams of guides, events staff, constables, maintenance staff and technical staff. Within the wider National Historic Properties family of the OPW, I would particularly like to thank Joanne Bannon, our Historic Collections Registration Officer, and Dolores Gaffney at Kilkenny Castle, for their assistance.

This project has been more than three years in the making and during that time, the kindness of my family and friends has relieved tiredness, satisfied hunger and lifted spirits. My heartfelt thanks go out to each and every one of them, most especially my parents, Seán and Genevieve, my dear friends Donna Brady and Katy Milligan, who took such a close interest in the project, and Rafael, who more than merits his angelic name.

Finally, it is with the greatest thanks that I acknowledge the support, encouragement and vision of the General Manager of Dublin Castle, Mary Heffernan. I am deeply grateful to her for giving me the opportunity to develop this project. Like many of the women featured in this book, she has made an important mark on Dublin Castle.

Myles Campbell
Editor and Curator

Editor's Note

The wife of the chief governor of Ireland was not afforded an official title but was variously styled vicereine, vice queen or lady lieutenant and was granted the official honorific style, Her Excellency. The term vicereine is used predominantly throughout this volume, except where an alternative appears in an original quotation.

The chief governor of Ireland was variously styled lord deputy, deputy, justiciar, lord justice, lord lieutenant or viceroy. In the interests of clarity and consistency, the term viceroy is used predominantly throughout this volume, except with reference, in certain instances, to the medieval and early modern periods or where an alternative appears in an original quotation.

Irregularities and inconsistencies in spelling, grammar and punctuation, where they appear in direct quotations, have been allowed to remain in their original form.

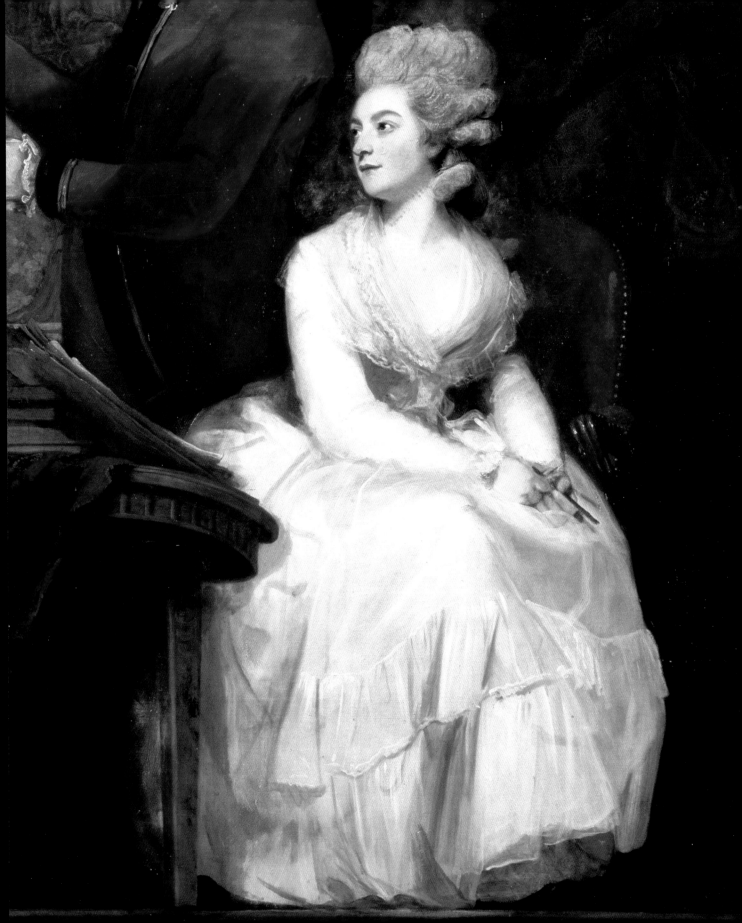

Introduction

The Side Gallery of History

The Role of the Vicereine
of Ireland

Myles Campbell

On Sunday we went to the Castle Chappel [sic]. The Lord Lieut[enant] sits
in a gallery by himself. <u>He</u> represents the King – but it would appear that <u>I</u>
do not represent the Queen, as I am not worthy to sit on his left hand, but
have a horrible dirty arm chair in a side gallery ...[1]

Such was the lot of Elizabeth, Countess of Hardwicke (1763–1858) as she came
to terms with her new position as vicereine of Ireland in July 1801. Writing from
Dublin just days after her arrival as the wife of the British monarch's representative
in Ireland, she had already become dismally aware of her status as something less
than the equivalent of a royal consort. Despite initial obeisances such as the 'low bow'
made by an official on her departure from Holyhead, which, she noted, 'confessed
my vice regality', material inequalities had now made it clear to her that the wife of
the Lord Lieutenant of Ireland, or viceroy, was not considered worthy of her own
throne at Dublin Castle in the way that the king's wife was in London.[2] If then, the
vicereine was not the consort of the viceroy in the same way that the queen was the
consort of the king, what was the nature of her position and what did her role entail?
Notwithstanding the vicereine's pre-eminent social status as the female figurehead
of Ascendancy Ireland for centuries, it is a question that has received little scholarly
attention and one that, as a result, this volume now seeks to address.

Left alone in a side gallery to ponder this question in 1801, it seems that
the Countess of Hardwicke eventually had some success in finding an answer to
it. More than a year later, in September 1802, it was reported that she was to be
accorded the status of a royal representative in Ireland in her own right:

We understand from unquestionable authority, that by his Majesty's special
command, the amiable consort of our excellent Viceroy, is in future to be
styled 'Her Excellency Lady Hardwicke,' as representing her Majesty in this
part of the united kingdom [sic]. This compliment ... we believe has not hith-
erto been conferred on the Lady of any former Lord Lieutenant ...[3]

Prompted perhaps by Lady Hardwicke's almost proto-feminist dissatisfaction with
her subordinate position as much as by the *tabula rasa* hewn by the architects of
Ireland's new political union with Britain, this departure represented the first
attempt to codify and formalize the vicereine's role. Whereas her predecessors had
often been referred to informally as 'Vice-Queen', the Countess of Hardwicke's
position as the queen consort's deputy in Ireland was now official. While this
episode serves as a rare and valuable illustration of a particular vicereine's percep-
tion of her role, on the one hand, and of official attitudes towards it, on the other,
its exceptionality precludes its application, in a general way, to the question of the
vicereine's position and its nature. As a second contemporary report implied, the
honour accorded to Lady Hardwicke as vicereine was attached to the person rather
than to the position: 'Lady Hardwicke is known to be a woman of great talents,
and her council is supposed to be of no small value. In this way, it may justly be
supposed she deserves the title of *vice-queen*.'[4] For the women who would follow

her in the role, no similar devolution of royal status would be forthcoming. In the renewed absence of any official recognition, the vicereines of Ireland were, once again, left to ponder the parameters and possibilities of their ill-defined role from the oblique vantage point of the side gallery.

If the *tabula rasa* of the new century had quickly assumed a disappointingly familiar aspect for the vicereines as they sought to mitigate the ambiguities of their position in the early 1800s, it did provide them with a foundation upon which to write some new rules of engagement. The presence of a resident vicereine in Ireland can be traced back to at least the early fourteenth century when Marguerite de Clare (d.1342), wife of Piers de Gaveston, established herself in a state of 'great pomp' in Dublin in 1308.[5] A similarly regal regime was maintained by Matilda (Maud) of Lancaster (d.1377), who was said to have 'lived like a queen in the land of Ireland' while her husband Ralph Ufford served as Justiciar from 1344 to 1346.[6] Following the Restoration in 1660, the frequency with which vicereines accompanied their husbands to Dublin as consorts gradually increased and as the pace of social and cultural life in Ascendancy Ireland quickened following the Battle of the Boyne and the Hanoverian succession, the vicereine soon became a much more familiar figure as the chatelaine of Dublin Castle.[7] It was not until 1767, however, when permanent residency was made compulsory for viceroys, that her continuing presence was more or less guaranteed.[8] With this regular presence came greater opportunities for public engagement as well as for sustained rather than fitful patronage of industrial and cultural institutions such as the Irish Silk Warehouse.[9] Throughout the palmy days of the 1780s, when social life at the Castle reached a dazzling zenith in the era of legislative independence for Ireland, the vicereine was a firm and fashionable fixture.[10] But in the aftermath of the 1798 Rebellion and the abolition of the Irish parliament in 1800, the purpose of the viceregal court in a country that was now, ostensibly at least, an integral part of the newly created United Kingdom of Great Britain and Ireland, seemed less certain.[11] As the first vicereine of the Union era, the Countess of Hardwicke sensed both the need to reaffirm the relevance of the viceregal court at this uncertain juncture and the opportunity to expand her role by helping to do so. 'It will be a good thing,' she wrote, 'to shew [show] the tradespeople that the union does not do away [with] the Court.'[12] Turning uncertainty to her advantage, she embarked on a series of fresh artistic, social and charitable initiatives that helped to set a new template for the women who would succeed her.

As the nineteenth century progressed, the old rules of engagement were gradually rewritten by vicereines who pushed the boundaries of their role through greatly increased visibility, activity and travel across Ireland, and through unprecedented levels of engagement with the newly emancipated Roman Catholic majority. By now a ubiquitous presence at schools, orphanages, hospitals and retail outlets as much as in gilded ballrooms and drawing rooms, the vicereine came to be seen as the softer face of the periodically hard-line British administration as the clamour for Irish self-determination grew louder. Her increasing identification and engagement with the social and cultural causes of the general public, and her

practical support for the poor and the marginalized, often led to an overwhelming outpouring of popular sentiment upon her departure. Through what can perhaps best be understood as the viceregal equivalent of welfare monarchism, several nineteenth-century vicereines such as Charlotte Florentia, Duchess of Northumberland (1787–1866), Maria, Marchioness of Normanby (1798–1882), and Frances Anne, Duchess of Marlborough (1822–1899) achieved extraordinary levels of popularity that few if any of the viceroys ever managed to attain. As an added advantage, the Irish origins and Catholic faith of several vicereines allowed them to identify closely with the Irish people in ways that their husbands, who were almost always English and, from 1690 to 1921 invariably Protestant, rarely could.[13] In the eyes of conservative Protestant press organs, the confessional alignment of vicereines such as Marianne, Marchioness Wellesley (1788–1853) with the Irish Catholic majority represented an unwelcome threat and evoked nightmarish visions of 'the Host' being 'carried before the illustrious lady from all the Romish Churches to Dublin Castle'.[14] Conversely for newspapers with nationalist and Catholic leanings, the provision of a viceregal guard of honour for Lady Wellesley's attendance at a 'grand High mass' in 1833 was a source of not inconsiderable satisfaction.[15]

By the early twentieth century, some popular sense of the vicereine's position and what it entailed had finally begun to emerge, as a profile of the role published in 1910 illustrates:

> The position of the wife of the Lord-Lieutenant of Ireland has been one of increasing importance, and to-day she plays a part in public life almost equal to that of her husband ... Success depends on her ability to realise the Irish point of view. That is more important than slavish adherence to points of Viceregal etiquette ... The great task of the Vicereine is to make the Castle popular. From it deeds of beneficence must flow in ceaseless succession ... The Vicereine must be an indefatigable worker. Innumerable bazaars and balls and visits to hospitals, convents, colleges, schools, and national manufactories will fill in every crevice of time ... The position of Vicereine of Ireland may be difficult and arduous enough, but it affords great possibility for interesting and benevolent work ...[16]

That this acknowledgement of the vicereine's increasingly prominent public position was published under the heading 'Women in Great Social Positions' is testament in itself to the progress the vicereines had made in carving out a meaningful role for themselves since the distant days of the Countess of Hardwicke more than a century earlier. So too are rare contemporary photographs of the vicereine's boudoir (Fig. 00.01) at the Viceregal Lodge (now Áras an Uachtaráin) and at Dublin Castle, which offer a glimpse into the private world of the vicereine at the turn of the twentieth century. Strewn with papers and writing materials, these densely furnished work spaces reflect the busy life of the vicereine and the 'enormous post-bag' she was, by now, dealing with 'every day'.[17] But in spite of all the feverish activity and social agency that often brought about meaningful improvements

in the fields of charity, the arts and healthcare in Ireland, to the advantage of the poor, the vicereines have frequently been overlooked and sometimes dismissed or misrepresented as little more than court ornaments or titular patrons of 'pet' charities, and are now largely forgotten figures in Irish history.[18]

Among the earliest attempts to write the vicereines of Ireland into history was the publication in 1912 of *The Viceroys of Ireland: The Story of the Long Line of Noblemen and their Wives who have Ruled Ireland and Irish Society for over Seven Hundred Years*. Though concerned only with the supporting role played by them as consorts, this milestone publication nonetheless highlighted the commonly overlooked efforts of vicereines such as Fermanagh-born Henrietta, Countess de Grey (1784–1848), who was credited with helping her husband to win 'the respect of all classes' in the early 1840s (see Cat. 24).[19] Its authority, however, is circumscribed by a questionable and arguably jaundiced view of the 'sectarianism' of Catholic vicereines such as Frances, Duchess of Tyrconnell (*c*.1649–1731), as well as by a fixation with the physical appearance of some vicereines that is, at best, misplaced and, at worst, misogynistic.[20]

Unbeknown to its writer, *The Viceroys of Ireland* would soon prove to be something of a requiem for a vanished institution. Ten years after the book was published, the viceregal court was swept away as part of the creation of the Irish Free State in 1922. In the decades that followed, interest in its history and legacy was understandably limited but almost a century later, a rising scholarly interest in the court and its personalities has become discernible.[21] This interest has coincided with the welcome proliferation of pioneering studies on the lives and experiences of women in Irish history.[22] But, with the exception of a landmark journal article by Rachel Wilson outlining the activities and experiences of vicereines in the early eighteenth century, and a handful of biographies of individual vicereines, these two areas of study have yet to intersect in a way that sheds light on the evolving role of the vicereine across a broad time period.[23] Writing in 2003, R.B. McDowell acknowledged that 'the vicereine was often an energetic and influential patroness of good causes in her own right'.[24] More recently, Peter Gray and Olwen Purdue have observed that the literature on the contribution of the vicereines to Irish history is limited and that this is 'an area that needs further research'.[25] This volume aims to respond to that need.

As unelected holders of an unofficial position, the vicereines of Ireland were largely left alone to define the role as they saw fit. Operating with only a fraction of the official support and guidance available to their husbands, whose duties were much more clearly defined, but without much of the restrictive bureaucratic oversight associated with such support, they were often able to shape the role according to their own interests. Once the routine ceremonial and social obligations of the early months of the year at Dublin Castle had been fulfilled (Fig. 00.02), this creative freedom enabled the vicereine to pursue as many or as few causes as time and enthusiasm allowed, across any number of areas of interest. In this way, the position of vicereine evolved not in line with official policy but largely in accordance with the individual personality and energy of the woman who occupied it

Fig. 00.02.

Unknown photographer

The presentation of debutantes at a drawing room held by the vicereine, Ishbel, Countess of Aberdeen, and her husband, in St Patrick's Hall at Dublin Castle

c.1906–14

Reproduced courtesy of the National Library of Ireland.

at any given time. For this reason, and in the absence of an official series of papers pertaining to the role, it is to the private papers, portraits and personal objects of these individual women that this volume turns, as a means of charting the evolution of the position from the late seventeeth to the early twentieth century.

Arranged as a series of individual studies of individual vicereines, this bipartite volume of essays and catalogue entries aims to bring together text and image to create new and vivid portraits of these forgotten women and their contributions to Irish life. The possibilities and limitations of historical portraiture as a medium for reflecting the public impact of the female sitter, rather than for merely recording her social rank or familial responsibilities, is an implicit concern across the catalogue entries featured in this book. Whereas official and unofficial portraits of the viceroys of Ireland regularly include military uniforms, medals, books and other signifiers of their public activities and achievements, depictions of their wives tend to emphasize qualities such as gentleness and loyalty, through the inclusion of flowers and animals, but rarely offer clues to their wider talents, concerns and public activities in a similar way. This volume accordingly seeks to augment and question the images projected in portraits of certain vicereines by examining them in the context of written records that sometimes paint an alternative picture of the sitter's public life.

Though the activities of the vicereines differed considerably over time, their main spheres of activity and influence remained relatively constant from the seventeenth to the twentieth century. Chief among these was charity work, which is a recurring theme across several of the essays and entries in this volume. As vicereine in the first decade of the eighteenth century, Mary, Duchess of Ormond (1665–1733) was one of the earliest to use her position for the benefit of the poor by developing Ireland's first workhouse (Fig. 00.03; see also Cats 03 & 04). Under the early Georgian monarchs, charitable and cultural causes combined in novel ways to propel vicereines like Frances, Baroness Carteret (1694–1743) into the public consciousness as dedicatees of literary works, thereby increasing the pres-

Fig. 00.03.

After T. Bowles

Front elevation of the Workhouse on James's Street, Dublin, Ireland

1766

Reproduced courtesy of the National Library of Ireland.

Fig. 00.04.

Unknown artist

The Countess of Hardwicke

1801

Published in *Walker's Hibernian Magazine*, December 1801. Reproduced courtesy of the National Library of Ireland.

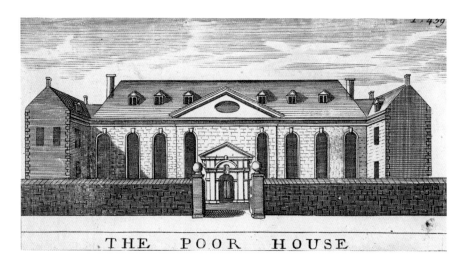

THE POOR HOUSE

sure for a charitable response (see Cats 06 & 07). The case of Mary, Marchioness of Buckingham (1758–1812), who was vicereine on two separate occasions in the 1780s (see Cats 12 & 13), highlights the challenging balance many vicereines had to strike between responding adequately to these philanthropic pressures while at the same time fulfilling their own arduous maternal and conjugal responsibilities. Thrust into the spotlight of the viceroyalty at the age of only 24, having scarcely had time to recover from the death of her infant daughter, Lady Buckingham's public fundraising efforts on behalf of the Dublin Lying-In Hospital (now the Rotunda Hospital) seem all the more heroic in light of her private struggles, as Janice Morris reveals in her essay in this volume (see Chapter Three). By the turn of the nineteenth century, vicereines were beginning to concentrate their efforts on measures that not only helped the poor, through direct acts of charity, but also provided structures that helped them to help themselves. At the forefront of this ideological shift was Elizabeth, Countess of Hardwicke (Fig. 00.04) who, in 1805, looked to Manchester for a sustainable model of charitable enterprise when she established the Charitable Repository in Dublin. This important institution provided struggling artisans with an outlet through which to sell the fruit of their looms. Frequented by fashionable figures and supported by successive vicereines, it would remain a cornerstone of the city's charitable infrastructure for decades

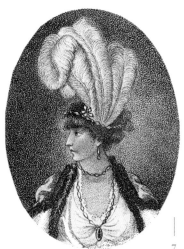

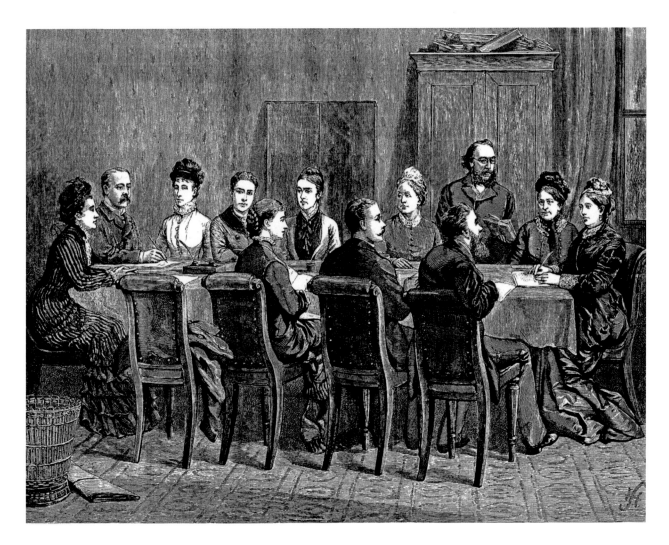

Fig. 00.05.

After **Harry Hamilton Johnston**

The Distress in Ireland: The Duchess of Marlborough's Relief Fund

1880

Frances Anne, Duchess of Marlborough is depicted at the head of the table, near the window.

Published in *The Graphic*, 27 March 1880. Bridgeman Images.

(see Cat. 17). Towering above the many fundraising efforts of her fellow vicereines is that of Frances Anne, Duchess of Marlborough, the paternal grandmother of Sir Winston Churchill. When, in 1879, a deepening agricultural depression threatened to bring about a repeat of the Great Famine of the 1840s, Frances moved quickly to set up and lead an international relief fund that eventually raised the equivalent of an astonishing €9.6 million (see Cat. 26). 'I may seem a useless old woman now,' she later remarked to another grandson, 'but this … will show you I was once of some importance and did good in my day' (Fig. 00.05).[26]

Vicereines also did much good in various branches of the arts, particularly in the fields of fine art, interior design, music, literature and, most especially, fashion and textiles. Throughout the eighteenth century, the focus of women such as Caroline, Countess of Buckinghamshire (c.1755–1817), who cut a stylish figure as vicereine in the 1770s (Fig. 00.06), was on supporting Irish artisans by buying and wearing Irish silks and thereby setting an example for elite women to follow (see Cat. 10). This paternalistic form of support, though often well-meaning, was ultimately of finite value unless in the hands of prodigious spenders

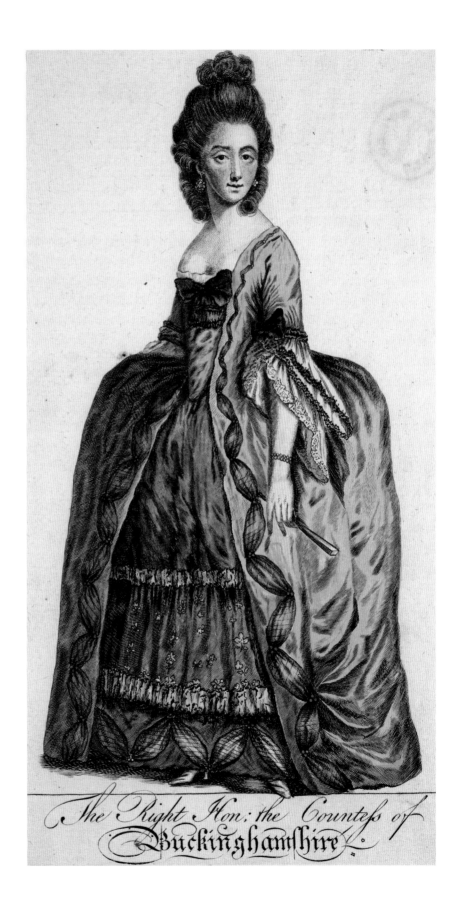

The Right Hon: the Countess of Buckinghamshire.

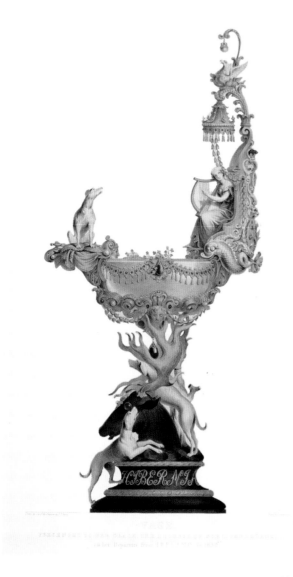

such as Mary Isabella, Duchess of Rutland (1756–1831). As Rachel Wilson demonstrates in her essay, exceptionally lavish patronage and all-night entertainments at Dublin Castle were the essential ingredients of the Duchess's recipe for success as vicereine in the 1780s (see Chapter Four). Combined liberally, they guaranteed the success of her husband's initially unpalatable viceroyalty, but ultimately at a tragically high financial and personal cost (see Cats 14 & 15). While this top-down model of cultural patronage endured well into the nineteenth century, it was gradually complemented by more ambitious, co-ordinated initiatives aimed at empowering artists and artisans. During the tenure of Charlotte Florentia, Duchess of Northumberland from 1829 to 1830, commissions, purchases and visits to exhibitions all signalled the vicereine's support for Irish artists such as Martin Cregan and Henry Kirchhoffer in the traditional way (see Cats 19 & 20). At the same time, however, her role in forming the Irish Ladies' Patriotic Association for the encouragement of fabric weaving represented a move towards a more sustainable approach. It earned her the plaudits not only of elite women in and around Dublin, who honoured her with an allegorical Irish-made vase, but also the respect of Daniel O'Connell's supporters, who put aside political animosities towards her husband to acknowledge the 'infinite good' she was doing (Fig. 00.07; see also Cat. 21).

The arrival of Maria, Marchioness of Normanby as vicereine, less than five years later, marked a major turning point in the relationship between the vicereine and the Irish people (see Cats 22 & 23). Having witnessed the emancipation of black slaves during her husband's governorship of Jamaica, one of whom she adopted as an orphan and brought with her to Dublin, she arrived in Ireland impatient to deliver social justice for a people that, in her own words, had 'never received justice from any English sovereign before'.[27] By designing, promoting and securing royal warrants and orders for Irish poplin (Fig. 00.08), by facilitating the diversification of Irish fabric production and by creating rich interiors at Dublin Castle, which served as a patriotic shop window for the best of Irish craftsmanship, Lady Normanby demonstrated an awareness of Ireland's artistic and cultural potential that was matched by few of her male contemporaries in the British administration (see Chapter Five).

Part of Lady Normanby's success as vicereine lay in her non-partisan, apolitical approach to discharging her duties. Whereas her predecessors had often moved to isolate the political foes and cultivate the political allies of their husbands, Lady Normanby considered it essential to entertain politicians of all hues at Dublin

Fig. 00.07.

After E.T. Parris

Vase, Presented to Her Grace the Duchess of Northumberland on her Departure from Ireland, in 1830

c.1830

© Collection of the Duke of Northumberland, Alnwick Castle.

Castle, including Daniel O'Connell, and to face down the vested interests of what she referred to as 'violent Orangemen' and the powerful Protestant minority. That the opposite approach taken by Elizabeth, Duchess of Ormonde (1615–1684) in the seventeenth century was, as Naomi McAreavey explores, equally successful, is a measure of how the shifting profile of the vicereine's public audience was shaped by the changing socio-political circumstances of the day (see Chapter One). Few vicereines could have been more aware of this truth than Frances, Duchess of Tyrconnell (c.1649–1731) who, as Frances Nolan outlines in her essay, paid a cripplingly high price for her Catholic and Jacobite convictions as vicereine when she found herself on the wrong side of history after the Battle of the Boyne (see Chapter Two; see also Cats 01 & 02). Similarly, for Theresa, Marchioness of Londonderry (1856–1919), whose riches were expended to a large degree in service of Ireland's political union with Britain during her time in the role, as Neil

Fig. 00.08.

Richard Atkinson and Co.

Irish brocaded poplin sample

c.1850

Victoria and Albert Museum, London.

Watt demonstrates, the initially healthy return on investment would ultimately be devalued by partition shortly after her death (see Chapter Six; see also Cat. 28). Of the handful of vicereines who became invested in the competing political cause of Home Rule for Ireland, the name of Ishbel, Countess of Aberdeen (1857–1939) looms largest. As Éimear O'Connor reveals in her essay, Lady Aberdeen's extraordinary personal investment in the lives of the sick, the powerless and the vulnerable in Ireland both exploited and transcended the political status quo to yield life-saving returns in the fight against tuberculosis in the early twentieth century (see Chapter Seven; see also Cats 30 & 31).

For every vicereine whose contribution to Irish life is examined in this book, there are still more whose efforts have yet to be more widely understood. Among the most influential of these women was Rachel, Countess of Dudley (1867–1920), whose pioneering district nurse scheme in remote parts of the west of Ireland in the early 1900s was the forerunner of the modern public health nursing system (Fig. 00.09).[28] But there are more women, too, whose tenure as vicereine struck a discordant note or saw little progress in any of the areas discussed above. For some of these women, the uneven playing field set out by frequent pregnancies, familial responsibilities, feelings of powerlessness and short stays on Irish soil left little time or opportunity to build on the meaningful interventions of their predecessors. For others, ignorance, arrogance or apathy appears to have held them back. Fresh from what she described as an 'extremely magnificent' way of living as the wife of the British ambassador at Paris, Isabella, Countess of Hertford (1726–1782) found her social obligations as vicereine less to her taste when she arrived in Dublin in 1765 (Fig. 00.10).[29] Writing in January 1766, Lady Louisa Conolly of Castletown House, County Kildare bemoaned the Countess's unwillingness to respond to the

particular demands of the Irish social milieu: 'Lady Hert-
ford has given it out that she likes small parties like those
at Paris which don't at all do here, for by that means half
the people are left out ... Don't you think it tiresome to
want to metamorphose poor little Dub[lin] into Paris
[?].'[30] More poignantly, one visitor to a drawing room held
at Dublin Castle in 1849 by the then vicereine Katharine,
Countess of Clarendon (1810–1874), at the height of the
Great Famine, noted a similar but more disturbing lack
of engagement with the Irish perspective. 'There were
many handsome, and some shabby dresses,' she noted,
'but it seemed odd to see so splendid a scene in a land of
famine and misery.'[31]

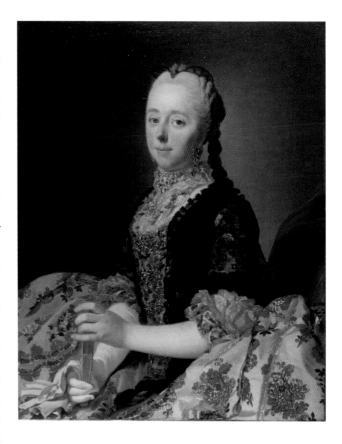

While this book represents an attempt to record
and interpret the identities, actions and experiences
of an unprecedentedly large number of women who
served as vicereine of Ireland across several centuries,
it is necessarily selective. Further research into the lives
of the women it profiles, and into those it does not (Fig.
00.11), as well as into broader contextual themes, such as
the comparative experiences of vicereines in countries
like India, and the relative significance of the position
of vicereine as an outlet for exercising female power in
a patriarchal society, is needed.[32] Based on the diverse and often highly ambitious
activities highlighted in this book, however, it would appear that the actions of the
vicereines of Ireland serve as important and hitherto largely overlooked illustra-
tions of the ways in which elite women accessed and exercised power in Ireland
and Britain in the period under study. Their activities also point to the value of a
more inclusive and multi-faceted reading of the workings of British rule in Ireland
based on female social and cultural initiatives rather than principally or exclusively
on male administrative and political activities.

In 1843, the then viceroy of Ireland Thomas, Earl de Grey, set about creating
a gallery of portraits at Dublin Castle to honour each of the men who had served as
viceroy since 1800.[33] With matching heraldic frames crafted by the Dublin-based
carver Cornelius de Groot, the first thirteen portraits, including de Grey's own
likeness by George Bullock, set a template for a series of portrait commissions
that would continue until the troubled years of the early twentieth century (Fig.
00.12).[34] Surveying this gallery on a visit to Dublin Castle in the 1860s, Charles Dick-
ens was struck more by the narrative value than the artistic merits of its contents.
'A study of these portraits,' he wrote, 'is full of profit, and in these faces we might
almost read the story of the government of the country. For here are clever, and
weak, and cunning faces ...'[35] Today, the story read by the hundreds of thousands
of visitors who pass by these same paintings in the Portrait Gallery at Dublin
Castle annually is remarkably similar to that read by Dickens on his visit all those

(opposite)

Fig. 00.09.

Hayman Seleg Mendelssohn
(photographed by)

Rachel (née Gurney), Countess
of Dudley

c.1891

© National Portrait Gallery,
London.

Fig. 00.10.

Alexander Roslin

Isabella, Countess of Hertford

1765

© The Hunterian, University of
Glasgow.

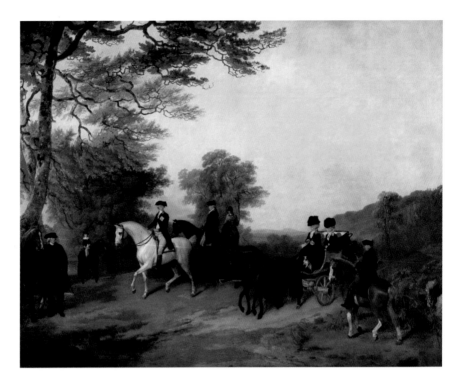

years ago. Then, as now, it is an incomplete story; one that leaves no room for the women who were the faces of the British administration in Ireland for so long. For them, there was to be no commemorative portrait gallery. But as the essays and entries in this book demonstrate, many of the women who served as vicereine of Ireland, whether motivated by personal and political self-interest or genuine altruism, touched the lives of the Irish people in ways that their husbands rarely did or rarely could. Many made a real and tangible difference to the fortunes of the destitute, the sick and the poor in Ireland. Many helped to bridge the religious divide by reaching out to the disenfranchised Catholic majority. Many spoke up for and engaged closely with those who could not speak for themselves – orphans, people of colour, prostitutes, struggling artisans, and female workers (Fig. 00.13) – and kept valuable records of humble Irish lives that would otherwise be lost to history. And many did more than just one of these things. As they went about their work, they faced numerous challenges on account of their gender and the ambiguous boundaries of their position. But for ambitious, self-motivated women, the role of vicereine provided a vital channel through which to exercise power in the public interest, and exercise it they often did. More than a century and a half after Dickens visited the Portrait Gallery at Dublin Castle, it is hoped that a study of the alternative collection of female portraits presented in this book will likewise be 'full of profit'. In the equally clever, weak and cunning faces that stare out from this book's pages, we might well read a different story of the government of Ireland, one told not through its men but through its women, who, alongside the Countess of Hardwicke, are finally beginning to emerge from the side gallery of history.

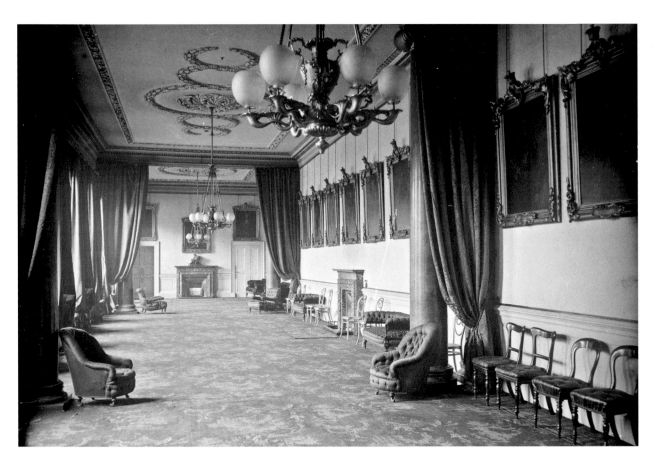

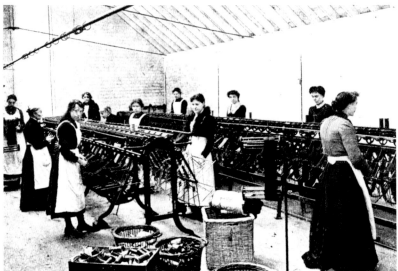

Endnotes

1 Letter to Agneta Yorke from Elizabeth, Countess of Hardwicke, 24 July 1801, Yorke Family Papers, Cambridgeshire Archives, 408/F1/16.

2 Ibid.

3 *Saunders's News-Letter*, 15 September 1802.

4 *Morning Post*, 21 September 1802.

5 J.T. Gilbert, *History of the Viceroys of Ireland; With Notices of the Castle of Dublin and its Chief Occupants in Former Times* (Dublin: James Duffy, 1865), p. 127.

6 B. Williams, 'The Dominican Annals of Dublin', in S. Duffy (ed.), *Medieval Dublin II* (Dublin: Four Courts Press, 2001), p. 165. I am grateful to Peter Crooks for bringing this source to my attention. See also Gilbert, *History of the Viceroys*, p. 198.

7 See R. Wilson, 'The Vicereines of Ireland and the Transformation of the Dublin Court, c.1703–1737', *The Court Historian*, 19, 1 (June 2014), pp. 3–28.

8 J. Kelly, 'Residential and Non-Residential Lords Lieutenant – The Viceroyalty 1703–1790', in P. Gray and O. Purdue (eds), *The Irish Lord Lieutenancy, c.1541–1922* (Dublin: University College Dublin Press, 2012), p. 67.

9 See M. Dunlevy, *Pomp and Poverty: A History of Silk in Ireland* (London: Yale University Press, 2011), pp. 80–2.

10 See C. Maxwell, *Dublin under the Georges 1714–1830* (London: Faber and Faber, 1956), pp. 110–11; J. Robins, *Champagne & Silver Buckles: The Viceregal Court at Dublin Castle 1700–1922* (Dublin: The Lilliput Press, 2001), pp. 66–79.

11 For the changing nature of the viceroyalty in the early years of the Union period and contemporary debate about its future, see J. Hill, 'The Building of the Chapel Royal, 1807–14', in M. Campbell and W. Derham (eds), *The Chapel Royal, Dublin Castle: An Architectural History* (Dublin: Office of Public Works, 2015), p. 41.

12 Letter to Agneta Yorke from Elizabeth, Countess of Hardwicke, 24 July 1801, Yorke Family Papers, Cambridgeshire Archives, 408/F1/16.

13 Among the notable vicereines of Irish origin in the eighteenth and nineteenth centuries were Caroline, Countess of Buckinghamshire (c.1755–1817) whose family seat was Castletown House, County Kildare; Frances Thomasine, Countess Talbot (1782–1819) who was raised at Beauparc, County Meath; and Henrietta, Countess de Grey (1784–1848) who grew up at Florence Court, County Fermanagh. Mary, Marchioness of Buckingham (1758–1812) and Marianne, Marchioness Wellesley (1788–1853) were Roman Catholics.

14 *Dublin Evening Packet and Correspondent*, 5 December 1833. See also A. Fraser, *The King and the Catholics: The Fight for Rights 1829* (London: Weidenfeld & Nicolson, 2018), pp. 152–3.

15 *Dublin Evening Packet and Correspondent*, 5 December 1833. See also *Freeman's Journal*, 4 December 1833.

16 S.A. Tooley, 'Women in Great Social Positions: The Vicereine of Ireland', in *Every Woman's Encyclopaedia* (London: s.n., 1910), vol. 1, pp. 216–17.

17 Ibid., p. 217. A photograph of the vicereine's boudoir at Dublin Castle was published in 1893. It depicts the poet and novelist Florence Henniker (1855–1923) seated at the vicereine's writing table during her time fulfilling the duties of vicereine for her widowed brother Robert, 2nd Baron Houghton (later 1st Marquess of Crewe), who was viceroy from 1892 to 1895. The boudoir is the last (easternmost) room in the suite of first-floor spaces now known as the State Apartment Galleries at Dublin Castle. For the 1893 photograph, see *The Idler Magazine*, 3 (May 1893).

18 E. Fingall, *Seventy Years Young: Memories of Elizabeth, Countess of Fingall* (Dublin: The Lilliput Press, 1991), p. 164.

19 C. O'Mahony, *The Viceroys of Ireland* (London: John Long, 1912) p. 243.

20 Ibid., p. 113.

21 See, for example, Gray and Purdue (eds), *The Irish Lord Lieutenancy;* R.B. McDowell, 'The Court of Dublin Castle', in R.B. McDowell, *Historical Essays 1938–2001* (Dublin: The Lilliput Press, 2003), pp. 1–52; R. Wilson, '"Our late most excellent viceroy": Irish Responses to the Death of the Duke of Rutland in 1787', *Journal for Eighteenth-Century Studies*, 42, 1 (Spring 2019), pp. 67–83; M. Campbell and W. Derham (eds), *Making Majesty: The Throne Room at Dublin Castle, A Cultural History* (Dublin: Irish Academic Press, 2017).

22 See, for example, M. O'Dowd, *A History of Women in Ireland, 1500–1800* (London: Routledge, 2014); R. Wilson, *Elite Women in Ascendancy Ireland, 1690–1745: Imitation and Innovation* (Woodbridge: The Boydell Press, 2015); M. MacCurtain and M. O'Dowd (eds), *Women in Early Modern Ireland* (Edinburgh: Edinburgh University Press, 1991); G. Meaney, M. O'Dowd and B. Whelan, *Reading the Irish Woman: Studies in Cultural Encounters and Exchange, 1714–1960* (Liverpool: Liverpool University Press, 2013); A. Hayes and D. Urquhart (eds), *The Irish Women's History Reader* (London: Routledge, 2001); D. Urquhart and A. Hayes (eds), *Irish Women's History* (Dublin: Irish Academic Press, 2004).

23 See Wilson, 'The Vicereines of Ireland'. For individual vicereines see, for instance, M.E. Forster, *Churchill's Grandmama: Frances, 7th Duchess of Marlborough* (Stroud: The History Press, 2010); É. O'Connor, '(Ad)dressing Home Rule: Irish Home Industries, the Throne Room and Lady Aberdeen's Modern Modes of Display', in Campbell and Derham (eds), *Making Majesty,* pp. 237–63; P. Maume, 'Lady Microbe and the Kailyard Viceroy: The Aberdeen Viceroyalty, Welfare Monarchy, and the Politics of Philanthropy', in Gray and Purdue (eds), *The Irish*

Lord Lieutenancy, pp. 199–214; M. Pentland, *A Bonnie Fechter: The Life of Ishbel Marjoribanks, Marchioness of Aberdeen & Temair, G.B.E., LL.D., J.P., 1857 to 1939* (London: B.T. Batsford Ltd, 1952); E.H. Chalus, 'Manners [née Somerset], Mary Isabella, duchess of Rutland (1756–1831)', in H.C.G. Matthew and B. Harrison (eds), *Oxford Dictionary of National Biography* (Oxford: Oxford University Press, 2004), vol. 36, pp. 472–4; P. Sergeant, *Little Jennings and Fighting Dick Talbot* (London: Hutchinson & Co., 1913), 2 vols; F. Seymour, *Charlotte, Countess Spencer: A Memoir* (Northampton: W. Mark, 1907); R. Trethewey, *Mistress of the Arts: The Passionate Life of Georgina, Duchess of Bedford* (London: Review, 2002).

24 See McDowell, 'The Court of Dublin Castle', p. 26.

25 P. Gray and O. Purdue, 'Introduction: The Irish Lord Lieutenancy, c.1541–1922', in Gray and Purdue (eds), *The Irish Lord Lieutenancy*, p. 6.

26 See Forster, *Churchill's Grandmama*, p. 140.

27 Letter to Constantine, Marquess of Normanby from Maria, Marchioness of Normanby, 18 August 1838, Mulgrave Castle Archives, NN/302.

28 See C. Breathnach, 'Lady Dudley's District Nursing Scheme and the Congested Districts Board, 1903–1923', in M.H. Preston and M. Ó hÓgartaigh (eds), *Gender and Medicine in Ireland, 1700–1950* (New York: Syracuse University Press, 2012), pp. 138–53.

29 H. Jacobsen, 'Magnificent Display: European Ambassadorial Visitors', in D. Kisluk-Grosheide and B. Rondot (eds), *Visitors to Versailles* (New York: The Metropolitan Museum of Art, 2018), p. 107.

30 Letter to Lady Sarah Bunbury from Lady Louisa Conolly, 19 January 1766, Conolly Archive, OPW-Maynooth University Archive and Research Centre, Castletown House, PP/CON/4/2.

31 Letter to Lady Smythe from Anna, Baroness Bellew, 29 January 1849, Bellew Family Papers, Barmeath Castle.

32 For a useful contextual study of the ways in which elite women exercised power and authority within the constraints of a patriarchal society in Victorian Britain, see K.D. Reynolds, *Aristocratic Women and Political Society in Victorian Britain* (Oxford: Clarendon Press, 1998).

33 Anon., 'Portrait Gallery at Dublin Castle', *The Gentleman's Magazine* (December 1843), p. 643.

34 Ibid. The portrait of Earl de Grey by Bullock has hitherto been attributed to Frederick Richard Say; see R. Kennedy, *Dublin Castle Art* (Dublin: Office of Public Works, 1999), pp. 43–5. For the design and production of the first thirteen heraldic frames for the Portrait Gallery at Dublin Castle, see record of a proposal from Cornelius de Groot forwarded to Jacob Owen, undated [April/May 1843], OPW letter book, National Archives of Ireland, OPW1/1/2/7.

35 C. Dickens, 'The Castle of Dublin', *All the Year Round*, 15, 370 (26 May 1866), p. 464.

One

'The Goverment of the Familie'

The First Duchess of
Ormonde's Understanding
of the Role of Vicereine

Naomi McAreavey

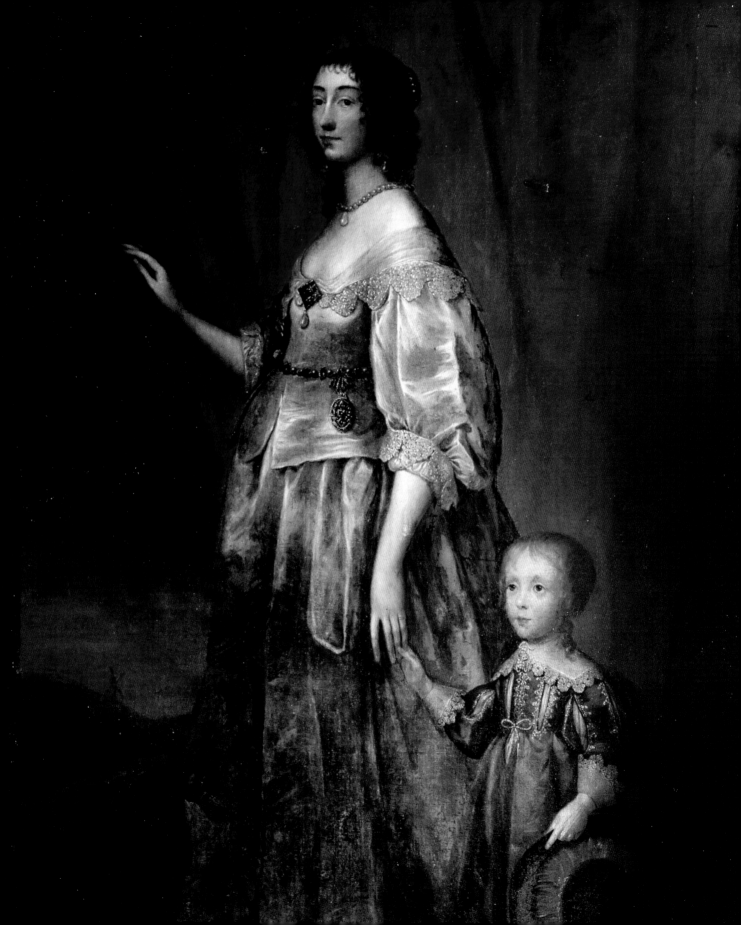

James, 1st Duke of Ormonde and his wife Elizabeth (née Preston, 1615–1684), Duchess of Ormonde, made their triumphal entry into Dublin as the new viceregal couple on Sunday 27 July 1662, accompanied by what John Evelyn described as an 'extraordinary retinue'.[1] During this, the Duke's second term as viceroy, the couple oversaw the significant development of the viceregal court as well as the flourishing of Dublin's literary culture. The celebrated poet, Katherine Philips (1632–1664), came to Ireland at this time, and she became part of a coterie developing around the Duke and Duchess of Ormonde.[2] Philips seems to have begun work on her translation of Pierre Corneille's tragedy, *La Mort de Pompée*, in Dublin, and less than a month after her arrival, she wrote that the Earl of Orrery (a playwright himself) had read a portion of the manuscript and urged her to complete it.[3] *Pompey* would be the first original play performed in the new Theatre Royal at Smock Alley when it was staged on 10 February 1663. Smock Alley theatre had opened under the Duke of Ormonde's patronage less than four months earlier as a replacement for the defunct Werburgh Street theatre where James Shirley had been resident in the late 1630s. Philips's letters suggest that the Duchess of Ormonde might have shared her husband's enthusiasm for the theatre, since she 'would not be refus'd' a copy of Philips's play, and also allowed 'several persons to take Copies' from the manuscript.[4] The Duchess also seems to have helped bring the play to the stage: Philips notes that 'by her Order', one Monsieur le Grande, a painter who was in the Duchess's employ, set the fourth song of *Pompey* to music.[5] It is likely that the 'Monsieur le Grande' in question was the Anglo-French painter David des Granges (*c.*1610–1671/2), who may have been the artist responsible for a full-length portrait of the Duchess and her son, Lord Ossory, which dates from about 1637 (Fig. 01.01).[6] Evidently, the Duchess of Ormonde was closely engaged in the development of the cultural life of the viceregal court from the beginning of her time in Dublin.

Unfortunately, we learn none of this from the Duchess of Ormonde's own surviving correspondence.[7] Extant letters tell us nothing about these events, nor about her experiences as vicereine in Restoration Dublin. This second viceregal period is under-represented in her extant correspondence, and the letters that survive tend to focus on business or other matters, offering little insight into her activities and experiences as vicereine. We are fortunate, however, that one of the largest collections of her extant letters focusses on the period in which her husband was dismissed from his second term as viceroy following questions about his execution of the land settlement.[8] There are about 100 letters from this period, starting in September 1668, when the Duchess was reunited with her husband in London after his recall, and extending to May 1672, when Arthur Capel, 1st Earl of Essex (1631–1683) was named as the new viceroy – the third viceroy appointed in the three years following the Duke of Ormonde's dismissal (Fig. 01.02).[9] Most of the letters are written from England to Captain George Mathew, the Duke's half-brother and the couple's estate manager. However, there are also six letters written to her husband during her short visit to Ireland in early summer 1669. The letters are largely concerned with the family's political interests in Ireland during a period when they had been seriously undermined. At this vulnerable time, the

Duchess was alert to the danger of interception, on one occasion telling Mathew: 'I shallnot speake my thoughts to you in that nor anye other subgect I consider unfitt for others veue [view] … sense I have some resone to dout it will not be sayfe to doe.'[10] Despite this, the letters offer valuable insight into the couple's experiences as the outgoing viceroy and vicereine, particularly in terms of their changing political position in Ireland.

The Duchess of Ormonde's letters, written as she was coming to terms with a new life beyond the walls of Dublin Castle, offer valuable evidence of her understanding of the role and responsibilities of the vicereine. For her, the vicereine's primary role was to support her husband, the viceroy, and to help uphold his political position. She saw the viceroyalty as the most powerful political position in Ireland and one for which her husband was the natural choice. If the viceroy was responsible for the good government of Ireland as the king's representative, she believed that the vicereine was responsible for the good government of the viceregal family and household as the viceroy's representative. Thus, when her eldest son was serving as lord deputy, in his father's absence from Dublin as viceroy, she insisted in the strongest terms that her daughter-in-law 'bee

Fig. 01.02.

Letter to Captain George Mathew from Elizabeth, Duchess of Ormonde

22 November 1668

Reproduced courtesy of the National Library of Ireland.

Consernede [with] the Goverment of the Familie'.[11] The language she adopted signals her understanding of the politicization of the family of the viceroy, characterized by a conception that the 'Goverment' of the family and household reflect the government of the State. The Duchess understood that the viceroy's family had the potential to confer honour or dishonour on him, and thus to support or undermine his position. Since the good government of his family helped to bolster the viceroy's political authority, the Duchess saw the role of vicereine as having a distinctly political inflection.

The letters of the Duchess of Ormonde reveal that she believed the vicereine was responsible for maintaining the honour, and appearance of honour, of the family. Honour is a complex virtue that she defined in relation to the family's reputation for exemplary conduct. As vicereine, she took upon herself the role of safeguarding the family's honourable reputation by overseeing the well-ordered households of her family. This work was supported by a financial resilience that is reflected in the careful management of debt and credit, and which, in turn, funded the maintenance of the magnificence and splendour needed to sustain the position. Ironically, these responsibilities were brought into focus when her husband's position was threatened and circumstances forced her to take a tighter rein on the family. When the Duke lost the viceroyalty, it was the Duchess who oversaw the family's withdrawal from Dublin Castle, which largely involved the discreet

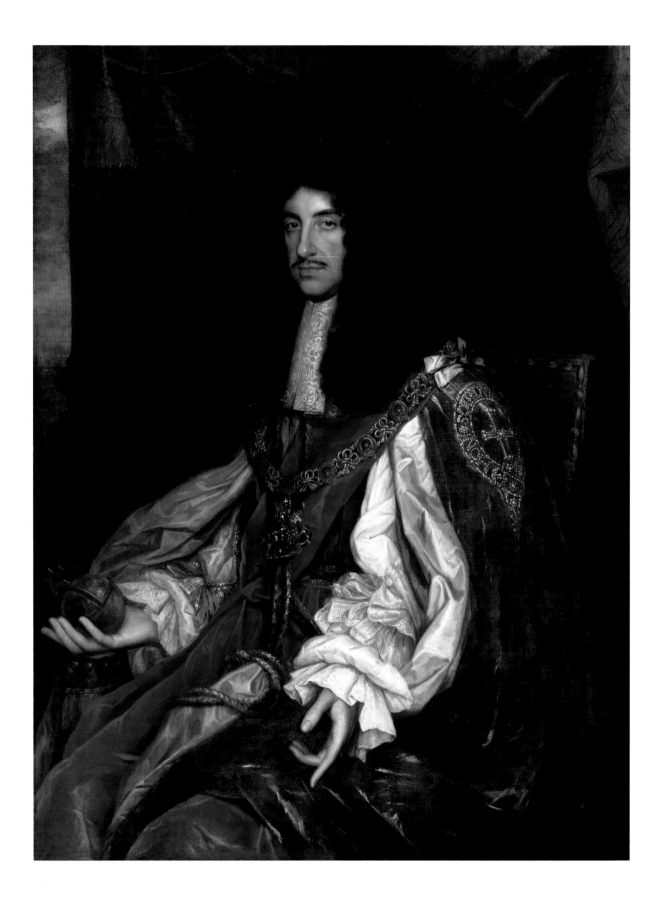

retrenchment of the family and the ordered removal of their property from Dublin to Kilkenny. As she facilitated the family's return to Kilkenny Castle from the viceregal properties, she ensured that the family retained some influence in Dublin by making friends with the incoming viceroy and his wife and helping to ease their move to Ireland by giving them practical support and introducing them to their social network. But the Duchess also tried to strengthen the family's position in Ireland by consolidating their local power base in Kilkenny. Representing her absent husband, she made a public visit to Ireland, leading a procession from Dublin to Kilkenny; she also tried to fortify Kilkenny Castle as the ancient seat of the Ormonde Butler family. Overall, the letters reveal that the Duchess of Ormonde understood the role of vicereine as a distinctly gendered one in which she supported her husband's political career by helping to maintain the honour, influence and resilience of the family, evidence for which will be discussed in this essay. The first section of the essay will examine the Duchess's understanding of the vicereine's role in supporting the political position of the viceroy. The second section will explore her sense of the vicereine's responsibility for maintaining the honourable reputation of the family. The third section will outline the Duchess's strategies for helping to preserve the family's influence in Dublin Castle and in Ireland despite her husband's dismissal as viceroy. Ultimately, the essay will assert the Duchess of Ormonde's belief that the viceregal Sword of State naturally belonged to her husband, and will demonstrate that she saw her own role as tied to the 'Goverment' – of the family and of Ireland.

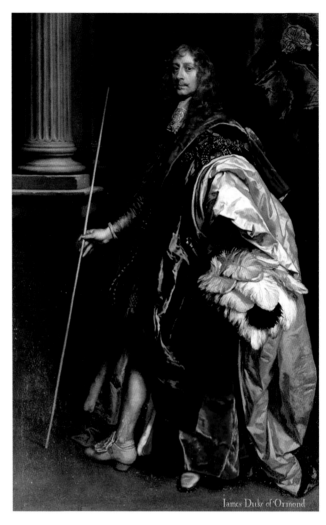

(opposite)

Fig. 01.03.

John Michael Wright

King Charles II

*c.*1660–5

© National Portrait Gallery, London.

Fig. 01.04.

Sir Peter Lely

James Butler, 1st Duke of Ormonde

1662

Courtesy of the Office of Public Works, Kilkenny Castle.

Supporting the Political Position of the Viceroy

The Duchess of Ormonde saw the viceroyalty as a reflection of her husband's, and by implication the whole family's, power in Ireland, and it was, therefore, in her interests to support him in the role. Her social and emotional investment in her husband's viceregal position can be gleaned from the numerous letters she sent from London in late 1668 and early 1669 after the Duke had been recalled to court and the couple anxiously awaited the decision of King Charles II (Fig. 01.03) as to whether or not the Duke (Fig. 01.04) would continue as viceroy. On 26 October, the Duchess told Captain Mathew, her husband's half-brother and estate manager, that the Duke's fate was 'soe Litell [agreed] as Leaves uss [more in a] Conjecture then s[art]antie [certainty] of what willbee'.[12] On 14 November, she wrote: 'I am

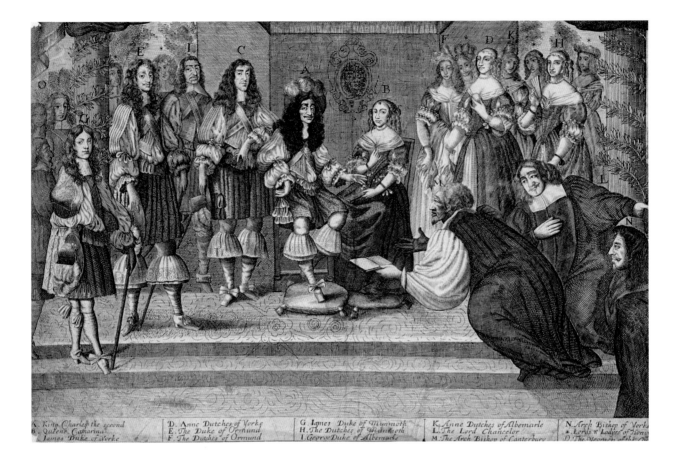

A. King Charles the second
B. Queene Catharina
C. James Duke of Yorke

D. Anne Dutches of Yorke
E. The Duke of Ormund
F. The Dutches of Ormund

G. James Duke of Munmoth
H. The Dutches of Munmoth
I. George Duke of Albemarle

K. Anne Dutches of Albemarle
L. The Lord Chancelor
M. The Arch Bishop of Canterbury

N. Arch Bishop of Yorke
* Lords & Ladyes of Hon...
O. The Yeomen of his...

of opinione that you will See My Lord [her husband] returne Lord Liftenant [viceroy] agayne in Spight of all his Enimies, this in brife is as much as I shall venter to Say, and what I suppose will Satisfie you.'[13] A short time later, she reported: 'heare is greate discourse of My Lords beinge to Leave the Goverment, but the kinge has Never spokene unto hime as yet consarninge it, and trulie I think will not upon that Subgect'.[14] By 5 December, she wrote: 'I cannot tell you for Sartane that My Lord willbee Continowed in the Goverment though it is generalie soe sayede and belevede both in the Court and Towne, by resone I see soe great Changes as I cannot beleve anye thinge Shure.'[15] And as late as 5 February, she wrote: 'though my beleufe is still that it willbee the same it was Notwithstandinge all that you heare unto the contrarye, and I think I have some resone to bee of that oppinione which it is Not convenient for mee to write'.[16] Hope and fear commingled as the Duchess speculated on her husband's political future during this prolonged period of uncertainty.

The Duchess of Ormonde complained about the couple's lack of friends and allies at court but did her bit to help strengthen their political network. In a letter written to Mathew a few days after her arrival in Whitehall (her husband had gone ahead of her as she was left to settle family business), she said: 'I have bine soe imployede in payinge my dewtie to My Beters, and reseving the serimonye of vissets, as I had not Time and Scarslie have yet to write unto anye of my Frinds.'[17] Clearly she was nurturing her friendships and alliances at court, and her husband, whom she told Mathew

had 'gone this day to wayte upon the kinge whoe has bine abrode at Bagshott and other plasses a huntinge', seems to have done the same (Fig. 01.05).[18] Later, she admitted to Mathew that if her husband managed to keep his position, 'it may bee ownede to his innosensie [innocence]' rather than 'to any favour hee has Found from anye Man that dous yet appiere; but Let this bee kept to your Selfe for it may perhaps bee beter the world should beleve hime beter befrinded then I dout hee is'.[19]

The Duchess acknowledged the political impact of her husband's diminished position at court. When her close friend Anne Hume asked her to speak to the Duke about lands she had on lease from the crown, the Duchess told Mathew that she 'immediatlie movede My Lord in, whoe tould Mee that hee belevede it a very improper time for hime to desier anye thinge of the kinge in his owne behalfe or in anye others'.[20] She relayed her husband's belief that:

> Nothinge that should come recomended by hime of this Nature but wouldbee opposede and Not only Soe but might more provablie bee a menes to questione what wass allredie granted then obtane beyond it, and therfor advisede ~~the Person~~ a Suspense as much sayfier at this time unto the Person consernede, then anye further prosidinge in that affare couldbee.[21]

The Duke and Duchess were no longer able to utilize their position at court to help their friends.[22]

The Duke of Ormonde had been recalled as viceroy due to charges of negligence and corruption levelled by his political rivals whom the Duchess characterized as jealous conspirators. She blamed her husband's recall entirely on the scheming and underhand manoeuvrings of his enemies. When she first arrived in London to support her discredited husband as he awaited his fate, she informed Mathew that 'preparations [are] on Foote when the Court returns ^to^ prosecute all the designes that are Layede against My Lord ... soe as a very Litell time will make a full discovrye of what My Lords Enimies are able to doe against hime'.[23] She never wavered in her belief in her husband's 'innosensie in Not haveinge provede Negligent or Corrupt in his Goverment'.[24] She remained convinced that her husband's enemies had set out to 'Ruene hime', adding: 'theris nothinge that Thay will, and dous more indevour, haveinge ingadged themselfes soe Farr ~~will beleve themselfes unsayfe if hee Stands~~ and therfor will Laye the Strength of ther whole Intrest upon it'.[25] The Duchess told Mathew that 'all' of her husband's 'actions were ~~ransa ransaktt~~ ransact into by his greatest Enimies'.[26] Elsewhere, she said:

ROGER Earl of ORRERY
5th Son of RICHARD Earl of CORKE.

My Lords Enimies are very industerious to gett hime out of the Goverment and all his out of Comand in Ireland tell when thay Say thay Cannot goe on in ther bussenes (what that is I Cannot tell but what is generalie belevede, is the distroction of all, if Gods Mercye and the kings wisdome dous not prevent them[)].[27]

She never entertained the possibility that there was any truth in the charges being gathered against her husband – nor did they lead to a formal impeachment – and she blamed his predicament entirely on his enemies.

The Duchess identified Roger Boyle, 1st Earl of Orrery (1621–1679) as the worst of the offenders (Fig. 01.06). The silver lining in the cloud of her husband's eventual dismissal as viceroy was Orrery's failure to obtain the viceregal position for himself: 'My Lord of Ororye is as Litell Satisfiede with this Change that is is made and the Duke of Buckingham as if my Lord had continowede,' she wrote, 'and I am of opinione that thay will Find Cause at the Least I wish it may fall out Soe, and soe I am Shure dous Many More.'[28] She hoped that the new viceroy would not be 'soe indulgent ^I supose^ to My Lord of Ororye as my lord was; hee understandinge very well what that Person has bine from the begininge and what hee is still; the most false and ingratfull Person ^Man^ livinge; and under that Estime I cane asshure you hee passes heare with all the considerable Persons of this kingdom'.[29] She went on to say: '[I hear he is] degected at the disapoyntment that hee has mett with, and soe are all his adherents; which is some satisfactione yet; and more I Expect willbee in the downfall of some Ere Longe that has bine My Lords Enimies.'[30] Orrery was unfavourably compared with her husband who, she stated, 'presarves I thank God a reputatione beyond what anye of them cane Blast, and has, at this Time the kindnes and respect of all this Natione beyond what hee Ever had'.[31]

Preserving the Honourable Reputation of the Family

The Duchess's pride in her husband's exemplary reputation was counterbalanced by her anxiety about the dishonourable conduct of her children. The most pressing of these concerns related to her eldest son, Thomas, 6th Earl of Ossory (1634–1680), who served temporarily as lord deputy in his father's absence from Ireland as viceroy from 1664 to 1665, and his wife, Emilia (Figs 01.07 & 01.08). The Duchess's expectations for Lady Ossory 'to bee Consernede [with] the Goverment of the Familie' have already been mentioned.[32] They reveal her understanding of the duties and responsibilities of the wife of a lord deputy – and by implication, of the vicereine herself; they also reveal her own role in overseeing the government of the families of her adult sons. The Duchess was alert to her daughter-in-law's perceived failings, confessing to Mathew: 'I doe feare My daughter willnot aplye hir selfe To [the responsibilities of the role].'[33] Although she was eager to avoid Emilia 'taking anye Exseptions as posiblie shee might at my findinge Fault', the Duchess asserted: 'I may very Justlie [complain] unto ^of^ hir Neglect and want of Conduct in hir affares which has made a great discovrye of hir weaknes heare and is generalie takene Notisof at the Court at which I am much troubled.'[34] The failures of her daughter-in-law as the absent vicereine's representative

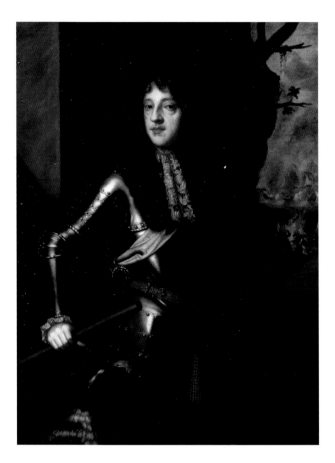

in Dublin were reaching as far as London, where they were harming the reputation of the whole family at a time when, and in a place where, they were already vulnerable.

Excellent financial management was one of the pillars of the family's reputation, yet this was one of the areas in which her daughter-in-law and other members of the family fell short. The Duchess complained that Lady Ossory 'gave to[o] Large a power unto hir Sarvants to goe on the Score without Loukinge or Correcting the Bills hir selfe'.[35] She asked Mathew to press her daughter-in-law and eldest son 'to Manadge ther Expenses with more Care'.[36] She also complained that Ossory himself was 'indepted to Many Tradsmen heare whoe complans of hime to bee a bad paymaster and I cannot but feare and suspect hime soe because that Nether [neither] hee nor his Lady dous know what ther depts are or to whom thay owe'.[37] Book-keeping was evidently the responsibility of Ossory's wife. The Duchess anxiously confessed her belief that 'ther depts at Dublin are great'.[38] She also criticized 'the Negligent way' in which her youngest son, John (later Earl of Gowran, 1643–1677) was 'orderinge his affares', which, she complained to Mathew:

> made hime to increase his depts sense Last thay were ajustede by you; and will Sartanlie bringe some Shamfull disgrase upon hime; now that ~~wee~~ his Father and I are absent, and in a Condistione besides not abell [able] to pay his depts if hee dous not himselfe uss [use] some [endea]vour towards it.[39]

By late June 1669, she numbered John's debts at £1,500 in Dublin and £1,000 in London.[40] As she anticipated the arrival of the new viceroy, she specifically mentioned that she was 'in great Feare upon the comminge over of the New Governer Lest his Creditor[s] should Fall upon hime and desier Leave to Arrest or Seue hime for his depts, which I see noe possible way to prevent'.[41] Managing her own debts, and those of her husband, was something that occupied much of the Duchess's time. At the peak of their political crisis, she told Mathew: 'I wish our depts might bee payede ofe, and then wee shouldbee the beter abble to ~~bide~~ defend our selfes.'[42] She worried about how injurious 'beinge Criede out upon for depts to mene peple wouldbee at this Time unto ~~uss all~~ My Lord and all his relations'.[43] A priority for her was to preserve the family's 'credit', which in this period was, as Craig Muldrew has compellingly shown, 'synonymous with reputation'.[44] Poor debt management could therefore be extremely damaging to the reputation of the whole family.

The Duchess of Ormonde and her family had to maintain a delicate balance in their financial affairs. High on her list of concerns was the wish to avoid 'the apperanse of ~~a trouble~~ povertie', especially when she and members of her family were serving in viceregal roles.[45] When her eldest son, Lord Ossory, was deputizing for his father as viceroy at the end of 1668, she told Mathew: 'theris nothinge canbee more important then the desent support of the Familie Ther whilst My Sonn Continows in the Goverment'.[46] When it became clear that she and her husband would be forced to remain in England for the foreseeable future, she shared with him her concerns about their financial future. She awaited news of 'the kings Leter', which she considered to be 'of Soe absolute an Nesesitie towards your Support in England as without it theris Noe possibilitie for you to Subsist'.[47] Informing her husband of Mathew's latest observations on their finances, she wrote: '[he] tells mee of prodigious Soms that has bine transmi[tted] Sense your beinge in England, which terifies mee; with the Feares of beinge Ruenede if wee must Live Ther'.[48] Small economies were important in seeking to manage the family's finances. When she had first arrived in England, she had boasted to Mathew:

> I have bine soe good a Manager of my owne, as payinge the Charge of Both the Shipes which cost mee threscore and 5 pound and 10 Shillinge a head dewtie for Evrye Horse ^besids^ ~~of My owne~~ I broght threscore pound of my 2 hundreth with mee hether, which has purchast mee all that I shall Laye out upon my Selfe untell Cristmas Next.[49]

She modelled the behaviour that she expected from other members of her family and, accordingly, was angry at the lifestyle choices of Lord John: 'I heare hee Eats constantlie at a Taverne which is not only the most Chargeble but the most discreditinge way of Living.'[50] Given her own careful economizing, she had little patience with the excesses of her youngest son.

The Duchess also had no sympathy for her eldest son's desire to move to London after his term as lord deputy ended – a move that she understood only in

terms of the accumulation of debt. She anticipated that a move to London would mean that 'in six Months hee willbee forst to Rune in dept if anye body will trust hime and not bee abble to gett ofe with the Charge of a healples wife and a Nomber of Small Children'.[51] With this damning assessment of Lady Ossory's abilities to govern her own family, she also laid part of the blame for her son's bad decision at the feet of her daughter-in-law: she scoffed at her son's plan 'to carrye his wife and Familie into England and Live at London, at the Least (Leave hir ther) where Shee has a mind to bee and goe himselfe to Itelie'.[52] Lord and Lady Ossory were censured for putting their own desires above the interests of the family, by following a course that the Duchess told the Duke 'willbee allmost as prejudistiall unto you hime and to his owne; and your Intrests'.[53]

The Duchess of Ormonde also complained further of her daughter-in-law's dishonourable behaviour. Writing to Mathew, she reported: 'I heare Shee Eats more in hir Chamber then at the Table, ^which^ is not the way to Live with that desensie [decency] that both is ^Now^ and willbee hearafter Expected from hir.'[54] In this comment, the Duchess acknowledged the need for a vicereine, as represented temporarily by her own daughter-in-law in Dublin, to prioritize public duty and display over personal comfort, and for the family to mind their manners now more than ever. Much space in the letters to Mathew is also given to complaints about her ne'er-do-well youngest son. Denouncing his expensive preferences for dining and sleeping at the aforementioned tavern, she proposed a more economical alternative:

> the Lodginge and bourdinge in Some [pri]vat House which I Longe sense proposed, would sartanlie have bine the fittest ~~course that hee could take~~ ^For Hime^ provided hee wouldnot kiepe Ieregular howers [hours] or bee disorderlie; which it is high time for hime to give over, sense it has both [redus]ede hime in his Fortune by kiepinge hime still in want ^and^ ~~[also]~~ Lessened his reputatione, amongst all persons that are [cons]iderable; for it is heare reported that hee is givene ^soe much^ to drinkinge ^as hee^ ~~and~~ Minds Nothinge Ellse; this you may Judge is noe small trouble to his Frinds.[55]

Disorderly conduct and heavy drinking came together with excessive spending to mark Lord John's behaviour as dishonourable and damaging to his reputation and that of his family.

The Duchess of Ormonde begged Mathew to intercede with her errant adult children. Of Lord and Lady Ossory, she asked Mathew to 'give them both some advise from your Selfe without Naminge mee'.[56] Of Lord John, she similarly asked Mathew:

> I pray Brothar bee Soe Charitable as onse more to trye what may bee done to make hime Sensibell of his Faults, and healpe hime in prescribinge some beter way how hee may Live within The Compas of his Fortune then as hee dous; otherwiss Let hime Never Expect that his Parents will bee Consernede for a Person that vallews not his Contianse or his honner.[57]

The Duchess relied on Mathew to do what she could not do from a distance, which was to encourage her children to behave in a way that better befitted the position of the family, at this critical time more than ever.

Maintaining Political Influence in Ireland

After five months of uncertainty, it was only on Saturday 16 February 1669 that the Duchess was at last able to write to Mathew with the news of 'what happened on sonday Last; which was My Lords dismiss from the goverment of Ireland, declarede by his Magestye; and the Lord Roberts [John Robartes, 2nd Baron Robartes of Truro] Namede to suckside hime; with the Tytell of Lord Liftenant'.[58] The abrupt and business-like style of her letter gives the impression of calmness, but the six-day delay in receiving the news and sharing it with Mathew perhaps reveals the emotional turmoil that she and her husband are likely to have endured since the King's pronouncement. It might also represent the culmination of nearly a week of conversation, advice and planning involving the Duke and Duchess and their closest advisors. The subsequent activities of the Duchess certainly suggest that the couple had carefully planned how to manage the crisis.

The Duchess of Ormonde assumed responsibility for the various tasks that were required after her husband's dismissal from office, such as overseeing her son's removal from Dublin Castle, the reduction of his household, and the removal or selling of the family's property. She sent instructions for Ossory's relocation from Dublin Castle to another of the viceregal residences, telling Mathew to prepare either the Phoenix Park or Chapelizod for her son.[59] By the time she had sent her next letter, she had decided that the Phoenix Park residence was 'a much Fitter Plase for My Sonn to bee at when he Leaves the Sword' than Chapelizod.[60] She dictated that Ossory was 'to kiepe but a private Table whilst hee is Ther, and soe dismiss as manye Sarvants of all kinds as may be sparede'.[61] And in no uncertain terms, she conveyed her expectation that Lady Ossory, no longer representing her as vicereine, and her children, would remove themselves from Dublin altogether. The Phoenix Park residence, she said, was intended 'for My Sonn Singlie to make uss [use] of, (his Lady and Chilldrene) beinge Fitter to remove with mee to killkenye som Time befor the New governors arrivall, then to be ther at that Time'.[62] The Duchess's eagerness to get Lady Ossory out of Dublin before the new viceroy's arrival indicates her poor assessment of her daughter-in-law's abilities.

The Duchess took upon herself the overall responsibility for the 'ordering of the affares of the Familie' as they withdrew from Dublin Castle.[63] This involved 'the removinge of it with and Modelinge of it as may sute our presant condistione'.[64] She sought information about the 'Familie' in Dublin, by which she meant their paid servants.[65] She aimed to reduce the size of the family, and later congratulated Mathew on his efforts to cut the number of servants:

I heare theris some retrenchments made in the Familie sense this Change of the goverment wh by Lesseninge of the Nombers of them which I doe aprove

very well of, and the more; that I hope it is done with your approbatione and advise that I am shure will consider that the best ~~are to~~ ^Sarvants^ in ther severall kinds are to bee retaynede.[66]

The Duchess was eager to remove their property so 'that Dublin Castell may bee the souner Clearede for the new Governer'.[67]

She also asked Mathew for an inventory of what remained in Dublin Castle in the hope that she would be able to sell provisions (coal, beer, hay, oats, wine), furniture (chairs, bedsteads, tables) and fixtures and fittings (such as locks and keys), to the new viceroy.[68] The Duchess recognized that the execution of these tasks provided the family with an opportunity to start building a relationship with the incoming viceroy. She emphasized the need to have the viceregal residence 'well kept; that My Lord Roberts may Find it Soe whoe I have some resone to hope willbee a Frind'.[69] In the weeks following Robartes's appointment, she spoke often to Mathew of her hopes that the new viceroy 'willbee very Just and Frindlie unto My Lord and all his relations'.[70] The Duchess made a concerted effort to ensure that Robartes *would* become a friend to the family by offering him and his wife the assistance they needed to ease their transition to government in Dublin Castle. She instructed Mathew that 'when anye Person Comes from the Lord Roberts to make provistione for hime I would have the Steward and Controwler to bee Sivell [civil] in offeringe hime anye ordenarye assistanse that hee [Should Nide]'.[71] Importantly, she had done the same with Lady Robartes, offering her 'anye thinge [in] the castell belonginge to uss that may untell hir owne Goods Comes bee ussfull [useful] to hir'.[72] The Duchess happily reported that this gesture towards her successor as vicereine 'was Extremlie well takene'.[73]

The Duchess also activated her existing female social and political network to support her developing friendship with Lady Robartes. She asked Mathew to encourage his new bride, Anne Hume, a long-standing friend of the Duchess, to make Lady Robartes welcome in Ireland: 'I pray tell my sister Mathews that my Lady Roberts did inquier for hir with great kindnes and promisises [sic] hir selfe much Content in haveinge hir Companye and Estime for shee knows Non ther but hir Selfe and My Lady of Desmond.'[74] She went on to describe Lady Robartes as '[a very] vertious and a worthye Person and goes preparede to bee verye oblidginge to all our relations and soe I doe hope thay will all bee to hir'.[75]

The Duchess oversaw these tasks at a distance. However, she was also keen to visit Ireland in person, and began to plan her trip as soon as she learned of the Duke's dismissal, telling Mathew: '[I] still hould my resolutione of goeinge for Ireland about the Midell of the Next Month Soe as I doe hope to bee ther time Enough befor the Lord Roberts his arrivall to healpe in the orderinge of the affares of the Familie.'[76] The Duchess advised Mathew that she planned to travel to Ireland on 20 April 1669.[77] The earliest surviving letter written to her husband from Ireland is dated 31 May (although in a letter dated 18 June she mentioned her husband's acknowledgement of 'the ressept of some of mine sent you befor and at the time of my Leavinge Dublin', which confirms that an earlier correspondence took place).[78]

By that stage, she had already left Dublin (where she presumably spent a month) and had recently arrived in Kilkenny. Despite the loss of correspondence from Dublin (and one wonders if this was deliberate), the surviving letters still provide some important information about her time there. She told her husband: 'upon friday Last I came from dublin accompanede with all the ~~companye~~ ^Persons of qualitie^ in Towne whoe to Exprese ther respect to you did bringe mee part of the way with the greatest conserne for your Leavinge the Goverment that ~~Ever~~ could-bee exprest'.[79] She was delighted to report that the couple still had the respect of the important people of Dublin. Her procession from Dublin to Kilkenny was not only reminiscent of the couple's arrival in Dublin as viceroy and vicereine in 1663, but also marked the movement of Ormonde Butler power from Dublin to Kilkenny, a performance that she herself enacted and led as her husband's representative.

As she prepared for her visit to Ireland, she insisted 'that noe time may bee Lost to put killkenye into a Redenes to reseve My Sonns Familie and my Selfe'.[80] Importantly, as well as providing a home for her and her son's family, she emphasized that she wanted to be able to 'make My Frinds wellcome to that Plase whilst I staye'.[81] Part of this approach was to ensure that in moving the family's things from Dublin Castle, 'the best of the[m]' should go to Kilkenny.[82] The Duchess was already overseeing repairs to Kilkenny Castle at the time of her husband's dismissal as viceroy.[83] Now that they no longer occupied Dublin Castle, the proper maintenance of Kilkenny Castle was a priority as they attempted to consolidate their position in Ireland through their local power base. When the Duchess visited Kilkenny Castle, she was happy to report to her husband that she 'found this Plase in very good condistione, and your Jese [geese] house; ~~Full~~ out of which I had some this day'.[84] She also spoke warmly of her own house, specifically 'the greatest improvments of plantings at Dunmore that Ever I saw in Soe Short a time and has made it very bewtifull by the great Nomber of Trees and the order that thay are Sett in'.[85] She was happy to reassure her husband that the family was being well represented in their absence through their houses and estate.[86]

The Duchess was eager at his time to consolidate the family's position in Ireland by strengthening their network in and around Kilkenny. During her visit to Ireland, she called on her husband's Catholic relations, including his youngest brother and his mother: 'I Laye on Night at kilcash and the ^Next^ Night at Thurles where I found my Lady your Mother well unto a wonder consideringe hir Age and very inquisitive after you.'[87] After these visits, she returned to Kilkenny Castle, where she wrote: 'I have bine tyrede [tired] with readinge Petitions; and somthinge pourer in stocke then I was by what I have givene away a Mongst my poure kindred and Frinds, whoe I hope are somthinge relivede by it.'[88] She was evidently keen to perform her duty as an aristocratic woman and landlord, and in doing so, to maintain the family's position in the area.

Writing from Ireland, she told her husband: '[I]willnot trouble you with an accompt of your greater Consarnments sense I hope to doe it by discourse with you very Shortlie.'[89] Her anxiety about the possible interception of her letters meant that she did not provide any detail about the specific nature of her activi-

ties. Nevertheless, she was bold enough to admit: 'Though I have had more trouble then plesure sense my beinge heare; yet you will Find ther was some Resone for my Cominge.'[90] Even as she endured 'with great impatianse' a delay of some three weeks as she waited for a favourable sea crossing, she told her husband: '[I] apply-ede my selfe to what Litell Conserns heare that I was capable to be ussfull in, and Espetialie ~~in~~ such perticulers as I had your derections in, wherof I hope to bringe you a good accompt.'[91] She sent her husband:

> a paper that a Frind of yours gott in Monster [Munster] amongst the Lord
> of Ororys Creaturs, that willbee thay say presented by some Nobellmen and
> gentellmen ^heare^ unto the Parlement of England [it] was givene mee but
> this day; soe as I cannot as yett Fastene upon ~~that~~ ^the^ person that gave the
> Coppie of it, but hope I shall know whoe it is befor I goe, from hense; ~~most~~
> it is all but one continowede [continued] Lie, how ever I pray Let it bee kept
> by you (at the Least untell I come); and not throwne a way for it is possible I
> may Find the oughters and gett proufs whoe thay are ~~whoe are~~ to confirme
> what is a[t] presant but suspected.[92]

The Duchess used her visit to Ireland to gather intelligence for her husband that he might then leverage for his own and his family's interests at court.

The Duchess was also keen to make longer-term arrangements for the maintenance of the family's position in Ireland when she and her husband were unable to return to Kilkenny. In a letter to her husband, she expressed her desire for her eldest son to stay in Kilkenny Castle, which she described as 'a Plase where hee may Live Soe Noblie and presarve your Intrest and his owne'.[93] She busied herself arranging a household for her son, Lord Ossory, in Kilkenny Castle, asking Mathew to ensure that 'the best ~~are to~~ ^Sarvants^ in ther severall kinds are to bee retaynede to make upe a Familie proper for My Soon [son] ossorye to kiepe at kilkenye when hee parts with the Goverment (for ther) I doe take for granted hee must reside; at the least, untell such Time as his Fathers Mony is Securede and the kingdom Settlede'.[94] She even secured a 'Clarke of the Kitchen' and a 'Larder Man' for her son 'when hee Settells himselfe at kilkenye where I doe hope hee willbee contented to spend some time untell hee Sees the publicke and his Fathers affares beter Settled then at the presant thay are'.[95]

Ossory's plans for his future diverged from his mother's, however. A short time later, she was forced to revisit her arrangements for Ossory's household servants. She told Mathew:

> I am prest to give an answar unto a Person that I am offerede, to bee Clarke
> of the kichine and I doe not well know what to resolve consarninge hime; for
> if my sone willnot Stay in Ireland; then it willbee Niedles to Entertane hime,
> and if hee doe settell himselfe in anye other Sarvise it willbee hard to gett the
> ~~a Nothar~~ ^like of This Person^ that is fitt for such an imployment, therfor
> if you Cane gess; or Find out, what My Sonn dous propose unto himselfe I

shouldbee glad to reseve [receive] some private intematione [intimation] of it from you that I might order my owne affares accordinglie, and Leave hime to Manadge his as he pleases.[96]

Despite the veneer of equanimity, the Duchess was evidently disappointed and angered by her son's decision, which she attributed, in part, to his wife. She wrote from Kilkenny to inform her husband that 'in this Plase I find that Nether of them has a mind to Staye; though I doe asshure you thay have not wanted such incoridgments as might a bundantlie [abundantly] satisfie anye resonable persons'.[97] She represented her son's residence in any place *except* Kilkenny Castle as damaging to the family. Writing to her husband, she condemned Ossory's plan to move his family to London and to spend time in Italy.[98] She also blamed her son's friends and advisers, saying that Ossory was:

> incoridged therunto by My Lord Arlingtons desiringe and wisshinge hime ther and mr Pages approvinge of what Ever My Son dous Fansie whoe hee alltogether trusts and advises with (a weake Counselor you may Say) but a very ^unluckye^ one I feare hee willbee, and his Brother in Law as bad (a Frind) if hee perswads [persuades] hime to Leave ...[99]

For the Duchess of Ormonde, the interests of the family came before the interests of the individual, and the interests of the family were best served in Ireland.

Conclusion

Although the Duchess of Ormonde had hoped that Robartes would be a friend to her family, she quickly became disillusioned with the new viceroy. As early as 24 July 1669, she shared with Mathew her hopes that her husband would receive a payment from the King 'before the Lord Roberts goes over to prevent anye stope ^of it^ that may be givene by hime'.[100] On 29 December, she was finally able to report that 'The order that is now sent by the kinge unto the Lord Liftenant will as is consevede heare; bee sufficient to remove all the obgections that his Lordshipp has made unto both the Payments that are dew unto My Lord'.[101] Around the same time, the Duchess told Mathew, 'your Lord Liftenant is Not Like to trouble you Longe'.[102] She was quick to reassure him: 'Nor doe you Nide to Feare that Lord Ororye will Suckside hime, Sense the Parlement will and his own Late Follie will hinder That, which is Neuse that I do Supose will as Litell troubell you as it dous.'[103] Earlier she had reported: 'I send you heare [a Petition read] in the House of [Commons] consarninge the Lord of [Ororye] whoe is still under Coustodie yesternight Late.'[104] Orrery's impeachment was the result of a vengeful counter-attack on Orrery by Ormonde, possibly facilitated by the intelligence that the Duchess shared during her visit to Ireland.[105]

Robartes would be recalled from the post of viceroy in May 1670, to be replaced by John Berkeley, 1st Baron Berkeley of Stratton. The Duchess's response

to his appointment was similar to her response to the appointment of Robartes. She told Mathew: 'My Lord Barcklye is preparinge for his Journye into Ireland whoe I doe not dout will kiepe a beter correspondansie with My Lord then his predesesor did.'[106] She offered the new viceroy and his wife the same support as she did their predecessors, even though she was now further removed from Dublin Castle. She informed Mathew:

> My Lord and Lady Barcklye has desirede the assistanse of Baxter [their steward] to advise the Person that thay intend to imploye about the makinge of provistions for hime and bargonninge for the Goods that are Ther which it is supposed willbee Sould, soe as by my Lords derectione I have writene to hime that to repayre to Dublin soe soune as hee heares from My Lord Barcklys Steward whoe is ordered to give hime Nottis [notice] soe soune as hee arrives.[107]

When the Duchess gave Mathew notice of the new viceroy's impending arrival, she once again shared her hopes that he would come to Ireland '[prepared to be oblidging to] My Lords relations'.[108]

On 10 August 1670, the Duchess of Ormonde wrote to Mathew to inform him that the new viceroy intended to journey into Munster, during which he expected to stop in Kilkenny. The Duchess instructed Mathew that she and her husband:

> dous think it Fitt that his Lordshipp shouldbee Lodged and Entertanede in the Castell ~~which~~ as well, as in his ~~owne~~ absense; and the Shortnes of the Time cane admitt ~~of~~ which it is his desier and mine Both may bee Countenanst by your beinge Ther and My Sone Arran, and that you will Conserne your Selfe by giveinge such derections unto Baxter and others as you Shall Judge Nesesarye for makinge Fitt provistion for his reseptione, and well orderinge of the Entertanment.[109]

Her next letter, of 13 August, confirmed that the viceregal visit to Kilkenny Castle had taken place:

> I understand that My Lord Liftenant was Entertaned at kilkenye at My Son Arrans Charge which My Lord Bid mee to tell you that Hee ^would^ allow For, as intendinge the same thinge himselfe as you will Find by his owne Leters, which it should sime came Not soe Timelie as was hopede to have intemated [intimated] his plesure in that perticuler.[110]

She continued: 'Hee bid mee allsoe to desier you to give derections that ther may bee allways a convenient quantitie of wine and Beare ~~allo~~ still kept in the Castell, that upon anye sudane [sudden] ocatione, or persons of qualities Cominge thether to See the House, thay may bee offerede to drinke.'[111] Even as it was becoming clear that the couple would be required to remain at a distance from Ireland for the foreseeable future, the Duchess was keen to ensure that they would maintain their

presence in Ireland through the careful upkeep of Kilkenny Castle and in the person of their middle son, Richard, 1st Earl of Arran (1639–1686).

During her continued absence from Ireland, the Duchess remained alert to potential threats from political rivals. On 22 October 1670, she updated Mathew on 'the Compounding with the 49 Men which the Lord Roberts did attempt to doe my Lord a prejudis, [which] is Now Effected by the Lord Liftenant whoe has it Should Sime drawne the Counsell to Joyne with hime in it; a Perfect Tricke of My Lord of Ororye'.[112] Here she imagined that the previous viceroy and the current viceroy were joining forces with Orrery to lay siege on her husband's reputation once again. Yet the Duke's reputation remained intact after the dismissal of the second viceroy, Berkeley, and the appointment of a third. On 20 February 1672, the Duchess told Mathew: 'I supose you heare the generall discourse that is of the Earle of Essexe beinge to goe over Lord Liftenant which though it has not bine as yet publicklie declared by the kinge yet it is generalie beleved that hee willbee the Person Chossen'.[113] Her information was correct: Arthur Capel, 1st Earl of Essex, succeeded Berkeley as viceroy on 21 May 1672. The Duchess said of Essex, 'whoe beinge Soe temperate and prudent as hee is Sayede to bee; will give Soe good Example as My Sonn John will have very Litell resone to beleve that hee cane have Creditt or Intrest in his Lordshipps Favour if hee Continows to Live as hee dous'.[114] Once again, the Duchess responded to the appointment of the viceroy by galvanizing her family to ensure they were in the best position to benefit from the new regime. Both from within and without the walls of Dublin Castle, as vicereine and afterwards as a supporter of her successors in the role, the Duchess of Ormonde had contributed in no small part to upholding the reputation of her husband. By countering the manoeuvres of his political enemies, cultivating good relationships with his viceregal successors (as influential conduits to the King in London) and, ultimately, exercising strict control over her household, she ensured that the 'Goverment of the familie' would pay dividends in the future. And so it did. Essex's successor as viceroy would be the Duke of Ormonde: his third appointment as viceroy would take place in 1677, when the couple would return to what the Duchess of Ormonde saw as their rightful position leading the government of Ireland.

Endnotes

1 E.S. de Beer (ed.), *The Diary of John Evelyn* (London: Everyman, 2006), p. 400. The terminal 'e' has been adopted in the spelling of 'Ormonde' throughout this chapter as this was the spelling used by the Duchess of Ormonde herself. Her personal preference for the terminal 'e' is captured in a memorandum written to her close friend Anne Hume, in May 1660, in which she requested that her husband be acquainted 'that such recommendations as comes from mee, in the behalfe of Persons done rathar out of Complianse then respect, shallbee subcribed with the leauinge [leaving] out of the leter E, at the Ende of the word ormond'; letter to [Anne] Hume from Elizabeth, Duchess of Ormonde [May 1660], Carte Papers, Bodleian Library, MS Carte 214, fols 221–2. A rather half-hearted recommendation that follows is duly signed 'E:ormond'; letter to James, Duke of Ormonde from Elizabeth, Duchess of Ormonde, 20 May 1660, Ormond Papers, National Library of Ireland, MS 2324, no. 1339, p. 235.

2 Philips's letters from this time reveal much about the culture of the viceregal court. See P. Thomas (ed.), *The Collected Works of Katherine Philips, the Matchless Orinda, Volume II: The Letters* (London: Stump Cross Books, 1992). The poetry of the coterie surrounding the Duke and Duchess of Ormonde is held in the Osborn Collection, Beinecke Library, Yale University; see A. Carpenter, 'A Collection of Verse presented to James Butler, First Duke of Ormonde', *The Yale University Library Gazette*, 75 (October 2000), pp. 64–70. For an examination of the literary patronage of the Duke of Ormonde, see J. Ohlmeyer and S. Zwicker, 'John Dryden, the House of Ormond, and the Politics of Anglo-Irish Patronage', *The Historical Journal*, 49, 3 (September 2006), pp. 677–706.

3 See Thomas, *Collected Works*, pp. 46–9. For an edition of *Pompey*, see G. Greer and R. Little (eds), *The Collected Works of Katherine Philips, the Matchless Orinda, Volume III: The Translations* (London: Stump Cross Books, 1993), pp. 1–91.

4 See Thomas, *Collected Works*, pp. 59–61.

5 Ibid., pp. 74–5. For the fourth song, see Greer and Little (eds), *Collected Works*, pp. 72–3.

6 Jane Fenlon has suggested that Monsieur le Grande is possibly the painter, David des Granges (*c*.1610–1671/2); see J. Fenlon, 'Episodes of Magnificence: The Material Worlds of the Dukes of Ormonde', in T. Barnard and J. Fenlon (eds), *The Dukes of Ormonde, 1610–1745* (Woodbridge: Boydell Press, 2000), p. 156, n. 121.

7 See N. McAreavey (ed.), *The Letters of the First Duchess of Ormonde* (Tempe, Arizona: ACMRS, forthcoming).

8 For an examination of the political circumstances of the Duke of Ormonde's dismissal, see J.I. McGuire, 'Why was Ormond Dismissed in 1669?', *Irish Historical Studies*, 18, 71 (March 1973), pp. 295–312, and more recently, D. McCormack, *The Stuart Restoration and the English in Ireland* (Woodbridge: Boydell Press, 2016).

9 The letters can be found among the Ormond Papers in the National Library of Ireland and the Carte Papers in the Bodleian Library.

10 Letter to Captain George Mathew from Elizabeth, Duchess of Ormonde, 26 October 1668, Ormond Papers, National Library of Ireland, MS 2503, no. 3.

11 Letter to Captain George Mathew from Elizabeth, Duchess of Ormonde, 22 November 1668, Ormond Papers, National Library of Ireland, MS 2503, no. 7.

12 Letter to Captain George Mathew from Elizabeth, Duchess of Ormonde, 26 October 1668, Ormond Papers, National Library of Ireland, MS 2503, no. 3.

13 Letter to Captain George Mathew from Elizabeth, Duchess of Ormonde, 14 November 1668, Ormond Papers, National Library of Ireland, MS 2503, no. 5.

14 Letter to Captain George Mathew from Elizabeth, Duchess of Ormonde, [November] 1668, Ormond Papers, National Library of Ireland, MS 2503, no. 6.

15 Letter to Captain George Mathew from Elizabeth, Duchess of Ormonde, 5 December 1668, Ormond Papers, National Library of Ireland, MS 2503, no. 11.

16 Letter to Captain George Mathew from Elizabeth, Duchess of Ormonde, 5 February 1668/9, Ormond Papers, National Library of Ireland, MS 2503, no. 32. The Duchess of Ormonde's letters are dated using the Old Style calendar, where the year started on Lady Day (25 March). Dates are given in the Old Style: however, for dates between 1 January and 24 March, the year is identified using both Old and New Style.

17 Letter to Captain George Mathew from Elizabeth, Duchess of Ormonde, 19 September 1668, Ormond Papers, National Library of Ireland, MS 2503, no. 2.

18 Ibid.

19 Letter to Captain George Mathew from Elizabeth, Duchess of Ormonde, 5 December 1668, Ormond Papers, National Library of Ireland, MS 2503, no. 11.

20 Letter to Captain George Mathew from Elizabeth, Duchess of Ormonde, 19 September 1668, Ormond Papers, National Library of Ireland, MS 2503, no. 2.

21 Ibid.

22 For other examples of the withholding of applications/petitions, see letter to Sir George Preston from Elizabeth, Duchess of Ormonde, 27 October 1668, Rosse Papers, Birr Castle, A/1/39; and letter to Captain George Mathew from Elizabeth, Duchess of Ormonde, 4 December 1668, Ormond Papers, National Library of Ireland, MS 2503, no. 9.

23 Letter to Captain George Mathew from Elizabeth, Duchess of Ormonde, 12 September 1668, Ormond Papers, National Library of Ireland, MS 2503, no. 20. The

caret symbol within quotations indicates interlineal insertions in the original letters.

24 Letter to Captain George Mathew from Elizabeth, Duchess of Ormonde, 5 December 1668, Ormond Papers, National Library of Ireland, MS 2503, no. 11.

25 Letter to Captain George Mathew from Elizabeth, Duchess of Ormonde, 12 September 1668, Ormond Papers, National Library of Ireland, MS 2503, no. 20.

26 Letter to Captain George Mathew from Elizabeth, Duchess of Ormonde, 19 September 1668, Ormond Papers, National Library of Ireland, MS 2503, no. 2.

27 Letter to Captain George Mathew from Elizabeth, Duchess of Ormonde, 9 November 1668, Ormond Papers, National Library of Ireland, MS 2503, no. 24.

28 Letter to Captain George Mathew from Elizabeth, Duchess of Ormonde, February 1668/9, Ormond Papers, National Library of Ireland, MS 2503, no. 33.

29 Letter to Captain George Mathew from Elizabeth, Duchess of Ormonde, 9 March 1668/9, Ormond Papers, National Library of Ireland, MS 2503, no. 15.

30 Ibid.

31 Ibid.

32 Letter to Captain George Mathew from Elizabeth, Duchess of Ormonde, 22 November 1668, Ormond Papers, National Library of Ireland, MS 2503, no. 7.

33 Ibid.

34 Ibid.

35 Ibid.

36 Ibid.

37 Ibid.

38 Ibid.

39 Letter to Captain George Mathew from Elizabeth, Duchess of Ormonde, 4 December 1668, Ormond Papers, National Library of Ireland, MS 2503, no. 9.

40 Letter to James, Duke of Ormonde from Elizabeth, Duchess of Ormonde, 18 June 1669, Carte Papers, Bodleian Library, MS Carte 243, fols 24–5.

41 Ibid.

42 Letter to Captain George Mathew from Elizabeth, Duchess of Ormonde, 9 November 1668, Ormond Papers, National Library of Ireland, MS 2503, no. 24.

43 Letter to Captain George Mathew from Elizabeth, Duchess of Ormonde, [November/December 1668], Ormond Papers, National Library of Ireland, MS 2503, no. 130.

44 C. Muldrew, The Economy of Obligation: The Culture of Credit and Social Relations in Early Modern England (Basingstoke: Palgrave, 1998), p. 149.

45 Letter to Captain George Mathew from Elizabeth, Duchess of Ormonde, [November/December 1668], Ormond Papers, National Library of Ireland, MS 2503, no. 130.

46 Ibid.

47 Letter to James, Duke of Ormonde, from Elizabeth, Duchess of Ormonde, 18 June 1669, Carte Papers, Bodleian Library, MS Carte 243, fols 24–5.

48 Ibid.

49 Letter to Captain George Mathew from Elizabeth, Duchess of Ormonde, 19 September 1668, Ormond Papers, National Library of Ireland, MS 2503, no. 2.

50 Letter to Captain George Mathew from Elizabeth, Duchess of Ormonde, 4 December 1668, Ormond Papers, National Library of Ireland, MS 2503, no. 9.

51 Letter to James, Duke of Ormonde from Elizabeth, Duchess of Ormonde, 20 June 1669, Carte Papers, Bodleian Library, MS Carte 243, fol. 26.

52 Letter to James, Duke of Ormonde from Elizabeth, Duchess of Ormonde, 18 June 1669, Carte Papers, Bodleian Library, MS Carte 243, fols 24–5.

53 Ibid.

54 Letter to Captain George Mathew from Elizabeth, Duchess of Ormonde, 22 November 1668, Ormond Papers, National Library of Ireland, MS 2503, no. 7.

55 Letter to Captain George Mathew from Elizabeth, Duchess of Ormonde, 4 December 1668, Ormond Papers, National Library of Ireland, MS 2503, no. 9.

56 Letter to Captain George Mathew from Elizabeth, Duchess of Ormonde, 22 November 1668, Ormond Papers, National Library of Ireland, MS 2503, no. 7.

57 Letter to Captain George Mathew from Elizabeth, Duchess of Ormonde, 4 December 1668, Ormond Papers, National Library of Ireland, MS 2503, no. 9.

58 Letter to Captain George Mathew from Elizabeth, Duchess of Ormonde, 16 February 1668/9, Ormond Papers, National Library of Ireland, MS 2503, no. 13.

59 According to Barnard, 'The Ormondes' failure to acquire an Irish townhouse of their own betrayed their assumption that the government of Ireland, together with its physical appurtenances, belonged naturally to them'; see T. Barnard, 'Introduction', in Barnard and Fenlon (eds), Dukes of Ormonde, p. 41.

60 Letter to Captain George Mathew from Elizabeth, Duchess of Ormonde, February 1668/9, Ormond Papers, National Library of Ireland, MS 2503, no. 33.

61 Letter to Captain George Mathew from Elizabeth, Duchess of Ormonde, 16 February 1668/9, Ormond Papers, National Library of Ireland, MS 2503, no. 13.

62 Letter to Captain George Mathew from Elizabeth, Duchess of Ormonde, February 1668/9, Ormond Papers, National Library of Ireland, MS 2503, no. 33.

63 Ibid.

64 Ibid.

65 Letter to Captain George Mathew from Elizabeth, Duchess of Ormonde, 26 October 1668, Ormond Papers, National Library of Ireland, MS 2503, no. 3; letter to Captain George Mathew from Elizabeth, Duchess of Ormonde, 5 February 1668/9, Ormond Papers, National Library of Ireland, MS 2503, no. 32.

66 Letter to Captain George Mathew from Elizabeth, Duchess of Ormonde, 9 March 1668/9, Ormond Papers, National Library of Ireland, MS 2503, no. 15.

67 Letter to Captain George Mathew from Elizabeth, Duchess of Ormonde, 16 February 1668/9, Ormond Papers, National Library of Ireland, MS 2503, no. 13.

68 Ibid.

69 Letter to Captain George Mathew from Elizabeth, Duchess of Ormonde, 6 March 1668/9, Ormond Papers, National Library of Ireland, MS 2503, no. 14.

70 Letter to Captain George Mathew from Elizabeth, Duchess of Ormonde, 9 March 1668/9, Ormond Papers, National Library of Ireland, MS 2503, no. 15.

71 Letter to Captain George Mathew from Elizabeth, Duchess of Ormonde, February 1668/9, Ormond Papers, National Library of Ireland, MS 2503, no. 33.

72 Ibid.

73 Ibid.

74 Letter to Captain George Mathew from Elizabeth, Duchess of Ormonde, 9 March 1668/9, Ormond Papers, National Library of Ireland, MS 2503, no. 15.

75 Ibid.

76 Letter to Captain George Mathew from Elizabeth, Duchess of Ormonde, February 1668/9, Ormond Papers, National Library of Ireland, MS 2503, no. 33.

77 Letter to Captain George Mathew from Elizabeth, Duchess of Ormonde, 16 March 1668/9, Ormond Papers, National Library of Ireland, MS 2503, no. 38[b].

78 Letter to James, Duke of Ormonde from Elizabeth, Duchess of Ormonde, 18 June 1669, Carte Papers, Bodleian Library, MS Carte 243, fols 24–5.

79 Letter to James, Duke of Ormonde from Elizabeth, Duchess of Ormonde, 31 May 1669, Carte Papers, Bodleian Library, MS Carte 243, fols 12–13.

80 Letter to Captain George Mathew from Elizabeth, Duchess of Ormonde, February 1668/9, Ormond Papers, National Library of Ireland, MS 2503, no. 33.

81 Ibid.

82 Letter to Captain George Mathew from Elizabeth, Duchess of Ormonde, 16 February 1668/9, Ormond Papers, National Library of Ireland, MS 2503, no. 13. The rest were to be sent to her own house of Dunmore 'by resone That House is Emptie'. On the Duchess's role in maintaining the splendour of the couple's houses, see Fenlon, 'Episodes of Magnificence', pp. 137–59.

83 Letter to Captain George Mathew from Elizabeth, Duchess of Ormonde, 6 January 1668/9, Ormond Papers, National Library of Ireland, MS 2503, no. 12; letter to Captain George Mathew from Elizabeth, Duchess of Ormonde, 10 January 1668/9, Ormond Papers, National Library of Ireland, MS 2503, no. 30; letter to Captain George Mathew from Elizabeth, Duchess of Ormonde, 5 February 1668/9, Ormond Papers, National Library of Ireland, MS 2503, no. 32.

84 Letter to James, Duke of Ormonde from Elizabeth, Duchess of Ormonde, 31 May 1669, Carte Papers, Bodleian Library, MS Carte 243, fols 12–13.

85 Ibid.

86 Ormonde Castle in Carrick-on-Suir was not so well maintained. Since writing her previous letter to her husband, she had visited the residence, and could now provide a report of its condition: 'I went to Carrike where I had a veue [view] of a very Ruenous House, in the outward apperanse of it,' although thankfully it was 'presarvede from anye greater or more dayngerous decayes as to the fallinge of it'; see letter to James, Duke of Ormonde from Elizabeth, Duchess of Ormonde, 9 June 1669, Carte Papers, Bodleian Library, MS Carte 243, fol. 18.

87 Ibid.

88 Ibid.

89 Ibid.

90 Ibid.

91 Letter to James, Duke of Ormonde from Elizabeth, Duchess of Ormonde, 15 June 1669, Carte Papers, Bodleian Library, MS Carte 243, fol. 22.

92 Letter to James, Duke of Ormonde from Elizabeth, Duchess of Ormonde, 31 May 1669, Carte Papers, Bodleian Library, MS Carte 243, fols 12–13.

93 Letter to James, Duke of Ormonde from Elizabeth, Duchess of Ormonde, 20 June 1669, Carte Papers, Bodleian Library, MS Carte 243, fol. 26.

94 Letter to Captain George Mathew from Elizabeth, Duchess of Ormonde, 9 March 1668/9, Ormond Papers, National Library of Ireland, MS 2503, no. 15.

95 Letter to Captain George Mathew from Elizabeth, Duchess of Ormonde, 16 March 1668/9, Ormond Papers, National Library of Ireland, MS 2503, no. 38[b].

96 Letter to [Captain George Mathew] from Elizabeth, Duchess of Ormonde, [March 1668/9], Ormond Papers, National Library of Ireland, MS 2484, no. 241, p. 269.

97 Letter to James, Duke of Ormonde from Elizabeth, Duchess of Ormonde, 18 June 1669, Carte Papers, Bodleian Library, MS Carte 243, fols 24–5.

98 Ibid.

99 Letter to James, Duke of Ormonde from Elizabeth, Duchess of Ormonde, 20 June 1669, Carte Papers, Bodleian Library, MS Carte 243, fol. 26.

100 Letter to Captain George Mathew from Elizabeth, Duchess of Ormonde, 24 July 1669, Ormond Papers, National Library of Ireland, MS 2503, no. 16.

101 Letter to Captain George Mathew from Elizabeth, Duchess of Ormonde, 29 December 1669, Ormond Papers, National Library of Ireland, MS 2503, no. 27.

102 Letter to Captain George Mathew from Elizabeth, Duchess of Ormonde, 18 December 1669, Ormond Papers, National Library of Ireland, MS 2503, no. 26.

103 Ibid.

104 Letter to Captain George Mathew from Elizabeth, Duchess of Ormonde, 27 November 1669, Ormond Papers, National Library of Ireland, MS 2503, no. 25. See *Journal of the House of Commons, Volume 9, 1667–1687* (London: His Majesty's Stationery Office, 1802), p. 122 (25 November 1669), viewable online: https://www.british-history.ac.uk/commons-jrnl/vol9/pp112-113#h3-0006 (accessed 20 December 2019).

105 See McCormack, *Stuart Restoration*, p. 72.

106 Letter to Captain George Mathew from Elizabeth, Duchess of Ormonde, 29 January 1669/70, Ormond Papers, National Library of Ireland, MS 2503, no. 31.

107 Ibid.

108 Letter to Captain George Mathew from Elizabeth, Duchess of Ormonde, 16 April 1670, Ormond Papers, National Library of Ireland, MS 2503, no. 40.

109 Letter to Captain George Mathew from Elizabeth, Duchess of Ormonde, 10 August 1670, Ormond Papers, National Library of Ireland, MS 2503, no. 50.

110 Letter to Captain George Mathew from Elizabeth, Duchess of Ormonde, 13 August 1670, Ormond Papers, National Library of Ireland, MS 2503, no. 51.

111 Ibid.

112 Letter to Captain George Mathew from Elizabeth, Duchess of Ormonde, 22 October 1670, Ormond Papers, National Library of Ireland, MS 2503, no. 53.

113 Letter to Captain George Mathew from Elizabeth, Duchess of Ormonde, 20 February 1671/2, Ormond Papers, National Library of Ireland, MS 2503, no. 86.

114 Ibid.

Two

'That Caballing Humour, which has Very Ill Effects'

Frances Talbot, Jacobite Duchess of Tyrconnell and Vicereine of Ireland

Frances Nolan

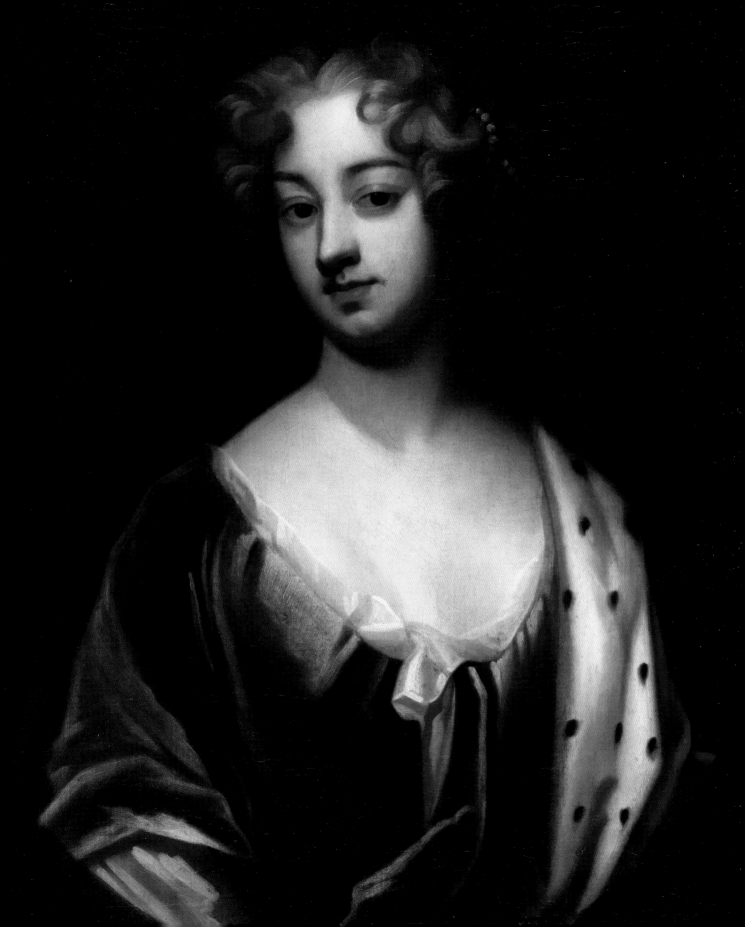

On the evening of 1 July 1690, a troop of 200 horse guards rode hard for Dublin, among them the figure of a broken king. James II had taken flight from the Battle of the Boyne as the tide turned in favour of his Dutch nephew and son-in-law, William III. The Catholic James had lost his crown in 1688, when the Protestant William was invited to England to seize the throne and rule jointly with his wife, James's eldest daughter, Mary. Exiled to France, James had the strategic support of Louis XIV, whose expansionist ambitions set him at odds with other European powers and resulted in the eruption of war on the Continent in 1688. The following year, William formed the Grand Alliance, an anti-French coalition between England, the Dutch Republic, the Archduchy of Austria and, later, Spain and Savoy. Louis, a Catholic, was naturally inclined to support his co-religionist and cousin, James (whose mother, Henrietta Maria, was Louis's aunt), but he also recognized the importance of keeping William busy in Ireland.[1] For the French, the War of the Two Kings (1689–91) was a tactical move in a much wider conflict. For James, on the other hand, victory in Ireland was a route back to the three kingdoms. For Irish Jacobites, the majority of whom were Catholic, the war demonstrated their loyalty to James; it also represented a chance to secure political ascendancy and to cast off many of the limitations that had been imposed upon them in the name of religion. James's personal capitulation and his army's defeat at the Boyne did not bring the Irish war to a close, however.[2] Fighting continued for another fourteen months before the Jacobites surrendered at Limerick in October 1691.[3]

James's flight in the high summer of 1690 took him south from the Boyne, to Dublin and the castle that lay at the city's heart. There, he was met by the vicereine, Frances Talbot (née Jennings), Jacobite Duchess of Tyrconnell (c.1649–1731), wife of the lord deputy and lieutenant general of James's army in Ireland, Richard Talbot (1630–1691).[4] Popular tradition holds that the King greeted the Duchess of Tyrconnell with the words, 'Your countrymen madam, can run well', to which she replied, 'Not quite so well as your Majesty, for I see you have won the race.'[5] No contemporary record of the exchange exists, however, and it is more likely a product of popular Irish resentment for the runaway king; a manifestation of the same sentiment that resulted in the epithet, *Séamus an Chaca* ('James the Shit'). A contemporary account instead held that the King entered the city around nine o'clock in the evening and was met by the Duchess of Tyrconnell 'at the Castle-gate, and after he was upstairs, her ladyship askt him what he would have for Supper? who then gave her an Account of what a Breakfast he had got, which made him have but little stomach to his Supper'.[6] The next morning, James left the Castle and made his way to Waterford, whence he sailed into exile in France.[7] One day later, the Williamite army entered Dublin and brought Jacobite control of the city to an end. Those who numbered among James's Irish court at Dublin Castle, including the Duchess of Tyrconnell (Fig. 02.01), had already followed their king's example and taken flight.

James II's ill-fated reign, its calamitous end, its legacy in continental exile, and its endurance in the hearts, minds and plots of eighteenth-century English and Scottish Jacobites have been examined in considerable detail.[8] Jacobite Ireland

has received less scholarly attention, but the mechanics of James II's Irish administration, the Jacobite army's campaign and defeat in the War of the Two Kings, the fate of elite Catholics in Ireland after the war, and of the Wild Geese on the Continent have nonetheless formed the basis of a number of books and articles.[9] There has also emerged a significant body of work on the cultural and political legacy of Jacobitism in eighteenth-century Ireland.[10] This scholarship shines a valuable light on James's Irish government and army and on the diaspora that resulted from the Jacobite defeat, but it does little to illuminate other constituents of a significant period in Irish history. As a consequence, many of those who played a prominent part in Jacobite Ireland have been relegated to the margins. This has been the fate of the woman who reportedly walked out of the State Apartments to the gates of Dublin Castle to greet James II on his inglorious return from the Boyne. The Duchess of Tyrconnell's diminution in the historiography is, in part,

a consequence of her status as one of history's losers and the not unrelated treatment of her husband in Irish nationalist and British Whig traditions.[11] It is also a result of the long tradition of diminishing or completely ignoring women in historiography and, to some degree, of the complicated relationship of women's and gender history with 'women worthies' and traditional biography.[12] The Duchess of Tyrconnell has, nonetheless, fared better than other historical women: Philip W. Sergeant's joint-biography of the Talbots, *Little Jennings and Fighting Dick Talbot*, is remarkable for its inclusion of the lady alongside the lord; that it is, in part, a biography of a Catholic and Jacobite woman makes it all the more remarkable. Yet *Little Jennings*, published in 1913, is no groundbreaking representation of an early modern woman and Frances never commands Sergeant's attention in the same way, or to the same extent, as her husband. There has been little progress made since, and Frances's life has, instead, been broken down and remoulded to decorate the biographies of 'great men' and, unusually, her great sister, Sarah Churchill, Duchess of Marlborough (Fig. 02.02). The result is that the Duchess of Tyrconnell's

role in Jacobite Ireland is commonly reduced to an anecdote about a cowed king, when, in fact, she occupied a highly significant position at a time of great upheaval and left a not insignificant mark on the historical record.

Frances Talbot was almost 40 years of age when her second husband, Richard, was appointed lord deputy of Ireland in 1687, and her path to the position of vicereine was circuitous and highly formative. Born to a minor gentry family *c.*1649, as the English Civil War reached its bloody crescendo, Frances was the daughter of Richard Jennings, who served as MP for St Albans in Hertfordshire, and Frances (née Thornhurst), who was sole heiress to a considerable estate in Kent. Richard's support for the Parliamentarians in the Civil War left him heavily indebted, but he did not support Charles I's execution and was among the MPs expelled from Westminster during Pride's Purge in 1648, before resuming his seat at the Convention Parliament in 1660.[13] It has been observed (not unfairly) that little of Frances's origins would be remembered if she were not such a near relation

of Sarah, Duchess of Marlborough.[14] It is fair also to suggest, however, that Sarah's rise began in a trail blazed by her elder sister, through the Restoration Court of Charles II. In 1664, Frances journeyed the short distance from St Albans to the royal court in London, where she became Maid of Honour to Anne Hyde, Duchess of York, the first wife of the future James II. A miniature portrait by the English artist Samuel Cooper, painted at this time, captures the youthful countenance and blond tresses that helped her to achieve early fame at court (Fig. 02.03). Anthony Hamilton, in his *Memoirs of the Count de Grammont*, observed that she had 'the fairest and brightest complexion that ever was seen', was 'full of wit and sprightliness' and through her conduct, had 'so well established the reputation of her virtue'.[15]

Hamilton's *Memoirs* also gives the impression of a woman who was highly aware of her purpose at court, attributing to her the maxim 'that a lady ought to be young enough to enter the court with advantage, and not [too] old to leave it with a good grace … and that in so dangerous a situation, she ought to use her utmost endeavours not to dispose of her heart until she gave her hand'.[16] Frances adhered to her own advice and was married in 1666, within two years of her arrival at court. She had caught the eye of Charles II, James, Duke of York, and Richard Talbot, among others, but in the end, she married the Catholic Irishman and officer, George Hamilton. He was the elder brother of the aforementioned Anthony Hamilton; a circumstance that provides some measure of caveat to the flattering recollection of Miss Jennings in the *Memoirs*. More importantly, he was the grandson of James Hamilton, 1st Earl of Abercorn, and the nephew of the powerful James Butler, 1st Duke of Ormonde (see Fig. 01.04).[17] In Charles II's newly restored court, the Hamiltons' noble blood and Royalist credentials made George a very good match for Frances, a woman from a minor gentry family who could count the regicide James Temple as her maternal grand-uncle.[18] The King's expulsion of Catholics from the army in 1668 damaged the Hamiltons' prospects considerably, however, and they were compelled to travel to France, where George enlisted in the army and Frances tried to establish herself at the glittering court of Louis XIV. She was aided by her sister-in-law, Elizabeth (née Hamilton), Comtesse de Gramont, who had married a French nobleman and served as *dame du palais* (lady-in-waiting) to Queen Maria Theresa.[19]

Before leaving London, Frances gave birth to a daughter, Elizabeth (known affectionately as Betty), and suffered the stillbirth of a son. In Paris, the Hamiltons welcomed three more daughters and Elizabeth was joined in the nursery by Frances, Mary and Henrietta. Despite recruiting a 'sober' and 'discreet' Church of England chaplain to minister to her privately, Frances also converted to Catholicism in this period.[20] There is evidence to suggest that Frances's conversion was born of pragmatic concerns, social and cultural interaction, and spiritual awakening. She was certainly not innocent of the risks her husband faced in battle and did not hide her fear of widowhood and insecurity.[21] These fears were realized in the summer of 1676, when George Hamilton was killed in combat.[22] On the death of her husband, Frances was reported to be 'reduced to a deplorable condition and without anything', 'inconsolable, and ruined beyond redemption'.[23] Her misery was compounded by the death of her youngest child, Henrietta, in 1677.[24]

Fig. 02.04.

Henri Gascar

Frances Talbot (née Jennings),
Duchess of Tyrconnell

*c.*1675–7

Bridgeman Images.

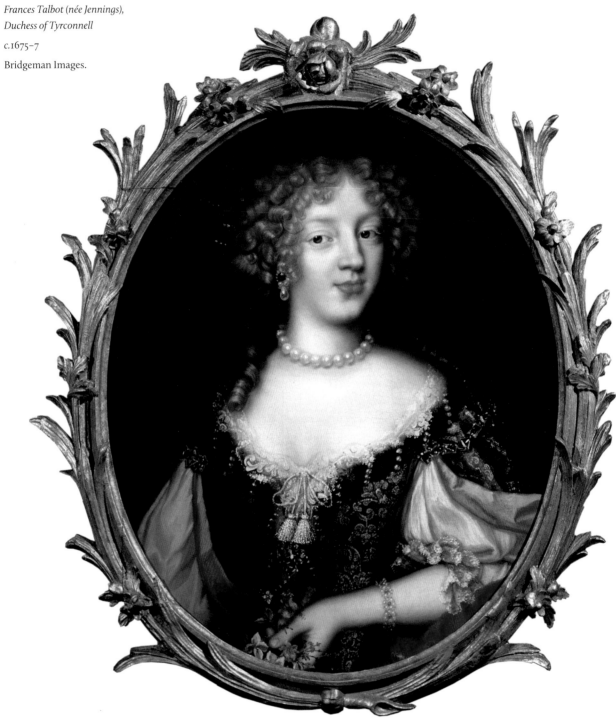

With her circumstances changed, Frances was determined to secure a court position and income from Louis XIV and her case was improved by her new-found Catholicism. Her conversion may have offered material advantages, but it was also the result of her immersion in a deeply Catholic culture. Her close relationship with the Comtesse de Gramont was important in this period, bringing her into contact with theologians and clergymen, among whom were members of the controversial Jansenist movement. Named for theologian Nicholas Jansen, the movement closely adhered to the teachings of Augustine of Hippo and was despised by many among the Catholic hierarchy, particularly the Jesuits and the papacy.[25] Frances's exposure to Jansenism made a deep and lasting impression on her faith, but Louis XIV's condemnation of the movement meant that she could not support their doctrine openly.[26] Instead, she worked to forge connections with the English Catholic community in Paris, both religious and lay. Recognizing that religious patronage offered elite women protection and a means by which to exercise power, she provided considerable financial support to the Blue Nuns, for which they described her as 'next after god ... the preservation of our hous ...'[27] She also donated 260 *livres* to the English Benedictines at Pontoise in 1680.[28] Her association with both of these orders would prove to be significant during her time as vicereine of Ireland. While successfully cultivating links with exiled English religious houses, Frances experienced mixed fortunes in soliciting the support of Charles II and Louis XIV. The cash-strapped English king created her Countess of Bantry in the peerage of Ireland, providing her the nominal sum of £20 *per annum*.[29] Louis, who continued to refuse her a position at the French court, consoled her with a pension and the proceeds from the sale of one of her late husband's regiments.[30]

Frances quickly placed herself back on the marriage market, too, commissioning two portraits in the first years of her widowhood, both of which are attributed to the French-born painter Henri Gascar (1634/5–1701). Having made his name in England, Gascar decamped to Paris in the late 1670s and it was likely there that Frances sat for him. A depiction of Frances as the Roman goddess Flora, in which she holds flowers in both hands and is flanked by two putti, is believed to have been painted by Gascar in about 1675.[31] A second, half-length portrait, in which she is adorned in rich silks and fat pearls, was completed by Gascar in about 1677 (Fig. 02.04). There was little ambiguity in these portraits, which were intended to signal her fertility and thus, her marriageability. One or other may have caught the eye of Frances's former suitor, Richard Talbot, who was exiled to Paris following his implication in Titus Oates's fictitious 'Popish Plot' in 1678. The couple contracted to marry before Frances visited England in 1680. While there, she commissioned a portrait, painted in the style of Peter Lely, which is thought to indicate her betrothal. Dressed in a blue nightgown, Frances holds part of her red cloak over her waist, and rests her hand on a spaniel. The image emphasizes her high status, as well as her morality and fidelity (see Cat. 01).[32]

Frances and Richard married in 1681 and remained in France until 1683, when Charles II permitted their return. Following that king's death and the accession of

Fig. 02.05.

After **Sir Godfrey Kneller**
King James II
c.1690
© National Portrait Gallery, London.

James II (Fig. 02.05) to the throne in February 1685, the couple's rise was meteoric. In a few short months, they were created Earl and Countess of Tyrconnell and Richard was placed at the head of the army in Ireland. Frances was appointed Lady of the Bedchamber to James's queen, Mary Beatrice d'Este (Fig. 02.06), and was included in her coronation procession, as Countess of Bantry (Fig. 02.07).[33] This was possibly the point at which she commissioned a half-length portrait (the head of which closely resembles that of her prenuptial portrait), which included the ermine cape of her peeress's coronation robe (see Fig. 02.01). Attributed variously to Mary Beale and Godfrey Kneller, it was later reproduced as an engraving by Charles Eden Wagstaff, which was published in 1832 (Fig. 02.08).

In early 1687, Lord Tyrconnell was appointed Lord Deputy of Ireland (Fig. 02.09), becoming the first Catholic to occupy the position since the Reformation, and Lady Tyrconnell took her place alongside him, as vicereine. Frances's role in her husband's political ascent during the reign of James II is not amply documented, but she undoubtedly played a considerable part. It was not unusual for viceroys to rely on allies at court to provide intelligence, run interference, and exert influence, and as Pádraig Lenihan has observed, Richard's absences from court during his time as lord deputy left him vulnerable to the intrigues of his enemies. Without any genuine support base there, he almost certainly relied on his wife to act on his behalf and promote his interests.[34] Frances was very well placed to meet these demands; intelligent and ambitious, with a healthy appetite for political intrigue, she held a senior position in the Queen's household and had a long-standing and cordial history with the King.

Evidence of her political instincts can be found in the 'Narrative' of Thomas Sheridan, written in 1702. For Sheridan, it was an exculpatory account of events that had occurred in 1687 and 1688, after James II had made him a revenue commissioner and one of two secretaries to the new lord deputy.[35] Lord Tyrconnell accepted the appointment of the 'weak and compliant' Alexander Fitton as one secretary, but he deeply resented the imposition of Sheridan, who had no affection for his new master.[36] Given this mutual dislike, it is no surprise that Sheridan was labelled a 'suspect witness' by J.G. Simms, but a majority of historians have accepted the veracity of the 'Narrative'.[37] The historiography only briefly considers what the 'Narrative' can tell us about the Tyrconnells as a political power couple, or about Frances's role in Sheridan's demise, however. She first appeared in the 'Narrative'

Fig. 02.07.

R. Wilkinson (published by)
*Coronation of James II and Mary
of Modena, 1685*

c.1793–1815

Royal Collection Trust/© Her
Majesty Queen Elizabeth II
2021.

at Windsor in early 1687, at a dinner celebrating her husband's appointment to
the lord deputyship. In an otherwise convivial atmosphere, she perceived Sher-
idan's unhappiness and endeavoured to draw him out; he confessed that he had
been insulted by Lord Tyrconnell, who had earlier cautioned him against corrup-
tion, and admitted to having 'no share' in the couple's joy.[38] The next morning,
the lord deputy summoned his secretary and upbraided him for his indiscretion.[39]
Lady Tyrconnell had done her job well; listening, learning and reporting back on
Sheridan's discontent. It was an early indication of her capacity for intrigue and
demonstrated the viceregal couple's close relationship.

By the winter of 1687, the Tyrconnells had fattened Sheridan for the slaugh-
ter and he was forced to defend himself against allegations of corruption. Failing
to plead his case with James II in London, he returned to Dublin and was put on
trial before a panel of judges who were largely supportive of the lord deputy.[40]
With the odds against him, Sheridan sought leave to request another audience

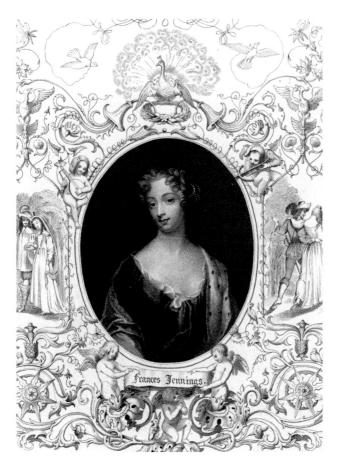

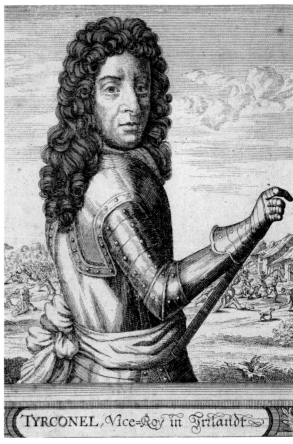

TYRCONEL, Vice=Roy in Irlandt

with the King. Instead, Lord Tyrconnell detained him in Dublin for a period, while sending Lady Tyrconnell to court. There, she easily gained the King's ear and worked to considerable effect, reporting 'all things to Sheridan's disadvantage' and specifically alleging that he had libelled her and her husband as a whore and a knave respectively.[41] Her efforts ensured that Sheridan was refused permission to see the King when he finally made his way to London. In his 'Narrative', Sheridan reflected with some frustration that 'Tyrconnell and his lady had taken as much pains to run him down, as another would have done to gain a kingdom' and that 'soon after Lady Tyrconnell prevailed to have another [Revenue] Commissioner named in his stead'.[42]

At the same time as she conspired to have Thomas Sheridan dismissed, Lady Tyrconnell was involved in plans to create a Catholic hegemony in Dublin. Central to this was the establishment of an order of Benedictine nuns in Great Ship Street, adjacent to the Castle. Plans for an Irish foundation were some time in the making and Frances had an early and important role in developments: in 1686, the Benedictines at Pontoise wrote to her and asked that she advocate for a foundation in Ireland.[43] In 1687, the King told Lord Tyrconnell to invite Mary Joseph Butler, Abbess of the Irish Benedictines at Ypres (and cousin of the Duke of Ormonde), to Dublin.[44] Welcomed there by the Tyrconnells on 31 October 1688,

she was promised a royal patent granting the 'most ample privileges … under the denomination of his Majesty's own first, chief and royal Abbey of his three kingdoms'.[45] The importance of the Benedictine order in promoting Catholic interests in Dublin, and in Ireland more generally, was made plain. Once Butler entered her enclosure, 'the Divine Office, Holy Mass, and all the regular observances were daily performed, to the consolation and edification of the nobility and gentry of Ireland, who hastened to place their children for education, under the care of the venerable Abbess'.[46]

Having realized the power of religious patronage during her time in Paris, Lady Tyrconnell was instrumental in the early success of the Dublin foundation and had an important part to play in choosing the nuns who came to Great Ship Street. In 1687, Anne Neville, Abbess of the English Benedictines at Pontoise, noted that:

> Some of o[u]rs from ys Comunity [at Pontoise] beeing desired by Lord Tirconnels Lady yn ViceRoy of Irland, and yt in so obliging a manner as could not be refusde, ye desighne beeing soe much for Gods Glory and good of Religion as obligde us to send some yt might be of advanntage for such a work, in establishing regularity, with a tru fond of vertu in yt beginning hows.[47]

Having been instrumental in the foundation, it is not surprising that Frances was also heavily involved in a dispute that arose between Abbess Butler's community and another Benedictine house, which had been established by Mary Joseph O'Ryan in Channel Row (now Brunswick Street North) on the north side of the River Liffey in 1685.[48] Dame O'Ryan had travelled from Ypres to Ireland at the beginning of James's reign, tasked with recruiting pupils and raising money for the order in Flanders. Encouraged by a favourable political climate and supported by the Archbishop of Dublin, Patrick Russell, she remained in Ireland and established a Benedictine school for the children of the Catholic elite.[49]

The dispute between the Benedictine sisters began before Abbess Butler had even left the Continent, as Archbishop Russell wrote to her and to the Grand Vicars of Ypres to condemn the foundation of a second community in Dublin. Abbess Butler retorted by alleging that Dame O'Ryan had disseminated unfavourable reports about the continental school, which had almost caused one mother to remove her daughters from the nuns' care. Disaster was averted, Butler revealed, by the intervention of Lady Tyrconnell, who stressed 'the falsity of the reports' concerning the convent in Flanders. The vicereine's involvement did not stop there, as Butler was forced to refute an accusation that Frances had directed Barbara Philpott, a nun who had travelled ahead of Butler to Dublin, in a campaign to 'drive away' O'Ryan. To make matters worse, Lady Tyrconnell was alleged to have acted without the knowledge of her husband. Butler rejected such claims out of hand, hardly believing 'that a lady so virtuous as the Vice-Reyne would undertake an affair without consulting her husband'.[50] Despite Frances's best efforts, Archbishop Russell and Dame O'Ryan eventually secured the support of the King. In August 1687, the nun reported to Abbess Caryll at Dunkirk that:

> [t]he only person who opposes me is the Countess of Tyrconnell; the rest of
> the nobility and people of quality have regard for my labours and the pains
> which I take ... My Lord Archbishop has received to-day a letter from his
> majesty, giving him full power to establish Religious, men and women, in
> his Diocese, and it depends entirely on him, and not on Madame Tyrconnell
> or any other, to make such a choice ...[51]

Frances maintained an active interest in the Benedictine foundation on Great Ship Street and, undeterred, continued to work against Dame O'Ryan. In May 1689, as the Jacobite parliament opened in King's Inn, she requested that her husband 'remember the pore nuns when ocation is in parlement'. This was followed by the observation that 'the other are making great briges and friends. Wee know how well thay deserve'.[52] This continued opposition to the Channel Row convent was in vain, however, and James II attended the consecration of the chapel there in June 1689.[53] Lady Tyrconnell's involvement with the competing Benedictine communities suggests that she saw a role for herself in the re-establishment of Catholic orders under her husband's viceroyalty. Indeed, while she waged war against Dame O'Ryan, she likely had a hand in another continental mission to Dublin. In 1688, 'having been invited so to do by friends in that country', the Blue Nuns dispatched Catherine Mectildis Rice and Jane Frances Sanders from Paris to begin a filiation in Ireland.[54] There is good reason to believe that Lady Tyrconnell was involved in this scheme, as her longstanding patronage of the Blue Nuns meant that she would have significant sway over the development of their community in Ireland. Rice and Sanders never made it to Ireland, however, as they travelled through England *en route* to Dublin and were held up there by the Revolution of 1688, which forced their return to France.[55]

William, Prince of Orange, landed in Torbay in November 1688 and easily wrested power from James II, who famously threw the Great Seal into the River Thames as he fled London. The Dutch prince, married to James's Protestant eldest daughter, Mary, seemed an obvious solution to the problem of a Catholic monarch; a problem that extended into an unquantifiable future when James's queen, Mary Beatrice, gave birth to a prince and heir, James Francis Edward, in June 1688. As Lady of the Bedchamber, Lady Tyrconnell lived at close quarters with the Queen when at court, but she may well have learned of the royal pregnancy in Ireland, after she returned there to negotiate the marriage of her daughter, Mary, in late 1687. For Lady Tyrconnell, the marriages of her three surviving daughters by George Hamilton provided significant occasions to demonstrate her ambition both before and after she became vicereine. In 1685, her eldest, Betty, married Richard Parsons, 1st Viscount Rosse; two years later, her second daughter, Frances, married Henry Dillon, later 8th Viscount Dillon of Costello-Gallen; and in May 1688, Mary became the wife of Nicholas Barnewall, 3rd Viscount Barnewall of Kingsland.[56]

With family business taken care of, Lady Tyrconnell returned to England to attend the heavily pregnant Queen. For many at James's court and beyond, the prospect of a Catholic heir was unconscionable and caused the political and

religious fault lines that ran through English society to shift; haltingly at first, and then decidedly and profoundly. The Queen's pregnancy precipitated the 'Orangeist conspiracy' to supplant James and put William and Mary on the thrones of England, Scotland and Ireland.[57] Anti-Catholic sentiment had long encouraged speculation about the Queen's ability to conceive and rumours that a surrogate child would be presented as a prince and heir began to surface after the announcement of Mary Beatrice's pregnancy. These rumours found a receptive audience in the highest circles.[58] In March 1688, James's youngest daughter, Princess Anne of Denmark, wrote to her sister, Mary, and observed that there was 'some cause to fear there may be foul play intended' and that there was 'much reason to believe it is a false belly'.[59] Frances was not ignorant of the changing mood at court, in Parliament, and further afield; in fact, the employment of her sister, Sarah Churchill, in Princess Anne's household meant that she was blood-tied to one of the principal hubs of dissatisfaction.

Lady Tyrconnell was present when Mary Beatrice gave birth at St James's Palace on 10 June 1688 and remained in attendance on the Queen for several weeks thereafter. James had been unnerved by the rumours of an infant interloper and ensured that there were a large number of noble witnesses to his son's birth. In October, a number of these witnesses were asked to appear before the Privy Council to attest to the legitimacy of the Prince of Wales, but Lady Tyrconnell was not among them. She had returned to Ireland and had resumed her duties as vicereine in August, where she likely spent time on the Tyrconnell estate at Carton, in County Kildare, and oversaw her family's transfer from the viceregal lodge in Chapelizod to Dublin Castle. A fire in 1684 had destroyed most of the State Apartments, but the Castle had long made for a miserable residence and plans to renovate it had been in the works for some time. Despite a difficult relationship with Tyrconnell, his predecessor as viceroy, Henry Hyde, 2nd Earl of Clarendon, had pressed on with construction, describing the 'reparations of this no-castle', in April 1686, as 'very great'.[60] In August 1686, Lord Clarendon had told his brother, Laurence Hyde, 1st Earl of Rochester, that he did 'not think it necessary he [Tyrconnell] should have a royal palace, fit to hold the King, Queen, and the whole court: but a good house he ought to have, and the country deserves it'.[61] In October 1688, it was reported that the new building in the Castle was completed and that the Tyrconnells had moved in (Fig. 02.10).[62]

It may have been in this new building at Dublin Castle that they learned of William's arrival in England, in November 1688, and James's hasty departure for France. Lady Tyrconnell's frustration over developments in England was compounded by the defection of her sister and brother-in-law, John, to the Prince of Orange's side. The Churchills' defection was both principled and pragmatic. On principle, Sarah was 'a true born Whig' who was ideologically sympathetic to the Revolution, while John diverged with James's Catholicism and policy of religious toleration.[63] Pragmatically, the Churchills occupied a favoured position in Princess Anne's circle and recognized that the childless William and Mary's accession paved the way for Anne's eventual succession. In this light, it is hard to believe that

Fig. 02.10.

Charles Brooking

The Castle [of Dublin], 1728.
Published in *A Map of the City
and Suburbs of Dublin …*

1728
Courtesy of the Office of Public
Works, Dublin Castle.

Frances was blindsided by the Churchills' decampment, but the speed at which the sisters' interests diverged and the scale of that divergence must have been sobering.

The Tyrconnells and the Churchills had enjoyed a good relationship and in January 1687, Lord Tyrconnell (alongside Sidney Godolphin) even stood as godfather for John and Sarah's firstborn son, John.[64] Sarah had not always appeared oppositional in political matters either, and at one point Lord Tyrconnell believed that he might use his sister-in-law to effect Princess Anne's conversion to Catholicism.[65] The birth of the Prince of Wales in June 1688 altered the political landscape profoundly, however. Weeks after William's arrival in England, John Churchill abandoned James II for a 'higher principle'.[66] At that same juncture, Sarah played a central role in Anne's backstairs flight from her lodgings in Whitehall, as the princess abandoned her father and took her place in opposition to his reign.[67] The Churchills' switch in allegiance left the sisters and their husbands at opposite ends of a growing divide and in a matter of months, they would be at war. Indeed, John and Sarah were created Earl and Countess of Marlborough shortly after William and Mary's coronation in 1689, and John augmented his reputation as a military commander by leading the successful Williamite Siege of Cork in 1690.[68]

After a short period in France, James set sail for Ireland and landed at Kinsale on 12 March 1689, before moving to Cork, where he met his lord deputy and elevated him to the dukedom of Tyrconnell, with Frances thus becoming duchess.[69] James and his entourage departed Cork on 20 March and arrived in Dublin four days later, on Palm Sunday. The Duchess of Tyrconnell does not appear in extant accounts of the King's jubilant entry into Dublin.[70] As vicereine, however, she was almost certainly present. Her absence from the historical record at this juncture prompted the Tyrconnells' early twentieth-century biographer, Philip W. Sergeant, to surmise that 'the condition of Ireland [in 1689] was such that a woman had few opportunities to make herself prominent'.[71] In focussing squarely on the social or ceremonial functions of the vicereine, however, Sergeant overlooked spaces in which Lady Tyrconnell might exercise power. Dated 2 May 1689, the sole surviving letter between Frances and Richard suggests that she was involved in directing affairs on her husband's behalf from Carton, and that she was aware of wider military and political developments. She reported that her son-in-law,

Henry Dillon, had 'gone to Sligo with Mr Sarsfild about the geting subsistence fer his regement but I heard befer they went that Macke Donell had alltogether imbesiled [embezzled] what was so that I doubt it will not answer expections. He will obey your commands as soone as he returns and will hasen to Dublin'. She also expressed relief that her husband was 'in a much better way then when there was forsis [forces] going in to Londondery, which I hope will be soone yuer o[w]ne'.[72]

Lady Tyrconnell may have felt that she was more useful beyond the city walls in the summer of 1689, as she managed the family estate and hired men to keep their livestock safe from pillage (her own sheep were reported to be grazing in the Phoenix Park).[73] At the same time, she made clear that she 'shold soone abandon all things heare' if and when she was needed in Dublin.[74] There may not have been a regular social function for the vicereine during the war and indeed the role had not yet assumed the pageantry that would later define it in the eighteenth century.[75] However, there were occasions at which Lady Tyrconnell's presence was necessary; not least because the King was in Ireland and resided in Dublin for a time. As war drew the King, the Duke of Tyrconnell, and other Jacobite noblemen away from the city, the vicereine served as a recognizable figurehead for the Jacobite and Catholic community there. She was present when Christ Church was seized and reconsecrated for Catholic worship on 27 September 1689, leading a procession to the Cathedral in her coach.[76] The next evening, she hosted a celebratory ball and, from his prison cell, the Church of Ireland Archbishop William King reported hearing 'great rejoicing in the Castle', although he mistakenly believed that the celebration was to mark Queen Mary Beatrice's birthday.[77] Frances was required to play the hostess in other ways, while the war was ongoing: in June 1690, she sent a note to William Fitzgerald, the Tyrconnells' agent in Kildare, requesting that some malt and two cows be sent to the Castle in haste, presumably for an impromptu dinner party.[78]

Frances's actions in Dublin, her patronage of Catholic religious houses, her commitment to Catholic hegemony, and her visibility as a Jacobite figurehead, earned her few friends among the Protestant population. At the same time, it did not excite the ire of her enemies as much as her alleged love of money and abuse of the power that her position afforded her. Accusations of greed and corruption (frequently levelled at her younger sister, the Duchess of Marlborough, in an English context) followed the Duchess of Tyrconnell around and were not without foundation. In August 1689, Archbishop William King, who was imprisoned in Dublin Castle during the war, wrote in his diary of a 'Mrs C-----', who visited him and told him that Frances owed her a debt of £12, with £6 due in rent and the other £6 spent on malt, which was given as a charitable donation to the convent on Great Ship Street.[79] Following 'frequent' petitions, Frances had promised to pay what was due of the two-year-old debt and asked 'Mrs C-----' to collect it from her steward. When she did, 'Mrs C-----' found that she was to be paid in copper, valued at £60. When 'Mrs C-----' protested, the steward told her to 'make application to his Lady, which she did and with much ado obtained of her Grace an order to stop bringing the copper on condition she should not call for the £12'.[80]

Frances's alleged abuse of the 'gun money' James II introduced during the war, which was made of copper, brass or pewter, and was to be redeemed for silver coins following a Jacobite victory, was also the subject of a 1690 tract, titled *An Account of the Transactions of the late King James in Ireland*. The anti-Jacobite pamphlet alleged that Frances used copper coins to pay Colonel Roger Moore for an encumbrance on the estate of her son-in-law, Henry Dillon. Frances appeared willing to relieve her daughter's estate 'in ready money' and such was Moore's eagerness to collect, that he abated £1,000 of the £3,000 owed to him. When he arrived and signed a release, Frances allegedly 'opened a door and shewed him a long table covered over with copper and brass, and tendered it for his payment'. The author of the *Account* did not know whether Moore 'rejected [it] in passion or hired a cart to carry it away'.[81] To some extent, these accusations of greed can be attributed to anti-Catholic and anti-Jacobite feeling. There was a clear political motivation in the *Account* and likewise, William King did not restrict his criticisms to his diary, providing a less than flattering account of two of Frances's daughters in his *State of the Protestants of Ireland*. King claimed that Catholics with

> ready Mony, tho' they had been formerly Customers to Protestants, and in their Books, they never came near them any more. This Practice was so universal amongst them, that even the Women learn'd it; particularly the Lady *Tyrconnel*'s Daughters: For thus the Lady *Ross* and her Sister *Dillon* treated several Shopkeepers, falling furiously upon them in the former Terms, because their Servants refused to trust.[82]

The Duchess of Tyrconnell and her family were loathed by a large part of the Protestant population and reports of their behaviour must be understood in this context. It was a reputation that stuck, not least because of the role played by Whig historians in shaping the narrative around the Revolution of 1688. In 1716, for example, the English historian John Oldmixon referred to Frances as 'a great *Oeconomist*' and alleged that she had been foremost among the 'Papists' who reacted to the fixing of prices on provisions by going to the shops and houses of Protestants and taking their goods by force before paying in gun money.[83]

Gender played an important role in contemporary and subsequent interpretations of the Duchess of Tyrconnell's actions, too, and it is notable that a number of the charges laid at her door were connected to her (or her daughters') consumer power. This is not to say that the accusations levelled at her were baseless; her attainder in 1694 was at least partly the result of corrupt practices during her time as vicereine in Dublin. The strength of Protestant disdain for her was, however, bound up with her womanhood and the belief that she had transgressed accepted boundaries. When Queen Mary tried to stop treason proceedings against her in 1693 (presumably at the contrivance of Princess Anne, who was heavily influenced by Sarah Churchill), the Irish lord justices argued that she had 'exceeded most others of her sex' in her behaviour during the war and had acted 'not with the duty of a wife to her husband, but with ye malice of an open enemy'.[84]

Such was the resulting level of ill-feeling toward Frances, the lord justices argued, that 'it would tend to the great discouragement of the protestant subjects here if further acts of grace be shown her (as they impute a great part of their sufferings to her instigation)'.[85]

The viceregal couple faced accusations of misbehaviour from among the Jacobite ranks, too. These should be understood, to some extent, as the product of an anti-Tyrconnellite sentiment among some of James's supporters, but they were not without foundation. Nepotism was hardly out of the ordinary in seventeenth-century government, but the extent to which the Tyrconnells gifted their extended family with civil and military posts was notable. Similarly, the use of patronage as a means of amassing wealth was not unusual, but it left the couple open (not unreasonably) to allegations of corruption. The Jacobite, Charles Leslie, who provided an answer to King's *State of the Protestants*, observed that the 'carriage' of the Jacobite government, even before the war, 'gave greater occasion to King James's enemies than all the other maladministrations' charged against it.[86] For her part, the Duchess of Tyrconnell was accused by Thomas Sheridan of taking money for civil appointments alongside Sir William Ellis, who served as her husband's *de facto* secretary from 1687 and was reputed to have been in love with her.[87] While Sheridan was not enamoured of the Tyrconnells, his allegations were corroborated, to some extent, by the vicereine's involvement in securing the appointment of Christopher Malone to the position of Surveyor General in July 1689. This was through the contrivance of the Prime Sergeant, Gerald Dillon, with the fees and profits of the post given over to the use of Frances's middle daughter, Lady Frances Dillon.[88]

In a position of such prominence, the Duchess of Tyrconnell's actions left her open to attack, particularly if they were attached to political ambition. The Duke of Tyrconnell's great Jacobite rival, the Scottish nobleman and James II's Secretary of State, John Drummond, 1st Earl of Melfort, was savage in his criticism of her when he wrote to James from Saint-Germain in October 1689. Melfort complained that the Comte d'Avaux, the French ambassador who accompanied James to Ireland, would clash with the French general, the Duc de Lauzun, and this disagreement would 'draw in' the Duchess of Tyrconnell. According to Lord Melfort, her entry into the fray would bring the Duke of Tyrconnell into the dispute and would precipitate 'a war in your own court', so he suggested that she be sent to France 'for her health'. This was no sign of Melfort's concern for the vicereine's well-being (indeed, health was a common excuse for expedient travel to the Continent). He further told James that he was not aware she 'had been so well known here as she is; but the terms they give her, and which, for your service, I may repeat unto you, is that she has *l'âme le plus noire que se puisse concevoir*' ('the blackest soul ever conceived'). This was followed by the suggestion that her removal from Ireland would 'prevent that caballing humour, which has very ill effects'.[89]

Lord Melfort asserted that his dislike of Frances was not personal and that his account of her was 'not for the outward appearance, but because there is a secret spring at bottom I confess I like not; and that on two accounts'.[90] His first

concern was her ties to the 'other side', and while he discounted the idea that John Churchill had any political 'influence' over her, he observed that she had sent her money into England for safekeeping. Lord Melfort's second concern shone a light on the Tyrconnells' allegiance and ambitions, and criticized the Duchess of Tyrconnell's role (perceived or otherwise) in political intrigue. He claimed that she was corresponding with Honoré Courtin, the former French ambassador to England, whom she had come to know at Charles II's Restoration court.[91] This was put forward as evidence of her involvement with a group of Irish in France 'who begin to have discourses of the freedom of their nation'. Alluding to the power the Tyrconnells wielded in Ireland and underlining the threat of a coup against James, Lord Melfort advised that it be put 'out of the power of any one family to make Ireland change a master'.[92] One month later, he openly accused the Duchess of Tyrconnell of plotting with some of the Irish, identifying her as 'the main instrument in … this design' and again casting suspicion on her French correspondence.[93] Melfort had grounds for his complaints regarding the Tyrconnells' monopolization of power in Ireland and their means of accruing wealth, but his suggestion that they represented any threat to James's Irish crown in late 1689 was rooted in political rivalry and personal dislike.

Failing to implicate the Duchess of Tyrconnell, Melfort joined some of her other enemies in complaining about her greed and tendency toward corruption. In October 1690, he wrote to his agent in Ireland, Father Maxwell, and alleged that she was 'robbing in a manner Irlande of so much money, and pretending it was the king's'. Dismayed, he added that 'she is of the number of the fortunate may do what they please and shall be better looked on than others, whatever their services are'.[94] By this time, the Duchess of Tyrconnell had fled Ireland for France, arriving in Brest on 25 August 1690, along with her youngest daughter, Mary, Lady Kingsland, and the Duke of Tyrconnell's surviving daughter from his first marriage, Charlotte Talbot.[95] Her reputation for rapaciousness followed her to the Continent: in late August, the *Gazette d'Amsterdam* reported that she had lodged in the Bishop of Limerick's palace on her way to take ship in Waterford and having 'found some of the furniture there very good … took it with her'.[96] The same publication reported, in early September, that 'the countess of Tyrconnell is daily expected in Paris with all the valuable belongings she is bringing with her from Ireland; it is said that her retinue is much more magnificent than that of James's queen'.[97] Her actual arrival appears to have been more muted, as she temporarily lodged with her old friends, the Blue Nuns, on the Rue de Charenton.[98] From there, she probably travelled to Fontainebleau, to join James and Mary on their visit to Louis XIV's court and to resume her position as Lady of the Bedchamber to the now exiled queen.[99]

As well as conveying money and goods into France, Frances undertook a political mission on leaving Ireland. In his anti-Tyrconnellite *Macariae Excidium*, the Jacobite Charles O'Kelly observed that, on arriving at Louis XIV's court, 'she gave out, (pursuant to Instructions), that all *Cyprus* [Ireland] was lost' if help from the French was not forthcoming.[100] She laid the groundwork for her husband: the Duke of Tyrconnell followed his family to France in September 1690, working

to buttress his position at the head of the Jacobite government and secure more support from Louis XIV. He was successful, as Louis promised him reinforcements and James elevated him to the position of lord lieutenant.[101] Pádraig Lenihan has rightly noted of the Duke of Tyrconnell that '[i]t is hard to see any other Irishman with the requisite stature to impress on the French just how useful it would be to continue a diversion in Ireland'.[102] At the same time, however, it is hard to imagine that the Duchess of Tyrconnell, a woman who was well connected to the French court, well versed in court etiquette and well known to the French King, had no bearing on her husband's success. She was also on good terms with senior political figures such as Courtin and the Marquis de Louvois. The sway she held with the latter was attributed by some to a past sexual relationship.[103] Certainly, the minister had not been averse to using his position as Secretary of State for War in his dealings with officers' widows.[104]

The Duke of Tyrconnell's health was failing when he began his journey back to Ireland in January 1691 and the Duchess would soon be widowed. He died in Limerick on 14 August 1691, as preparations for the second siege of the city were under way; not with the expectation of a Jacobite victory, but in the hope of surrendering on favourable terms.[105] These terms were eventually secured by an Irish and French delegation, led by his great rival, Patrick Sarsfield. The result was the Treaty of Limerick, which facilitated the migration of thousands of Jacobite soldiers and their families to the Continent.[106] At Saint-Germain-en-Laye, the Duchess of Tyrconnell continued in her duties as Lady of the Bedchamber to Mary Beatrice, but she also acted as a figurehead and source of charity for the émigré Irish who fell into poverty as the fortunes of the Jacobite court declined. She remained in exile in France until 1702, by which time the principal players in the War of the Two Kings had died.[107] For Frances, the death of James II was of far greater personal and political significance, but the expiration of William III had a more material impact on her life. Queen Anne's accession placed Sarah Churchill firmly in the ascendant and she lobbied successfully for a private bill to reverse her sister's attainder and restore her jointure lands in Ireland. The Duchess of Marlborough's influence was summed up by the Bishop of Clogher, St George Ashe, who noted, in April 1702, that '[m]y Lady Tyrconnel's bill was hurried with such unusual expedition through both houses, both whigs and tories striving who could favour it most, that we could not overtake it with our saving in either house; *this* it is to be the sister of a favourite'.[108] Frances returned briefly to Ireland in 1702, before relocating to the Low Countries.[109] With the War of the Spanish Succession (1701–14) under way, she acted as a Jacobite intelligencer and an intermediary between the commander of the Allied army, the Duke of Marlborough, and the Jacobite court at Saint-Germain.[110]

The Duchess of Tyrconnell returned to Ireland in 1708.[111] It has been variously observed that 'from that point her history practically ceases until her death twenty-three years later', and that 'she never left Ireland again in the twenty-odd years of life that remained to her'.[112] She does disappear from the historical record for periods of her old age, but the assumption that 'her history practically ceases'

is underpinned by a past tendency among scholars to look away from the archive once all the men of consequence have quit the scene and by outmoded assumptions around gender and age. She has long been acknowledged as a patron of the Poor Clare and Dominican convents on the north side of Dublin's River Liffey, which has informed a belief that she retired to a life of pious devotion.[113] In fact, she was highly active in her old age, travelling regularly between Dublin and London, engaging in a number of law suits, and maintaining a transnational investment portfolio.[114] In 1719, she bought a townhouse on Conduit Street in London and in the 1720s, she lived comfortably among the Protestant elite on Dublin's Grafton Street.[115] In 1728, she wrote from Dublin to her friend, Jane Guidott, of the rumoured departure of the incumbent viceregal couple, Lord and Lady Carteret (see Cat. 06). She confided her disappointment, noting that 'one may count it a loss for I never saw people behave better here or more oblidgeingly and tho I have been but once at the Castle since they came I have often compliments and tis my being unwell has hindred her making me severall visitts as well as himself'.[116] The septuagenarian Duchess of Tyrconnell was not particularly active on the Dublin social scene, but she was shown the courtesy her rank afforded and made the viceregal guest list on at least one occasion. As her carriage trundled through the Castle gate on that unknown night in the 1720s, for a ball or perhaps for a dinner, it is not difficult to imagine the past gathering around her; the light of a brief ascendancy casting long the shadows of defeat.

Frances, Duchess of Tyrconnell died in Dublin at one o'clock in the morning, on 7 March 1731.[117] She remained a Catholic to the end, but was interred in the Ranelagh vault on the north steps of the altar in the Church of Ireland St Patrick's Cathedral on 9 March (a result of her close connection to the Jones family, who were cousins of her late son-in-law, Lord Rosse).[118] She remained a figure of fame (or infamy) in British and Irish popular imagination throughout the eighteenth and nineteenth centuries.[119] However, this interest did not last and no modern scholar has attempted to build on the valuable but limited foundations of Sergeant's *Little Jennings*. Without in-depth scholarly attention, the Duchess of Tyrconnell has endured as a fragmented figure in historiography and her role in her husband's viceroyalty has, for the most part, been overlooked. Evidence indicates, however, that she played an active and ambitious part, owned an appetite for political intrigue and was unafraid to enter realms that were jealously guarded by men. Her position in the royal household during James II's reign made her an important asset for her husband, who was not in a position to remain at court and in close proximity to the King. The Duke of Tyrconnell trusted her to advance their interests with the King and Queen and she demonstrated her aptitude for the task by successfully disparaging Thomas Sheridan. At a time when Franco–Irish relations were of paramount importance, furthermore, it is fair to suggest that her connections in France were politically beneficial to her husband (and irking to Lord Melfort), too. The Duchess of Tyrconnell's previous life in France also shaped her ambition as vicereine of Ireland. It was evident in her commitment to establishing Catholic hegemony through the foundation of religious communities

in Dublin. Her patronage of nunneries, which had begun with the Blue Nuns in Paris, was a reflection of her religious conviction, as was her prominent position in the procession to reconsecrate Christ Church Cathedral in 1689. At the same time, her campaign against Dame O'Ryan, her championing of the Benedictines on Great Ship Street, and the Blue Nuns' intended mission to Ireland suggest that she used religious patronage to create a space in which she could exercise authority.

In the end, the Jacobite defeat in the War of the Two Kings ensured that her efforts came to nought; the Benedictines returned to the Continent, the Blue Nuns never arrived, and the cathedrals of Dublin were reclaimed for Protestant worship. Just as Frances's material legacy as vicereine was washed away by the Jacobite defeat, so her reputation in posterity was shaped by the Williamite victory. Some of the accusations made against her were justified, but the notion that she acted without restraint or scruple is rooted in polemic and bound up with early modern expectations of gender. Perhaps her most enduring success was her family, as she negotiated good marriages for her three daughters by George Hamilton during James II's reign. In doing so, she succeeded in establishing a noble dynasty. In life, it was a circumstance that gave her little satisfaction; she was predeceased by her favourite daughter, Lady Rosse, in 1724, died unreconciled with Ladies Dillon and Kingsland, and counted as many enemies as friends among her grandchildren. At the time of her death, however, the Duchess of Tyrconnell's blood coursed through the veins of some of the greatest families in Britain and Ireland. It was a legacy celebrated in her funeral elegy by the Westmeath poet Laurence Whyte, who wrote of 'Tyrconnel, once the Boast of the British Isles, / Who gain'd the Hearts of Heroes by her Smiles, / Whose wit and Charms throughout all *Europe* rung, / From whom so many noble Peers have sprung.'[120]

The author wishes to thank Professor Marian Lyons (Maynooth University) and Denise Nestor for reading drafts of this essay and for providing invaluable feedback and encouragement. It is with sincere gratitude that the author wishes to acknowledge the support of the Irish Research Council (IRC), as the provision of an IRC Postdoctoral Fellowship has made this research possible.

Endnotes

1 For more on the Nine Years' War, see J.A. Lynn, *The Wars of Louis XIV, 1667–1714* (London: Routledge, 2013); J. Childs, *The Nine Years' War and the British Army, 1688–97* (Manchester: Manchester University Press, 2013).

2 Daniel Szechi has observed that James was 'uncharacteristically hesitant' during the Irish campaign, which supports theories that the events of 1688 broke his nerve. See D. Szechi, *The Jacobites: Britain and Europe, 1688–1788* (Manchester: Manchester University Press, 1994), p. 47.

3 For more on the Irish war, see J. Childs, *The Williamite Wars in Ireland, 1688–1691* (London: Hambledon Continuum, 2007).

4 The dukedom of Tyrconnell was awarded to Richard Talbot in March 1689, after James II was understood to have abdicated the throne. As a result, while Frances was recognized as a duchess in the Jacobite peerage, she was only recognized as a countess in the British and Irish peerage. She will be referred to by the Jacobite title of duchess in this essay. In much of the literature, and indeed on the inscription on a portrait of Frances at Fyvie Castle in Scotland, 'Tyrconnell' appears with only one 'L', as 'Tyrconnel', in reference to the dukedom. However, Frances always signed off letters with 'Tyrconnell' and this is the spelling used throughout.

5 The earliest reference to the reported exchange between Frances and James appears in Charles Henry Wilson's *The Polyanthea: or, a Collection of Interesting Fragments in Prose and Verse* (London: printed for J. Budd, 1804), vol.1, p. 332.

6 G.W. Story, *A True and Impartial History of the Most Material Occurrences in the Kingdom of Ireland during the Last Two Years* (London: printed for Ric. Chiswel, 1691), p. 88; *Report on the Manuscripts of the Late Allan George Finch. Esq., of Burley-on-the-Hill, Rutland* (London: Historical Manuscripts Commission, 1922), vol. 2, p. 344.

7 P. Lenihan, *The Last Cavalier: Richard Talbot (1631–91)* (Dublin: University College Dublin Press, 2014), p. 156.

8 See, for example, P. Kléber Monod, *Jacobitism and the English People, 1688–1788* (Cambridge: Cambridge University Press, 1989); P. Monod, M. Pittock and D. Szechi (eds), *Loyalty and Identity: Jacobites at Home and Abroad* (Basingstoke: Palgrave Macmillan, 2010); Szechi, *The Jacobites*; idem, *1715: The Great Jacobite Rebellion* (London: Yale University Press, 2006); idem, *Britain's Lost Revolution?: Jacobite Scotland and French Grand Strategy, 1701–8* (Manchester: Manchester University Press, 2015); E. Cruickshanks and E. Corp (eds), *The Stuart Court in Exile and the Jacobites* (London: Hambledon Press, 1995); E. Cruickshanks and H. Erskine-Hill, *The Atterbury Plot* (Basingstoke: Palgrave, 2004); J. Miller, *James II* (London: Yale University Press, 2000); E. Corp, *A Court in Exile: The Stuarts in France, 1689–1718* (Cambridge: Cambridge University Press, 2004); M. Pittock, *The Myth of the Jacobite Clans: The Jacobite Army in 1745* (Edinburgh: Edinburgh University Press, 2009); A.J. Mann, *James VII: Duke and King of Scots* (Edinburgh: John Donald, 2014).

9 For the Jacobite army's campaign and defeat in the War of the Two Kings, see J.G. Simms, *The Treaty of Limerick* (Dundalk: Dundalgan Press, 1965); idem, *Jacobite Ireland, 1685–91* (London: Routledge & K. Paul, 1969); J. Miller, 'The Earl of Tyrconnel and James II's Irish Policy, 1685–1688', *Historical Journal*, 20, 4 (December 1977), pp. 803–23; J. McGuire, 'James II and Ireland, 1685–1690', in W.A. Maguire (ed.), *Kings in Conflict: The Revolutionary War in Ireland and its Aftermath, 1689–1750* (Belfast: The Blackstaff Press, 1990), pp. 45–57; idem, 'Richard Talbot, Earl of Tyrconnell (1630–91) and the Catholic Counter-Revolution', in C. Brady (ed.), *Worsted in the Game: Losers in Irish History* (Dublin: The Lilliput Press, 1989), pp. 72–83; P.A.C. Wauchope, *Patrick Sarsfield and the Williamite War* (Dublin: Irish Academic Press, 1992); B. Whelan (ed.), *The Last of the Great Wars: Essays on the War of the Three Kings in Ireland* (Limerick: University of Limerick Press, 1995); É. Ó Ciardha, *Ireland and the Jacobite Cause, 1685–1766: A Fatal Attachment* (Dublin: Four Courts Press, 2000); Childs, *Williamite Wars in Ireland*. For the fate of elite Catholics in Ireland after the war, see E. Kinsella, *Catholic Survival in Protestant Ireland, 1660–1711: Colonel John Browne, Landownership and the Articles of Limerick* (Woodbridge: The Boydell Press, 2018); E. Lyons, 'Morristown Lattin: A case study of the Lattin and Mansfield families in County Kildare, c.1600–1860' (unpublished PhD thesis, University College Dublin, 2011); K.J. Harvey, *The Bellews of Mount Bellew: A Catholic Gentry Family in Eighteenth-Century Ireland* (Dublin: Four Courts Press, 1998); J.G. Simms, *The Williamite Confiscation in Ireland, 1690–1703* (London: Faber, 1956). For the fate of the Wild Geese on the Continent, see M.A. Lyons, '"Digne de Compassion": Female Dependants of Irish Jacobite Soldiers in France, c.1692–c.1730', *Eighteenth-Century Ireland*, 23 (2008), pp. 55–75; N. Genet-Rouffiac, 'The Wild Geese in France, 1688–1715: A French Perspective', *The Irish Sword*, 26, 103 (2008), pp. 10–50; idem, 'The Irish Jacobite Exile in France, 1692–1715', in T. Barnard and J. Fenlon (eds) *The Dukes of Ormonde, 1610–1745* (Woodbridge: The Boydell Press, 2000), pp. 195–210; E. Corp, 'The Irish at the Jacobite Court of Saint-Germain-en-Laye', in T. O'Connor (ed.), *The Irish in Europe, 1580–1815* (Dublin: Four Courts Press, 2001), pp. 143–56.

10 See V. Morley, *The Popular Mind in Eighteenth-Century Ireland* (Cork: Cork University Press, 2017); B. Ó Buachalla, *Aisling Ghéar: Na Stíobhartaigh agus an tAos Leinn, 1603–1788* (Dublin: An Clóchomhar Tta, 1996); Ó Ciardha, *Ireland and the Jacobite Cause*; S.J. Connolly, 'Jacobites, Whiteboys and Republicans: Varieties of Disaffection in Eighteenth-Century Ireland', *Eighteenth-Century Ireland*, 18 (2003), pp. 63–79; D. Dickson, 'Jacobitism in Eighteenth-Century Ireland: A Munster Perspective', *Éire-Ireland*, 39, 3/4 (2004), pp. 38–99.

11 See Lenihan, *Last Cavalier*, pp. 1–2.

12 See, for example, N.Z. Davis, '"Women's History" in Transition: The European Case', *Feminist Studies*, 3, 3/4 (Spring–Summer 1976), pp. 83–103; G. Lerner, 'Placing Women in History: Definitions and Challenges', in G. Lerner, *The Majority Finds its Past: Placing Women in History*

(New York: Oxford University Press, 1979), pp. 145–59; C.G. Heilbrun, *Writing a Woman's Life* (New York: Norton, 1988).

13 M.W. Helms and E.W. Edwards, 'Jennings, Richard (c.1616–68), of Sandridge, Herts.', in B.D. Henning (ed.), *The History of Parliament: The House of Commons, 1660–1690* (London: Secker & Warburg, 1983), 3 vols.

14 P. Sergeant, *Little Jennings and Fighting Dick Talbot* (London: Hutchinson & Co., 1913), vol. 1, p. 2.

15 A. Hamilton, *Memoirs of the Count de Grammont: Containing the History of the English Court under Charles II* (London: Swan Sonnenschein & Co., 1911), p. 254.

16 Ibid., p. 257.

17 É. Ó Ciardha, 'Hamilton, Sir George', in J. McGuire and J. Quinn (eds), *Dictionary of Irish Biography* (Cambridge: Cambridge University Press, 2009), viewable online: http://dib.cambridge.org/viewReadPage.do?articleId=a3739 (accessed 6 January 2020).

18 A. Davies, 'Temple, Sir Alexander (1583–1629), of Longhouse, Chadwell, Essex; Haremere, Etchingham, Suss. and Holborn, London', in A. Thrush and J.P. Ferris (eds), *The History of Parliament: House of Commons, 1604–1629* (Cambridge: Cambridge University Press, 2010), viewable online: https://www.historyofparliamentonline.org/volume/1604-1629/member/temple-sir-alexander-1583-1629 (accessed 20 January 2020).

19 E. Corp, 'Hamilton, Elizabeth, Countess de Gramont [called La Belle Hamilton] (1641–1708), courtier', in H.C.G. Matthew and B. Harrison (eds), *Oxford Dictionary of National Biography* (Oxford: Oxford University Press, 2004), viewable online: https://www.oxforddnb.com/view/10.1093/ref:odnb/9780198614128.001.0001/odnb-9780198614128-e-12061 (accessed 18 January 2020).

20 When Frances travelled to England in 1675, John Evelyn described her as a 'sprightly young woman' who had 'now turned Papist'. See J. Evelyn, *The Diary of John Evelyn, Edited from the Original Mss. by William Bray* (London: M. Walter Dunne, 1901), vol. 2, p. 108 (12 November 1675).

21 Letter to Marquis de Pomponne from Marquis de Ruvigny, 23 March 1676, Archives du Ministère des Affaires Étrangères: Correspondence Politique Angleterre, vol. 118, f. 23–4.

22 *Gazette de France*, 1676, pp. 433, 456; letter to Louis XIV from Marquis de Louvois, 2 June 1676, Archives du Ministère de la Guerre, vol. 508, no. 114; J.C. O'Callaghan, *History of the Irish Brigades in the Service of France, from the Revolution in Great Britain and Ireland under James II, to the Revolution in France under Louis XVI* (Glasgow: Cameron & Ferguson, 1870), pp. 33–4.

23 *Fourth Report of the Royal Commission on Historical Manuscripts* (London: printed for

Her Majesty's Stationery Office, 1874), vol. 1, p. 245; Marie de Rabutin-Chantal, Marquise de Sévigné, *Letters of Madame de Sévigné to her Daughter and her Friends* (London: printed for J. Walker et al., 1811), vol. 4, p. 190.

24 There is little evidence of Frances's reaction to Henrietta's death but she included news of her daughter's death and described herself as 'the most unhappy person in the world' in a letter she wrote to the Marquis de Louvois, the French Secretary of State for War, in October 1677. Letter to Marquis de Louvois from Lady Hamilton, October 1677, Archives du Ministère de la Guerre, vol. 567, p. 143.

25 For an overview of Jansenism in France, see W. Doyle, *Jansenism: Catholic Resistance to Authority from the Reformation to the French Revolution* (Basingstoke: Macmillan, 2000).

26 During a period of residence in the Low Countries in the early eighteenth century, Frances corresponded with Johan Christiaan van Erkel, Dean of the Chapter of Utrecht in the (Jansenist) Old Catholic Church of the Netherlands, and acted, to some degree, as an intermediary between English and Dutch Jansenists. Letters from Tyrconnel, Duchesse de, Aachen, 9 July, 9 September, 29 December, 1705, Utrecht Archives, 1835/4.I.22.I/773–780. See also R. Clark, *Strangers and Sojourners at Port Royal: Being an Account of the Connections between the British Isles and the Jansenists of France and Holland* (Cambridge: Cambridge University Press, 1932), pp. 170, 246.

27 J. Gillow and R. Trappes-Lomax (eds), *The Diary of the 'Blue Nuns' or Order of the Immaculate Conception of Our Lady, at Paris. 1658–1810* (London: printed for the Catholic Record Society, 1910), pp. 31–2.

28 Registers of the English Benedictine Nuns of Pontoise, compiled by Abbess Anne Neville, Douai Abbey Archive, T. IV. 1. f. 17. See also 'Registers of the English Benedictine Nuns of Pontoise', in *Catholic Record Society: Miscellanea* (London: printed for the Catholic Record Society, 1913), vol. 10, p. 256.

29 Warrant for the grant of the dignity of a countess of Ireland to Dame Hamilton, relict of Sir George Hamilton, for her life, 7 July 1676; F.H. Blackburne Daniell (ed.), *Calendar of State Papers, Domestic Series, of the Reign of Charles II, 1676–7* (London: His Majesty's Stationery Office, 1909), p. 210.

30 P. Pellisson-Fontanier, *Lettres Historiques de Monsieur Pellisson* (Paris: François Didot, 1729), vol. 3, p. 112; see *Fourth Report of the Royal Commission*, vol. 1, p. 245.

31 Portrait of Frances Hamilton, attributed to Henri Gascar, c.1675–80, three-quarter-length, seated, holding up flowers in her left hand, attended by two putti, private collection.

32 David Taylor has observed that Frances's

hairstyle places the portrait sometime after 1670 and that its symbolic allusions to fidelity and loyalty may refer to her forthcoming second marriage to Richard Talbot, but notes erroneously that this marriage took place in 1679. As a result, Taylor suggests 1677–78 as a possible date for the portrait. Given that Richard and Frances married in 1681, it was more likely to have been painted in about 1680. See https://vads.ac.uk/large.php?uid=85741 (accessed 30 October 2019).

33 Frances is included in Francis Sandford's illustrations of the coronation of King James II and his consort, Queen Mary Beatrice, in 1685, as the Countess of Bantry. See F. Sandford, *The History of the Coronation of the Most High, Most Mighty, and Most Excellent Monarch, James II* (London: In the Savoy, printed by Thomas Newcomb, 1687), p. 78.

34 See Lenihan, *Last Cavalier*, pp. 113–14.

35 For an in-depth consideration of Sheridan's 'Narrative' see J. Miller, 'Thomas Sheridan (1646–1712) and his "Narrative"', *Irish Historical Studies*, 20, 78 (September 1976), pp. 105–28.

36 See Miller, *James II*, p. 218.

37 See Simms, *Jacobite Ireland*, p. 38; Lenihan, *Last Cavalier*, p. 110; see Miller, 'Thomas Sheridan', p. 114.

38 *Calendar of the Stuart Papers Belonging to His Majesty the King, preserved at Windsor Castle* (London: Historical Manuscripts Commission, 1916), vol. 6, p. 13.

39 Ibid., p. 14.

40 See Miller, 'Thomas Sheridan', pp. 123–4.

41 Ibid., p. 127.

42 See *Calendar of the Stuart Papers*, vol. 6, p. 49.

43 Miscellaneous extracts from various records, Montagu Manuscripts, British Library, Add MS 25266, f. 39, cited in C. Watkinson, 'Engaging nuns: Exiled English convents and the politics of exclusion, 1590–1829' (unpublished PhD Thesis, University of Westminster, 2016), p. 92.

44 F. Clarke, 'Butler, Dame Mary Joseph', in McGuire and Quinn (eds), *Dictionary of Irish Biography*, viewable online: http://dib.cambridge.org/viewReadPage.do?articleId=a1272 (accessed 7 January 2020).

45 P. Nolan, *The Irish Dames of Ypres: Being a History of the Royal Irish Abbey of Ypres founded A.D. 1665 and Still Flourishing and Some Account of Irish Jacobitism with a portrait of James II and Stuart Letters Hitherto Unpublished* (Dublin: Browne & Nolan, 1908), p. 150.

46 Ibid., p. 151. According to an account from 1828, some thirty girls were sent to the convent, with eighteen becoming postulants before the outbreak of the war in 1689. See P. Lynch, *The Life of Saint Patrick, Apostle of Ireland, to which is added Saint Fiech's Irish Hymn: also a copious appendix of the various*

ecclesiastical institutions, & c. in Ireland (Dublin: printed by Thomas Haydock & Son, 1828), p. 284.

47 Registers of the English Benedictine Nuns of Pontoise, Douai Abbey Archive, T. IV. 1. f. 88. See also *Catholic Record Society: Miscellanea*, vol. 10, p. 275.

48 See Nolan, *Irish Dames of Ypres*, pp. 173–207.

49 Among those entrusted to Dame O'Ryan's care were two daughters of William Bourke, 7th Earl of Clanricarde and his wife Helen (née McCarthy). The elder, Margaret, married Bryan Magennis, 5th Viscount Iveagh, and later Thomas Butler, with whom she had eight children, including John Butler, 15th Earl of Ormond. Honora first married Patrick Sarsfield and then James II's illegitimate son, James FitzJames, 1st Duke of Berwick; see Nolan, *Irish Dames of Ypres*, p. 189; A. Creighton, 'Burke, William', in McGuire and Quinn (eds), *Dictionary of Irish Biography*, viewable online: http://dib.cambridge. org/viewReadPage.do?articleId=a1191 (accessed 18 December 2019).

50 See Nolan, *Irish Dames of Ypres*, pp. 181–2.

51 Ibid., pp. 188–90.

52 Letter to Richard, Earl/Duke of Tyrconnell from Frances, Countess/Duchess of Tyrconnell, 2 May 1689, Letters to Richard, Earl of Tyrconnel[l] and other Documents, 1687–89, National Library of Ireland, MS 37/94.

53 The foundation stone is still in existence today and is on display in Kylemore Abbey in County Galway, watched over by a portrait of Abbess Mary Joseph Butler.

54 See Gillow and Trappes-Lomax, *Diary of the 'Blue Nuns'*, p. xii.

55 Ibid.

56 P. de Courcillon, Marquis de Dangeau, *Journal du Marquis de Dangeau, Publié en Entier pour la Première Fois par MM. Soulié, Dussieux, de Chennevières, Mantz, de Montaiglon avec les Additions Inédites du Duc de Saint-Simon* (Paris: Firmin Didot Frères, 1854) vol. 1, p. 228 (7 October 1685); Draft release of lands in Cos Mayo and Westmeath, Theobald, Viscount Dillon to his son, Henry, re. his marriage settlement with Lady Frances Hamilton and a marriage portion of £3,000, June 1687, Westport Estate Papers, National Library of Ireland, MS 40,898/1(15); G.E. Cockayne (ed.), *The Complete Peerage of England, Scotland, Ireland, Great Britain and the United Kingdom: Extant, Extinct or Dormant* (London: The St Catherine Press Ltd, 1910), vol. 1, p. 428; The Right Honourable Nicholas Lord Viscount Kingsland, appellant. Frances Countess Dowager of Tyrconnell respondent. Et e contra, 1725, House of Lords Irish Appeal Cases, National Library of Ireland. LO LB 627 (79–80).

57 W.A. Speck, 'The Orangist Conspiracy against James II', *The Historical Journal*, 30, 2 (June 1987), pp. 453–62.

58 For a detailed account, see R.J. Weil, 'The Politics of Legitimacy: Women and the Warming-pan Scandal', in L.G. Schwoerer, *The Revolution of 1688–89: Changing Perspectives* (Cambridge: Cambridge University Press, 1992), pp. 65–82.

59 J. Dalrymple, *Memoirs of Great Britain and Ireland, from the Dissolution of the last Parliament of Charles II, until the Sea-Battle off La Hogue* (Dublin: printed by the executors of David Hay, 1773), vol. 3, p. 224.

60 S. Weller Singer (ed.), *The Correspondence of Henry Hyde, Earl of Clarendon and of his Brother Laurence Hyde, Earl of Rochester; with the Diary of Lord Clarendon from 1687 to 1690, Containing Minute Particulars of the Events Attending the Revolution; and the Diary of Lord Rochester during his Embassy to Poland in 1676* (London: Henry Colburn, 1828), vol. 1, p. 355.

61 Ibid., pp. 530–1.

62 R. Loeber, 'The Rebuilding of Dublin Castle: Thirty Critical Years, 1661–1690', *Studies: An Irish Quarterly Review*, 69, 273 (Spring 1980), p. 68.

63 R. Holmes, *Marlborough: England's Fragile Genius* (London: Harper Press, 2008), pp. 139–40.

64 F. Harris, *A Passion for Government: The Life of Sarah, Duchess of Marlborough* (Oxford: Clarendon Press, 1991), p. 44.

65 Ibid., p. 43.

66 W. Churchill, *Marlborough, His Life and Times* (London: George G. Harrap & Co., Ltd., 1947), vol. 1, p. 263.

67 See Harris, *A Passion for Government*, pp. 50–1.

68 For Marlborough's campaign in Cork see Childs, *Williamite Wars*, pp. 267–80.

69 These marks of James's affection were accompanied by a financial boon from the King of France, who sent him the Cordon Bleu and a casket containing 12,000 *louis*; quoted in Sergeant, *Little Jennings*, vol. 2, p. 426.

70 Anon., *Ireland's Lamentation: Being a Short, but Perfect, Full, and True Account of the Situation, Nature, Constitution and Product of Ireland* (Dublin: printed by J.D., 1689), pp. 26–7.

71 See Sergeant, *Little Jennings*, vol. 2, p. 446. Sergeant's observations were echoed by Charles Petrie, in his biography of Tyrconnell. See C. Petrie, *The Great Tyrconnel* (Cork: Mercier Press, 1972), p. 180.

72 Letter to Richard, Earl/Duke of Tyrconnell from Frances, Countess/Duchess of Tyrconnell, 2 May 1689, Letters to Richard, Earl of Tyrconnel[l] and other Documents, 1687–89, National Library of Ireland, MS 37/94.

73 Ibid.; S. Mulloy (ed.), *Franco-Irish Correspondence, December 1688–February 1692* (Dublin: Stationery Office for the Irish Manuscripts Commission, 1983), vol. 1, no. 683.

74 Letter to Richard, Earl/Duke of Tyrconnell

from Frances, Countess/Duchess of Tyrconnell, 2 May 1689, Letters to Richard, Earl of Tyrconnel[l] and other Documents, 1687–89, National Library of Ireland, MS 37/94.

75 See R. Wilson, 'The Vicereines of Ireland and the Transformation of the Dublin Court, c.1703–1737', *The Court Historian*, 19, 1 (June 2014), pp. 3–28.

76 *Calendar of the Manuscripts of the Marquess of Ormonde. K.P. preserved at Kilkenny Castle* (London: Historical Manuscripts Commission, 1920), vol. 8, p. 372; H.J. Lawlor (ed.), *The Diary of William King, D.D., Dean of St Patrick's, afterwards Archbishop of Dublin Kept During his Imprisonment at Dublin Castle* (Dublin: The University Press, 1903), pp. 72–3.

77 See Lawlor, *The Diary of William King*, p. 73.

78 This note was stored in the Muniments Room of Davidstown House in County Kildare, but is missing or destroyed. For a reference to it, see M. Comerford, *Collections Relating to the Dioceses of Kildare and Leighlin* (Dublin: J. Duffy, 1883), vol. 2, p. 231.

79 H.J. Lawlor, in *The Diary of William King*, asserts that Frances must have made a donation to the Channel Row convent, as her debt to 'Mrs C----' was two years old. The likelihood of Frances making such a gift at the same time that Dame O'Ryan was complaining of her opposition to the foundation is very slim. It is probable that Frances donated £6 worth of malt to the Benedictine sisters, including Margaret Markham, who travelled to Ireland ahead of Abbess Butler to prepare for her arrival and for the establishment of the royal priory on Great Ship Street.

80 See Lawlor, *The Diary of William King*, pp. 45–6.

81 Anon., *An Account of the Transactions of the Late King James in Ireland* (London: n.p., 1690), pp. 16–17. This attitude was echoed by the anti-Tyrconnelite Jacobite, Charles O'Kelly, in the 1690s, when he referred in print to 'Coridon's [Tyrconnell's] Lady comonly giveing Double the Quantity of Brass, for soe much Silver'. See C. O'Kelly, *Macariae Excidium: or The Destruction of Cyprus; Being a Secret History of the War of the Revolution in Ireland* (Dublin: printed for the Irish Archaeological Society, 1850), p.100.

82 W. King, *The State of the Protestants of Ireland under the Late King James's Government* (London: printed by Samuel Roycroft for Robert Clavell, 1692), pp. 97–8. Lady Rosse was, in fact, married to a Protestant, but this was not considered relevant, as he was a Jacobite and she remained avowedly Catholic.

83 J. Oldmixon, *Memoirs of Ireland from the Restoration to the Present Times* (London: printed for J. Roberts, 1716), p. 189.

84 F.H. Blackburne Daniell (ed.), *Calendar of State Papers, Domestic Series, of the Reign*

of William III, 1676–7 (London: His Majesty's Stationery Office, 1909), pp. 357–8.

85 Ibid.; Correspondence of the Duchess with her eldest sister, Frances, wife of Sir George Hamilton, and (1681?) of Richard Talbot, titular Duke of Tyrconnel; including letters from Lady Tyrconnel's London agent, Daniel Arthur, and letters and papers relating to her attempts to recover her jointure in Ireland, Blenheim Papers, British Library, Add MS 61453, ff. 54–54v.

86 C. Leslie, *An Answer to a Book, Intituled, The State of the Protestants in Ireland under the Late King James's Government* (London: n.p., 1692), p. 73; see also Lenihan, *Last Cavalier*, pp. 118–19.

87 G.A. Ellis, *The Ellis Correspondence. Letters Written During the Years 1686, 1687, 1688, and Addressed to John Ellis, Esq.* (London: Henry Colburn, 1829), vol. 1, p. 9.

88 Copy of deed of trust re. Christopher Malone's appointment as Surveyor General by Gerald Dillon at the request of [Frances] Duchess of Tyrconnell, 24 July 1689, Westport Estate Papers, National Library of Ireland, MS 40,899/1(1).

89 J. Macpherson, *Original Papers; Containing the Secret History of Great Britain, from the Restoration, to the Accession of the House of Hanover* (London: printed for W. Strahan & T. Cadell, 1775), vol. 1, p. 338.

90 Ibid.

91 See J.J. Jusserand, *A French Ambassador at the Court of Charles the Second: Le Comte de Cominges, from his Unpublished Correspondence* (London: T. Fisher Unwin, 1892).

92 See Macpherson, *Original Papers*, p. 338.

93 Instructions for Mr Maxwell going into Ireland, October 1689, see Macpherson, *Original Papers*, p. 342. Philip Sergeant has observed that there may have been grounds to suspect Lord Tyrconnell's nephew, Sir Neal O'Neill, of scheming against James; see Sergeant, *Little Jennings*, vol. 2, pp. 464–5.

94 Letter to Father Maxwell from Lord Melfort, October 1690, Lansdowne MS, British Library, MS 1163 C.

95 See Mulloy, *Franco-Irish Correspondence*, vol. 2, no. 908. See also D.C. Boulger, *The Battle of the Boyne: Together with an Account Based on French and other Unpublished Records of the War in Ireland (1688–1691) and of the Formation of the Irish Brigade in the Service of France* (London: M. Secker, 1911), p. 200.

96 'News from Dublin dated 22 August 1690', *Gazette d'Amsterdam*, quoted in C. Giblin, 'Catalogue of Material of Irish Interest in the Collection "Nunziatura di Fiandra"', Vatican Archives, Part 2, vols 51–80, *Collectanea Hibernica*, 3 (1960), p. 132.

97 'News from Paris dated 1 September 1690', *Gazette d'Amsterdam*, quoted in Giblin, 'Catalogue of Material of Irish Interest', p. 133. It was also reported that she carried 40,000 gold coins out of Ireland. See S.J. Connolly, *Divided Kingdom: Ireland 1630–1800* (Oxford: Oxford University Press, 2008), p. 186.

98 See Gillow and Trappes-Lomax, *Diary of the 'Blue Nuns'*, p. 38.

99 Ibid., p. 39; see Dangeau, *Journal*, vol. 2, p. 352 (11 October 1690).

100 See O'Kelly, *Macariae Excidium*, p. 57.

101 See Lenihan, *Last Cavalier*, pp. 162–4.

102 Ibid., p. 164.

103 See O'Kelly, *Macariae Excidium*, pp. 78–9.

104 While Lenihan observes that the allegations (hinted at by Melfort) that Frances 'played the whore' in Versailles after George Hamilton's death had 'circumstantial plausibility', he also acknowledges that she was 'in a very vulnerable position' and may well have succeeded 'through the merits of her case alone'; see Lenihan, *Last Cavalier*, p. 141.

105 See Sergeant, *Little Jennings*, vol. 2, p. 560.

106 See J. McGuire, 'The Treaty of Limerick', in Whelan (ed.), *The Last of the Great Wars*, pp. 127–38; J.G. Simms, 'Williamite Peace Tactics, 1690–1', *Irish Historical Studies*, 8, 32 (September 1953), pp. 303–23; see Simms, *The Williamite Confiscation*; see Simms, *The Treaty of Limerick*; see Simms, *Jacobite Ireland*; see Kinsella, *Catholic Survival*.

107 See Sergeant, *Little Jennings*, vol. 2, p. 574.

108 See Simms, *The Williamite Confiscation*, p. 132.

109 See Sergeant, *Little Jennings*, vol. 2, p. 576.

110 See French letters from Frances, Countess/Duchess of Tyrconnell, 1707, Carte Papers, Bodleian Library, MS Carte 210, fols 5–77.

111 See Sergeant, *Little Jennings*, vol. 2, p. 583.

112 Ibid.; L. Ó Broin, 'Fanny Jennings, Duchess of Tyrconnell', *The Irish Ecclesiastical Record*, ser. 5, 97, 6 (June 1962), p. 381.

113 See Sergeant, *Little Jennings*, vol. 2, p. 583; see Lenihan, *Last Cavalier*, p. 180.

114 She invested in John Law's Mississippi Scheme and the South Sea Company; see Stock Ledger, Old South Sea Annuities 1, T–V, 25 June 1723–29 September 1728, Accountant's Department: Stock Ledgers, Bank of England Archive, AC27/6451, f. 239; Child & Co. customer account ledger for Frances, Duchess of Tyrconnell, 1722–31, Royal Bank of Scotland Archives, CH/194/14, ff. 175, 327. M. Murphy, *The Duchess of Rio Tinto: The story of Mary Herbert and Joseph Gage* (Oxford: St Clements Press, 2015), p. 27; P. Walsh, *The South Sea Bubble and Ireland: Money, Banking and Investment, 1690–1721* (Woodbridge: The Boydell Press, 2014), p. 76.

115 Hussey v. Berkeley, 1757, Records created, acquired, and inherited by Chancery, and also of the Wardrobe, Royal Household, Exchequer and various commissions, National Archives of the United Kingdom, C 11/1684/3; Hussey v Lady Dillon and Lady Kingsland, testamentary cause: goods of Dowager Countess Tyrconnell, 1733, Records of the High Court of Delegates, National Archives of the United Kingdom, DEL 1/442, vol. 2, 462. In London, the press reported that the house was on the newly developed Hanover Square, the confusion arising from the fact that Conduit Street was only 300 metres away. See *Original Weekly Journal*, 3 October 1719; *The Weekly Packet*, 3 October 1719.

116 Letter to Jane Guidott from Frances, Duchess of Tyrconnell, [10?] February 1728, Royal Bank of Scotland Archives, CH/560/16/1.

117 Letter to Sarah, Duchess of Marlborough from Frances, Viscountess Dillon, 15 March 1731, Blenheim Papers, British Library, Add MS 61,454, f. 60.

118 C.H. Price and J.H. Bernard (eds), *The Registers of Baptisms, Marriages, and Burials in the Collegiate and Cathedral Church of St. Patrick, Dublin, 1677 to 1800* (Dublin: printed for the Parish Register Society of Dublin, 1907), p. 33.

119 The Duchess of Tyrconnell was the subject of an anecdote, apparently originating with Horace Walpole, about a figure who appeared in London's Covent Garden dressed entirely in white and disguised as a milliner, sometime in the late seventeenth or early eighteenth century. In some imaginings, she was supposed to have set up incognito in order to facilitate a Jacobite scheme. The story was printed first in T. Pennant, *Of London* (London: printed for Robt. Paulder, 1790), pp. 134–5, and reappeared in a number of periodicals, including *The European Magazine and London Review*, 51 (January to June 1807), p. 178; C. Mackay, *The Thames and its Tributaries; or Rambles among the Rivers* (London: Richard Bentley, 1840), vol. 1., p. 45; P. Cunningham, *Hand-book of London: Past and Present* (London: John Murray, 1850), vol. 1, p. 354; W. Gaspey, *Tallis's Illustrated London; In Commemoration of the Great Exhibition of 1851* (London: John Tallis & Company, 1851), vol. 1, p. 84. It eventually formed the basis of Douglas Jerrold's stage play, *The White Milliner: A comedy in two acts* (London, 1841), which travelled across the Atlantic to Philadelphia, despite poor reviews, and of Katherine Thomson's novel, *The White Mask* (London, 1844). Frances also featured in Anna Brownell Jameson's popular *The Beauties of the Court of King Charles the Second* (London: Richard Bentley, 1833), as Miss Jennings.

120 L. Whyte, 'A Funeral Elegy on the Death of Frances, Lady Dutchess of Tyrconnell', in M. Griffin (ed.), *The Collected Poems of Laurence Whyte* (Lewisburg: Bucknell University Press, 2016), pp. 243–6.

Three

'She Made Charity and Benevolence Fashionable'

Mary, Marchioness of Buckingham, Vicereine of Ireland

Janice Morris

When the viceroy of Ireland, the Marquess of Buckingham, wrote to his absent wife, Mary (Fig. 03.01), in 1789: 'Your picture is my only comfort and it is my constant companion and relieves many gloomy moments', he showed just how important her presence was to his well-being.[1] The 'picture' to which he referred is likely to be the miniature painted in watercolour on ivory by Horace Hone (1754–1825), an artist who went to Dublin at Mary's invitation in 1782 and established a practice there under her patronage (see Cat. 12).[2] Mary's delicate face made its appearance in print in April of 1783 when *The Hibernian Magazine* published a full-length mezzotint of the young vicereine.[3] The headdress, and the soft and modestly flattering bodice of the dress, are the same as those in the Hone miniature, but the uncomfortable apparatus of courtly attire is in evidence in the wide, stiff skirt (Fig. 03.02). Encased in a dress befitting her role as consort to the viceroy of Ireland, the two-dimensional figure of Mary Elizabeth Grenville (née Nugent, 1758–1812), Countess Temple (later Marchioness of Buckingham) stares mannequin-like from the page. The fulsome praise for the young countess in the accompanying narrative provides evidence that she met contemporary expectations of elite female charitable activity. As well as being 'possessed of every exterior and mental qualification', she was credited with 'bringing the long-neglected attributes of charity and patriotism into fashion'.[4]

The stereotypical impressions created by successive vicereines can be gleaned from newspapers and magazines, which provide records of events and contemporary opinion of viceregal performance.[5] To complement these sources, archival material held at the Huntington Library, California, which has been largely overlooked until now, is used here to offer a more nuanced understanding of how Mary Elizabeth Grenville interpreted her role. Letters written and received during two separate tours of duty as vicereine, from 1782 to 1783 and again from 1787 to 1789, provide a unique insight into how an elite wife and mother reconciled her duties as consort with her marital, familial and local responsibilities. The twofold appearance of Mary in Dublin provides a pair of discrete snapshots of an aristocratic Georgian female in a public role: at the side of her ambitious husband, the young Countess Temple of the first tour of duty reappeared as the Marchioness of Buckingham during the second.

Aside from the political obligations of every viceroy as the monarch's representative in Ireland, duties customarily included entertainment at Dublin Castle – seat of the viceregal court – patronage of the arts, support for local industry and, finally, charitable gestures.[6] Mary played a role in each of these recorded, public duties, whilst behind the scenes she acted as confidante to her husband in personal and political matters. She acted as his consort at official events, many of them held in the Castle, where her considerable artistic skill and appreciation led to the couple's discerning and fruitful patronage of artists, the most positive legacy of their presence in Dublin. Visiting factories and warehouses to encourage and promote local industry was an established part of the viceregal routine. Together, they also attended fundraising command performances at local theatres. However, the most effusive praise in print was reserved for the vicereine's benev-

olence. Mary was indeed, during the first tour of duty, a philanthropist in-the-making: her example provides a clear illustration of the changing nature of charitable practice in eighteenth-century Ireland, and the role of elite women within it.[7]

Two tours as viceroy and vicereine of Ireland alerted the Marquess and Marchioness of Buckingham to problems of poverty, sickness and unemployment in Dublin and to the philanthropic systems in place to alleviate them. The experience opened their eyes to possibilities for personal intervention, which they would later deploy on their estates and, ultimately, in support of the émigrés who would come to Britain as refugees of the French Revolution. Evidence suggests that Lady Buckingham's charitable activity, rooted in a strong religious faith, singled her out as an early proponent of a type of elite female philanthropy that was beginning to differ from earlier practices by being more proactive, more diverse, and more public. Such changes were gaining in momentum towards the end of the eighteenth century as women began to 'carve out spheres of influence for themselves' in charities which focused primarily on women and children.[8]

Mary, an Anglo-Irish Catholic, was born and brought up at Gosfield in Essex. She enjoyed a close bond with her father, Robert, Viscount Clare, later 1st Earl Nugent (1709–1788), whose ancestral estate was in Carlanstown, County Westmeath. His rise from Irish Catholic gentry to landed aristocracy was facilitated by apostasy and three lucrative marriages which led to the apt description of him as 'a jovial and voluptuous Irishman who left Popery for the Protestant religion, money and widows'.[9] Mary was the product of his third marriage, to Elizabeth (née Drax), Dowager Countess of Berkeley (1720–1792), but the couple separated on hostile terms during Mary's infancy, leaving her in the care of her father and his unmarried sister, Lady Margaret Nugent (c.1724–1794).[10]

The lively personality of her father had a lasting impact on Mary and undoubtedly helped to build her confidence for the public role she was to play in Dublin. As a child, she seems to have been encouraged 'to make a noise and sparkle', in defiance of the usual contemporary advice to parents of girls.[11] Evidence suggests that mischief-making was one way in which she engaged with intelligent adults, part of an apparently haphazard educational programme that cultivated wit and repartee, important ingredients in the art of pleasing that was central to eighteenth-century politeness and sociability. An anecdote in a family memoir shows Mary as a child, completely at ease in the company of the playwright Oliver Goldsmith (c.1728–1774), a close friend of Earl Nugent:

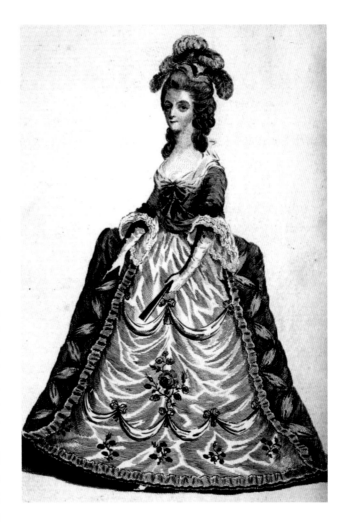

Fig. 03.02.

Unknown artist

Mary, Countess Temple, later Marchioness of Buckingham

1783

Published in *The Hibernian Magazine*, April 1783. Reproduced courtesy of the National Library of Ireland.

Nugent's daughter Mary was a great favourite of Goldsmith's, and an amusing story is told of how on one occasion, when he was asleep after dinner, she tied his wig to the back of his chair, so that on waking and rising to his feet his wig was dragged from his head exposing his baldness. He treated the joke, however, with the utmost good nature, and put the incident in his delightful comedy, *She Stoops to Conquer*.[12]

Emboldened by the formative influence of paternal ebullience, in adulthood, her effervescent personality delighted those around her and lightened the politically charged atmosphere of Stowe, her marital home in Buckinghamshire after 1779 (Fig. 03.03).[13]

In contrast, the early life of Mary's future husband, George Nugent-Temple-Grenville (1753–1813), with two brothers and four sisters to whom he was very close, particularly after the death of their parents, promoted an insularity which resulted in him finding it hard to forge friendships outside the immediate family circle.[14] A feeling of insecurity was accentuated by a stutter, which though not unusual, in his case did cause comment, suggesting it may have been more serious than most.[15] At Bath from 1771 to 1772, he underwent a programme of correction by the Irish actor and orthoepist, Thomas Sheridan (c.1719–1788) whose methods left sufferers with such stilted speech that they were said to have sounded pompous.[16] The young man's social unease was apparent in Paris in September 1773: he distanced himself from his fellow grand tourists, declaring of their behaviour: '[it] is not compatible with my views in travelling'.[17] Though understood by those closest to him, he appeared priggish to others.

The arranged marriage of these two very different personalities has much to tell us about the functioning of an elite partnership in the public eye in Dublin.[18] Unpublished correspondence gives an insight into the birth and evolution of an

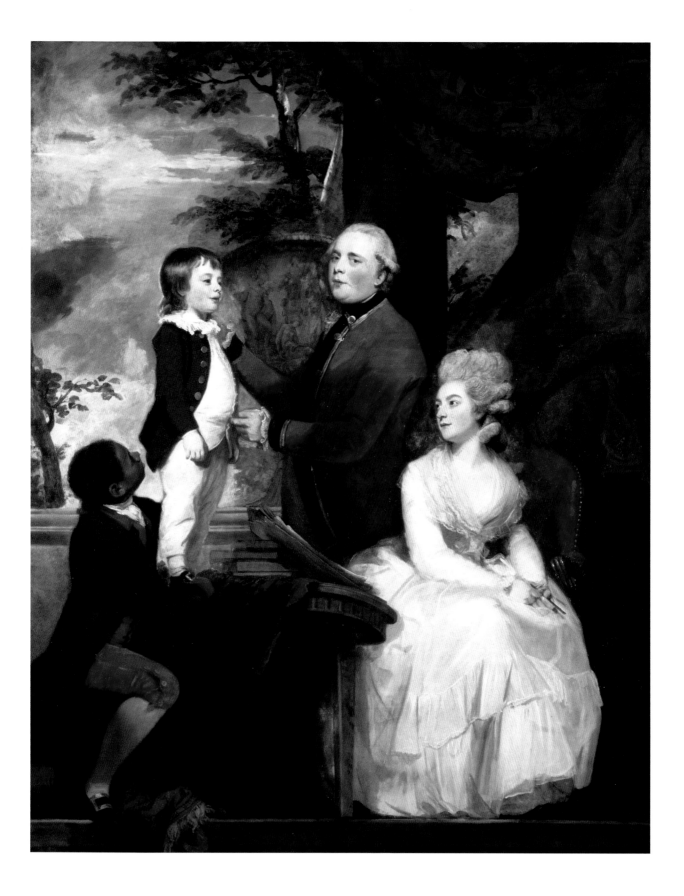

enduring and effective partnership between the socially awkward George and the self-assured Mary, based on affection on both sides. He was fortunate that his inclination coincided with his duty; upon his engagement, he announced: 'I am now the happiest man in England, in the prospects of my future life.'[19] The match was financially advantageous on both sides. The childless Richard, 2nd Earl Temple (1711–1779) was set to bequeath his estates in Buckinghamshire and Dorset to his nephew, George, who had been in receipt of a highly lucrative tellership of the exchequer since the age of ten.[20] In turn, Mary's appeal had been enhanced when, upon the death of her half-brother in 1771, she became heiress to her father's significant fortune.[21] George's letters to Mary throw light on their joint aspirations, in tune with contemporary aristocratic ideals of patriotism and duty.[22] They show clearly that a classical education had drilled into him the idea that wealthy men had an obligation to play an active part in public life, and it was here that he felt he could excel. However, an insular home life, followed by Eton and Oxford, left him ill-equipped for the sociability of the Protestant Ascendancy in Dublin where stress was often dispelled and popularity gained through flirtatious and raucous behaviour.

In August 1782, George Nugent-Temple-Grenville, 3rd Earl Temple, was selected as lord lieutenant (viceroy), replacing William Cavendish-Bentinck, 3rd Duke of Portland (1738–1809) who, because of a change of government, had served for only five months.[23] A family portrait by Sir Joshua Reynolds (1723–1792), painted at about this time, provides a sympathetic view of the young man, accompanied by his wife, who became vicereine at the age of 24, and their young son, Richard (Fig. 03.04).[24] A second child, Mary, died in April 1782.[25] Temple's right hand rests on his son's shoulder, keeping him gently in place, while Mary draws or paints his portrait, as a black pageboy observes. Reynolds, from whom Mary took lessons, deliberately portrayed her engaging in an activity in which her skill was admired.[26] Evidence of her studentship survives in the form of an artist's palette prepared for her by Reynolds, which she used while copying his celebrated work *Sarah (Kemble) Siddons as the Tragic Muse*, under his direct supervision, at Stowe House (see Cat. 13). The copy she produced was listed in the catalogue of contents sold from Stowe in 1848 but its whereabouts have not been traced.[27] According to an account published in the year of her death, numerous other works by Mary were also on display at Stowe during her lifetime.[28] Her appreciation of art led to her patronage of promising artists, including the miniaturist, Horace Hone, mentioned earlier, whose career in Ireland she initiated as vicereine. Josiah Wedgwood was commissioned to capture her likeness and that of her husband, as a mark of their fashionable taste. Wedgwood produced at least two cameo medallions of Mary's profile, one in white relief on solid blue jasper (Fig. 03.05), and another in black basalt jasperware, which is now in the collection of the Metropolitan Museum of Art, New York (see Fig. 03.01).

The painting by Reynolds alludes to Countess Temple's artistic skill and also, through the Borghese Vase in the background, to the classical discernment of her husband.[29] Their taste is much in evidence at their marital residence, Stowe,

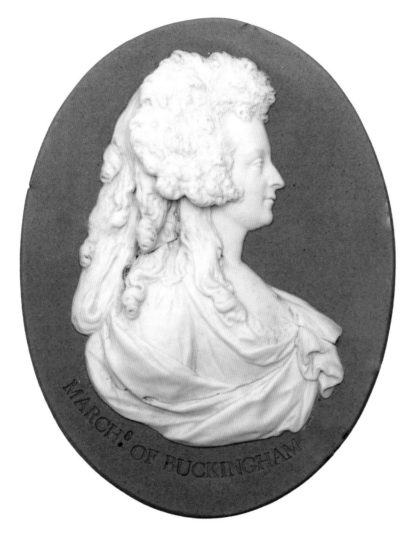

Fig. 03.05.

Josiah Wedgwood

Mary Elizabeth Nugent, Marchioness of Buckingham

c.1785–90

Courtesy of the Wedgwood Museum.

where the Music Room, completed in about 1780, was designed in the fashionable Neoclassical style for Countess Temple.[30] Her musical talent is celebrated in a representation of her image in one of the panels, an imaginative creation based on Raphael's decoration of the Vatican Loggia (Fig. 03.06).[31] It was created by Vincenzo Waldrè (1740–1814), an artist first recorded in England in 1774, whom Richard, 2nd Earl Temple had commissioned to work on the mansion at Stowe.[32] Upon the death of his uncle, George, 3rd Earl Temple, continued the artist's employment, and subsequently brought him to Dublin (during his second viceroyalty) where he commissioned him to paint the ceiling of St Patrick's Hall in Dublin Castle.[33] At around the same time as his work on the Music Room, Waldrè designed and decorated a Neoclassical garden building known as the Menagerie.[34] It was conceived as a retreat from the crowds who flocked to Stowe, hoping to catch a glimpse of the beautiful chatelaine. The Menagerie enabled the Countess to demonstrate, on the short walk from the mansion, the accessibility that was increasingly expected of enlightened and responsible aristocrats. It then provided her with a resting place from which she could still be seen.

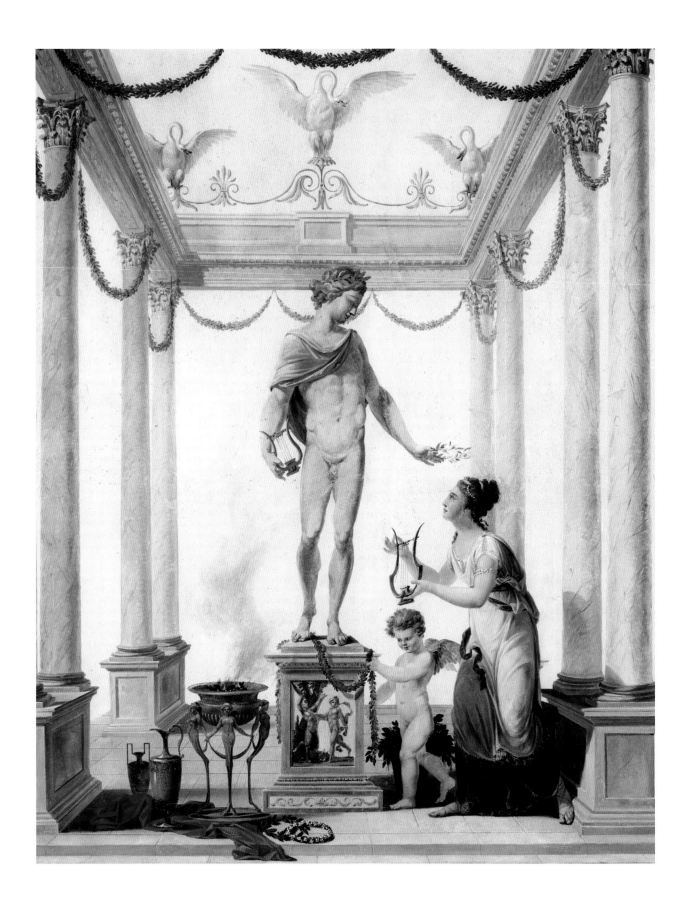

Presiding over the viceregal court at Dublin Castle, Temple was placed in a position of authority and power greater than he had ever experienced before. At his side, Countess Temple was granted the same access to influence through sociability as preceding consorts had enjoyed. Temple's high-profile role, at all times subject to censure, was one which, as James Kelly has observed, most incumbents found demanding, or even disagreeable.[35] This was, in part, because when the position of viceroy became full-time and salaried in 1767, the incumbent was expected to reside in Dublin; a lodge in the Phoenix Park was purchased in 1781 to serve as the viceregal summer residence.[36] Toby Barnard has commented on the difficulty of determining whether successive vicereines were present or not but, for the Temples at least, the question is answered by their exchange of letters whenever they were apart.[37] Their correspondence not only throws new light on the viceroy's official activities, but also reveals the impact on health and family life of the obligation to relocate to Dublin.

When Temple took office in August 1782, the political situation in Ireland was a challenging one: four months before his arrival, under the leadership of the patriot, Henry Grattan (1746–1820), Irish legislative independence had been granted.[38] The Protestant Ascendancy, the landowning ruling elite, was determined to maintain its dominant position and so, amid demands for concessions for Catholics, careful handling was required. The viceroy needed to placate both sides of the political divide and in this he was, according to *La Belle Assemblée*, aided by his wife who 'well knew how to unite the reserve becoming her station, with that affability of manner necessary to conciliate all parties without appearing to give a preference to any'.[39] Countess Temple's 'reserve' was, in part, due to the need for discretion in the profession of her faith as steady progress towards emancipation was being made. Her Catholicism – a reversion to the religion of the Nugent family – was as central to her identity as her aristocratic status but set her apart from her peers, whose sensitivities needed to be carefully managed. In the privacy of their own home in England, her husband could turn a blind eye to her religious practices, but in Dublin, the way they chose to decorate their living accommodation was potentially contentious as it was an official residence. Myles Campbell has drawn attention to the unusually large number of religious pictures recorded in an inventory of the Viceregal Lodge on 31 October 1782.[40] The display suggests that Earl Temple indulged the taste of his wife.

Massaging ascendancy egos by conferring honours, and satisfying their appetite for socializing, had to be managed amid accusations of parliamentary corruption.[41] Temple's interest lay in domestic affairs, particularly economic reform, in which sphere his assiduousness was noted.[42] Whereas others were content to leave the business of parliament to 'undertakers', Lord Charlemont (1728–1799) recorded:

> From nine in the morning until five or six in the afternoon he never left his
> closet, where all the time that was not taken up in audiences was employed,
> sometimes in writing, but principally in the inspection of the national
> accounts, by which means he soon made himself perfect in all the complicated
> business of the revenue, and in everything relative to receipt and expenditure.[43]

(opposite)

Fig. 03.06.

Vincenzo Waldrè

Wall painting in the Music Room, Stowe House, Buckinghamshire

c.1780

© Andy Marshall, by permission of the Stowe House Preservation Trust.

Temple worked hard to reduce the number of sinecures.[44] In this, he faced several difficulties, not least the fact that he was in possession of a significant sinecure himself which made him vulnerable to accusations of hypocrisy. Appeals to Countess Temple reveal that this issue affected her directly too, and was ingrained in all aspects of viceregal life in a complex web of patronage. Even minor roles involved complicated issues of dependency: in a letter written to Lady Temple by Lady Harcourt on behalf of a court trumpeter who could not perform the duty in person, it was made clear that his sisters were as reliant as he on the money the sinecure brought in.[45]

These were formative years for the Temples; they threw themselves into every aspect of the role. They gained visibility and approval through the well-established custom of support for theatres in the city. As well as command performances with which they 'intended to honour their presence', their attendance was noted at, for example, a performance of *Othello* on Thursday 21 November 1782, after which they were surrounded and jostled by well-wishers: 'His Excellency and his Countess sat out the whole entertainment with apparent Pleasure; and so eager were the many hundreds disappointed of Places in the Front of the House, to see their Excellencies, that they forced in the Stage door, to join in the general Joy which was evinced on their Appearance.'[46] A certain degree of separation between their public and private lives was maintained by residing mostly at the Viceregal Lodge in the Phoenix Park, rather than at the Castle.[47] Letters written during the delay in the Countess's arrival caused, in part, by Portland's continued presence at the Lodge, demonstrate Temple's concern for his wife's material comfort. 'I have been employed,' he wrote in September 1782, 'in what to me is the only pleasant employment, the getting ready of our apartments.'[48] His eagerness for her company is also apparent: 'I was overjoyed to hear of your quick and safe passage.'[49] The letters also hint at the toll his attitude to work would take on his health: 'I was much worn down yesterday by the council and the people whom I was obliged to see ... my cough ... (as usual) exhausts me but it has got looser and consequently less troublesome.'[50]

Confining himself to his cabinet during the working day, Temple nevertheless revelled in the opportunity for ostentation afforded by the Castle. His love of pageantry and ceremony was satisfied by the creation of the Most Illustrious Order of St Patrick, approved by George III as a means of placating those seeking English peerages which he was unwilling to bestow.[51] The benefit of the Order went beyond providing an acceptable form of recognition for loyalty to the Crown by the Irish elite; commissions for silk regalia provided work for Ireland's struggling textile industry.[52] Continuing the practice of earlier vicereines, the Countess played her part in this and other viceregal events by insisting guests follow her example of patronizing local industry: 'None were countenanced at the Castle, of either sex, but such as appeared in Irish Manufacture; and in her ladyship's exertions were at the same time experienced, the happy qualifications of bringing the long-neglected attributes of charity and patriotism into fashion.'[53]

Official viceregal rounds of the city would have brought to the attention of Countess Temple projects initiated and overseen by the philanthropist Lady

Arbella Denny (1707–1792), who in her later years continued to take an interest in the Dublin charities to which she had devoted herself since being widowed at the age of 35.[54] She had pushed the boundaries of elite female activity beyond the conventional norms through her involvement with the Dublin Society (later the Royal Dublin Society), becoming its first female member in 1766.[55] This opening up of the possibility of a more active role for women is likely to have resonated with the energetic young vicereine. Promoting local industry was part of the remit of the Dublin Society and as the viceroy was automatically nominated president, visiting factories and warehouses was a viceregal obligation. As Clarissa Campbell Orr has observed, visiting workshops and commissioning items to decorate homes and public buildings became a fashionable elite pastime.[56] This gave Countess Temple the opportunity to gain an insight into the process of manufacturing as a route out of poverty. A sense of her determination to build upon this insight, and to use her position as vicereine and her personal connections in Ireland for the benefit of the working poor, is apparent in an address she made to a deputation of weavers who 'attended on her' at Dublin Castle, in December 1782:

> I shall always be happy to give every encouragement and protection to the labour and to the produce of a kingdom, with which I am connected by so many ties, and particularly to that important and valuable branch of commerce, the Silk Manufacture, which will always have my best wishes and support.[57]

Lady Arbella Denny demonstrated what could be achieved by relating agriculture to industry through the introduction of sericulture on her estate for the production of silk clothing and regalia.[58] It seems likely that this initiative interested the young viceregal couple: the agriculturalist Arthur Young (1741–1820) credited both the Marquess and the Marchioness of Buckingham with the introduction of the straw-plait industry to Gosfield, Essex, in about 1795, for the production of straw hats, which saved the local population from penury.[59] A connection can also be seen between Lady Arbella's offer of premiums for carpet-making, and the tapestry industry subsequently established in Winchester by Countess Temple (by then Marchioness of Buckingham) to enable French émigré clergy to achieve self-sufficiency.[60]

Viceregal endorsement of the Irish textile trade emulated the highly publicized patronage of local manufacturers, including the Spitalfields silk-weavers, by Queen Charlotte and other members of the royal household.[61] Support for Irish silk-weavers would have met with royal expectation and approval, but as in other instances, Temple overstepped the mark. George III was renowned for his frugality and dislike of pomp so it was unlikely that over-exuberant displays of loyalty to the Crown through lavish ceremonies and extravagant dress, even if it was locally manufactured, would meet with his approval. Oblivious as ever, Temple commissioned a painting to celebrate the installation of the Knights of St Patrick; Countess Temple can be seen seated on the left, looking admiringly at her husband, holding court, centre-stage (Fig. 03.07).

Although pomp was very much to Temple's taste, the niceties of less formal socializing were beyond him; the social demands of office were best shared with his wife. He no doubt basked in the praise lavished upon the Countess when she was the subject of the eulogizing article in *The Hibernian Magazine* mentioned earlier. With no evidence to support the statement, she was described as an 'ornament of the British court' prior to her marriage to Earl Temple. Her 'travel to foreign courts' also appears to be without foundation.[62] Yet, however fictitious these statements may have been, they differed from views expressed about the wife of the viceroy who held office between Temple's two tours of duty. The Duchess of Rutland, vicereine from February 1784 to October 1787 (see Chapter Four in this volume), was praised for her beauty, but other qualities were rarely noted (see Cat. 14). 'This superb production of nature' a contemporary observed, was not 'lighted up by corresponding mental attractions'.[63] By contrast, although Lady Temple's beauty was alluded to, it was not extolled to the disadvantage of her other appealing attributes.

Lady Temple's appearance in Dublin at a time of chronic food shortages was portrayed as miraculous; she was described as an 'administering angel'.[64] *The Hibernian Magazine* recounted that 'her charity was unlimmited [sic]' when a crowd of destitute room-keepers descended on Dublin Castle to appeal for aid.[65] She was credited with providing relief, using Earl Temple's funds: 'Hundreds of poor wretched room-keepers crowded round the castle, and were as abundantly relieved, as if the princely fortune of Earl Temple, were to be directed to no other appropriation, but that of benevolence.'[66] While the extent of Lady Temple's contribution is uncertain, the example suggests her participation in the growing trend towards a reliance on personal judgement in directing funds: she was reported to have instructed 'ministers and church-wardens of the different parishes' to prioritize the cases of greatest need.[67]

Although there were changes in expectations and in the nature of female philanthropic activity in the late eighteenth century, charity was still dictated by religious faith and considered an aristocratic responsibility. However, increasingly, the moral duty to foster improvement at all levels of society was being strongly instilled into the female elite. Their specific role in this process was endlessly discussed, and prescriptions for appropriate behaviour abounded.[68] At the same time, the growing importance of 'associated and institutional philanthropy' resulted in charitable activity moving away from 'feminine' sympathy towards 'masculine' practicality.[69] Although more women were becoming actively involved in philanthropic work, there was a move towards excluding them from decision-making in the context of increasingly masculinized philanthropy.[70] Charities which supported men and women were progressively being taken over by men, but charities which supported women and children were considered appropriate objects of female concern, so it was here that they had the greatest chance of finding meaningful activity.[71] Although, as has been seen, Lady Arbella Denny ventured into territory considered 'male', her concerns did include women and children. One of her initiatives was the founding of the Magdalen Asylum for Penitent Females in 1767, for the rescue and rehabilitation of prostitutes.[72] The

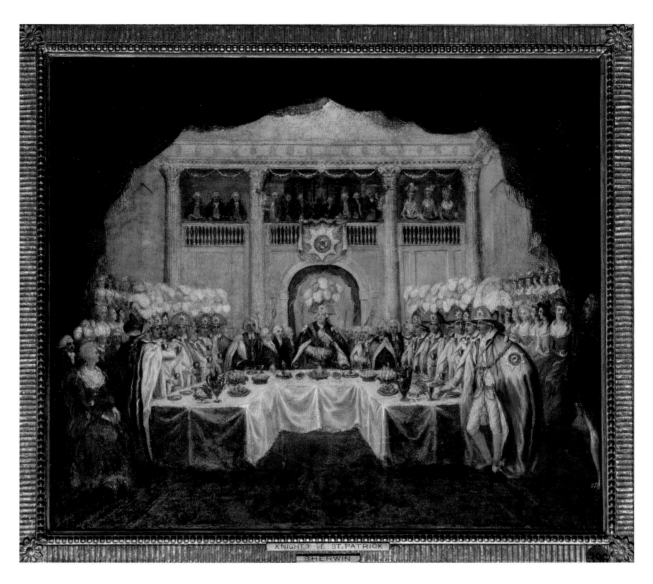

Fig. 03.07.

John Keyse Sherwin

The Installation Banquet of the Knights of St Patrick, 1783

1785

© National Gallery of Ireland.

idea had originated in London, and was implemented at the request of the viceroy of Ireland at the time, Francis Seymour-Conway, 1st Earl of Hertford (1718–1794). His wife, Isabella Seymour-Conway (1726–1782), and Queen Charlotte, were nominated patronesses for life.[73] This illustrates the movement of ideas between England and Ireland and is indicative of the influence that the viceroy and his wife could bring to bear on social and welfare matters.

The viceroyalty brought Countess Temple face to face with contrasts between the prosperity of the Irish elite and the destitution of the lower orders in Dublin, but protocol dictated the activity in which she could be involved.[74] A viceregal event neatly encapsulates the interplay between the recreations of the aristocracy and the needs of the poor. On 18 March 1783, the day after the inauguration of the Knights of St Patrick at Dublin Castle, a celebratory ball was held. As the Castle was not considered suitable for a gathering of this nature, it was held at the Rotunda, the fundraising entertainment space attached to the Lying-In Hospi-

tal which, from 1767, gave the hospital its name (Fig. 03.08).[75] Countess Temple dutifully played her part by opening the ball:

> Tuesday night there were a ball and supper given at the Rotunda by the illustrious Knights of St Patrick, which for splendour and magnificence exceeded any thing of the kind ever given in this kingdom. About ten o'clock his Grace the Duke of Leinster, and the Countess of Temple, opened the ball, and at one the whole company, amounting to above 800, sat down to supper, which consisted of every delicacy that art could produce.[76]

The hire of the rooms at a cost of £300 contributed a far greater sum to the hospital than the usual fee of £50.[77] On this occasion, there was, however, a tension between the various functions of the building: financial gain for the institution came at considerable inconvenience to patients and staff. As a result of the presence of so many aristocratic guests at the ball, rooms in the hospital itself were used, resulting in poor pregnant women who should have been accommodated there being treated in their own homes instead.[78] The irony of this occurrence demonstrates that the rich saw no incongruity between their own enjoyment of polite entertainment and meeting the needs of the poor.[79] It also highlighted the increasing overcrowding at the hospital, which was partly a result of the governors' decision, in 1780, to extend to Catholic clergy the right to recommend patients.[80] This was a significant move away from the original charity's Protestant emphasis: Dr Bartholomew Mosse, founder of the hospital, had instructed that the painting in the newly constructed chapel (opened in 1762) should be 'free from any superstitious or Popish representations'.[81] In Ireland, as in England, there was an increasingly ecumenical dimension to charitable activity which must have gratified the Catholic countess.

Countess Temple followed in the footsteps of earlier vicereines in donating the profits from regular fundraising balls to the Rotunda. In line with customary practice, on a commemorative board in the hospital, her name headed the list of donors, as an example to others: 'Lady Temple, Proceeds of Ball, £104'.[82] But a difference can be seen between the board dated 1783, headed by Countess Temple, and those for subsequent years. Her donation was followed by the contributions of nineteen other donors; some of the subsequent years listed on the boards show only one, two or three donations, or smaller amounts of money, indicating that later vicereines were less assiduous, or less successful, in eliciting support for the lying-in charity.[83] This early indication of her motivational impact was later acknowledged in *La Belle Assemblée*: 'She made charity and benevolence fashionable; and the hospitals, for the relief more particularly of her own sex, owed much to her munificence and example.'[84] This comment reflects approval of her focus on female welfare, which was increasingly encouraged. The more money she raised for the hospital, the more potential there was for an improvement in the conditions under which poor women gave birth.

Earl Temple's first tour was hailed as a success and regret at his departure in May 1783 was recorded in *The Hibernian Magazine*: 'This day at noon, earl Temple had a most numerous and brilliant levee of the nobility, gentry, and great officers of state at the castle, where he received assurances of their unfeigned regret at the departure of the best of governors, and most distinguished of noblemen.'[85] But Temple's pursuit of the King's favour resulted in an error of judgement which tarnished his political reputation: in December 1783, he delivered to parliament, on behalf of George III, a speech on the East India Bill which suggested that anyone who voted in its favour would be regarded as an enemy of the King.[86] This loyal but constitutionally dubious utterance brought down the Fox–North coalition, which the King despised, but it compromised Temple's position and, fearing impeachment, he resigned after just three days in post as Secretary of State in the newly formed government of his cousin, William Pitt (1759–1806).[87] Family loyalty, however, remained intact: on 23 December, Pitt wrote to Temple two letters which were 'not only cordial but affectionate in tone'.[88] George III considered himself severely let down.[89]

It was in a quite different frame of mind that the young man, by then Lord Buckingham, approached his next tour as viceroy. He had the advantage of increased age and experience but being elevated again to this prestigious position catapulted him back into the limelight. It flattered his vanity but resulted in a feeling of anxious isolation that only the company of his wife could dispel. Unfortunately, problems with Lady Buckingham's health and that of their children caused difficulties from the start. At the St Patrick's Day celebration in March 1788, although Lord Buckingham socialized with the guests, and Lady Buckingham showed her support for Irish industry by wearing a locally made satin dress 'brocaded with shamrocks and harp', as a result of a recent illness she was: 'afraid to mingle with the crowd, [and] beheld the dancing from a box prepared for her on purpose, at the upper end of St. Patrick's Hall'.[90] For both the Marquess and

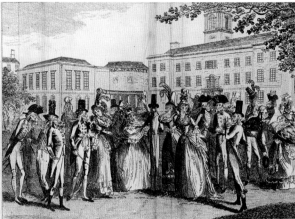

Fig. 03.09.

Unknown artist

Taste, a la Mode 1790

1790

Published in *Walker's Hibernian Magazine*, July 1790.

Reproduced courtesy of the National Library of Ireland.

Marchioness of Buckingham, the second tour proved more challenging than the first. Another child, named Mary like her deceased sister, had been born in July 1787.[91] The young mother was pregnant again when her father, to whom she was very close, passed away. The death of Earl Nugent on 14 October 1788 in Dublin increased Buckingham's workload: under the terms of the will, he inherited heavily encumbered estates in Essex and Ireland, which needed to be managed in addition to those that he had inherited from his uncle in 1779.[92] The responsibility of managing such a portfolio of properties was to prove an immense burden to the obsessively hard-working Marquess at a stage when he was at his lowest ebb politically.[93]

During this difficult second tour, in support of her husband, the Marchioness fulfilled her viceregal duties as far as she was able. She headed the 1788 list of female subscribers to the new Public Assembly Rooms, an addition to the fund-raising entertainment space at the Rotunda.[94] The foundation stone had been laid by the Duke of Rutland on 17 July 1784, and he and his duchess had enjoyed the first use of the rooms on 12 March 1787.[95] Their extravagant entertainment (for details of which see Chapter Four in this volume) reflected contemporary taste and resulted in increased expectations of splendour, which Lord Buckingham attempted to match (Fig. 03.09). When the interior decoration of the great supper-room was still incomplete in 1788, as a result of a shortage of funds, he received a petition accompanied by drawings of the intended decorative scheme, which provides evidence of a link between the hospital and the Knights of St Patrick.[96] A copy of Robert Hunter's portrait of Lord Buckingham wearing the ceremonial robes of the Grand Master of the Order (Fig. 03.10) can be seen occupying pride of place over the fireplace.[97] This association of the new Order with the new rooms would undoubtedly have appealed to the Marquess's sense of self-importance and gratified the Marchioness as public recognition of his aristocratic, charitable credentials, which in a less elevated role, she shared.

The Marquess's position as viceroy made him automatically one of the governors of the Rotunda, the body of men who made decisions regarding the running of the maternity hospital. A practical role was allocated to twelve wives or daughters

of governors who were 'requested to become monthly visitors in rotation'.[98] Having inspected diet, accommodation and cleanliness, they were to meet once a month to present their comments in writing. A weekly 'Ticket' was presented to the 'Ward-maid' who was 'most exemplary for Cleanliness and Attendance' and an annual prize was given to the ward with the most tickets.[99] In addition, 'Flannel Cloathing, or otherwise, to the Relief of the most necessitous Patients' was allocated 'at the Discretion of … the Wives of Governors'.[100] Even though, once again, the Marchioness may personally have done little more than lend her name to the cause, she would have been aware of the process involved in fundraising and in improving standards of care. Her subsequent active involvement in maternity and lying-in provision for local women and French refugees in England strongly suggests that she built on such experience.[101]

Inventive ways of raising funds were employed. In March 1788, the viceregal couple did not attend the command performance of Handel's *Judas Maccabaeus* in aid of the Lying-In Hospital.[102] However, in May of the same year, their presence was noted at a performance of *As You Like It* in aid of 'Distressed Free and Accepted Freemasons'.[103] On this occasion, it was the Marchioness's mode of transport that helped raise money for the Rotunda: Lord Buckingham travelled in a carriage, while his 'amiable consort' followed in a sedan chair.[104] Her example encouraged emulation from which the hospital benefited. By Act of Parliament, the hospital was entitled to collect duty of £1.15.6 on each privately owned chair.[105]

In view of Lady Buckingham's interest in maternity and infant care, it is ironic that her own experience of childbirth in Ireland caught the unfavourable attention of the press. Rather than at the Viceregal Lodge, or the Castle, where building work was under way in the State Apartments, her second son, George, was born on 31 December 1788 during a stay in temporary lodgings at the Royal Hospital, Kilmainham, a home for wounded soldiers.[106] The event was captured in a satirical print dated 1 January 1789, which implied that her baby had been born at public expense (Fig. 03.11).[107] Compounding Lord Buckingham's state of anxiety, his recently bereaved wife suffered a bout of ill health following the birth with the result that, part way through his tenure, Buckingham was deprived of her reassuring presence. When she returned to Stowe with their children, he was anxious about their health. He feared particularly for their daughter, Mary, a feeling made all the more intense by their earlier loss of her namesake: 'I trust in God that our dear little girl will do well. I cannot describe to you the anxiety I feel for

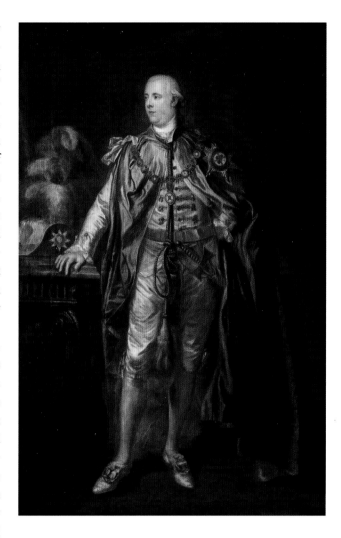

Fig. 03.10.

Robert Hunter

George, Marquess of Buckingham, first Grand Master of the Order of St Patrick

1783

Photograph by Davison & Associates, courtesy of St Patrick's Cathedral, Dublin.

The Vice 2—'s delivery at the Old Soldier's Hospital in Dublin.

In Holland's Exhibition Rooms may be seen the largest Collection of Caricature and other humorous Prints in Europe. Admittance One Shilling.

Fig. 03.11.

William Holland (published by)

The Vice Q-[ueen]'s delivery at the Old Soldier's Hospital in Dublin

1789

© The Trustees of the British Museum.

this sweet infant.'[108] Although infant mortality rates were high in all classes in the late eighteenth century, this shows clearly that losses were still deeply felt. Mary's illness and return home exemplify the difficulty of balancing public duties with the responsibilities of motherhood, a difficulty which was particularly intense for vicereines as they had unusually heavy social burdens.

Whilst missing Mary, Lord Buckingham forged ahead with grandiose events, designed to impress the Irish Ascendency and to honour his king. As before, when parted from his wife, he wrote frequent letters to her that reveal the strength of the bond between them. Letters written between February and June 1789 give an indication of how hard he was working, seeking as ever to please and impress on all fronts. Myles Campbell's descriptions of the architectural transformation of Dublin Castle at this time demonstrate that Buckingham was determined to proclaim his support for George III.[109] He oversaw the creation of a visual pane-gyric: the central ceiling painting in St Patrick's Hall. Painted by Vincenzo Waldrè, it depicts the monarch flanked by Hibernia and Britannia, signifying the virtues of unity.[110] For his new presence chamber at the Castle, he commissioned the Irish artist Solomon Williams (1757–1824) to produce copies of Allan Ramsay's full-length state portraits of George III and Queen Charlotte in their coronation robes, one of which appeared in an engraved view of the room published in 1795 (Fig. 03.12).[111] Williams's portraits remain on display in the State Apartments at Dublin Castle today. Buckingham also employed Waldrè to decorate the Castle

Fig. 03.12.

Unknown artist

*Catholic Congratulation, 14th
January 1795*

1795

Published in *Walker's Hibernian
Magazine*, January 1795

Reproduced courtesy of the
National Library of Ireland.

for an event which he hoped would regain the approval of the Irish Parliament, which he had alienated by his refusal to transmit an address to the Prince of Wales seeking the establishment of a regency during George III's first bout of insanity.[112] A St Patrick's Day Ball was arranged for 17 March 1789, to celebrate the King's recovery, an occurrence which Buckingham mistakenly felt vindicated his controversial inaction. Some news reports heaped scorn on the event.[113] In a renewed bid for approval, on Queen Charlotte's birthday in May, Buckingham again emblazoned the venue with transparencies for an event for 500 guests. Exhausted, he nevertheless wrote a description to his wife, and included a drawing of the layout of the room as the preparations were being made: 'St Patrick's Hall is the most splendid sight you can imagine. It will hold 500 covers of whom 400 will be seated. ... I have sketched the portrait to amuse you ... Valdrè paints transparencies for the two galleries at the ends. One compliments the K. the other the Queen ... The columns are lighted by about 800 lamps at each end.'[114]

Full of pride, he sent her a favourable news cutting even though he felt sure that, by the time his letter arrived, she would have seen reports in *The World*, in which the guests' attire was described, support for Irish industry was applauded, and finally, on 25 May, a full account of the event was given.[115] It included a description of a fourteen-foot-high triumphal arch, twelve-foot-high orange trees and 'festoons of flowers hanging from the lustres'.[116] Although the Marquess was grateful that: 'every servant of the house has exerted himself to the most magnificent

fete that was ever yet given', he was not happy.[117] In a letter written to Lady Buck-
ingham on the day of the event, he described 'the most magnificent decorations
of lamps and transparencies 40 feet wide', but made it clear that splendour meant
nothing to him while he missed her and was concerned about the health of their
infant daughter: 'But in the midst of this every feeling of my heart looks to that
which alone can give me true pleasure, & the glare of magnificence & of rejoicing
in the King's recovery can but ill compensate me for your sufferings and mine for
that dear little girl.'[118]

Buckingham's letters to his wife during this period were not just about social
events and family matters. He took for granted her understanding of his politi-
cal concerns, naively boasting about his successes: 'We here beat … Grattan my
dearest love upon a most offensive motion which he levelled against my brother
… we are wild with transport for I have carried against the whole aristocracy.'[119]
He appreciated her acceptance of his duty as a 'publick man' – a man who serves
the public – a responsibility he took very seriously.[120] In February 1789, during the
Regency Crisis, he lamented their 'cruel separation' and wrote with regret: 'It will
be impossible for me from any sense of Publick duty or private honour to quit this
wretched kingdom till the Government shall have prorogued.'[121] Just two days later,
he wrote: 'I should indeed be tempted to abandon everything and fly to you, but I
know that you are fonder of my good sense and of my conscientious discharge of
my duty, than of my society', suggesting that they both felt that duty should come
before pleasure.[122] The following month, just before the ill-fated St Patrick's Ball,
he knew he could rely on her understanding of his need to remain apart from her
and fulfil his patriotic duty: 'I know that this statement of it will grieve you, but
you feel for my character and duty as much as I do.'[123] This example reflects the
very considerable importance of the vicereine as a source of private support for
the public work of the viceroy.

By his own admission, Lord Buckingham could not cope with the demands
of office alone. In May 1789, he wrote: 'But indeed my dearest Mary I cannot
live without you.'[124] Without the moderating company of his wife, he subjected
himself to a punishing schedule of work in the service of king and country. This
may have satisfied his conscience, but a lack of interest in homosocial interaction
did nothing for his popularity amongst his peers. As Joseph Robins has noted, 'He
found distasteful the long nights of eating and drinking.'[125] His need for reassur-
ance that he had fulfilled his public duty, and for recognition that he had done it
well, resulted in a dependence on marks of favour for services rendered that would
dog his later life. His expectation of a dukedom was out of all proportion with the
work he had undertaken, which was simply an accepted component of respon-
sible aristocratic life. It was unfortunate that his demand coincided with George
III's determination to keep to a minimum the number of honours he conferred,
confining dukedoms to his family, in order to preserve their exclusivity.[126]

While the Marquess carried out his viceregal duties in Dublin, the Marchion-
ess met familial and local obligations whilst also overseeing maintenance and
repairs at Stowe.[127] Upon the King's recovery in March, she demonstrated patri-

otism that equalled her husband's when she organized an event at the mansion for over 2,000 guests. In a letter to Buckingham's brother, William Wyndham Grenville (1759–1834), she jokingly professed herself to be so overjoyed at the recovery of George III that she almost forgot to order an ox roast for the celebration.[128] She provided him with an account of the event, diplomatically thanking him for his instructions:

> I obeyed your commands; and flatter myself it was done not only according to the letter but also to the spirit of them. Our ox, accompanied by loaves, was divided *regularly* to above two thousand people; the rest was a scramble as you may imagine, though, considering we were not sparing of our beer, there was very little riot.[129]

Realizing that what she referred to as 'the quality of Buckingham[shire]' would attend, in her husband's absence, she made arrangements for their entertainment: 'As I had had hint that might be the case I had provided accordingly; we had a supper in the hall, made a Ranelagh of the saloon, which all ended with an impromptu dance in the dining room.'[130]

By April 1789, there was a marked deterioration in the Marquess's health. Worn down by the burden of office, he described the discomfort he endured in his weakened state when weighed down by the ceremonial robes he was obliged to wear: 'I hardly ever suffered more from the heat of the Royal Robes which I was obliged to wear for five hours together in Church, and although I had put off my underwastecoat [sic] I almost sank under it.'[131] In June, when Lady Buckingham was back at her husband's side in Dublin, she showed great concern over his well-being. Letters to his brother, William Wyndham Grenville, suggest mutual trust and respect, and a shared concern for Lord Buckingham: 'His health is most dreadfully impaired by all he has gone through; he looks extremely yellow, can bear no exercise.'[132] She wrote to Grenville without her husband's knowledge: 'I am scribbling this in all haste for fear of his catching me at it; as, in the first place, he is not himself aware of the very bad way he is in; and, if he was, would not perhaps wish you to know it; so keep this a most profound secret, and make the best use of it.'[133] Referring to his 'lassitude', 'dejection of spirits' and 'want of appetite', she wished her brother-in-law could be there to support her: 'Would to God you was with us, for I shall not long support this weight.'[134]

When the Marquess, in turn, wrote to his brother of his wife's 'affectionate and constant attentions', he reported that he had been 'fully employed in talking with her on the very many points which were mutually interesting to us', a comment that suggests a discussion of patronage interests which may in fact have added to, rather than alleviated, his workload.[135] Still anxious to regain the King's favour, against medical advice, Lord Buckingham refused to vacate his post until a suitable replacement could be found. The Marchioness's response showed her to be aggrieved at the King's lack of understanding. Her concern was personal; she wanted her husband's hard work to be recognized: 'Lord Buckingham will not hear of it [resigning]; he says the king would never forgive such a step. Surely just

after his own release from a malady brought on by over application to business, he could not have the heart to refuse the only means of restoring a life sacrificed in his service as Lord Buckingham's has been.'[136]

Lord Buckingham's position became untenable when government supporters, led by the Duke of Leinster and others, joined the opposition.[137] Suffering from ill health, fatigued and disillusioned, his sense of entitlement disappointed, the Marquess gave vent to petulant outbursts which lost him support in both England and Ireland; at the age of just 36, he had little choice but to step down.[138] He resigned on 30 September 1789.[139] A contemporary commentator compared the end of his two tours as viceroy: 'the retreat of the Marquis from this kingdom … was neither glorious or honourable, and how widely dissimilar to the triumphant departure of a [sic] Lord Temple'.[140] With his intentions of rooting out corruption thwarted, Buckingham was accused of the very abuses he had endeavoured to eradicate: 'In his administration a wanton increase of nominal and unnecessary employments and real sinecures took place, and the scandalous barter of places, offices and pensions.'[141] The writer regretted the 'credulous cordiality' with which the Marquess had been welcomed, but showed that whereas he had not lived up to their expectations second time around, admiration for the Marchioness remained undiminished: 'The Marchioness of Buckingham possesses every virtue that human nature can boast of – affability, politeness, courtesy and charity; she is the perfect pattern of conjugal affection and domestic oeconomy.'[142]

The miniature treasured by Lord Buckingham encapsulates the image of the person upon whom his happiness and peace of mind depended. Lady Buckingham, acting as vicereine, served her apprenticeship as a philanthropist in the full glare of publicity, winning approval despite being vulnerable to attack as she was married to an increasingly unpopular politician in a precarious, prominent position. The relative scale of her fundraising for the Lying-In Hospital, and the way in which she fulfilled her maternal duty and met local obligations at Stowe, exemplify the support that was vital to her husband, enabling him to fulfil his public role as viceroy, and to keep the image of government going even when it was collapsing behind the façade of Dublin Castle. Self-belief, rooted in a strong religious faith, enabled her to act as an emotional prop to her husband in his darkest hours and, when he resigned in September 1789, she helped him to reinterpret his aristocratic persona. The greatest opportunity came in 1792, when in his role as Lord Lieutenant of Buckinghamshire, a position he had occupied for ten years, Lord Buckingham was present with his troops in Winchester where he witnessed the arrival of hundreds of Catholic clergy fleeing revolutionary France.[143] The Marquess and Marchioness immediately embarked on a programme of relief for French refugees, which continued for the rest of their lives. It satisfied, initially, their philanthropic aspirations, but ultimately, their aristocratic pride: it culminated in the reception of the exiled Bourbons at Stowe.

Endnotes

1 Letter to Mary, Marchioness of Buckingham from George, Marquess of Buckingham, 14 March 1789, Stowe Papers, Huntington Library, STG Box 47 (22).

2 W.G. Strickland, *A Dictionary of Irish Artists* (Shannon: Irish University Press, 1969), pp. 508–9.

3 Reproduced in J. Robins, *Champagne & Silver Buckles: The Viceregal Court at Dublin Castle 1700–1922* (Dublin: The Lilliput Press, 2001), after p. 56.

4 Anon., 'Character of the Right Honourable Countess Temple (With a Beautiful Likeness of her Ladyship)', *The Hibernian Magazine: or, Compendium of Entertaining Knowledge*, April 1783, pp. 169–70.

5 See, for example, regular reportage of their activities in *The Dublin Evening Post*, *Freeman's Journal* and *World*.

6 See P. Gray and O. Purdue (eds), *The Irish Lord Lieutenancy, c.1541–1922* (Dublin: University College Dublin Press, 2012).

7 See R. Raughter, 'A Natural Tenderness: The Ideal and Reality of Eighteenth-Century Female Philanthropy', in M.G. Valiulis and M. O'Dowd (eds), *Women & Irish History: Essays in Honour of Margaret MacCurtain* (Dublin: Wolfhound Press, 1997), pp. 71–88.

8 K. Sonnelitter, *Charity Movements in Eighteenth-Century Ireland: Philanthropy and Improvement* (Woodbridge: The Boydell Press, 2016), p. 125.

9 J. Beckett, 'Gosfield Hall: A Country Seat and its Owners', *Essex Archaeology and History*, 25 (1994), p. 187.

10 Ibid., p. 188.

11 J. Bennet, *Letters to a Young Lady on a Variety of Useful and Interesting Subjects* (Warrington: printed by W. Eyres, 1789), vol. 1, p. 6.

12 C. Nugent, *Memoir of Robert, Earl Nugent: With Letters, Poems and Appendices* (London: W. Heinemann, 1898), p. 22.

13 *The Manuscripts of J.B. Fortescue, Esq.,* preserved at Dropmore (London: Historical Manuscripts Commission, 1892), vol. 1, p. xxxii.

14 J.J. Sack, *The Grenvillites, 1801–29: Party Politics and Factionalism in the Age of Pitt and Liverpool* (Urbana; London: University of Illinois Press, 1979).

15 W. Lefanu (ed.), *Betsy Sheridan's Journal: Letters from Sheridan's Sister, 1781–1786 and 1788–1790* (New Brunswick: Rutgers University Press, 1960), p. 91.

16 E.K. Sheldon, *Thomas Sheridan of Smock Alley: Recording his Life as Actor and Theater Manager in both Dublin and London, and including a Smock-Alley Calendar for the Years of his Management* (Princeton: Princeton University Press, 1967), p. 257; *Public Advertiser*, 21 August 1788.

17 Letter to Henry Grenville from George Grenville, 14 September 1773, Stanhope of Chevening Manuscripts, Kent History and Library Centre, U1590/S2/C1.

18 The marriage was arranged by his uncle, Richard, Earl Temple, and Mary's father, Robert, Earl Nugent, political allies and friends.

19 J.V. Beckett, *The Rise and Fall of the Grenvilles: Dukes of Buckingham and Chandos, 1710 to 1921* (Manchester: Manchester University Press, 1994), p. 67; letter to Henry Grenville from George Grenville, Bolton St., London, 16 December 1774, Stanhope of Chevening Manuscripts, Kent History and Library Centre, U1590/S2/C1.

20 Royal grant to George Grenville the Younger of the expectancy of office of one of the four tellers of the receipt of the Exchequer, 1763, Miscellaneous deeds, accounts and other papers relating to the Stowe estate, Centre for Buckinghamshire Studies, D/104/106.

21 Edmund Nugent (1709–1771). See Beckett, *Rise and Fall*, p. 68. Mary inherited a personal fortune estimated to be around £200,000. Earl Nugent's property passed to George.

22 Letters to Mary, Marchioness of Buckingham from George, Marquess of Buckingham, Stowe Papers, Huntington Library, STG Box 47 and STG Box 48. Mary's letters to George have not survived, with one exception, STG Box 34 (12) 1803.

23 The Duke of Portland left office upon the collapse of the Rockingham Whig administration; see J. Kelly, 'Residential and Non-Residential Lords Lieutenant – The Viceroyalty 1703–1790', in Gray and Purdue (eds), *The Irish Lord Lieutenancy*, p. 83.

24 Richard Temple-Nugent-Brydges-Chandos-Grenville, 1st Duke of Buckingham and Chandos (1776–1839).

25 Epitaph in All Saints Church, Wotton: 'Mary Grenville, infant daughter of George Earl Temple and Mary Elizabeth Nugent his wife. Died 10th April 1782'.

26 M. Bevington, 'The 1st Marquess and the 1st Duke of Buckingham', in *Stowe Landscape Gardens* (London: The National Trust, 2005), pp. 74–5.

27 H. Rumsey Forster, *The Stowe Catalogue, Priced and Annotated* (London: David Bogue, 1848), p. 153.

28 E. Brydges, *Collins's Peerage of England* (London: printed for F.C. & J. Rivington, 1812), vol. 2, p. 615.

29 M. Campbell, '"Sketches of their Boundless Mind": The Marquess of Buckingham and the Presence Chamber at Dublin Castle, 1788–1838', in M. Campbell and W. Derham (eds), *Making Majesty: The Throne Room at Dublin Castle, A Cultural History* (Dublin: Irish Academic Press, 2017), p. 74.

30 The Music Room was first described in *Stowe. A Description of the Magnificent House and Gardens of the Right Honourable George Grenville Nugent Temple, Earl Temple, Viscount and Baron Cobham ...* (Buckingham: printed by B. Seeley, 1780), p. 36.

31 Ibid.

32 U. Valdrè, B. Lynch and C. Lynch,

Vincenzo Valdrè, Faenza 1740–Dublino 1814 (Faenza: Tipografia Valgimigli, 2014), p. 111.

33 See Campbell, 'Sketches of their Boundless Mind', p. 92, n. 93.

34 Erected in 1781; see J.M. Robinson, *Temples of Delight: Stowe Landscape Gardens* (National Trust & George Philip, 1990), p. 143.

35 See Kelly, 'Residential and Non-Residential Lords Lieutenant', p. 67.

36 Ibid., pp. 72–4; C. O'Mahony, *The Viceroys of Ireland* (London: John Long Limited, 1912) p. 182.

37 T. Barnard, 'The Lord Lieutenancy and Cultural and Literary Patronage c.1660–1780', in Gray and Purdue (eds), *The Irish Lord Lieutenancy*, p. 106.

38 P. Jupp, 'Earl Temple's Viceroyalty and the Question of Renunciation, 1782–83', *Irish Historical Studies*, 17, 68 (September 1971), p. 502.

39 Anon., 'Biographical Sketches of Illustrious Ladies. The Most Noble the Marchioness of Buckingham', *La Belle Assemblée*, January 1812, pp. 3–5.

40 See Campbell, 'Sketches of their Boundless Mind', pp. 52–3.

41 For ascendency socialising see Robins, *Champagne & Silver Buckles*. For corruption see Jupp, 'Earl Temple's Viceroyalty', pp. 509–10.

42 See Jupp, 'Earl Temple's Viceroyalty', p. 507.

43 *The Manuscripts and Correspondence of James, First Earl of Charlemont* (London: Historical Manuscripts Commission, 1891), vol. 1, p. 157.

44 J.S. Lewis, *Sacred to Female Patriotism: Gender, Class and Politics in Late Georgian Britain* (New York: Routledge, 2003), p. 85.

45 Letter to Mary, Countess Temple from Elizabeth, Countess Harcourt, 31 March 1783, Stowe Papers, Huntington Library, STG Box 48 (5); see Lewis, *Sacred to Female Patriotism*, p. 85.

46 J.C. Greene, *Theatre in Dublin, 1745–1820: A Calendar of Performances* (Bethlehem: Lehigh University Press, 2011), vol. 3, p. 2108.

47 See Robins, *Champagne & Silver Buckles*, p. 68.

48 Letter to Mary, Countess Temple from George, Earl Temple, c.19 September 1782, Stowe Papers, Huntington Library, STG Box 47 (16).

49 Letter to Mary, Countess Temple from George, Earl Temple, c.26 September 1782, Stowe Papers, Huntington Library, STG Box 47 (16).

50 Ibid.

51 J.E. Morris, 'An elite female philanthropist in late eighteenth-century England: Mary, Marchioness of Buckingham and the refugees of the French Revolution' (unpublished PhD thesis, University of Leicester, 2020), p. 55.

52 Ibid.

53 See Anon., 'Character of the Right Honourable Countess Temple', p. 170.

54 For example, in 1783, she provided premiums for wet-nurses at the Foundling Hospital; see C. Campbell Orr, 'Aunts, Wives, Courtiers: The Ladies of Bowood', in N. Aston and C. Campbell Orr (eds), *An Enlightened Statesman in Whig Britain: Lord Shelburne in Context, 1737–1805* (Woodbridge: The Boydell Press, 2011), pp. 52, 78.

55 H.F. Berry, *A History of the Royal Dublin Society* (London: Longmans, Green, and Co., 1915), p. 142.

56 See Campbell Orr, 'Aunts, Wives, Courtiers', p. 56.

57 *Dublin Evening Post*, 17 December 1782.

58 See Campbell Orr, 'Aunts, Wives, Courtiers', pp. 59, 77.

59 A. Young, *General View of the Agriculture of the County of Essex* (London: printed for Richard Phillips, 1807), vol. 2, p. 395.

60 See Campbell Orr, 'Aunts, Wives, Courtiers', p. 57; D.A. Bellenger, *The French Exiled Clergy in the British Isles after 1789: An Historical Introduction and Working List* (Bath: Downside Abbey, 1986), p. 76.

61 J. Styles, 'Trade, Industry, and Empire', in J. Marschner (ed.), *Enlightened Princesses: Caroline, Augusta, Charlotte, and the Shaping of the Modern World* (New Haven: Yale University Press, 2017), pp. 452–73.

62 See Anon., 'Character of the Right Honourable Countess Temple', p. 169.

63 N.W. Wraxall, *Posthumous Memoirs of his Own Time* (London: Richard Bentley, 1836), vol. 2, p. 354.

64 See Anon., 'Character of the Right Honourable Countess Temple', p. 169.

65 Ibid. Room-keepers were paupers who, ashamed of their condition, remained hidden in squalid lodgings where many died of starvation; see D. Lindsay, 'The Sick and Indigent Roomkeepers' Society', in D. Dickson (ed.), *The Gorgeous Mask: Dublin 1700–1850* (Dublin: Trinity History Workshop, 1987), p.133. A society was formed for their relief in 1790.

66 See Anon., 'Character of the Right Honourable Countess Temple', pp. 169–70.

67 Ibid.

68 See, for example, M. Wollstonecraft, *Thoughts on the Education of Daughters: With Reflections on Female Conduct, in the More Important Duties of Life* (London: printed for J. Johnson, 1787); H. More, *Strictures on the Modern System of Female Education* (London: printed for T. Caddel Jun. & W. Davies, 1799), 2 vols.

69 See Raughter, 'A Natural Tenderness', pp. 71–88; see Sonnelitter, *Charity Movements*, p. 125.

70 See Sonnelitter, *Charity Movements*, p. 125.

71 Ibid., pp. 125, 145.

72 See Campbell Orr, 'Aunts, Wives, Courtiers', p. 58.

73 See Sonnelitter, *Charity Movements*, pp. 131–2.

74 See Dickson, *The Gorgeous Mask*, for an overview.

75 N. Casey, 'Architecture and Decoration', in I. Campbell Ross (ed.), *Public Virtue, Public Love: The Early Years of the Dublin Lying-In Hospital, the Rotunda* (Dublin: The O'Brien Press, 1986), p. 77. Founded in 1745 by Dr Bartholomew Mosse, the Rotunda is the earliest maternity hospital in Europe to still be functioning today. It moved to its present location in 1757; the Rotunda was added in 1764. See T.P.C. Kirkpatrick and H. Jellett, *The Book of the Rotunda Hospital: An Illustrated History of the Dublin Lying-In Hospital from its Foundation in 1745 to the Present Time* (London: Adlard & Son, Bartholomew Press, 1913).

76 *The Scots Magazine*, March 1783.

77 See Casey, 'Architecture and Decoration', p. 77.

78 Ibid.

79 I. Campbell Ross, 'The Early Years of the Dublin Lying-In Hospital', in Campbell Ross (ed.), *Public Virtue, Public Love*, pp. 22–3.

80 The governors included Luke Gardiner, who had introduced the Relief Act of 1788; see Casey, 'Architecture and Decoration', p. 83.

81 See Campbell Ross, 'The Early Years', p. 30.

82 See commemorative board in Rotunda Hospital, Parnell Square, Dublin.

83 See commemorative boards in Rotunda Hospital, Parnell Square, Dublin.

84 See Anon., 'Biographical Sketches of Illustrious Ladies', p. 4.

85 Anon., 'Dublin Castle, June 3, 1783', *The Hibernian Magazine: or, Compendium of Entertaining Knowledge*, June 1783, p. 333.

86 See J. Cannon, *The Fox–North Coalition: Crisis of the Constitution, 1782–4* (Cambridge: Cambridge University Press, 1969), pp. 127–50.

87 Ibid.

88 E.A. Smith, 'Earl Temple's Resignation, 22 December 1783', *The Historical Journal*, 6, 1 (1963), p. 95; Pitt's letters to Temple were reproduced in P.H. Stanhope, *Miscellanies. Collected and Edited by Earl Stanhope* (London: John Murray, 1872), pp. 36–7. See also P.J. Jupp,

'Earl Temple's Resignation and the Question of a Dissolution in December 1783', *The Historical Journal*, 15, 2 (June 1972), pp. 309–13.

89 See Cannon, *Fox–North Coalition*, p. 153.

90 Anon., 'Domestic Intelligence', *The Hibernian Magazine: or, Compendium of Entertaining Knowledge*, April 1788, p. 223.

91 Mary Arundell (1787–1854).

92 Will of The Right Honorable Robert Craggs[,] Earl Nugent, 29 October 1788, Will Registers of the Prerogative Court of Canterbury, National Archives of the United Kingdom, PROB 11/1171/136.

93 See Beckett, *Rise and Fall*, p. 66: 'Sir Nathaniel Wraxall considered him "a nobleman of very considerable talents and indefatigable application to business".'

94 See 'Original Subscribers to the Public Assembly Rooms', in *A List of the Proprietors of Licenses for Private Sedan Chairs, at 25th March, 1788, Alphabetically Ranged, with their Respective Residences, Published as Required by Law* (Dublin: n.p., 1788), 18th page (unnumbered).

95 See Campbell Ross, 'The Early Years', pp. 47, 50.

96 See Casey, 'Architecture and Decoration', p. 88.

97 Ibid., plate 24. The original, dated 1783, hangs in the Deanery, St Patrick's Cathedral, Dublin. A copy after Hunter's portrait is in the collection of the National Gallery of Ireland.

98 See *Proprietors of Licences for Private Sedan Chairs*, p. 57.

99 Ibid.

100 Ibid., p. 61.

101 R. Holt, 'Extract from an Account of a Charity, for Assisting the Female Poor, at the Period of their Lying-In', in *The Reports of the Society for Bettering the Condition and Increasing the Comforts of the Poor*, vol. 1 (London: printed by Savage & Easingwood, 1805), pp. 194–7; Anon., *Committee of Ladies for the Relief of French Female Emigrants* (London: n.p., 1796), Wentworth Woodhouse Muniments, Sheffield City Archives, WWM/P/16/3.

102 See Greene, *Theatre in Dublin*, p. 2480.

103 Ibid., p. 2489.

104 Ibid.

105 See Campbell Ross, 'The Early Years', p. 49.

106 George Grenville (1788–1850). See Campbell, 'Sketches of their Boundless Mind', p. 76.

107 T. Rowlandson, *The Vice Q – 's delivery at the Old Soldier's Hospital in Dublin*, January 1789, British Museum; uncoloured version, Royal Collection Trust.

108 Letter to Mary, Marchioness of Bucking-ham from George, Marquess of Buckingham, 6 May 1789, Stowe Papers, Huntington Library, STG Box 47 (22).

109 See Campbell, 'Sketches of their Boundless Mind'.

110 J. Fenlon, *Dublin Castle Guidebook* (Dublin: Office of Public Works, 2017) pp. 42–4.

111 Letter to Henry Goulburn from Robert Gregory, 5 February 1824, Registered Papers of the Office of Chief Secretary of Ireland, National Archives of Ireland, CSO/RP/1823/2452. I am grateful to Dr Myles Campbell for this reference.

112 See, for example, N. Robinson, 'Caricature and the Regency Crisis: An Irish Perspective', *Eighteenth-Century Ireland*, 1 (1986), pp. 157–76.

113 *Dublin Evening Post*, 19 March 1789.

114 Letter to Mary, Marchioness of Bucking-ham from George, Marquess of Buckingham, 12 May 1789, Stowe Papers, Huntington Library, STG Box 47 (22).

115 *World, or Fashionable Advertiser*, 15 May 1789: 'The Men's Uniform: green frock, lined and edged with white silk, and white waistcoat, &c. G.R. on the buttons; an orange ribband in the button hole with *Vive le Roi*. The Ladies: white tabbinet, garter blue ribbands, bandeau, "God Save the King", orange breast knot, *Vive le Roi*'. See also *World, or Fashionable Advertiser*, 18 May, 25 May 1789.

116 *World, or Fashionable Advertiser*, 25 May 1789.

117 Letter to Mary, Marchioness of Bucking-ham from George, Marquess of Buckingham, 18 May 1789, Stowe Papers, Huntington Library STG Box 47 (22).

118 Ibid.

119 Letter to Mary, Marchioness of Bucking-ham from George, Marquess of Buckingham, 4 March 1789, Stowe Papers, Huntington Library, STG Box 47 (22).

120 For notions of elite male duty, see M. McCormack, *Public Men: Masculinity and Politics in Modern Britain* (Basingstoke: Palgrave Macmillan, 2007).

121 Letter to Mary, Marchioness of Bucking-ham from George, Marquess of Buckingham, 26 February 1789, Stowe Papers, Huntington Library, STG Box 47 (22).

122 Letter to Mary, Marchioness of Bucking-ham from George, Marquess of Buckingham, 28 February 1789, Stowe Papers, Huntington Library, STG Box 47 (22).

123 Letter to Mary, Marchioness of Bucking-ham from George, Marquess of Buckingham, 14 March 1789, Stowe Papers, Huntington Library, STG Box 47 (22).

124 Letter to Mary, Marchioness of Bucking-ham from George, Marquess of Buckingham, 6 May 1789, Stowe Papers, Huntington Library, STG Box 47 (22).

125 See Robins, *Champagne & Silver Buckles*, p. 76.

126 M.J. Turner, *Pitt the Younger: A Life* (London: Hambledon & London, 2003), p. 101; W. Hague, *William Pitt the Younger* (London: Harper Collins, 2004), p. 273. The only ducal creations between 1784 and 1789 were two of George III's sons: Prince Frederick, as Duke of York and Albany on 27 November 1784, and Prince William, as Duke of Clarence and St Andrews on 19 May 1789.

127 Letter to Mary, Marchioness of Bucking-ham from George, Marquess of Buckingham, 28 February 1789, Stowe Papers, Huntington Library, STG Box 47 (22).

128 See *The Manuscripts of J.B. Fortescue*, p. 431.

129 Ibid., pp. 433–4.

130 Ibid.

131 Letter to Mary, Marchioness of Bucking-ham from George, Marquess of Buckingham, 25 April 1789, Stowe Papers, Huntington Library, STG Box 47 (22).

132 See *The Manuscripts of J.B. Fortescue*, p. 476.

133 Ibid.

134 Ibid., p. 477.

135 Ibid., p. 476.

136 Ibid., p. 477.

137 See Robinson, 'Caricature and the Regency Crisis', p. 163.

138 N. Herman, 'Henry Grattan, the Regency Crisis and the Emergence of a Whig Party in Ireland, 1788–9', *Irish Historical Studies*, 32, 128 (November 2001), pp. 478–97.

139 Ibid., p. 495.

140 J. Mullala, *The Political History of Ireland, from the Commencement of Lord Townshend's Administration, to the Departure of the Marquis of Buckingham* (Dublin: printed by P. Byrne, 1793), p. 238.

141 Ibid., p. 237.

142 Ibid., pp. 236–7.

143 See Bellenger, *The French Exiled Clergy*, p. 73.

Four

'An Admirable Vice-Queen'

The Duchess of Rutland
in Ireland, 1784–7

Rachel Wilson

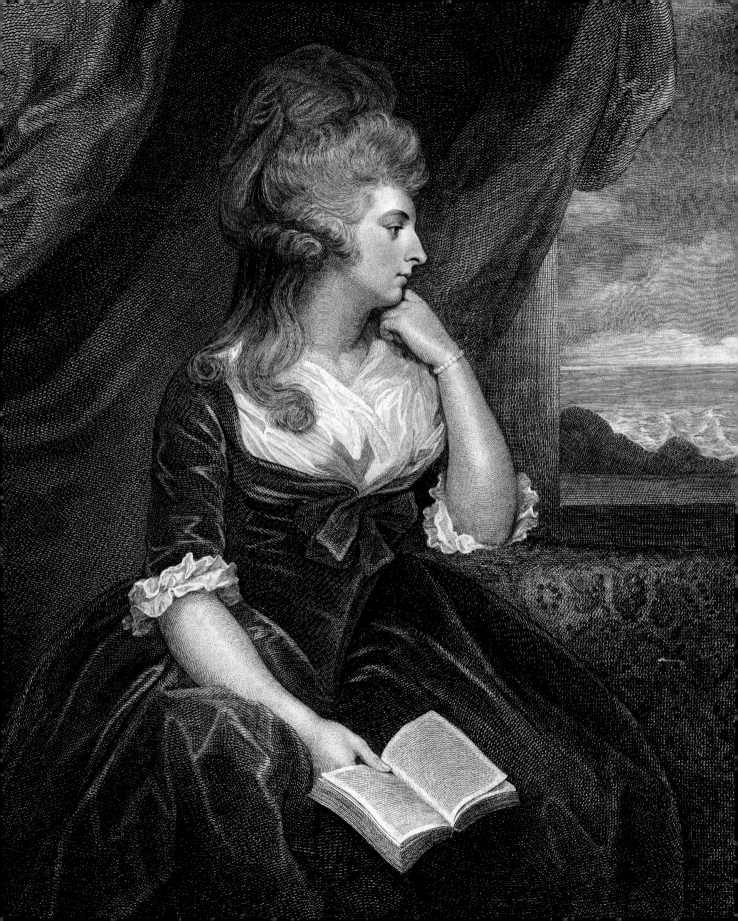

The Duke of Rutland is to be your L[or]d. L[ieutenan]t. and will set out very
shortly. I think he will be liked, as he is honorable and a gentleman. The
Duchess will be an admirable Vice-Queen, and will give uncommon gaiety
to your Capital.[1]

This letter, written in February 1784 by Francis Rawdon, later first Marquess of
Hastings, was one of the first hints of the kind of vicereine (or vice-queen, to use
contemporary parlance) that Mary Isabella, Duchess of Rutland (1756–1831) would
be. He was right to predict great things for her, for contemporaries would hail the
Duchess as one of the most successful vicereines of the eighteenth century.[2] This
chapter will show how and why she achieved this feat.

 The future Duchess of Rutland was born Lady Mary Isabella Somerset on 1
August 1756 (Fig. 04.01). Her father Charles, 4th Duke of Beaufort, died the same
year leaving his children to be raised by their mother, the former Elizabeth Berkeley.
In December 1775, Mary Isabella married Charles Manners (1754–1787), Marquess
of Granby (and from 1779, 4th Duke of Rutland) and together they had six chil-
dren (Fig. 04.02).[3] The couple were enthusiastic Whigs and supporters of Charles's
friend, William Pitt the Younger, and Mary Isabella was an especially active politi-
cal wife. Despite being heavily pregnant, she campaigned and solicited votes during
the general election of 1780, repeating her activities at the next such election four
years later (again, whilst pregnant) and becoming one of 'the Pittites's [sic] leading
political hostesses'.[4] She was also noted for her looks, being described by the Earl of
Charlemont as 'one of the most beautiful women perhaps in Europe'; yet, notwith-
standing her fame amongst contemporaries, little has been written about her by
modern historians.[5] Though she has an entry in the *Oxford Dictionary of National
Biography*, no books or articles are dedicated to her. Instead, she appears most often
as a background character in the stories of others, most notably her husband, and
Georgiana, Duchess of Devonshire, who was an ardent supporter of Pitt's rival,
Charles James Fox, and who was presented as Mary Isabella's political enemy by the
contemporary press. Her time in Ireland has barely been studied at all.[6]

 The Duke's appointment as viceroy was a direct result of his friendship with
Pitt (who was Prime Minister from 1783 to 1801 and again from 1804 to 1806) and the
choice was met with surprise and criticism from many of their peers. Dorothy, Duch-
ess of Portland (see Cat. 11), whose husband had been viceroy for four months in 1782,
wrote that 'if there is one man upon earth more unfit for that situation than another,
it is his Grace'.[7] Charles, 2nd Earl Cornwallis (who would later serve as viceroy himself
from 1798 to 1801) was a little more diplomatic, confessing that he had 'serious appre-
hensions' for the Duke, for 'he has a good heart but is hardly enough experienced in
business for so ticklish a situation'.[8] Modern commentators have been more gener-
ous. James Kelly has noted that Charles had greater abilities and experience than were
acknowledged by contemporaries, having 'been a member of Pitt's political circle for
several years' and 'served as steward of the household in the Earl of Shelburne's govern-
ment in 1782. Moreover his reputation for indolence was exaggerated'.[9] Both Charles
and Mary Isabella certainly took 'great joy' in his appointment and he expressed an

intention of going to Ireland for ten years; 'an odd thought to come into any man's head' wrote the Duchess of Portland, for 'It is pretty well if they can reckon upon as many months for any person to remain in any office.'[10] Nevertheless, he approached the task with enthusiasm, leaving behind his English seat, Belvoir Castle, Leicestershire, and arriving in Dublin on 24 February 1784, just thirteen days after his appointment.[11]

A Difficult Beginning

The Rutland viceroyalty got off to a rocky start. Ireland had been granted legislative independence from Britain in 1782 but at the time of Charles's arrival, 'few British or Irish observers had any illusions about how much remained to be done before the Anglo-Irish connection rested on firm and harmonious foundations'.[12] In particular, there were ongoing demands for parliamentary reform and for protection duties for the struggling Irish textile industry.[13] The viceroy and the British government were unwilling to agree to such measures, however, fearing they would undermine the British–Irish relationship. When the proposals were rejected by the Irish House of

Fig. 04.02.

Sir Joshua Reynolds

Charles Manners, 4th Duke of Rutland

c.1775

Private collection.

Commons in early April, just as a new tax for the upkeep of Dublin's streets was imposed, the result was serious violence. The House of Commons was invaded on 5 April and the general lawlessness which pervaded Dublin over the course of the summer was so severe, that it seemed as though governmental control might break down entirely.[14] Rutland himself was 'hooted and insulted' during his first appearance at the theatre, threatened with being tarred and feathered in July (Fig. 04.03) and despised by elements of the press who called him 'more thoroughly odious than any of his corrupt predecessors'.[15] Fresh problems emerged the following year when his Chief Secretary, Thomas Orde (1740–1807), suggested 'a series of propositions to regulate future commercial interchange' between the two islands.[16] Seized upon by Pitt as a method of creating a commercial union between Britain and Ireland, the propositions were heavily amended in England until they were no longer acceptable in Ireland. When the measure had to be abandoned, it was an embarrassment for both the viceroy and the Prime Minister.[17] Given these difficulties, one might reasonably assume that Rutland finished his viceroyalty mired in unpopularity. In reality, nothing could be further from the truth. By the time he died in office on 24 October 1787, the problems of 1784 and even the debacle of the commercial propositions had fallen by the wayside. He was widely loved by his adopted people and was provided with a lavish funeral procession before his body was shipped back to England, a remarkable turnaround in public opinion and one which owed much to the efforts of his wife.[18]

Fig. 04.03.

Isaac Cruikshank

The V[iceroy]'s Introduction at St J[ames]'s with a New Suit of Irish Manufacture

1784

© The Trustees of the British Museum.

Mary Isabella first landed in Dublin on 18 April 1784. By June, she and her husband were already becoming familiar to the people of Ireland, as the *The Hibernian Magazine* had moved quickly to publish engravings of them both (Figs 04.04 & 04.05). The Duchess stayed initially for six months, visiting again between February 1785 and May 1787.[19] Through a study of both trips, this chapter will argue that she was a shrewd politician who, upon arriving into a scene of political mayhem, set about supporting her husband's struggling viceroyalty and, by extension, British rule in Ireland, by establishing a busy social routine and combining it with a series of well-chosen philanthropic activities and theatrical patronage. It will show that this approach was implemented in partnership with the Duke (whose own social and cultural activities mirrored his wife's) and facilitated his political endeavours by allowing the couple to meet and ingratiate themselves with people from all walks of life and political persuasions. As well as their time in Dublin, the chapter will also study their tour of the south of Ireland in 1785.

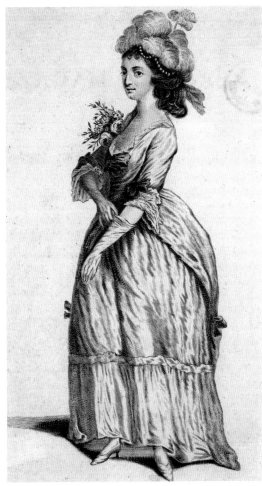

Hostess and Guest

The basic social routine of the vicereines had been established since the 1720s. Together with their husbands, they lived primarily in Dublin Castle (which doubled as the administrative centre of the British government in Ireland) and presided over a series of events throughout the year marking royal birthdays, anniversaries and state occasions such as St Patrick's Day (Fig. 04.06). The couple might also throw additional entertainments, including dinners, balls and assemblies, when desired. Separately, the viceroys held male-only dinners and levees in which they met local politicians, while their wives hosted drawing rooms for the local female elite.[20] This social calendar was governed in large part by Dublin's social season. By the 1780s, this ran from April to early September and from November to March, though the Rutlands were known to start the winter season as late as January.[21] As well as the Castle's programme of events, other entertainments available in the city included plays, musical and operatic performances, assemblies, public and private balls, sermons and outdoor parties.[22] One could also pass the time in visits to the homes of friends and acquaintances.[23]

Fig. 04.04.

Unknown artist

His Grace Charles Manners, Duke of Rutland, Lord Lieutenant of Ireland, 1784

Published in *The Hibernian Magazine,* April 1784

Reproduced courtesy of the National Library of Ireland.

Fig. 04.05.

Unknown artist

Mary Isabella Manners (née Somerset), Duchess of Rutland

1784

Published in *The Hibernian Magazine,* April 1784

Reproduced courtesy of the National Library of Ireland.

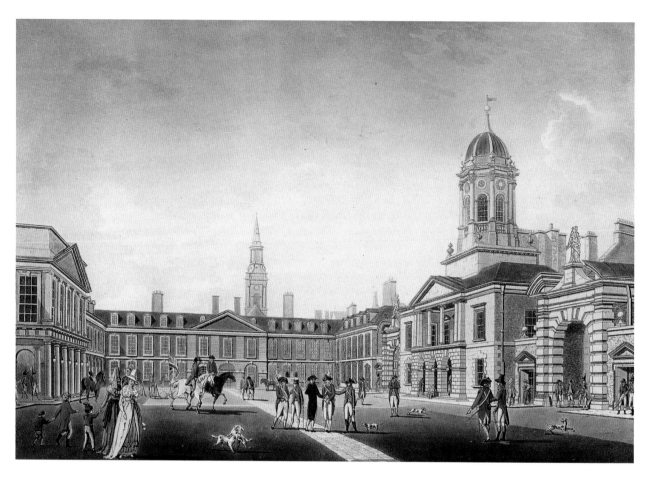

Fig. 04.06.

James Malton

Great Courtyard, Dublin Castle

1792

The Art Institute of Chicago, gift of Mrs Isaac K. Friedman.

The Rutlands' court was, by all accounts, unusually decadent. Politician Henry Grattan described it as a 'gay, luxurious, and extravagant' establishment 'upheld by a splendour hitherto unprecedented'.[24] The lawyer and politician Jonah Barrington called it 'much more brilliant and hospitable than that of the monarch'.[25] As chatelaine of the Castle, Mary Isabella's contribution to this extravagance was considerable and she quickly acquired a reputation for her frenetic social life. Just two days after her arrival, she held her first drawing room followed the next day by a ball attended by 'almost all the nobility and families of distinction that are now in town'. Here, her 'engaging sweetness of manner and deportment, and condescending affability [...] won her the love, esteem, and admiration of the most splendid groupe [sic] of people of real fashion that have for a long time been seen at the castle'.[26] Within weeks she had instituted a punishing routine of all-night parties at the Castle, at which she reportedly never joined the company until at least midnight and regularly stayed up until seven.[27] All this was a far cry from her more respectable entertainments in England, where she hosted 'very merry' cabinet dinners for the Whigs and held parties once described as 'a heavy, dull business' characterized by overcrowding, 'a great deal of high breeding and bon ton', but ultimately 'nothing to enliven you'.[28] There were good reasons to adopt a different approach in Dublin, however.

The pressure for Mary Isabella to perform well in her new role was intense and immediate. Just days after Charles's appointment, *The Hibernian Journal* promised readers that 'Her Grace the Dutchess of Rutland will add a Splendour to the Irish Court hitherto unknown', for, 'her Grace excels in Beauty, is the first Leader of Fashions; she is younger and handsomer than the Dutchess of Devonshire, and has, since her Marriage, become the first of the Beau Monde'.[29] There were political considerations too. Social events at the Castle had long provided an opportunity for the viceroy to mingle and curry favour with the local political elite (and *vice versa*) in a more relaxed and supposedly neutral setting than might be found in the Irish Parliament or private houses.[30] In Charles's case, the turbulence of his early months in office made it more important than ever that his court be a success and attract politicians of every ilk, as he sought to steady British control in Ireland and strengthen his grip over the Irish House of Commons.[31] He could not achieve this goal alone, however. As Elaine Chalus has noted, 'Social events were largely considered to be women's prerogative' during this period and the viceroy's experiences typified this.[32] Though he was an able and outgoing host who threw parties before Mary Isabella's arrival, the fact that the quantity and calibre of the Castle guests improved so dramatically after she joined him demonstrates that for a viceregal court to truly shine, it required a popular and competent vicereine at its helm. Mary Isabella's extensive sociability may therefore be seen as one strand of a strategy designed to assist her husband during the difficult early months of his viceroyalty, with the change in pace from her English-style entertainments reflecting the fact that they were not suited to the task of attracting a broad slice of the Irish political elite.[33] The intimate cabinet dinners she employed at home, for instance, relied on a level of familiarity she did not have with Irish politicians and indicated a special relationship with the chosen guests. In Ireland, only the most secure viceroyalties could afford to risk such favouritism at the Castle. As recently as 1781, the then vicereine, Margaret, Countess of Carlisle (1753–1824), had held 'an exceeding [sic] pretty ball' and supper for sixty or seventy people there. This was a relatively small cross-section of the local elite and it was 'reckoned a very bold thing to do' according to her husband, which 'could only have been attempted in a very strong Administration'.[34] In the early days of Charles's much weaker viceroyalty, the large, raucous parties Mary Isabella frequently presided over, though impersonal, allowed her to sidestep this problem. Instead, she could meet and dazzle many guests hailing from all political backgrounds. Newspapers reported that so determined was she 'to be happy in the good wishes of the people' that she had even declared 'her abhorrence of politics', clearly a lie, but a canny method of helping to present her parties as neutral ground.[35] Charles's social schedule was similarly intense, with heavy drinking and equally long hours. The parallels between husband and wife indicate that he approved of Mary Isabella's approach and that they were operating as a team in order to wow the Irish people and appeal to the entire political spectrum.[36]

Beyond the Castle walls, Mary Isabella supported Charles through her attentions to the local female elite. When the ladies of Dublin were presented to the

viceregal couple (as per established custom) before a ball held on 27 April 1784, she spent the next few days visiting those whom she had met.[37] This was more than simply a way to extend and maintain her social circle, however. Visits by elite women to one another's homes were highly politicized at this time and were often used to gather and exchange political information, source or advertise allegiances and keep lines of communication open between families whose men were not officially on speaking terms.[38] Someone as politically astute as Mary Isabella surely used the opportunity to establish which families might support or oppose her husband and build connections with those who could be of service to him. Certainly, she was keen to ensure that none were left out. Upon realizing that she had accidentally overlooked some of those she had intended to visit, a notice was placed in the local press asking that 'Those ladies who were presented at the castle, and through mistake have not been visited by her grace the duchess of Rutland, are requested to send their names to the chamberlain.'[39] This notice showed both Mary Isabella's diligence and her awareness of a problem which would have been less prevalent in England. Unlike at home, her status as an English duchess meant that she outranked every woman in Ireland, with social etiquette preventing those significantly further down the social ladder from approaching her directly to invite her to their homes.[40] Had she not taken the initiative to ensure that her visits went ahead, an opportunity to forge links with less grand but potentially useful political families may well have been lost. As it was, by deigning to call on Dublin's female elite, she flattered them and, by extension, the local politicians and grandees to whom they were related, for it had long been accepted as a mark of prestige to be visited, rather than to visit, especially if the caller was of a significantly higher rank.[41]

Mary Isabella also assisted Charles in cultivating strong relationships with Ireland's most prominent politicians by attending invitation-only events with him at their homes. There was a 'grand ball and entertainment' at the Earl of Shannon's house in May 1784, for instance; a party at the house of Sir Skeffington Smith, MP for Belturbet, in June and an indoor *fête champêtre* (a kind of garden party) held in the Rutlands' honour in September at the villa of Edmund Pery, Speaker of the Irish House of Commons.[42] By gracing these events with his presence, Charles could indicate specific political favour and build relationships with those who could be of greatest assistance to him in getting the King's business through the Irish Commons. By bringing his wife, he suggested a personal, even friendly relationship with the host, rather than a political alliance only and provided her with additional opportunities to befriend politically well-connected women. For those who welcomed them, there was also the chance to show off their high social standing, wealth and good taste by proving themselves capable of entertaining such a prominent and glamorous couple.

Trips to the capital's playhouses and other entertainment venues were another means of winning over the Irish and together with her husband, Mary Isabella commanded at least four performances in the Theatre Royal in Smock Alley or the Rotunda Assembly Rooms between early June and mid-August 1784, and was

Fig. 04.07.

After **John James Barralet**

*Mary Isabella, Duchess of
Rutland driving her Ponies from
Kingstown to Dublin*

*c.*1785

Reproduced from T. F. Dale's
The History of the Belvoir Hunt,
1899.

present at many others.[43] Viceregal support of the Dublin theatres stretched back
to the 1630s but in addition to being a pleasurable pastime, theatre visits provided
viceroys and vicereines with further opportunities to meet and ingratiate them-
selves with the local elite (again in a less politically charged venue than the Houses
of Parliament), as well as to show an interest in and commitment to Irish cultural
events.[44] They could also be seen there by those beyond the wealthy Castle circle,
for there were cheaper seats available to those of more limited means.[45]

Alongside theatre attendance, the Duchess's visibility amongst the middling
and lower orders (as well as the upper) was further maximized by her attendance at
daytime and open-air events. These included 'an elegant and superb BREAKFAST,
with a BALL and other ENTERTAINMENTS' at Dublin's Ranelagh Gardens in June
1784 and a morning review of the Dublin garrison in the Phoenix Park alongside
Charles, for which she supposedly stayed up all night.[46] Even the lowliest among
Dublin's populace knew her face. From her earliest days in Ireland, one of her
favourite activities was to drive herself through the streets of the capital on her
phaeton (a type of light, open carriage, drawn by two horses), with the Circular
Road a frequent destination.[47] These outings, one of which was recorded by the
Irish artist John James Barralet (Fig. 04.07), gave Mary Isabella, and by extension
her husband, an aura of approachability and accessibility outside court circles
and further enhanced their popularity. In June 1784, they were applauded upon
their arrival at the theatre and Mary Isabella's carriage rides drew great crowds
made up of people vying to catch a glimpse of the young and famously beautiful
vicereine.[48] Her reviews of the troops, though not unusual for a viceroy's wife,
were also particularly well received, attracting compliments from those who saw
her, on 'the splendid equipage and charms of her Grace' which 'made the most
brilliant appearance'.[49]

Giving and Receiving

As well as offering a pleasurable distraction and boosting her public profile, theatrical and musical performances were an easy way of distributing charity. Often, Mary Isabella operated in conjunction with Charles, as in August 1784, when they jointly commanded a concert at the Rotunda in aid of the Irish singer, Peter Duffey.[50] At others she (apparently) acted alone. On 19 August 1784, she commanded another Rotunda concert, this time in aid of the French violinist and composer, François Hippolyte Barthélémon, making it known via newspaper advertisements that she would be in attendance, and in mid-September, she ordered an additional benefit for Duffey.[51] Though there is no reason to doubt her good intentions, the highly visible nature of these seeming acts of kindness and the media exposure they generated suggest an additional motive beyond pure altruism. It is unlikely that she ordered any benefit performances without the knowledge and acquiescence of her husband, and the positive publicity they garnered further improved the couple's reputations. Duffey and Barthélémon both took out advertisements thanking the Duchess for her patronage, and Barthélémon even composed a minuet in her honour.[52] Other philanthropic endeavours sparked similarly good press, including financial donations (alongside Charles) towards the building of assembly rooms for the benefit of Dublin's Lying-In Hospital (Fig. 04.08) and the 'daily relief' Mary Isabella reportedly gave to distressed widows at the Castle.[53] Of all her charitable work though, the most widely discussed centred on the vicereine's choice of clothing.

Mary Isabella was an early and virtually unwavering supporter of Irish textiles, an industry which had been artificially suppressed by a series of export bans imposed by England beginning in 1699.[54] This support was not

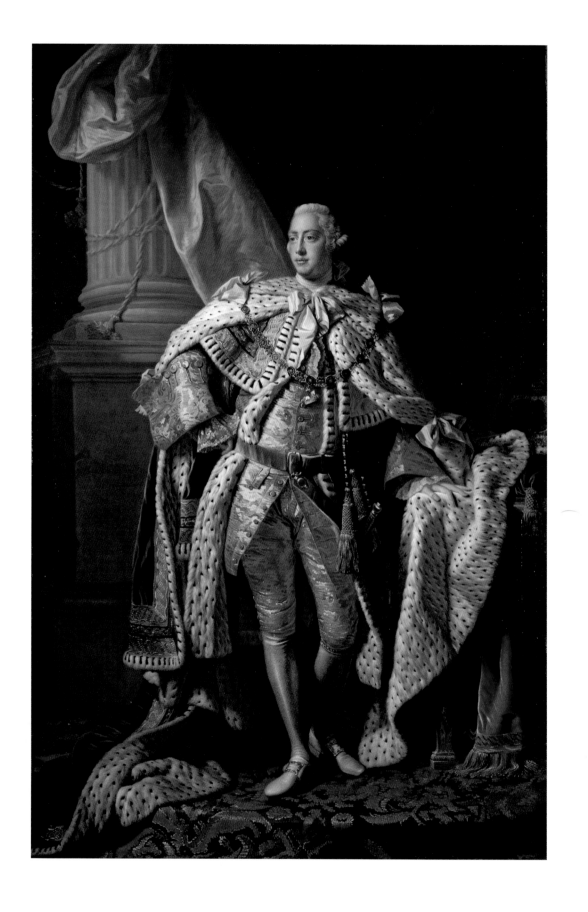

groundbreaking. As early as 1701, the viceroy, the Earl of Rochester, expressed a desire to have all linens used in the Castle during his tenure sourced locally, and the policy was copied by his successors and their wives so that by the 1720s it had become an intrinsic part of the viceroyalty.[55] In Mary Isabella's case, however, this oldest of tactics had particular resonance. Building on the calls of Jonathan Swift a generation earlier for Irish ladies to wear the produce of native manufacturers, by the 1770s, the country's Patriot movement was encouraging the purchase of a range of Irish-made products in preference to imported goods and urging women to wear Irish clothing to demonstrate their support for the principles of free trade.[56] Trade restrictions were eased in 1779 with the lifting of the export ban on woollens and the granting of access to colonial markets, but in the wake of the failed attempts to obtain protection duties for the beleaguered industry in 1784, viceregal patronage continued to be important and expected.[57] Before Mary Isabella had even set foot on Irish soil, the press looked forward to the 'new encouragement' local manufacturers would receive by her presence.[58] She did not disappoint. At her first ball at the Castle, she wore 'an elegant dress of Irish manufacture, a noble example to the brilliant crowd of Irish beauties that surrounded her'.[59] Days later, reports emerged that she had left almost her entire wardrobe in England and had 'already ordered three tabinet habits and as many silk morning gowns, with two rich spring silks for dress, all Irish [...] Our mantua-makers are completely hurried making up Irish dresses; her Grace intimating, immediately after her arrival, her wish to promote the manufacturers of this country, and hope the ladies here would second her inclinations'.[60] Whether or not Mary Isabella truly left the majority of her clothing in England is debatable, but the newspapers' hopes that the Irish

J⁹G⁹. des et fe.

Pub⁹ June 20ᵗʰ 1795, by H.Humphrey N°37
New Bond Street

Characters in High Life.

Sketch'd at the New Rooms, Opera House

"Delightful Task! to teach the young Idea how to shoot!"

ladies would follow her example show how important a fashionable and prominent benefactress was to the industry, and such high-profile support was wise for someone seeking to enhance her popularity. As spring turned to summer, her spending habits continued to attract positive comments, for she was 'occupied for several hours in the day, encouraging, by her liberal purchases, the manufacturers of this country'.[61] Again, Charles pursued a complementary strategy. He had their servants' entire liveries made in Ireland, though the lace required had been imported from England by some previous viceroys.[62] For the birthday dinner of King George III (Fig. 04.09) in June 1784, he asked guests at the Castle to don Irish garb.[63] Both husband and wife also ordered and attended benefit plays in aid of the manufacturers and made a point of wearing Irish-made clothing to Dublin's theatres and music halls.[64]

Such apparent enthusiasm for local textiles suggested the Rutlands' Irish patriotism, their sympathy for the manufacturers and their distaste (real or feigned) for the British government's policy on the matter. The Duke was commended for leaving 'no opportunity unembraced, that presents itself, of assisting our distressed manufacturers' and his efforts, according to one newspaper, 'must surely tend to endear him to the public in general'.[65] It was the Duchess's clothing which generated the greatest interest, however. *The Freeman's Journal* described her dress at the 1784 birthday dinner in honour of the King as 'a sky colour blue silk of Irish manufacture, finely trimm'd, and decorated in the highest taste with gold beading'. Of the Duke's outfit, it recorded only that it was 'the produce of the Irish loom'.[66] This gender imbalance was typical of the times. Padhraig Higgins has shown that attempts to improve the lot of Irish manufacturers often relied more heavily on appealing to elite women in Ireland, who were believed to 'set the tone of fashion and taste in polite society' and be able to influence the spending patterns of men.[67] The decision of *The Freeman's Journal* to focus on the Duchess's attire for the benefit of its female readers therefore made sense. Had Charles been unmarried or had a less fashion-conscious wife, his own support for Irish manufacturers may well have generated less press attention and done less to popularize his viceroyalty. As it was, Mary Isabella's efforts went down exceedingly well in Dublin where her suppliers used her name to drum up additional business by taking out advertisements in local newspapers announcing that they were the Duchess's mantua-maker or milliner.[68] In June 1784, the silk weavers of Dublin, having observed her silk dresses at theatre shows and the Rotunda, submitted an address to her asking for her continuing patronage. Mary Isabella duly responded, promising to 'do everything in my power to encourage their manufacturers by my own example, and by every other means in my power'.[69]

Setbacks

No one could dispute the efforts to which Mary Isabella went to be an active and conscientious vicereine during 1784. Unfortunately, in her determination to please and impress, she overdid it. Her exertions may have contributed to a miscarriage

she suffered in late June, and in October, the Earl of Mansfield warned both Duke and Duchess about 'the irregularity of the hours of the Castle' and Charles's heavy drinking, calling them 'the most general' complaint made about the viceroyalty.[70] He was right to be concerned. Though some enjoyed the party atmosphere the Rutlands brought to Dublin, others criticized them for having 'somewhat impaired the dignity of the Court'.[71] Mary Isabella in particular was singled out by the satirist Charles Pigott as having 'been infinitely less reserved in her behaviour; more dissipated and unguarded in her general deportment than at any other former period since her marriage; and it must be admitted that she introduced a system of irregularity and expence [sic] amongst the Irish that cannot be justified'.[72] The effects of her beauty and her ostentatious fashion sense also attracted the attention of cartoonists, several of whom made her a prominent feature of their satirical prints (Figs 04.10 & 04.11). On a practical level, the pace she was setting was also too much for some, and her attempts to win over the female elite began to backfire. As early as May 1784 it was reported that:

> The Irish ladies of fashion are preparing a *Round Robin* to be presented to her Excellency the Dutchess of Rutland, begging, that in compassion to their health, she will not insist on their staying from midnight until seven and eight o'clock in the morning, to *keep it up* with her Grace, and confess themselves unequal to rising at one in the afternoon, in order to attend her again on the Circular-road until six in the evening.[73]

As Mansfield's letter suggests, Charles's behaviour was no better. When Mary Isabella returned to England at the end of October 1784, he continued his hedonistic lifestyle until stopped by a 'bilious fever' in December, which almost killed him.[74] Yet more problems were caused by the expense of the viceregal establishment. The £20,000 salary afforded to the viceroy during this period was insufficient to run the Dublin court.[75] The Rutlands, however, made little attempt to economize.[76] Joseph Hill, the Duke's advisor in England, frequently bemoaned the deteriorating state of Charles's Irish finances, in letters such as that written on 6 November 1785:

> Your Grace has often sayd that your Table & Expenses are not, to outward appearance, beyond those of former Lords Lieutenant. I own I have my Doubts there. I know your Grace's Magnificence, & in many departments I am inclined to think you would not find the Comparison hold, particularly in the Number of Servants, the Expence of their Liveries, your high priced Wines, your Stables (in which the Expence is enormous) & many other articles.[77]

Some indication of the extraordinary lavishness of the Rutlands' court at Dublin Castle can be gleaned from their household accounts for 1784–5, during which the total wine bill alone reached £2,688 – more than thirteen per cent of the viceroy's entire annual salary.[78] By the close of 1786, the couple's debts in Ireland had soared to £12,000, a sum equivalent to approximately £921,000 today.[79]

There were other signs, too, that the couple were struggling. It was remarked after a performance at the Theatre Royal in June 1784 that 'so inattentive to her Grace were the ladies of the Irish Court, that but two females beside[s] the Castle-party that attended her, appeared in the boxes until the second act of the play'.[80] Whilst attending a command performance on 10 July, the Rutlands were booed and ultimately hounded all the way back to the Castle in retaliation for Charles's recent refusal to support a proposal that English woollens be embargoed for a year.[81] Mary Isabella came in for press criticism on other fronts, too. In May 1784, she was seen to be wearing Indian muslin at the Rotunda and some newspapers rounded on her, writing 'Its [sic] a *wonder* the Duchess of Rutland would set us so shameful an example, or that Irish ladies would follow it.'[82] Even the highly deferential address from the silk manufacturers the following month alluded to this *faux pas*, contending that a preference for 'Indian goods' was adding to 'their calamities'.[83] Yet when she did wear Irish, some were still determined to find fault, writing that her sartorial choices and attendance at benefit performances for the manufacturers ultimately had only a limited impact upon the industry.[84] Mary Isabella did not publicly respond to these criticisms but there is evidence that she felt their sting and did not enjoy her time in Ireland as much as her busy social life implied. During her trip to England in the winter of 1784–5, it was noted by Lady Bute that 'The Dutchess of Rutland seems in no hurry to return to her throne, which is a mystery not yet understood here.'[85] Similar thoughts were mooted in Ireland, where one woman mused that the vicereine had 'no wish to return to this country' after missing the celebrations for the Queen's birthday.[86]

Despite their difficulties, by the autumn of 1784, the tide of popular opinion was at last turning in the Rutlands' favour. Charles had successfully 'strengthened the authority of the administration and their command of the House of Commons', and during Mary Isabella's visit home, there were articles in the Dublin press bemoaning her absence and all but begging for her return, whether to support the manufacturers, relieve the miseries of the poor more generally or add some much-missed sparkle to the viceregal court.[87] In December, she was voted the freedom of the Corporation of Sheermen and Dyers, who presented her with a gold box, in recognition of her 'constant attention to encourage the MANUFACTURES of this COUNTRY'.[88] Her response to the gesture was telling. Having received the news in England, she thanked the corporation for the compliment and promised to continue her efforts 'as I know how agreeable it will be to the Duke of Rutland'.[89] Even in her absence, her priority remained promoting and popularizing Charles. She was true to her word too, wearing 'an Irish poplin, beautifully ornamented' to the highly publicized birthday celebrations for Queen Charlotte at St James's Palace the following month.[90] By the time she finally arrived back in Dublin on 18 February, the local press were little short of ecstatic.[91]

Second Visit

At first glance, Mary Isabella's routine during her second visit appears to have been much the same as before. Drawing rooms began again within days of her return and by early March, they were being held twice a week.[92] Over the next two years, there continued to be state balls at the Castle for St Patrick's Day and royal birthdays, with additional balls filling out the events calendar further, including a 'Fancy Ball' (meaning guests would appear in fancy dress) in April 1785.[93] She maintained relationships with the Irish political elite by continuing to attend them in their homes and was present at a 'superb' ball at Lord Earlsfort's shortly after her return (apparently without her husband) and a 'grand entertainment' at the home of the Attorney General, John Fitzgibbon (with whom Charles got along particularly well), in December.[94] There was a dinner with the wealthy and well-connected MP, Thomas Conolly, at his home, Castletown, County Kildare, in August 1786, and another ball that November at the house of Catherine Clements, wife of Henry Theophilus Clements, then Paymaster and Receiver General of Ireland, a trustee of the Irish Linen Board and MP for Cavan.[95] She also made frequent, short visits to the homes of these and other prominent politicians and their wives. Bills among the Belvoir Castle accounts show that in the space of barely a week, in early 1786, she visited Catherine Clements, Mrs Foster (the wife of the new Speaker of the House of Commons), Sir John Blaquiere (a long-time government supporter) and

Fig. 04.12.

M.E. Wall

Mr Crosbie's ascent from Leinster Lawn

1785

Reproduced courtesy of the National Library of Ireland.

Lady Langrishe, wife of Sir Hercules Langrishe, Commissioner of the Revenue, spending a total of £2.14.2 on her journeys to and from the Castle by sedan chair.[96] There were public balls as well, including one at the Rotunda, in March 1785, and one-off events such as the day, in July 1785, when Mary Isabella cut the rope of aeronaut Richard Crosbie's hot air balloon in the gardens of Leinster House, allowing him to float out over the Irish Sea, before being rescued by boat (Fig. 04.12).[97] She attended further military reviews, even when her husband did not, and remained an avid supporter of the performing arts, jointly commanding with Charles no fewer than thirty performances at Smock Alley, the Rotunda and St Werburgh's Church between 1785 and 1787.[98] Indeed her love of socializing and expectation that she be entertained were well known. Lady Louisa Conolly, wife of Thomas and sister of the Dowager Duchess of Leinster, remarked, in December 1786, that she must be sure to invite the vicereine 'to some of our little dances, which I had had thoughts of doing before, because I am told that she takes it *quite ill* to be left out'.[99]

Despite her obvious busyness during this second visit, a change from the routine of 1784 is detectable. Mary Isabella did not throw herself into life in Ireland with quite the same abandon as she had a year earlier. On 16 March 1785, one newspaper remarked that 'she has been seen but little in public since her return'.[100] When she did emerge, her hours were usually less extreme. Though the 'Fancy Ball' the following month began after 11pm and the Duchess arrived after midnight, as was her established custom, she stayed for only two hours.[101] This pattern continued over the next two years. A ball for the birthday of Queen Charlotte in February 1786 (though the Queen was actually born on 19 May) started at 10:30pm and was finished by 3am; a positively early night by Mary Isabella's previous standards.[102] There were no further suggestions that she was uninterested in politics either. In August 1785, she and the Duchess of Leinster attended the House of Commons together and Mary Isabella briefly reverted to her old ways by staying from four in the afternoon until nine the following morning.[103]

There were several reasons for the vicereine's altered schedule. First, as we have seen, the extremities of her first visit cost her dearly in terms of her health and reputation and produced only mixed results, with many criticizing the unrelenting and practically nocturnal nature of her lifestyle. Making some adjustments, particularly to her hours, to suit the demands of the locals made sense. Second were the continual health problems she suffered between 1785 and 1787. She was dangerously ill in April 1786, having experienced another miscarriage, and she missed a theatre performance the following month due to a cold, much to the disappointment of the audience who had hoped to see her.[104] Her health then remained poor as the months wore on. Lady Louisa Conolly described her as 'thin but beautiful' in late November 1786, suggesting a noticeable weight loss, and Mary Isabella missed the Castle celebrations for the Queen's birthday in March 1787.[105] Three months later, *Saunders's News-Letter* noted that 'her Grace the Dutchess of Rutland still continues extremely indisposed at the Castle. The unfortunate illness of this great lady during the whole winter, has thrown a great damp on all the amusements of the Vice-regal Court'.[106] Newspapers were sketchy

as to what her illness was, but letters from those who saw her once she returned to England indicate that she was depressed and exhausted from 'living up to the etiquette of the Queen of Ireland'.[107] Finally, during her second visit, Mary Isabella simply did not have to try as hard to win the approval of Dublin society. The crisis of the previous year was over, and her general popularity and that of her husband were on an upward trajectory, even as the issue of the commercial propositions gained traction. By April 1785, they were reckoned 'the most illustrious pair, that ever graced the British circle, or did honour to the Viceroyalty of the Irish nation', and poet after poet raved about the vicereine's beauty, philanthropy and personal merits.[108] When she was ill in 1786, further articles and poems appeared praying for her speedy recovery and assuring her of the people's love and esteem.[109] The favour of the political elite was generally secure too. Mary Isabella threw a 'rout and a ball' to celebrate her recovery, in May 1786, for which 'The principal nobility and Gentry' were said to have 'made it a particular point to remain in town'.[110] When she hosted another ball that December in the Viceregal Lodge in the Phoenix Park, it too was surprisingly well attended, despite the time of year.[111]

What did not change during her second visit was Mary Isabella's commitment to using her social and philanthropic activities to support Charles's viceroyalty, or their efforts to work as a team to accomplish this. The ongoing parties at the Castle and at the homes of prominent politicians continued and built upon the charm offensive they had used in 1784. Just as before, many of the plays and concerts the vicereine ordered and attended were benefit performances for a range of individuals and groups. These included the manufacturers of Irish tabinet and poplin in March 1785, the 'Distressed Freemasons' the following month, a Signor Raimondi that September and the Meath Hospital in May 1787.[112] She continued to wear Irish, as did the viceroy, and by promoting the 'introduction of gold-lace and embroidery', they supported not just the silk and poplin weavers, but those working in other areas of the textile industry.[113] The party they threw for the Queen's birthday at Dublin Castle in 1786 was credited with causing 'a circulation of near 25,000l. among the manufacturers, shopkeepers and trades-folk of this metropolis' and two months later, one newspaper cooed that 'never was a Lady in her exalted station known to have interested herself in behalf of the trade and manufactures of Ireland, so much as the beautiful Duchess of Rutland has done'.[114] That same month, the Dublin silk weavers presented her with an address of thanks for her patronage, which they credited with creating many jobs in the city, and Mary Isabella promised to continue her assistance.[115] The Duchess was further applauded for the care she took to investigate whether individuals who petitioned her for help were 'an object really distressed, or an imposter', thereby avoiding accusations that her charity encouraged begging or vagrancy, and she took an interest in the capital's Magdalen Asylum, for which she attended a charity sermon in March 1786.[116] Based on the London charity of the same name, this institution was founded and managed by Lady Arbella Denny and had opened in 1767 to rehabilitate penitent prostitutes. It was an obvious venture for Mary Isabella to encourage given its female-centric nature, overtones of social improvement, and

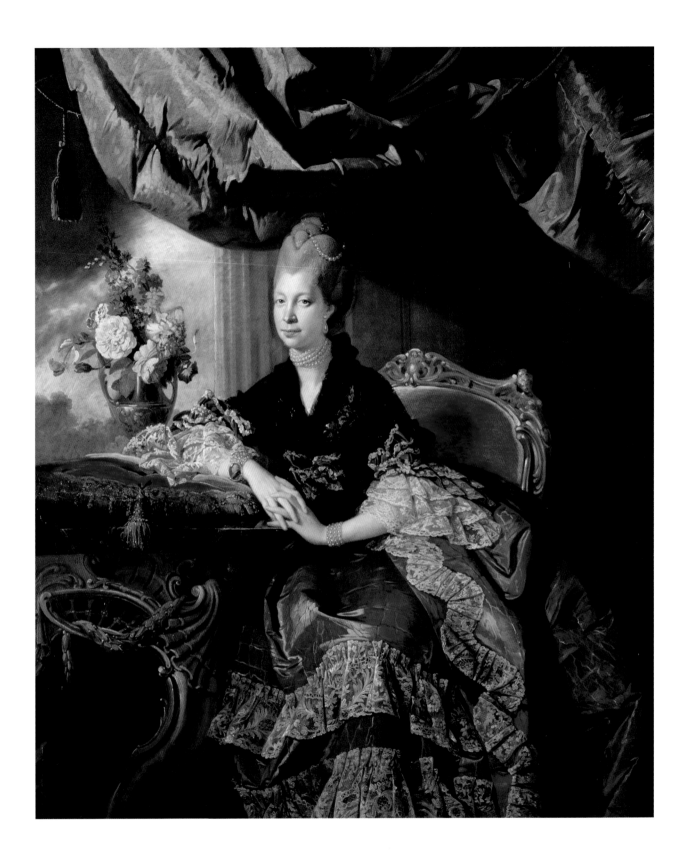

the fact that Queen Charlotte (whose role as consort was emulated by vicereines) was the patroness of the London asylum (Fig. 04.13). The payment of 10 guineas from the Duke's Dublin Castle account on behalf of 'her Grace, being Patroness of the Magdalen Asylum', on 10 May 1787, confirms Mary Isabella's application of the Queen's London example in Dublin.[117] The Dublin equivalent also had a long history of viceregal patronage, having likely been created at the bidding of former viceroy, Francis, 1st Earl of Hertford, who was its first president and whose countess, Isabella (see Fig. 00.10), was its life-long patroness.[118]

Helped by Mary Isabella's unrelenting sociability and philanthropy, the couple's star soared. In June 1786, the Earl of Mansfield congratulated them on their change of fortune, saying: 'By not running after, or otherwise courting popularity, than by deserving it, I hear it now follows you both.'[119] That said, there was still the occasional naysayer. Even *The Freeman's Journal* (a paper which, at that time, was pro-government and championed the Rutlands) had to admit, in October 1786, that the Duchess's support of Irish manufacturers was not always enough to convince the native ladies to follow suit, and *The Dublin Evening Post* felt that though her departure in 1787 would 'be a mortification to the ladies of the beau monde', it would have 'no injurious effect upon manufacture', for 'Irish fabrics were never *sported* for some time past, either in the ball or drawing-room at the Castle.'[120] Such problems were increasingly few and far between, however. By August 1785, an English newspaper wrote: 'The Duchess of Rutland's popularity in Ireland exceeds that of any of her predecessors in the Lieutenantcy [sic].' What was more, she had earned it, for 'she does all lengths for it. – At the dinner table our hostess mingles with society in the best grace that can be – and that till near one in the morning – the dinner beginning before eight!'[121] They did not appear to appreciate that, for Mary Isabella, this was an early night. Two months later, the vicereine proved equally successful in winning over those she met during a tour of the south of Ireland.

Viceregal Tour

This tour began on 7 October 1785 when the Rutlands stayed in Queen's County (Laois) at the home of Sir John Parnell, Chancellor of the Exchequer, whilst *en route* to Limerick. They then proceeded to County Kerry before spending several weeks in Cork and Waterford and finally returning to the Viceregal Lodge on 27 November.[122] For the most part, they were warmly greeted. City after city showered them with welcoming committees, assemblies, balls and dinners, all attended by the *crème de la crème* of local society. Crowds of ordinary people cheered them as they moved through the streets, and addresses of loyalty and welcome flowed in from the merchants of Limerick and Cork and the local dignitaries and clergy of Waterford.[123] In Cork, Charles was even presented with the freedom of the Corporation in a gold box and the city paid for the viceregal party's expenses during their stay.[124]

The motives for the trip were debated within the press. Some claimed it was for 'pleasure alone', others that 'a little spice of politics is blended with that [of busi?]ness'.[125] The latter assessment was closer to the truth. In the provinces, 'the

(opposite)

Fig. 04.13.

Johan Zoffany

Queen Charlotte

1771

Royal Collection Trust/© Her Majesty Queen Elizabeth II 2021.

smack of politics' involved in the tour was recognized by those tasked with entertaining the Rutlands, and letters between Charles and his advisors show that it was intended as a show of viceregal strength and an opportunity to build support for the lord lieutenancy.[126] This would hopefully make it easier for the viceroy to pursue his political agenda and 'render the Winter Campaign less formidable'.[127] It was no easy task though. The tour came hard on the heels of the collapse of the commercial propositions in August and parts of the southern counties were in a state of increasing lawlessness, with their loyalty to the Crown and its representative often dubious at best. During the course of the Rutlands' travels, the Whiteboys, a 'predominantly Catholic rural protest movement' which had first appeared in Tipperary in the 1760s, destroyed cattle and murdered Protestant clergy and tithe proctors.[128] This forced Charles to send cavalry to Mallow in County Cork to deal with the 'very alarming' situation which he worried would spark a resurgence of the Volunteer Corps, a militia group outside government control, which had been created in the late 1770s in response to the security concerns raised by the American War of Independence.[129] Worse still, he suspected that some locals 'in a better sphere of life' were deliberately undercutting his viceregal authority for that very purpose.[130] The cavalry he saw were poorly manned and often ill-disciplined and there was a mutiny in the previously loyal second regiment of horse.[131] The address from the merchants of Cork had been slow to appear and the city of Kilkenny snubbed the couple entirely.[132] In the face of these difficulties, it was more important than ever that Mary Isabella be at her most charming and attractive as Charles strove to smooth over the cracks in viceregal authority.

The Duchess's approach during the tour was to replicate the most successful tactics she had used to win over the people of Dublin. In Limerick, she rode through the streets in an open phaeton so that she could be seen by the masses and danced with local dignitaries at an assembly until 2am.[133] In Killarney, she reviewed the local troops with Charles and in the city of Cork, they jointly commanded 'a grand assembly [...] for the benefit of the Charitable Infirmary'.[134] There were numerous balls in their honour, including in Waterford, where Mary Isabella opened the dancing with the mayor and dazzled the assembled personages by wearing 'a profusion of diamonds' and staying until four in the morning.[135] Indeed when used sparingly, her late hours were taken as a compliment to the crowd, rather than the regular burden they had become for the Dublin elite the year before.[136] Charles, too, worked hard to flatter and impress. He socialized as heavily as his wife and in Cork, one onlooker swore of him that 'never was a man so delighted with any place'. He had even gone so far as to say that 'if the Dublin people misbehaved he would adjourn the Parliament here'.[137] While they were staying in the city, Mary Isabella helped to get a Mr Gray knighted by her husband, who dispensed further knighthoods to a Mr Kellet and a Dr Naly before bestowing the same honour on Waterford city's mayor and one of its sheriffs.[138]

The tour had its obstacles though. Those faced with hosting the Duchess panicked at the idea of welcoming a woman of such rank. Sir John Parnell 'begged' John, 1st Earl of Portarlington and his wife, Caroline, to come to dinner

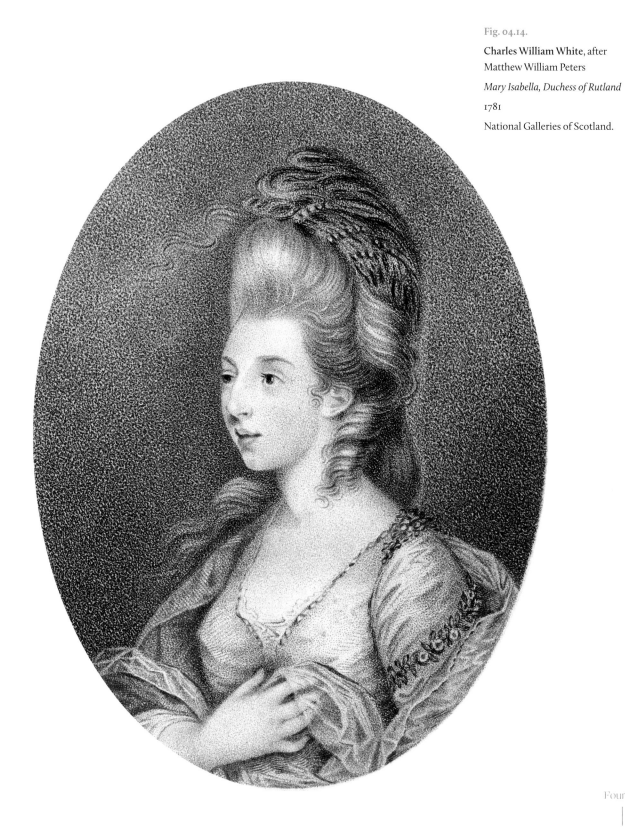

Fig. 04.14.

Charles William White, after
Matthew William Peters

Mary Isabella, Duchess of Rutland

1781

National Galleries of Scotland.

with Charles and Mary Isabella at his home, though Lady Portarlington 'felt very awkward at the thoughts of going' given that she had not previously been presented to the vicereine and worried that the Rutlands might then expect to be invited to her own home at Dawson Court, Queen's County (now Emo Court, County Laois). Knowing that Sir John 'would be in distress to know how to entertain them', however, she and her husband went.[139] There were similar concerns in Cork, where the disparity in status between Mary Isabella and those she would meet caused headaches. One man wrote that there were no ladies fit to receive or entertain the Duchess and worried about where a woman of her standing could be suitably accommodated.[140] Mary Isabella's reputation was apparently rather poor in the provinces. Lady Portarlington was surprised at how pleasant she was, saying that she 'was very good humoured and did not give herself airs, tho' they always make such storys [sic] about her'. She did not think Mary Isabella was enjoying herself though, for the vicereine was travelling with no female companion and the good weather had passed.[141] Writing from Cork eighteen days later, Charles, too, let slip his indifference to much of what he had seen up to that point, referring to the country he had travelled through as 'loyal but very dreary'.[142]

Whatever their private thoughts, the results of the couple's efforts were overwhelmingly positive and Mary Isabella's presence on the tour undoubtedly added to its success. Addresses to the Duke thanked his wife for joining him and noted that her appearances added 'a singular lustre' to proceedings.[143] She was presented with a poem on her departure from Limerick, declaring her 'our enchanting Queen' and later praised for her 'very polite condescension and affable conduct' which 'endeared her to the town of Killarney'.[144] In Waterford, there was talk of naming a bridge after them and upon her return to Dublin, Mary Isabella sat for a picture 'to be presented to the gentlemen and ladies of Waterford, and put up in the new ball-room, as a token of her Grace's remembrance of their attention during her short stay among them'.[145] A further reminder of the visit was a thirty-two-light glass chandelier, which was commissioned during their time in Waterford, at a cost of £277.[146] It was subsequently installed in the State Apartments at Dublin Castle.[147] The tour was credited with boosting the economy thanks to the money expended by the Rutlands and the employment opportunities generated amongst 'traders, mechanics and artificers' by 'the dresses, preparations, balls, &c. given in each town and city'.[148] Overall, wrote Joseph Hill, the whole affair had been 'both Useful and Amusing'.[149]

The couple had been missed in Dublin and upon their return, their busy social life resumed, as all the while their debts mounted and Mary Isabella became more and more unwell.[150] By the spring of 1787, her doctors were advising that she return to England and in May, she did so, leaving Charles to manage alone.[151] Once recovered, she again showed little inclination to rejoin him, despite the pleading of the local press and even Charles himself, who wrote to her of his dislike of sleeping without his wife by his side.[152] She did not entirely abandon her role as vicereine however, though her distaste for elements of the task is evident in correspondence with her husband. In June, Charles wrote to her, asking: 'If you meet

any of the Irish either at Tunbridge or at Spa – if you go there – pray be particularly attentive to them (even tho' they be twaddlers) – a set of unfortunate people whom you hold in such utter contempt.'[153] Meanwhile, perhaps with the success of the 1785 tour in mind, he now turned his attention to a similar venture around the north of Ireland. It was to prove his undoing. Over the course of the summer he socialized more heavily than ever, eating and drinking too much, sleeping too little and riding up to seventy miles a day.[154] When he arrived back at the Viceregal Lodge at the beginning of October, he was exhausted and ill. In a matter of weeks, he was dead, his liver having been destroyed by his excesses.[155] When Mary Isabella heard the news, her grief was so extreme that it was feared she too would expire.[156] Fortunately, she proved more resilient. Far from suffering an early death, she outlived Charles by over four decades, surviving until 1831, having never remarried or returned to Ireland.[157]

Final Reflections

Mary Isabella had been an outstanding success as vicereine. From a position in early 1784 when newspapers had doubted that the viceroy would last until Christmas, she helped Charles achieve a level of popularity few men in his office ever enjoyed, earning herself an equally enviable reputation among the Irish people along the way.[158] Henry Grattan later wrote in admiration of her success at blending the political with the social, saying that 'Ministerialist and oppositionist seemed to have laid down their arms at the feet of beauty in search of repose and enjoyment.'[159] The Irish press did not soon forget the 'lovely Duchess' either, immortalizing her nearly twenty years later as 'Fashion's superlative Queen' who had 'diffused a gaity in the brilliant circle' formed by Dublin's elite (Fig. 04.14).[160] Though financially crushing, the couple's display of 'luxury', aided in large part by Mary Isabella's spending habits, 'gave a powerful impulse to industry' and alongside her more overt charitable endeavours, added to their popularity amongst the common people, helping to diffuse the violent tensions of 1784.[161] As a lasting tribute, when a memorial fountain was erected in Charles's memory in Merrion Square in the early 1790s (see Cat. 15), it was ornamented with a carving of the Duchess as well, so that even today she may still be seen looking down on the street below, as striking as ever.

Endnotes

1 Letter to [Lord Moira?] from Francis Rawdon, 5 February [1784], Granard Papers, Public Record Office of Northern Ireland, T3765/M/4/3/28.

2 *Public Advertiser*, 24 August 1785.

3 E.H. Chalus, 'Manners [née Somerset], Mary Isabella, duchess of Rutland (1756–1831)', in H.C.G. Matthew and B. Harrison (eds), *Oxford Dictionary of National Biography* (Oxford: Oxford University Press, 2004), vol. 36, pp. 472–4; G.E. Cockayne (ed.), *Complete Peerage of England, Scotland, Ireland, Great Britain and the United Kingdom: Extant, Extinct or Dormant* (London: George Bell & Sons, 1895), vol. 6, p. 470.

4 See Chalus, 'Manners [née Somerset], Mary Isabella', p. 473; *General Evening Post*, 3–6 July 1784; J.S. Lewis, '1784 and All That', in A. Vickery (ed.), *Women, Privilege, and Power: British Politics, 1750 to the Present* (Stanford: Stanford University Press, 2001), pp. 89–122.

5 F. Hardy, *Memoirs of the Political and Private Life of James Caulfield, Earl of Charlemont* (London: printed for T. Cadell and W. Davies, 1812), vol. 2, p. 143.

6 See Chalus, 'Manners [née Somerset], Mary Isabella', pp. 472–4; E. Chalus, *Elite Women in English Political Life, c.1754–1790* (Oxford: Clarendon Press, 2005); A. Foreman, *Georgiana, Duchess of Devonshire* (London: Harper Collins, 1999); see Lewis, '1784 and All That', pp. 89–122; J. Robins, *Champagne & Silver Buckles: The Viceregal Court at Dublin Castle 1700–1922* (Dublin: The Lilliput Press, 2001), pp. 55, 67, 69–70, 73–5; D. Rutland and E. Ellis, *Resolution: Two Brothers, a Nation in Crisis, a World at War* (London: Head of Zeus, 2017).

7 D. Wilkinson, 'Bentinck, William Henry Cavendish Cavendish-, third duke of Portland (1738–1809)', in Matthew and Harrison (eds), *Oxford Dictionary of National Biography*, vol. 5, pp. 261–9; letter to Mrs Ponsonby from Dorothy, Duchess of Portland, 9 February [1784], Grey/Ponsonby Papers, Public Record Office of Northern Ireland, T3393/9.

8 C. Ross (ed.), *Correspondence of Charles, First Marquis Cornwallis* (London: John Murray, 1859), vol. 1, p. 167; R. Thorne, 'Manners, Charles, fourth duke of Rutland (1754–1787)', in Matthew and Harrison (eds), *Oxford Dictionary of National Biography*, vol. 36, pp. 458–60.

9 J. Kelly, *Prelude to Union: Anglo-Irish Politics in the 1780s* (Cork: Cork University Press, 1992), p. 77.

10 Letter to Mrs Ponsonby from Dorothy, Duchess of Portland, 15 February [1784], Grey/Ponsonby Papers, Public Record Office of Northern Ireland, T3393/10.

11 *Freeman's Journal*, 25 October 1787.

12 See Kelly, *Prelude to Union*, p. 76.

13 Ibid., pp. 76, 78–9.

14 Ibid., pp. 80–1. See also J. Smyth, *The Men of No Property: Irish Radicals and Popular Politics in the Late Eighteenth Century* (London: Macmillan Press, 1998 reprint), pp. 135–8; J. Kelly, 'The Politics of Protestant Ascendancy, 1730–1790', in J. Kelly (ed.), *The Cambridge History of Ireland, Volume III, 1730–1880* (Cambridge: Cambridge University Press, 2018), pp. 70–2.

15 For first quote, see Hardy, *Memoirs of the Political and Private Life*, p. 146. For second quote, see *Belfast Mercury; or Freeman's Chronicle*, 9 April 1784.

16 S.J. Connolly, *Divided Kingdom: Ireland 1630–1800* (Oxford: Oxford University Press, 2008), p. 421.

17 Ibid., pp. 421–2. See also Kelly, 'The Politics of Protestant Ascendancy', p. 71.

18 R. Wilson, '"Our late most excellent viceroy": Irish Responses to the Death of the Duke of Rutland in 1787', *Journal for Eighteenth-Century Studies*, 42, 1 (Spring 2019), pp. 67–83.

19 *Saunders's News-Letter*, 19 April, 2 November 1784, 19 February 1785; *Dublin Evening Post*, 3 May 1787.

20 R. Wilson, 'The Vicereines of Ireland and the Transformation of the Dublin Court, c.1703–1737', *The Court Historian*, 19, 1 (June 2014), pp. 3–28; T. Barnard, *Making the Grand Figure: Lives and Possessions in Ireland, 1641–1770* (New Haven: Yale University Press, 2004), p. 10.

21 T. Mooney and F. White, 'The Gentry's Winter Season', in D. Dickson (ed.), *The Gorgeous Mask: Dublin 1700–1850* (Dublin: Trinity History Workshop, 1987), pp. 1, 9; *Dublin Journal*, 31 December 1786–3 January 1787.

22 See Mooney and White, 'The Gentry's Winter Season', pp. 1–4, 8; J.C. Greene, *Theatre in Dublin, 1745–1820: A Calendar of Performances* (Bethlehem: Lehigh University Press, 2011), 6 vols, *passim*.

23 R. Wilson, *Elite Women in Ascendancy Ireland, 1690–1745: Imitation and Innovation* (Woodbridge: The Boydell Press, 2015), pp. 101–8.

24 H. Grattan, *Memoirs of the Life and Times of the Rt. Hon. Henry Grattan* (London: Henry Colburn, 1841), vol. 3, p. 278.

25 J. Barrington, *Historic Memoirs of Ireland; Comprising Secret Records of the National Convention, the Rebellion, and the Union; with Delineations of the Principal Characters Connected with these Transactions* (London: published for Henry Colburn, 1835), vol. 2, p. 216.

26 *Public Register, or, Freeman's Journal*, 17–20 April 1784. Quote from *Freeman's Journal*, 22 April 1784.

27 *Belfast Mercury; or Freeman's Chronicle*, 25 May 1784.

28 First quote from *The Manuscripts of His Grace the Duke of Rutland, K.G. preserved at Belvoir Castle* (London: Historical Manuscripts Commission, 1894), vol. 3, p. 81. Second quote

from C.L. Meryon (ed.), *Memoirs of the Lady Hester Stanhope, as Related by Herself in Conversations with her Physician; Comprising her Opinions and Anecdotes of Some of the Most Remarkable Persons of her Time* (London: Henry Colburn, 1845), vol. 2, p. 52. See also Chalus, *Elite Women*, p. 180.

29 *Hibernian Journal: or, Chronicle of Liberty*, 20 February 1784.

30 See Wilson, 'The Vicereines of Ireland', pp. 12, 20–1; see Barnard, *Making the Grand Figure*, p. 12.

31 See Kelly, 'The Politics of Protestant Ascendancy', p. 71.

32 See Chalus, *Elite Women*, p. 84.

33 Charles hosted a gala for St Patrick's Day, for instance. See Anon., 'Domestic Intelligence, Dublin', *The Hibernian Magazine: or, Compendium of Entertaining Knowledge*, March 1784, p. 164.

34 *The Manuscripts of the Earl of Carlisle, preserved at Castle Howard* (London: Historical Manuscripts Commission, 1897), pp. 532–3.

35 *Belfast Mercury; or Freeman's Chronicle*, 23 April 1784.

36 For evidence of the Duke's social activities, see *The Manuscripts of His Grace the Duke of Rutland*, vol. 3, p. 143.

37 *Hibernian Journal: or, Chronicle of Liberty*, 23 April 1784; *Freeman's Journal*, 20 May 1784. For more information on visits to the Dublin ladies by the vicereines of Ireland, see Robins, *Champagne & Silver Buckles*, pp. 44–5.

38 See Chalus, *Elite Women*, pp. 84–91.

39 *Freeman's Journal*, 20 May 1784.

40 Ireland did have one dukedom, that of Leinster. However, English titles were rated more highly than Irish ones; no one could sit in the House of Lords on the strength of an Irish peerage and the Dukes of Leinster only qualified because they were also Viscounts Leinster in the British peerage. See E. Magennis, 'Fitzgerald, James, first duke of Leinster (1722–1773)', in Matthew and Harrison (eds), *Oxford Dictionary of National Biography*, vol. 19, pp. 813–4.

41 S.E. Whyman, *Sociability and Power in Late-Stuart England: The Cultural Worlds of the Verneys, 1660–1720* (Oxford: Oxford University Press, 1999), p. 91.

42 *Saunders's News-Letter*, 11 May 1784; *Dublin Evening Post*, 26 June 1784; *Hibernian Journal: or, Chronicle of Liberty*, 15 September 1784; E.M. Johnston-Liik, *MPs in Dublin: Companion to History of the Irish Parliament, 1692–1800* (Belfast: Ulster Historical Foundation, 2006), p. 123.

43 See Greene, *Theatre in Dublin*, vol. 3, pp.

2260, 2262–3, 2269, 2277; *Saunders's News-Letter*, 11 June 1784; *Volunteer's Journal or Irish Herald*, 18 June 1784. Greene's record of the 1783–4 theatrical season at Smock Alley is around 83% complete, with that for Crow Street Theatre roughly 90% complete.

44 On viceregal support of the theatre in Ireland, see C. Morash, *A History of Irish Theatre, 1601–2000* (Cambridge: Cambridge University Press, 2002), pp. 4, 14–15, 35.

45 Ibid., pp. 71, 80.

46 *Hibernian Journal: or, Chronicle of Liberty*, 18 June 1784; *Dublin Evening Post*, 3 June 1784.

47 *Hibernian Journal: or, Chronicle of Liberty*, 23 April 1784.

48 *Freeman's Journal*, 12 June 1784; *Hibernian Journal: or, Chronicle of Liberty*, 23 April 1784.

49 *Freeman's Journal*, 3 June 1784. For similar comments several months later, see *Saunders's News-Letter*, 4 October 1784. For a less successful review of the troops by a vicereine, see the experience of Caroline, Countess of Buckinghamshire as described in a letter to Hotham Thompson from John, Earl of Buckinghamshire, 1 September 1777, Hotham Papers, Public Record Office of Northern Ireland, T3429/1/13.

50 See Greene, *Theatre in Dublin*, vol. 3, p. 2277; P.H. Highfill, *A Biographical Dictionary of Actors, Actresses, Musicians, Dancers, Managers & Other Stage Personnel in London, 1660–1800* (Carbondale & Edwardsville: Southern Illinois University Press, 1975), vol. 4, p. 496.

51 *Hibernian Journal: or, Chronicle of Liberty*, 11 August, 15 September 1784; see Highfill, *A Biographical Dictionary*, vol. 1, pp. 363–7.

52 *Freeman's Journal*, 19 August 1784; *Hibernian Journal; or, Chronicle of Liberty*, 27 August, 20 September 1784.

53 *Hibernian Journal: or, Chronicle of Liberty*, 26 May 1784. Quote from *Freeman's Journal*, 29 July 1784.

54 For the 1699 export bans see 10 Will. III, c. 5 [Ire.] (16 January 1699); 10 & 11 Will. III, c. 10 [Eng.] (4 May 1699).

55 Letter to Thomas Keightley from Laurence, Earl of Rochester, 1 July 1701, Inchiquin Papers, National Library of Ireland, MS 45,721/1; *The Craftsman*, 15 November 1729. Further export bans had been introduced as recently as 1776; see P. Higgins, 'Consumption, Gender, and the Politics of "Free Trade" in Eighteenth-Century Ireland', *Eighteenth-Century Studies*, 41, 1 (Autumn 2007), p. 91.

56 Swift wrote a pamphlet in 1729 entitled *A Proposal That All the Ladies and Women of Ireland Should Appear Constantly in Irish Manufactures.*

See H. Davis (ed.), *The Prose Works of Jonathan Swift, Vol. XII: Irish Tracts 1728–1733* (Oxford: Oxford University Press, 1955), pp. 124–5; see Higgins, 'Consumption, Gender, and the Politics of "Free Trade"', pp. 88–9, 94.

57 See Higgins, 'Consumption, Gender, and the Politics of "Free Trade"', pp. 92, 103; W.E.H. Lecky, *A History of Ireland in the Eighteenth Century* (London: Longmans, Green, and Co., 1892), vol. 2, pp. 242–3.

58 *Dublin Evening Post*, 2 March 1784.

59 *Freeman's Journal*, 22 April 1784.

60 *Belfast Mercury; or Freeman's Chronicle*, 23 April 1784.

61 *Freeman's Journal*, 10 June 1784.

62 *Saunders's News-Letter*, 9 March 1784.

63 *Freeman's Journal*, 3 June 1784.

64 Ibid., 29 May 1784; *Hibernian Journal: or, Chronicle of Liberty*, 4 June 1784; *Saunders's News-Letter*, 11 June 1784.

65 *Freeman's Journal*, 3 June 1784.

66 Ibid.

67 See Higgins, 'Consumption, Gender, and the Politics of "Free Trade"', p. 94.

68 *Freeman's Journal*, 1 May 1784; *Saunders's News-Letter*, 19 March 1785.

69 *Volunteer's Journal or Irish Herald*, 16 June 1784.

70 On the miscarriage, see *General Evening Post*, 3–6 July 1784; see *The Manuscripts of His Grace the Duke of Rutland*, vol. 3, p. 143.

71 See Grattan, *Memoirs of the Life and Times*, vol. 3, p. 279.

72 C. Pigott, *The Female Jockey Club, or a Sketch of the Manners of the Age* (London: printed for D.I. Eaton, 1794), p. 31.

73 *Hibernian Journal: or, Chronicle of Liberty*, 12 May 1784.

74 A. Aspinall (ed.), *The Later Correspondence of George III* (Cambridge: Cambridge University Press, 1962), vol. 1, no. 154.

75 J. Kelly, 'Residential and Non-Residential Lords Lieutenant – The Viceroyalty 1703–1790', in P. Gray and O. Purdue (eds), *The Irish Lord Lieutenancy, c.1541–1922* (Dublin: University College Dublin Press, 2012), p. 78.

76 See, for example, letters to Charles, Duke of Rutland from Joseph Hill, 11 December 1785, 10 and 25 August 1786, Belvoir Castle Muniments. Cited by kind permission of His Grace the 11th Duke of Rutland.

77 Letter to Charles, Duke of Rutland from Joseph Hill, 6 November 1785, Belvoir Castle Muniments. Quoted by kind permission of His Grace the 11th Duke of Rutland.

78 Household accounts of Charles, Duke of Rutland, for year ending 27 February 1785, Belvoir Castle Muniments. Cited by kind permission of His Grace the 11th Duke of Rutland.

79 Letter to Charles, Duke of Rutland from Joseph Hill, 2 December 1786, Belvoir Castle Muniments. Cited by kind permission of His Grace the 11th Duke of Rutland. For currency conversions, see 'The National Archives Currency Converter, 1270–2017', viewable online: http://www.nationalarchives.gov.uk/currency-converter/ (accessed 6 February 2020).

80 *Belfast Mercury; or Freeman's Chronicle*, 18 June 1784.

81 See Greene, *Theatre in Dublin*, vol. 3, pp. 2270–1; J.F. Molloy, *The Romance of the Irish Stage* (New York: Dodd, Mead and Company, 1897), vol. 2, pp. 226–7.

82 *Volunteer's Journal or Irish Herald*, 21 May 1784. Quote from *Dublin Evening Post*, 5 June 1784.

83 *Volunteer's Journal or Irish Herald*, 16 June 1784.

84 Ibid., 18 June 1784; *Hibernian Journal: or, Chronicle of Liberty*, 20 October 1784.

85 A. Clark (ed.), *Gleanings from an Old Portfolio: Containing Some Correspondence Between Lady Louisa Stuart and her Sister Caroline, Countess of Portarlington, and Other Friends and Relations* (Edinburgh: printed for David Douglas, 1896), vol. 2, p. 2.

86 Letter to Richard, Earl of Shannon from Lady Catherine-Henrietta Bernard, 18 February 1785, Shannon Papers, Public Record Office of Northern Ireland, D2707/A/2/7/7.

87 For quote, see Kelly, 'The Politics of Protestant Ascendancy', p. 71; *Hibernian Journal: or, Chronicle of Liberty*, 8 November, 6 December 1784; *Saunders's News-Letter*, 22 October, 10 and 31 December 1784.

88 *Freeman's Journal*, 10 March 1785.

89 Ibid.

90 *Saunders's News-Letter*, 25 January 1785.

91 Ibid., 19 February 1785; *Freeman's Journal*, 22 February 1785.

92 *Freeman's Journal*, 19 February and 3 March 1785.

93 Ibid., 19 February, 3 March and 12 April 1785; *Belfast Newsletter*, 24 February 1786; *Saunders's News-Letter*, 19 May 1786.

94 *Freeman's Journal*, 1 March 1785; *Saunders's News-Letter*, 31 December 1785. John Scott, Baron Earlsfort (later 1st Earl of Clonmell) was a long-time government supporter and Chief Justice of the King's Bench; R. Richey, 'Scott, John (1739–98)', in J. McGuire and J. Quinn (eds), *Dictionary of Irish Biography* (Cambridge: Cambridge University Press, 2009), vol. 8, pp. 803–4. On the relationship between Fitzgibbon and the Duke, see A. Kavanaugh, 'FitzGibbon, John, first earl of Clare (1748–1802)', in Matthew and Harrison (eds), *Oxford Dictionary of National Biography*, vol. 19, pp. 862–3.

95 *Saunders's News-Letter*, 14 August 1786; B. FitzGerald (ed.), *Correspondence of Emily, Duchess of Leinster (1731–1814)* (Dublin: Irish Manuscripts Commission, 1957), vol. 3, pp. 387–8; H.M. Stephens, rev. by A.T.Q. Stewart, 'Conolly, Thomas (1738–1803)', in Matthew and Harrison (eds), *Oxford Dictionary of National Biography*, vol. 12, pp. 985–6; J. Quinn, 'Clements, Henry Theophilus (1734–95)', in McGuire and Quinn (eds), *Dictionary of Irish Biography*, vol. 2, pp. 576–7.

96 Chairman's bill paid by Thomas Norris to White and Sheridan on behalf of the Duchess of Rutland, 8 March 1786, Belvoir Castle Muniments. Cited by kind permission of His Grace the 11th Duke of Rutland. T.G. Fewer, 'Langrishe, Sir Hercules, first baronet (c.1729–1811)', in Matthew and Harrison (eds), *Oxford Dictionary of National Biography*, vol. 32, pp. 505–6; A.P.W. Malcomson, 'Foster, John (1740–1828)', in McGuire and Quinn (eds), *Dictionary of Irish Biography*, vol. 3, pp. 1069–75; J. Kelly, 'de Blaquiere, Sir John (1732–1812)', in McGuire and Quinn (eds), *Dictionary of Irish Biography*, vol. 3, pp. 126–8.

97 B. McMahon, '"A most ingenious mechanic": Ireland's First Airman', *History Ireland*, 18, 6 (November/December 2010), p. 24.

98 *Volunteer's Journal or Irish Herald*, 11 August 1786; see Greene, *Theatre in Dublin*, vol. 3, pp. 2326, 2328, 2333–4, 2339–40, 2342, 2346, 2348–54, 2359, 2371–2, 2374, 2378, 2384, 2392–3, 2398, 2402, 2404–6. See also Greene, *Theatre in Dublin*, vol. 4, pp. 2412, 2419, 2430–1, 2438. The true number of plays was almost certainly higher as the record of performances is incomplete.

99 See FitzGerald, *Correspondence of Emily, Duchess of Leinster*, vol. 3, pp. 390–1.

100 *Saunders's News-Letter*, 16 March 1785.

101 *Freeman's Journal*, 12 April 1785.

102 *Belfast Mercury; or Freeman's Chronicle*, 27 February 1786. The holding of celebrations for Queen Charlotte's birthday in the wrong month echoes the practice of celebrating the monarch's official birthday separately from their real one.

103 Letter to Harriet [Skeffington] from [Lord] Roden, 12 August [1785], Massereene-Foster Papers, Public Record Office of Northern Ireland, D562/2530.

104 *Dublin Journal*, 30 March–1 April 1786; *Belfast Mercury; or Freeman's Chronicle*, 4 April 1786; see *The Manuscripts of His Grace the Duke of Rutland*, vol. 3, p. 291; see Greene, *Theatre in Dublin*, vol. 3, p. 2398.

105 See FitzGerald, *Correspondence of Emily, Duchess of Leinster*, vol. 3, p. 387; *Freeman's Journal*, 6 March 1787.

106 *Saunders's News-Letter*, 17 April 1787.

107 For quote, see *The Manuscripts of His Grace the Duke of Rutland*, vol. 3, p. 424; see also *The Manuscripts of His Grace the Duke of Rutland*, vol. 3, pp. 391, 414.

108 Quote from *Freeman's Journal*, 12 April 1785. For poetry on the Duchess, see *Freeman's Journal*, 30 July, 8 September and 5 November 1785; *Volunteer's Journal or Irish Herald*, 26 September 1785; *Dublin Journal*, 15–18 July and 14–17 October 1786.

109 *Volunteer's Journal or Irish Herald*, 10 and 14 April 1786.

110 Ibid., 12 May 1786.

111 See FitzGerald, *Correspondence of Emily, Duchess of Leinster*, vol. 3, p. 393.

112 See Greene, *Theatre in Dublin*, vol. 3, pp. 2326, 2334, 2359; see Greene, *Theatre in Dublin*, vol. 4, p. 2438.

113 *Volunteer's Journal or Irish Herald*, 19 December 1785. Quote from *Freeman's Journal*, 22 December 1785.

114 *Belfast Mercury; or Freeman's Chronicle*, 6 March 1786; *Volunteer's Journal or Irish Herald*, 17 May 1786.

115 *Freeman's Journal*, 18 May 1786.

116 Quote from *Freeman's Journal*, 14 October 1786; *Saunders's News-Letter*, 6 March 1786.

117 Record of payment to Magdalen Asylum, 10 May 1787, Account 366: English money paid on account of his Grace the Duke of Rutland, Dublin Castle, Belvoir Castle Muniments. Cited by kind permission of His Grace the 11th Duke of Rutland.

118 K. Sonnelitter, *Charity Movements in Eighteenth-Century Ireland: Philanthropy and Improvement* (Woodbridge: The Boydell Press, 2016), pp. 131–3.

119 See *The Manuscripts of His Grace the Duke of Rutland*, vol. 3, p. 311.

120 *Freeman's Journal*, 10 and 31 October 1786; *Dublin Evening Post*, 28 April 1787. On the funding of the *Freeman's Journal* and some general comments on relations between the Castle and the press during the 1770s and 1780s, see P. Higgins, *A Nation of Politicians: Gender, Patriotism, and Political Culture in Late Eighteenth-Century Ireland* (Madison: University of Wisconsin Press, 2010), pp. 45–7.

121 *Public Advertiser*, 24 August 1785.

122 *Dublin Evening Post*, 22 October, 8 and 24 November 1785; see *The Manuscripts of His Grace the Duke of Rutland*, vol. 3, p. 252; *Freeman's Journal*, 15 November 1785; *Volunteer's Journal or Irish Herald*, 23 November 1785; see *The Manuscripts of His Grace the Duke of Rutland*, vol. 3, p. 265.

123 Anon., 'Domestic Intelligence', *The Hibernian Magazine: or, Compendium of Entertaining Knowledge,* October 1785, pp. 557–8; see Clark, *Gleanings from an Old Portfolio*, vol. 2, p. 48; *Dublin Evening Post*, 22 October 1785; *Freeman's Journal*, 22 and 24 October 1785; *Belfast Newsletter*, 1 November 1785; *Volunteer's Journal or Irish Herald*, 23 November 1785; *Saunders's News-Letter*, 24 November 1785.

124 *Freeman's Journal*, 15 November 1785.

125 Ibid., 22 October 1785; *Dublin Evening Post*, 22 October 1785.

126 *The Manuscripts of the Duke of Beaufort, K.G., the Earl of Donoughmore, and Others* (London: Historical Manuscripts Commission, 1891), p. 314; see *The Manuscripts of His Grace the Duke of Rutland*, vol. 3, pp. 256–8, 265.

127 Letter to Charles, Duke of Rutland from Joseph Hill, 11 December 1785, Belvoir Castle Muniments. Quoted by kind permission of His Grace the 11th Duke of Rutland.

128 See *The Manuscripts of His Grace the Duke of Rutland*, vol. 3, p. 252. For quote, see Higgins, *A Nation of Politicians*, p. 133.

129 See *The Manuscripts of His Grace the Duke of Rutland*, vol. 3, p. 252; see Kelly, 'The Politics of Protestant Ascendancy', pp. 49, 65–6, 71.

130 See *The Manuscripts of His Grace the Duke of Rutland*, vol. 3, p. 252.

131 Ibid., pp. 252–3.

132 Ibid., p. 263.

133 *Dublin Evening Post*, 22 October 1785.

134 Anon., 'Domestic Intelligence', *The Hibernian Magazine: or, Compendium of Entertaining Knowledge*, November 1785, p. 613; *Saunders's News-Letter*, 31 October 1785.

135 See Anon., 'Domestic Intelligence', *The Hibernian Magazine: or, Compendium of Entertaining Knowledge*, November 1785, p. 613; *Freeman's Journal*, 26 November 1785.

136 See Anon., 'Domestic Intelligence', *The Hibernian Magazine: or, Compendium of Entertaining Knowledge*, November 1785, p. 613.

137 Letter to Christina, Baroness Donoughmore from Thomas Forrest, 1 November 1785, Donoughmore Papers, Public Record Office of Northern Ireland, T3459/C/2/152.

138 Ibid.; see *The Manuscripts of the Duke of Beaufort*, p. 315; *Saunders's News-Letter*, 24 November 1785.

139 See Clark, *Gleanings from an Old Portfolio*, vol. 2, pp. 47–8.

140 See *The Manuscripts of the Duke of Beaufort*, p. 314.

141 See Clark, *Gleanings from an Old Portfolio*, vol. 2, p. 48.

142 See *The Manuscripts of His Grace the Duke of Rutland*, vol. 3, p. 252.

143 *Saunders's News-Letter*, 24 November 1785.

144 Anon., 'Domestic Intelligence', *The Hibernian Magazine: or, Compendium of Entertaining Knowledge,* October and November 1785, pp. 558, 613.

145 *Volunteer's Journal or Irish Herald*, 23 November 1785. Quote from *Freeman's Journal*, 10 December 1785.

146 F. O'Dwyer, 'Making Connections in Georgian Ireland', *Bulletin of the Irish Georgian Society*, 38 (1996–7), p. 18.

147 Ibid. The chandelier now hangs, in reduced form, in the Council Chamber at Waterford City Hall.

148 *Freeman's Journal*, 15 December 1785.

149 Letter to Charles, Duke of Rutland from Joseph Hill, 11 December 1785, Belvoir Castle Muniments. Quoted by kind permission of His Grace the 11th Duke of Rutland.

150 *Freeman's Journal*, 26 November 1785.

151 *Dublin Evening Post*, 3 May 1787.

152 *Freeman's Journal*, 18 August and 13 September 1787; see Rutland & Ellis, *Resolution*, p. 415.

153 See *The Manuscripts of His Grace the Duke of Rutland*, vol. 3, p. 395.

154 H.B. Wheatley (ed.), *The Historical and the Posthumous Memoirs of Sir Nathaniel William Wraxall, 1772–1784* (London: printed for Bickers & Son, 1884), vol. 5, p. 34; Anon., 'Biographical Anecdotes of the Late Duke of Rutland', *The Gentleman's Magazine: and Historical Chronicle*, 62, 2 (1787), p. 1021.

155 See Wilson, '"Our late most excellent viceroy"', pp. 69, 71.

156 *Freeman's Journal*, 1 November 1787.

157 See Chalus, 'Manners [née Somerset], Mary Isabella', p. 474.

158 *Hibernian Journal: or, Chronicle of Liberty*, 12 April 1784.

159 See Grattan, *Memoirs of the Life and Times*, vol. 3, pp. 278–9.

160 *Belfast Commercial Chronicle*, 16 April 1806.

161 See Barrington, *Historic Memoirs of Ireland*, vol. 2, p. 216.

Five

'A Subject for History'

Maria, Marchioness
of Normanby as
Vicereine of Ireland,
1835–9

Myles Campbell

I <u>must</u> keep a journal!! How many thousand times have I said that and how
many books have I prepared and how many times begun and my heart has
failed me … But my husband I think will become [a] subject for history and
I have lived with him nearly 20 years and kept no journal of his eventful life
… so for the 50th time in my life I resolve I will keep a journal.[1]

Introduction

As night began to fall over London on Friday, 17 August 1838, the last rays of the
summer sun were about to be eclipsed by a brilliant display of diamonds, gilding
and candlelight. The venue was Buckingham Palace, the host was the young Queen
Victoria and the occasion was the birthday of the Queen's mother, the Duchess of
Kent.[2] The evening's festivities began with a lavish dinner, after which the party
was swelled by a host of ambassadors and aristocrats for a concert held in the grand
saloon.[3] For readers of London's newspapers the following morning, the abiding
impression was of 'brilliantly illuminated' rooms filled with princely chatter and
the tender strains of Rossini's *Ti Parli L'Amore*.[4] But for one woman, the luminous
evening at court had not been without its shadows. For Maria, Marchioness of
Normanby (Fig. 05.01), its most vivid aspect had been a provocative anti-Irish
outburst by the British Prime Minister, Viscount Melbourne, in the presence of
the Queen. Writing to her husband the next morning, Lady Normanby recounted
the tirade she had witnessed:

> He began abusing the Irish nation yesterday. I told him how ungrateful I
> thought him … but he went off in his way, you know, 'a perverse artful false
> and fickle people – never any good with them, true <u>Celts</u>'!!! It provokes me,
> his fury … before the Queen … it must prejudice her against a part of her
> own people that God knows have never received justice from any English
> sovereign before.[5]

With his anti-Irish rhetoric, Lord Melbourne had struck at the very heart
of Lady Normanby's campaign, as the serving vicereine of Ireland, to foster the
young Queen's support for the Irish people and their industries.[6] In seeking to do
so, Lady Normanby was working to address what she saw as the repeated failure
of successive English monarchs to ensure the just treatment of their Irish subjects
under British rule. This work had begun three years earlier when she had arrived
at Dublin Castle as the wife of the new Lord Lieutenant of Ireland (viceroy) in May
1835. Provoked by Melbourne's potentially harmful words at Buckingham Palace,
she now leapt to the defence of the Irish people and rebuked the most powerful
politician in the land, telling him how ungrateful she thought him, in the pres-
ence of the Queen. It was a typically courageous and sympathetic act on behalf of
the Irish people but like so many during her time as vicereine, one that would find
no place in either the morning newspapers, the pages of her journal or the annals
of Irish history. Despite being remembered in her obituary as a woman who was,

'in the hey-day of youth if not a queen upon one throne, almost a queen of many' and whose 'career was an eventful and conspicuous one', she has not been the subject of any dedicated article or book and there is no entry on her in either the *Oxford Dictionary of National Biography* or the *Dictionary of Irish Biography*.[7] Her life in general and in Ireland, in particular, has been almost entirely overlooked.[8]

Leafing through Lady Normanby's red leather-bound journal today, it is, perhaps, possible to identify one of the reasons why. Seven months before her encounter at Buckingham Palace, she had sat down in her viceregal quarters at Dublin Castle to write the inaugural entry in that journal. In the first lines that flowed from her pen, which open this essay, she had acknowledged a sense of duty to leave behind for posterity a record not of her own life, but of her husband's. Echoing the apparent views of most commentators who would later profile the leading figures of her generation, she believed that only her husband's 'eventful life', and not her own, could be considered a 'subject for history'.[9] The aim of this essay, which is based largely on her overlooked papers, is to retrieve her legacy as vicereine of Ireland and, in doing so, to show otherwise.

From Jamaica to Dublin Castle: The Making of a Vicereine

Maria, Marchioness of Normanby (1798–1882) began life as the Hon. Maria Liddell on 20 April 1798.[10] She was the eldest daughter of coal magnate Sir Thomas Henry Liddell (later 1st Baron Ravensworth) of Ravensworth Castle, County Durham and his wife, Maria (née Simpson).[11] In 1818, she married Constantine Henry Phipps (1797–1863), son of Henry, 1st Earl of Mulgrave, of Mulgrave Castle, Yorkshire.[12] Following the birth of their only child, George, in 1819, the young couple moved to Florence where they indulged their shared passion for staging theatrical productions at their residence, Palazzo San Clemente.[13] The death of Constantine's father in 1831 marked the beginning of a much more peripatetic lifestyle for Maria and her husband. Having succeeded his father to the earldom of Mulgrave, Constantine was soon appointed to his first major post, serving as Governor of Jamaica from 1832 to 1834.[14] By 1835, with their Jamaican experience behind them, the Earl and Countess of Mulgrave, as they were now known, were on their way to a whole new life in Ireland.

The arrival of Lord and Lady Mulgrave in Dublin as viceroy and vicereine of Ireland was a tumultuous one. Shortly before midday on Monday, 11 May 1835, the royal standard on the vessel carrying the new viceregal couple made its first appearance on the horizon beyond Kingstown (now Dún Laoghaire), just south of Dublin.[15] On board, the young earl and countess, both aged 37, were just minutes away from witnessing scenes of a kind they had never before experienced in their short lives. Their sleepless overnight crossing from Holyhead had been marked, as Lady Mulgrave later recalled, by 'the dreadful smell of hot grease' and 'the tumbling of the stern', which had combined to make them both 'as ill as possible'.[16] But illness, lack of sleep and the onset of the worst weather known on the east coast of Ireland 'for years' could not dampen the fervour of the day.[17] As they disembarked to the acclamation of the 'vast multitude which lined the pier', the tumultuous waves of

the Irish Sea were quickly superseded by the still stronger wave of public enthu-siasm that would carry them all the way to Dublin Castle.[18]

Writing to her mother-in-law a few days after their arrival, Lady Mulgrave described the staggering scale of the welcome that had awaited them in the streets of Dublin:

> I don't suppose I shall ever see such a pageant again, and I rubbed my eyes, and wondered if it could be possible that all that pomp and work could be about us. I only wish once again to see something like it, when we go away ... in every outlet and aperture, on the road, the squares, the houses, the Castle Yard, a distance of five miles was one dense mass of people.[19]

Grandiloquent newspaper reports abounded. In the estimation of one support-ive correspondent, 'the entire population of the city appeared to be pouring itself into the main streets'.[20] Another noted triumphal arches traversing the main thor-oughfares, three lines of carriages where traditionally there had been but one, and a cacophony of deafening cheers.[21] 'Never,' it was claimed, 'did we behold such a mass of human beings ...'[22] Even conservative press organs bitterly opposed to the new liberal viceroy could not fail, in branding the procession 'ostentatious and panoramic', to acknowledge its exceptional breadth and impact.[23] Notwithstand-ing the hyperbole of the liberal press, the triumphal reception of Lord and Lady Mulgrave was, by all accounts, the largest viceregal entry witnessed in Dublin since the United Kingdom of Great Britain and Ireland had come into being over three decades earlier. Flags fluttered, bands played 'God Save the King' and the young couple looked on in disbelief as an estimated 120,000 souls braved the rain to mark the beginning of their life in Ireland.[24]

A key source of this public adulation can be identified in a comical vignette recorded by Lady Mulgrave as she reflected on the day's proceedings:

> There were several droll Irish jokes, such as a very ragged man who climbed quite up to the top of King William's statue, and when we went by, he took out a very clean pocket handkerchief, and wiped the eyes of the statue, which was a funny idea and would have occurred to none but an Irishman.[25]

The contentious equestrian statue of King William III, Prince of Orange and victor of the Battle of the Boyne, had served as 'a focus of Protestant triumph and nation-alist hatred' since its installation on College Green in 1701.[26] Revered and reviled in equal measure, it was at once a rallying point where Protestants left votive offer-ings of orange lilies each July, and a flashpoint where Catholics practised rituals of tarring and attempted decapitation on its monumental bronze form. The wiping of the inanimate king's notional tears as the Mulgraves passed by may have been part of the longstanding rhetorical traditions of Dublin nationalism but it also symbolized a distinctly new and fresh sense of optimism among Irish Catholics. The general election of January 1835 had produced a Whig-led administration reli-

ant on the support of Daniel O'Connell's Irish Repeal Association. This alliance, known as the Lichfield House Compact, raised the hopes of Irish Catholics for the strengthening of their voice at Westminster and the weakening of the traditional Tory and Protestant interests that had dominated the administration at Dublin Castle.[27] The appointment of the liberal Lord Mulgrave as viceroy by the new Prime Minister, Lord Melbourne, was greeted as an outward sign that their hopes were about to be fulfilled, and Mulgrave would soon become 'as popular with the [Catholic] majority as he was unpopular with the powerful Protestant minority' in Ireland.[28] Striking out in a new direction, the government now sought, through its 'justice to Ireland' policy, to bring Ireland's Catholics in from the cold some six years after the passage of the Roman Catholic Relief Act of 1829.[29] This departure was broadly in line with their new assimilationist approach, which sought to make Ireland the integral part of the United Kingdom it had manifestly failed to become in the decades since the Acts of Union came into effect in 1801.[30] It would be a state in which, as Daniel O'Connell put it, 'there would be no distinction between Yorkshire and Carlow, between Waterford and Cumberland'.[31] Before setting out for Dublin, Mulgrave was given clear instructions by Melbourne to 'carry "the Roman Catholic Relief Bill into actual practical effect" and face down the violent opposition of the high Protestants'.[32] Armed with these orders and his own record as an MP whose first major speech, in 1819, had been in favour of Catholic relief, his appointment might well have brought tears to the eyes of the Protestant William III were it not for the immutability of the King's cold bronze expression.[33]

The other principal cause for public optimism that day was Lord Mulgrave's distinguished and largely benign record as Governor of Jamaica. Having served in the role from 1832 to 1834, he had presided over one of the most transformative episodes in the island's history – the abolition of slavery – in 1833.[34] 'No wonder, then,' trilled one Dublin newspaper correspondent, 'that the arrival of his Excellency among us, should be hailed with such unbounded joy.'[35] This joy could be heard loud and clear on the streets of Dublin that day. 'I am sure you would have been gratified,' wrote Lady Mulgrave to her mother-in-law, 'had you heard the people crying "God bless the black man's friend."'[36] An oil sketch by the Irish artist Nicholas Joseph Crowley, in the collection of the National Gallery of Ireland, casts Lord Mulgrave in just such a romantic light as Governor of the Caribbean island, attended by a young black boy whose raised hat denotes the respect of the Jamaican people (Fig. 05.02). A print of this painting in St Werburgh's Church, Dublin, allows for the young boy to be identified as John Mulgrave, a former African slave who, having been shipwrecked on the island of Jamaica as a child in 1833, was taken in by Lord and Lady Mulgrave as their godson and given their family name.[37] Having accompanied them back to England in 1834 and subsequently to Ireland as part of the household at Dublin Castle in 1835, he contracted smallpox and died in their care in Dublin, in February 1838, at the age of seventeen.[38] A memorial tablet erected by his godmother, Lady Mulgrave, remains on display at St Werburgh's Church today. Together with the National Gallery portrait of John and Lord Mulgrave, this tablet is an indicator of the warm relationship that

endured between the Mulgraves and their young godson in the years after their time in Jamaica. The apparent execution of the portrait in Ireland by an Irish artist, and its subsequent purchase for the National Gallery, offers perhaps some hint of the grip exercised by the viceregal couple's humane and kindly treatment of black people, on the Irish popular imagination.

Amid all the fanfare of the new viceroy's arrival in Dublin in May 1835, little mention was reserved in the official accounts of the event for his wife. Having devoted multiple column inches to almost every word and deed of Lord Mulgrave on his progress into Dublin, the newspapers had done nothing more than acknowledge Lady Mulgrave's existence. Labouring under a sense of guilt or, perhaps, an awareness of the revenue generated by its female readership, *The Freeman's Journal* attempted to amend the record:

> We owe an apology to our fair readers and the sex generally, for not saying anything yesterday about the Viceroy's consort. Her Excellency is a pretty woman – well suited in this respect with her noble lord – of very pleasing countenance and unaffected deportment.[39]

Far from being the mere decorative consort portrayed in this account, Lady Mulgrave's own distinguished record in Jamaica suggests that she might well have been as bright a source of hope to the Irish people as her husband, had that record not been overlooked. Among the initiatives pioneered by her in Jamaica between 1832 and 1834 was the establishment of the Female Refuge School at Fairfield. Instituted by her in October 1832, only five months after her arrival on the island, the school was run by women, for women. According to one of its contemporary annual reports, it accepted students 'either as boarders or orphans'.[40] By 1838, Lady Mulgrave was far away in Ireland serving as vicereine but according to the latest annual report sent to her from Jamaica, her school was still accommodating between twenty-five and twenty-eight students across the year and was in the process of expanding to accommodate more.[41] Notable among its students at that time were two young African girls who, according to the report, had been rescued by Lady Mulgrave from a Portuguese shipwreck some years earlier and placed in the institution's care prior to her departure from Jamaica.[42] Since that day, they had been 'generously supported' by her from afar and were by now preparing to leave the school, the younger to work as a maid and the elder to serve as a school assistant.[43] 'The latter,' it was noted, 'has shewn considerable abilities, and takes a delight in teaching, justifying the expectation, that she will make herself very useful.'[44] The young girl who had shown 'considerable abilities' can be identified as the former child slave who, having escaped slavery when she was washed up on the Jamaican coast in 1833, was fostered by Lady Mulgrave and given the name Catherine Mulgrave.[45] Catherine Mulgrave would eventually go on to exceed the school's expectations and to honour Lady Mulgrave's memory by becoming a noted educator and establishing many boarding schools of her own along Africa's Gold Coast (Fig. 05.03).[46]

(opposite)

Fig. 05.02.

Nicholas Joseph Crowley

Constantine Henry Phipps, Earl of Mulgrave, later Marquess of Normanby, with John Mulgrave

1835–9

© National Gallery of Ireland.

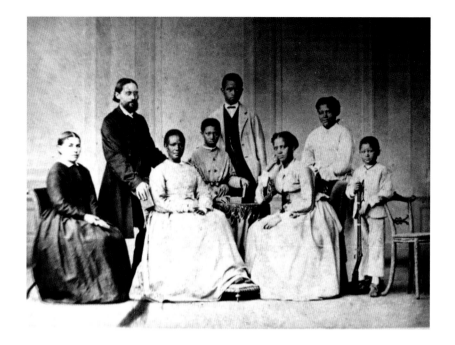

Letters written to her sister during her time in Jamaica reveal Lady Mulgrave's growing capacity to use her position of privilege as the governor's wife for the benefit of ordinary people. 'I have had one of my Receptions this morning,' she wrote on one occasion, 'where I sit in state and receive all the people that choose to come … and I graciously receive my poor subjects and soon put them at their ease …'[47] Leaping from the pages of these letters is a powerful sense of the injustices of slavery, which, she lamented, was a 'dreadful grievance' and which she earnestly yearned to see abolished.[48] At the same time, her words also betray a far-sighted awareness that a life-changing measure such as abolition demanded very careful planning. 'God knows,' she remarked in one of these letters, 'I think slavery a wicked unchristian practice. I think it demoralises a country altogether, both the slaves and slave-holders; but then that makes it doubly necessary for people to consider before they make a sudden change.'[49] When that momentous change finally came, she made sure to be present for its proclamation by her husband in the courthouse at Montego Bay, and to record her impressions for her sister:

> The cheers they gave when it was all done were deafening, and made a lump come in my throat; for think what a blessing it was to have in one's power to dispense … I am sure that you would have felt inclined to cry, had you seen their animated faces, with the tears glistening in their eyes … It is a thing I shall always be glad to have seen, it does not happen often that one has the power of seeing such happiness dispensed, still less have the power of dispensing it … I went all through the negro village to-day, and the people were so pleased, as they had never seen a lady come near a cottage or a hut.[50]

Her moving account of that historic day's events and of her role in celebrating them with the liberated slaves in their own humble homes reveals an awareness of the part she too could play, by virtue of her high social position, in initiating positive change. It was an awareness that would only continue to grow in the years that followed.

Not long after her return to England in 1834, Lady Mulgrave was busy making up 'a box for Jamaica' with 'many little presents' for the people she had been sorry to leave behind when her husband's term as governor ended.[51] Her investment in the life of the island is evident not only from her considered engagement with its politics and people but also from the copious detailed sketches she made of its topography, flora and fauna, many of which are carefully labelled and demonstrate her deep interest in botany and taxonomy. This valuable visual record of Jamaica in the early 1830s survives among her papers and does justice to her artistic abilities as much as her inquisitive mind (Figs 05.04 & 05.05).[52] Notwithstanding her contentment to be back at her beloved Mulgrave Castle in Yorkshire, a sense of regret at having been obliged to leave behind the meaningful role she had apparently come to relish fulfilling in Jamaica may explain the zeal with which she responded when a similar opportunity presented itself.[53] At the beginning of 1835, rumours began to circulate that Lord Mulgrave would be the new Whig government's choice for the position of viceroy of Ireland, and she immediately set her heart on the prospect of going to Dublin. Dismayed by reports from London of her husband's ambivalent response to the offer, she made her feelings known to him in no uncertain terms:

Fig. 05.04.

Maria Phipps, Countess of Mulgrave, later Marchioness of Normanby

Malphigia Coriacea, Large Tree, Sp[anish] Town [Jamaica]

1832–4

Photograph by Scott Wicking, reproduced courtesy of the Marquis and Marchioness of Normanby.

> Ireland is exactly the sort of thing in which you would succeed perfectly and I do think you a little mistaken when you think you will distinguish yourself much as a speaker … You have made many good speeches I can't deny that but none that have ever made much effect considering the length of time you have been in Parliament. I think you will not agree with me and perhaps you will be affronted … and perhaps you feel in yourself the <u>power</u> of <u>speaking</u> but I feel <u>more</u> sure that you would distinguish yourself in Ireland, and if you <u>could</u> have got it and if you have thrown it away I shall … be very much vexed as I had set my heart upon going to Ireland and as I told you I wished it [,] you might have tried for it.[54]

Were it not for her sobering intervention, it seems doubtful that Lord Mulgrave would have accepted the offer. Lady Mulgrave's letters to him reveal

her strong view that Ireland had, as she observed, been 'put down' by Tory governments at 'the point of the bayonet' for far too long, and that the time was right for a new approach.[55] The political wind had changed in Ireland and Lady Mulgrave sensed that its new direction would suit the attributes not only of her husband but perhaps equally those of herself. With her experience of major socio-political changes in Jamaica to her credit, she believed that Ireland now demanded, as she put it, 'activity' and 'energy' from Britain.[56] And so it came to pass that the young couple found themselves in Dublin Castle on the evening of 11 May 1835, as the new Irish representatives of King William IV and Queen Adelaide, and with the hopeful cries of the city of Dublin still ringing in their ears.

From Dublin to Derry: Official Duties

Initial reports of the new vicereine's activities in Ireland were largely unremarkable and recorded her appearance at the usual round of dinners, drawing rooms and social occasions associated with the viceregal court in Dublin.[57] Just over a week after her arrival, on 20 May 1835, she faced her first test when the jeers of what was described by *The Freeman's Journal* as a small 'Orange clique' were directed at the viceregal box during a command performance of *The Wife* at the Theatre Royal.[58] According to Lord Mulgrave's brother, Charles, who had accompanied the viceregal couple to Ireland as State Steward, this 'factious noise' was 'immediately put down by the thundering cheers of the body of the house' and did little to undermine the 'splen-

did reception'.[59] Ignoring the disturbances, Lady Mulgrave distinguished herself by maintaining her composure throughout the performance and rising 'more than once' to acknowledge 'the flattering compliments that were paid to her' by the majority of the house.[60] The performance of *The Wife* on the theatre's stage had been matched by that of the viceroy's consort in the box. 'The Lord Lieutenant and his lady,' wrote one bemused Scottish visitor, 'carried off their roles remarkably well, bowing gracefully, and with apparent feeling, to the congratulations of the audience.'[61]

If this display of stoicism and resolve in the face of adversity was a taste of things to come, then observers would not have to wait long to see it in action again. Following a spell of entertaining at Dublin Castle and the Viceregal Lodge (now Áras an Uachtaráin) in May and June, the couple spent several days in County Wicklow in July before Lord Mulgrave embarked on a five-week tour across Leinster, Munster and Connaught.[62] His progress took in numerous towns and cities including Lismore, Cork, Roscrea, Athlone, Galway and Ballina.[63] Such was the extent of public enthusiasm in the cities and towns he visited that he was soon being dubbed 'O'Mulgrave' and 'Dan's Lieutenant' by the more conservative Protestant press organs, in reference to Daniel O'Connell's support base in southern and western counties and to the viceroy's perceived Catholic and O'Connellite sympathies.[64] As the summer drew to a close, only the northern province of Ulster, the final frontier in this initial island progress, remained to be seen. As the stronghold of Orange sentiment, where the perceived Catholic and O'Connellite affinities of the Mulgraves were most likely to provoke disturbances, it is

perhaps surprising that Ulster became the destination for Lady Mulgrave's first major provincial tour with her husband. What is perhaps even more surprising is her willingness to participate in any such tour in the first place, regardless of the destination. Prolonged circuits of Ireland by the wives of the country's vice-roys had, until then, been rare.[65] Such an extensive tour of Ulster, which would include even its most remote parts, would be something of a new departure for a vicereine. In a letter written to her husband a few months earlier, Lady Mulgrave had outlined her views on the urgent need to appeal to the many in Ireland rather than to the privileged few. 'The days are gone by,' she had observed, 'when great dinners, balls and fêtes made a government popular in Ireland.'[66] Convinced of the potential of less elitist and exclusive interactions to effect change, and no doubt drawing on her similar experiences in Jamaica where she had visited the people of the island in their own homes, she resolved to exchange the polite world of the Dublin drawing room for the wilds of Ulster's remotest countryside and with it, the political maelstrom that might await her.

By late September, the viceroy and vicereine were in the throes of what Lady Mulgrave referred to in a letter as their 'long projected northern tour', which suggests that the plan to tour Ulster had been conceived soon after, or possibly even before, their arrival in Ireland.[67] The couple had set out from Dublin on 22 September and over the course of five weeks, allowing for a brief return to Dublin, their itinerary would include Omagh, Derry, the Giant's Causeway, Belfast, Bally-castle, Banbridge, Monaghan, Newry and Armagh.[68] Writing from Derry on 28 September, Lady Mulgrave recorded the 'great astonishment' that had greeted the appearance of the viceregal party on the isolated coastline of north Donegal two days earlier.[69] She also contrasted the warmth of the welcome extended by most people with the 'violent' reception mounted by others:

> With the exception of the Mayor and Corporation and some violent Orange-men we have been enthusiastically received, and warmly greeted, and hospi-tably treated wherever we have been. Nothing can more shew the necessity of some reform in corporations than the systematic way in which they have failed in their respect to Lord Mulgrave and opposed themselves to the general wishes of the great body of the respectable inhabitants ... Altogether his visit will have done a great deal of good if only to falsify all the indications that he <u>dare</u> not shew his face in the north.[70]

A few days later it was reported that the viceregal couple had overcome further challenges in Monaghan town, on 29 September, when an 'Orange faction' had likewise attempted to 'throw difficulties in the way'.[71] Judging from a second report, these factional disturbances had been no match for the promise of 'strict impartiality' made by Lord Mulgrave in his brief address to the townspeople, or for the 'kindliness of his lady', who 'delighted the assembly'.[72] It seemed that the tide of popular opinion in Ulster was now flowing in favour of the viceregal couple and that 'the current' had become 'too strong and rapid even in Monaghan'.[73] This was

the new, progressive, and by virtue of Lady Mulgrave's presence, 'kindly' face of the viceroyalty, and its message was clear. If, as Daniel O'Connell suggested, the Irish people should have a right to expect no distinction between Carlow and Yorkshire, then by the same token, they should now expect none between Dublin and Derry when it came to the public appearances of a viceroy or, for that matter, of his wife, regardless of political sympathies. It was a message that Lord Mulgrave delivered unambiguously in Derry, declaring, in spite of the hostilities, that he 'considered the personal inspection of different parts of the country as an appropriate duty'.[74] Lady Mulgrave's presence on this politically charged northern tour had helped to break new ground, not least because she and her husband became the first viceregal couple to visit County Donegal since the Union of 1801.[75] It also appears to have helped diffuse tensions such as those that surfaced in Monaghan, which might otherwise have run even higher in her absence. Her courage in the face of adversity and in the name of duty had already set a high bar for the vicereines who would follow her.

Back at Dublin Castle, the promise of strict impartiality made across Ulster was soon being honoured by the viceroy and vicereine as they drew up their guest lists. Welcoming such diverse visitors as an Indian juggler and a Bohemian prince, they made similarly few distinctions when it came to their Irish guests, as a report from Lady Mulgrave demonstrates:

> We have two great and <u>curious</u> dinners today and tomorrow. Today a good many Irish members amongst them O'Connell whom I have never seen. I am rather curious to see what sort of person he is. Tomorrow we have the Lord Mayor and Sheriffs and the Recorder <u>Shaw</u>, quite in the opposite tack but M[ulgrave] is quite right in being just the same in his invitations to all parties.[76]

Despite the 'sensation of alarm' caused in traditional Tory and Unionist circles by O'Connell's visit to the Castle, this even-handed approach to the fulfilment of their social duties was one in which both husband and wife firmly believed, as Lady Mulgrave's comments make clear.[77] While fitful attempts at viceregal impartiality had been initiated before, the scale of this offensive was quite novel, and 'captivated the Roman Catholic party'.[78] Gratitude for this impartial approach is revealed in a letter from Daniel O'Connell, which survives among Lord Mulgrave's correspondence as viceroy:

> I hope you will pardon me for this intrusion – I cannot however write without respectfully expressing my strong sense of obligation which every Irishman ought to feel for the dignified impartiality and temper with which your Excellency has conducted the affairs of Ireland.[79]

Even when it came to engaging with O'Connell in person, Lady Mulgrave recognized the need for tact and diplomacy, and developed a careful strategy to ensure that her curiosity would not be misinterpreted as partiality. Writing on 20 January 1838, she noted:

> Had a dinner last night of 40 people … amongst whom the great man of the
> day Daniel O'Connell. I never before had an opportunity of speaking to him
> at these large dinners but I made Lady Bellew speak to him and draw him up
> to our part of the room so that I had an opportunity of talking to him with-
> out being particular in my attention to him. I must say I found him quite gay
> and gentlemanlike … but I am afraid he has no scruples …[80]

Although privately more wary than her husband of O'Connell and convinced
that he was 'not to be trusted', Lady Mulgrave did not allow these misgivings to
colour her approach to the fulfilment of her duties as vicereine, or to undermine
the work of her husband.[81] In personally offering a warm welcome to O'Connell at
Dublin Castle, she showed the same bold spirit that had prompted her extensive
tour of Ulster. It was acts such as these that helped to shape perceptions of the vice-
royalty as a more inclusive and impartial institution in the mid-1830s, especially
among figures like O'Connell; an achievement for which Lady Mulgrave deserves
her share of credit. It is clear from her even-handed approach that, as has been said
of her husband, Lady Mulgrave was sincere in her belief that the Union of Britain
and Ireland 'could only be based upon equal rights'.[82] It was a belief that she would
quickly come to express not only in word and deed but also in material form.

From the Castle to the Palace: Poplin and Royal Patronage

Within days of her arrival in Dublin in 1835, Lady Mulgrave was writing to inform
her mother-in-law of the positive impact she was making on the city's working
poor, for whom she evidently felt sympathy. As a demonstration of that sympa-
thy, she had wasted no time in placing large orders with them for garments made
from Irish poplin:

> I hear I have lifted up the hearts of the people in the liberties by ordering
> a poplin train and some poplin gowns and I pray you if you can get me
> commissions for poplins do as the more I can buy the better for the poor
> people here, and I shall be too glad to execute them, they are very pretty and
> in all colours, plain 2s-6d to 3s-7d, figured 5s. I enclose you some patterns
> and pray recommend them.[83]

Though certainly well-intentioned and commendable, her efforts were by no means
novel. Down through the decades, countless vicereines before her had endeavoured
to do their bit for Irish industry by supporting the silk, muslin and poplin weavers
of Dublin, as demonstrated by the efforts (recorded elsewhere in this volume) of
women such as Mary Isabella, Duchess of Rutland, Charlotte, Duchess of Richmond
and Charlotte Florentia, Duchess of Northumberland to name but a few. As early
as 1745, the vicereine Petronilla Melusina, Countess of Chesterfield (1693–1778)
had reacted to a weavers' petition against imported fabrics by instructing guests
attending a ball at Dublin Castle to wear Irish poplin.[84] Despite her well-meaning

efforts and those of other vicereines like her, such strategies were, as Sarah Foster has pointed out, 'unlikely to tilt the economic balance to a sufficient degree, but made good "copy" for newspapers of the day'.[85] But such vigorous promotion of these fabrics by Lady Mulgrave among family and friends in England, after less than a week as vicereine, signalled a change of pace and approach.

According to the leading Irish poplin makers of the early nineteenth century, Richard Atkinson and Company, the origins of their craft could be traced back to the arrival in Dublin of a group of migrant Huguenot weavers in 1693.[86] Described by the company as 'the successful combination of silk and worsted', poplin combined an outward surface of 'pure silk' with an interior of 'the finest wool'.[87] This combination offered not only richness but also durability, all at a cost, they emphasized, *relatively cheaper than whole silks*.[88] By the time the Countess of Mulgrave was arriving in Dublin as vicereine in 1835, Richard Atkinson was establishing his new premises at 31 College Green. As Mairead Dunlevy has observed in her survey of the Irish silk industry, the increasing popularity of Irish poplin at this time was associated with a growing middle-class market and with it, a demand for 'silk unions'.[89] With the rise in demand for cheaper, more durable alternatives to silk, such as poplin and bombazeen, the traditional silk industry suffered, especially following the legalization of the sale of French silks in Ireland.[90] Failing to recognize these shifting market forces, or perhaps choosing to ignore them, Daniel O'Connell was quick to blame the decline of Dublin's silk industry on a lack of raw silk imports caused by the Union of Britain and Ireland.[91] But if O'Connell could blame the plight of distressed silk weavers on the Union, Lady Mulgrave could equally seek to attribute an improvement in the fortunes of the poplin weavers to the effects of that same Union. One of the key ways in which she would attempt to invigorate the poplin industry was by securing the influential patronage of the royal family. Another was through combining the influence of her position as vicereine with her artistic abilities in order to personally design, endorse and promote new and fashionable poplins to be woven by Dublin manufacturers. In a very short time, her two-stranded strategy, which has been entirely overlooked until now, would have a transformative impact on both the growing Irish poplin industry and the image of the vicereine.

In June 1835, the first fashionable fruits of this strategy came to ripeness and were reported in the Dublin press. A dress made from the so-called 'Mulgrave Summer Tissue', which had been 'particularly designed by Her Excellency the Countess of Mulgrave' was to be worn at court in London, on 25 June, by 'her Royal Highness the Duchess of Kent and Countess of Dublin'.[92] The dress had been woven by Richard O'Reilly of Dublin's College Green and was described by the Comptroller of the Duchess of Kent's household, John Conroy, as 'the first specimen of its kind made in Ireland'.[93] Some months later, in December 1835, it was reported that another new poplin pattern 'designed and painted' by Lady Mulgrave was now available for sale.[94] Woven by Richard Atkinson of College Green and known as the 'Mulgrave Brocaded Poplin', it featured coloured flowers and sprays 'tastefully brocaded' on a white ground.[95] The experience Lady Mulgrave had gained in

producing detailed drawings of flowers and foliage during her time in Jamaica would now prove to be of practical benefit in Dublin, where a new outlet for her botanical drawings began to open up (Fig. 05.06). Brocaded poplins were set apart from regular poplins by their raised patterns, which were often woven from gold and silver thread, and were said to be 'quite novel' in Ireland at this time.[96] They were also more expensive, as Lady Mulgrave had informed her mother-in-law when she set about soliciting commissions during her first week in Dublin. At a cost of 5s, they offered a higher return for the weaver than the plain varieties, which likely enhanced their appeal for the vicereine.[97] The version designed by Lady Mulgrave, a sample or possibly derivative of which survives in the collection of the Victoria and Albert Museum (Fig. 05.07), was said to create a beautiful effect that could not fail to attract the attention of

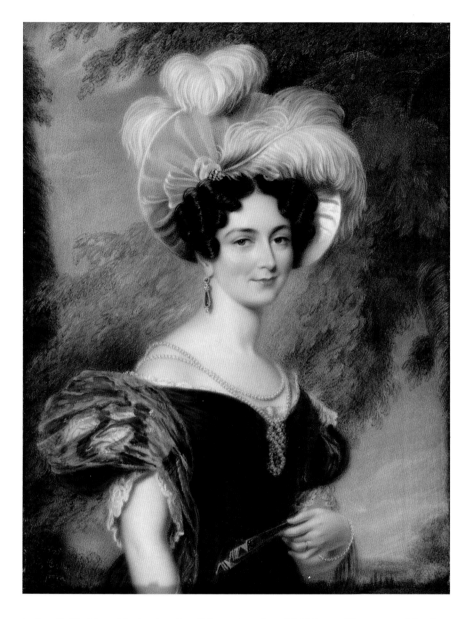

Fig. 05.08.

Henry Collen

Victoria, Duchess of Kent

1835

Royal Collection Trust/© Her
Majesty Queen Elizabeth II 2021.

Ireland's 'fashionables' as 'a splendid evening dress'.[98] If the public required further
proof of its desirability, then they need only look to the example set by the Duchess
of Kent in ordering the first dress to be made from it. The Duchess, it was reported
in December 1835, had again commissioned this dress through Lady Mulgrave as
part of another order for poplins from Dublin:

> We have just heard that her Royal Highness the Duchess of Kent … has sent
> a large order for poplins, through her Excellency the Countess of Mulgrave,
> to the different manufacturers of our city. Her Royal Highness has ordered a
> dress of the 'Mulgrave Brocaded Poplin'; the first dress was only just finished
> from the loom. Her Excellency expressed a wish to have it forwarded to her
> Royal Highness without any delay.[99]

Fig. 05.09.

Warrant appointing Messrs
Richard Atkinson & Co. poplin
and furniture manufacturers to
the viceroy, Lord Mulgrave

1835

Reproduced courtesy of the
National Library of Ireland.

There can be no doubting the veracity of these newspaper reports. Among Lady Mulgrave's surviving papers is a letter written to her by the Duchess of Kent the previous month, in which plans for the commission took shape:

> I am delighted to have an excuse to write to you, and I know, I may trouble you with a commission; and particularly an <u>Irish</u> one; It is to desire three or four of those persons who sell poplins, to send me over, with their addresses some few of their <u>newest</u> patterns, which perhaps you will be so good as to send to me in a letter.[100]

A symbolic and potentially lucrative channel to the royal family had now been opened up by the vicereine of Ireland. It resulted in the first regular and sustained arrangement of its kind for the patronage of Irish weavers by the monarchy.[101] It also helped to bring about a rare opportunity for Irish weavers to expand the market for their poplin products beyond Irish shores, as retail outlets such as Griffiths and Quick of London began to stock and advertise this 'much admired and fashionable article' in their Covent Garden premises.[102] That Lady Mulgrave should seek the support of the Duchess of Kent (Fig. 05.08) rather than the reigning royal couple, King William IV and Queen Adelaide, is perhaps surprising but it can be explained by the apparently unsympathetic attitude of the King and Queen towards Lady Mulgrave and her politics. Reporting on a visit to them at St James's Palace in July 1835, Lady Mulgrave described the whole event as 'a regular Tory party' at which she felt decidedly unwelcome.[103] 'The Queen,' she complained, 'was any thing but as civil as she ought to be as she spoke to me … As to the King, he never spoke to me or looked at me.'[104] By contrast, a 'long interview' with the Duchess of Kent during that same spell in London had generated hearty compliments for both Lady Mulgrave and her husband.[105] The presence of the Duchess's daughter, Princess Victoria (later Queen Victoria), who was by now first in line to succeed the elderly king to the throne, was no doubt an added attraction that made the Kent household a far more enticing prospect in the campaign for royal patronage.[106]

In addition to supplying Dublin's poplin manufacturers with original designs for dress fabrics, Lady Mulgrave was soon suggesting 'many judicious improvements' that would enable them to branch out into new markets.[107] Among the improvements that resulted from her interventions was the increased production of furnishing fabrics such as tabouret. Tabouret has been described as a 'practical, luxurious, furnishing union of silk and linen'.[108] One of the first and most successful weavers of this fabric in Ireland was Richard Atkinson, who has been credited with

producing it from 1838.[109] A newly identified report reveals that Atkinson was, in fact, weaving tabouret as early as December 1835, when he completed the first part of a large order of it for use by Lady Mulgrave at her Yorkshire seat, Mulgrave Castle:

> Her Excellency [the vicereine] has lately given a large order to Messrs. Atkinson and Co, College-green, for furniture tabouret for Mulgrave Castle. The first part of the order executed, we hear, is in every way a credit to our country; the ground is azure blue, with white satin stripes, which has all the effect of silver, and contrasted on the blue, has a very chaste and elegant effect.[110]

No trace of this fabric survives at Mulgrave Castle but a similar, striped example woven by Atkinson, which is in the collection of the National Museum of Ireland, gives some indication of the rich effect its iridescent sheen must have created when seen by candlelight in the Castle's grand rooms.[111] The experimental move of Messrs Atkinson and Company into the production of tabouret had evidently been deemed a success by Lady Mulgrave, so much so that, on 10 December 1835, a warrant was issued from Dublin Castle appointing them 'Poplin and Furniture Tabouret Manufac[turer]s' to her husband, the viceroy (Fig. 05.09). It was the very first of many such warrants the company would be granted by the viceregal court and by royal houses as far away as Portugal, Belgium and the Netherlands.[112]

Throughout 1836, numerous reports of Lady Mulgrave's intensive and sustained efforts to promote, commission and diversify the production of Irish poplin continued to appear in Irish and British newspapers. In September, it was said that the 'kind feeling' she had shown through 'the encouragement of Irish manufactures' since her arrival as vicereine was continuing with 'unabated liberality'.[113] Sales of poplin were up and new orders were on the books, to the benefit of the weavers in Dublin's Liberties:

> Since her Excellency's return from England, she has given large orders for Poplins to Messrs. Atkinson and Co., College-green. It will, at the present time, be of great advantage to our industrious Poplin weavers in the Earl of Meath's Liberties, as at this season employment is rather limited. We understand part of the orders are from some high and distinguished foreigners now in England … The Brocaded Poplin, a beautiful and novel style of Promenade or Drawing-room dress – Bouquets of coloured flowers on light and dark grounds – are in great request … The poplin manufacturers are greatly indebted to the Countess of Mulgrave for the late improvements, her Excellency, in the most affable and condescending manner, suggested to the manufacturers who have been honored with her commands, the advantages likely to result to the Poplin trade, in striking out some novelty in that article. It has been acted upon, and the best possible results have followed; the demand has considerably increased, especially for the *Mulgrave Brocaded Poplin*, painted and designed by her Excellency, which has been universally admired, and the sale unprecedented.[114]

Fig. 05.10.

Richard Atkinson and Co.
Irish brocaded poplin sample
c.1836
This image is reproduced with the kind permission of the National Museum of Ireland.

Rare samples of these Atkinson brocaded poplins featuring bunches of
coloured flowers on light and dark grounds survive in the Victoria and Albert
Museum and the National Museum of Ireland. The presence in both collections of
a sample distinguished by bunches of pink, white and red roses regularly arranged
on a dark ground may indicate its particular popularity (Fig. 05.10). Newspaper
reports from September 1836 also mentioned that Lady Mulgrave's large order of
tabouret for Mulgrave Castle, the first part of which had been delivered by Atkin-
son and Company the previous year, was now almost fully complete and had been
expanded to incorporate additional innovations:

> Another novelty is the Circular Satin Watered Tabouret, for Screens, the back
> and seat of Chairs, & c., manufactured expressly for her Excellency to embroi-
> der in Berlin wool and silk ... It is intended to cover some curiously antique
> Chairs in the state-rooms at Mulgrave Castle. Her Excellency has been there
> a short time, making arrangements for re-modelling the hangings, furni-
> ture, & c., of this ancient and stately edifice. These improvements have been
> executed with great promptness and spirit by Messrs. Atkinson ... A large outlay
> of capital has been expended in the purchase of powerful machinery for the
> new works. This respectable firm have no reason to regret the undertaking, as
> demand for these novelties has far exceeded their expectation ...[115]

With the passage of time and the changing of fashions, these novelties of the
1830s have not endured at Mulgrave Castle. However, the survival there of Lady
Mulgrave's templates for Berlin wool-work, which feature roses in vivid shades of
red, white, yellow and pink, allows for some idea of how the Irish tabouret ordered
for her antique furniture might have looked once it had been embroidered by her
according to these patterns (Fig. 05.11).

By 1837, Lady Mulgrave was turning her attention to harnessing the power of
symbols and emblems in a bid to weave a sense of patriotic support for Ireland into
the very fabric of the clothes she was wearing as vicereine. At a drawing room held in
Dublin Castle, on 18 April that year, she debuted an Irish dress of 'magnificent white

and silver brocaded poplin'.[116] It had been made by a Mrs Whitehead and featured a pattern, which Lady Mulgrave herself had designed, of 'roses, brocaded in silver and enriched with silver wreaths of shamrocks'.[117] This fusion of patriotic material and symbolism was widely reported and warmly received.[118] Just as the semiotic potential of poplin was beginning to dawn on the vicereine, a major opportunity for the further realization of that potential suddenly presented itself. On 20 June 1837, King William IV died. The accession of his young niece to the throne, as Queen Victoria, ushered in a new era. The Duchess of Kent's daughter was now the reigning monarch and, as such, presided over a court that could offer Lady Mulgrave an even more prestigious outlet for her Irish creations. The vicereine wasted no time in seizing the opportunity. On 8 July, Queen Victoria recorded in her journal a communication from the Prime Minister, Lord Melbourne, inform-ing her that Lady Mulgrave was 'very desirous' to become one of her ladies of the bedchamber.[119] It was a request to which the Queen was happy to accede and by 3 August, the vicereine of Ireland was serving simultaneously as a personal atten-dant to the reigning monarch.[120]

While Lady Mulgrave's new dual role necessarily meant less time spent on the spot in Dublin, its disadvantages were counterbalanced by the opportunities it presented for promoting Irish poplin to the new Queen in person rather than remotely. Her eagerness to move in the Queen's personal circle is palpable in the letter of thanks she wrote to Victoria upon her appointment, which survives in the Royal Archives at Windsor: 'I hope your Majesty will pardon my rather wish-ing to appear intrusive than ungrateful in thus presuming to address to you my thanks for conferring on me the honor [sic] of personally serving your Majesty, an honor which I may now be permitted to say I most desired.'[121] In London, *The Morning Post* had interpreted the appointment as an honour that the people of Ireland could take as 'a compliment to themselves'.[122] Shortly after her arrival at court, Lady Mulgrave wrote to her husband back in Dublin to report that she had already persuaded the Queen to grant royal warrants for Irish poplin to William Reynolds, Richard Atkinson and one Mr Sweeney:

> I have got ... two or three patents for poplin tradesmen from Lord Conyngham
> [the Lord Chamberlain], which he will send me to Dublin. A little bit of patronage
> you see. I asked the Queen myself for Reynolds, Atkinson and Mr. Sweeney ...[123]

For William Reynolds of Grafton Street, this seal of royal approval was an additional bounty from Lady Mulgrave, who had appointed him as her 'Irish Poplin Mercer' in May 1835.[124] The patent issued to Richard Atkinson by the Lord Chamberlain is dated 7 August 1837, confirming that it had been secured by Lady Mulgrave a mere four days after her arrival at court in London.[125] It has been observed that Richard Atkinson's 'much-coveted' royal warrant was awarded by Queen Victoria with the support of Lord Mulgrave as viceroy.[126] While he may have been supportive, it is now clear that this coup was first and foremost the achievement not of Lord Mulgrave as viceroy, but of his wife as vicereine.

Fig. 05.12.

Richard Atkinson and Co.

Irish brocaded poplin sample

*c.*1851

© Victoria and Albert Museum,
London.

(opposite)

Fig. 05.13.

Richard Atkinson and Co.

Irish brocaded poplin sample

*c.*1837–50

© Victoria and Albert Museum,
London.

As the personal relationship between the Queen and the Countess of Mulgrave developed, further acts of royal largesse were forthcoming. By September 1837, the vicereine was back in Dublin on a visit to Atkinson and Company to inspect newly invented machinery for producing brocaded poplin.[127] It had been copied from a French model at the Conservatory of Arts and Trade in Paris.[128] The visit provided her with an opportunity to demonstrate this latest innovation to the President of the Board of Trade, Charles Poulett Thompson, who had also journeyed to Dublin from London.[129] His presence was further evidence of the elevated position Irish poplin was now beginning to occupy in the economic and cultural life not only of Ireland but also of the wider United Kingdom, partly as a result of the vicereine's efforts. The visit was also an opportunity for Lady Mulgrave to collect a number of the latest poplin samples for Queen Victoria, and for the Queen's aunt-in-law, Louise of Orléans, Queen of the Belgians, and it was noted by reporters that her position at court in London would now provide a welcome means of submitting 'any new designs' for Irish poplin to the Queen.[130] The result of this mission was an inaugural order from Queen Victoria, notice of which appeared in the Irish press the following month:

> Her Majesty has sent a very extensive order for poplins to our manufacturers. The order came through her Excellency the Countess of Mulgrave … Amongst the poplins ordered by the Queen, are some magnificent patterns … the design, bouquets of roses, shamrocks and thistles …[131]

A letter sent by Lady Mulgrave to her husband in Dublin, on 18 October 1837, in which she requested him to send an enclosed order for poplins to Reynolds and Atkinson, and expressed dissatisfaction that their promised poplin samples had not yet arrived at court in England, verifies her reported role as a channel for the Queen's orders.[132] A sample of the poplin supplied as part of these orders, which were routinely transmitted to Atkinson's by Lady Mulgrave, survives in the Atkinson and Co. archives. It features sprays of roses, thistles and shamrocks framed by berried branches symbolizing national prosperity.[133] According to an original note that accompanies it, the pattern was worn by the Queen during the court

Fig. 05.14.

Henry Weekes

Bust of Queen Victoria

*c.*1838

Photograph by Scott Wicking, reproduced courtesy of the Marquis and Marchioness of Normanby.

season of 1838.[134] The adoption of the intertwined symbols of the English rose, Scottish thistle and Irish shamrock was the natural extension of Lady Mulgrave's earlier patriotic design experiments that featured only the shamrock. They would henceforth become an ever-greater staple of Richard Atkinson's designs (Figs 05.12 & 05.13), expressing as they did the idea of a kingdom of equals, one in which Irish weavers could now be said to enjoy a share of the cultural and economic patronage of the monarch and the British consumer.

The patronage of the new Queen was the crowning achievement of Lady Mulgrave's campaign to stimulate the Irish poplin industry. As time went on, Queen Victoria's support grew in proportion to her appreciation of Lady Mulgrave's qualities. 'She is,' the Queen noted in her journal, in November 1837, 'a most agreeable, amiable, cheerful person to have in the house, and always good-humoured and kind and ready to please, – and clever too.'[135] The feeling was mutual and in her reflections on the Queen's qualities, Lady Mulgrave came to a similar conclusion: 'her countenance is intelligent and beautiful, her manner always kind and peculiarly gracious when she wishes it ...'[136] Their mutual esteem for one another is still reflected at Mulgrave Castle in the form of a marble bust of the youthful Queen, which was commissioned by Lady Mulgrave in this period (Fig. 05.14), and an inscribed volume of *Fisher's Drawing Room Scrap-Book* given to the Countess as a Christmas present, in 1837, from her 'very sincere friend, Victoria R'.

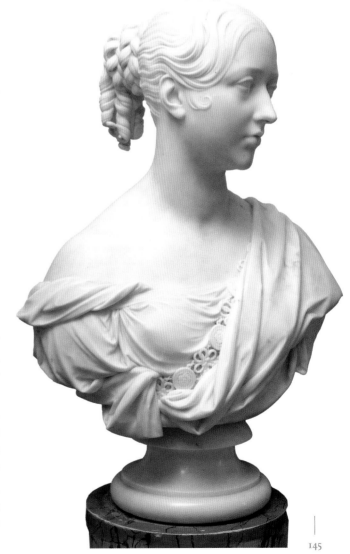

So favourable were the press reports of Lady Mulgrave's efforts on behalf of the Irish weavers that by Christmas 1837, it now seemed politically impossible for her to even consider importing a dress from London for the forthcoming drawing room at Dublin Castle, as she hinted in a letter to her husband:

> I expect to be in Dublin by the 16th. I must only make arrangements about my dress as I suppose it would give no pleasure if I brought it from London and indeed I have ordered the poplin for the train from Atkinson.[137]

Lord Mulgrave agreed. Responding to her letter, he highlighted the recent controversy caused in Ireland by the decision of Daniel O'Connell and some of his partners to have plates for printing Irish bank notes manufactured in England.[138] 'It would not do,' he warned, 'for you to <u>import</u> your dress. What is not tolerated in him and his <u>tail</u> could not be allowed in you and your train.'[139] The advice was duly heeded and reputational damage avoided; the vicereine appeared in an Irish dress of 'magnificent ponceau figured poplin' made by Mrs Whitehead.[140]

While the poplin merchants and newspapers of Dublin may have been delighting in the effects of the vicereine's friendship with Queen Victoria, not everyone had cause for such enthusiasm. Chief among Lady Mulgrave's detractors at court was the Prime Minister, Lord Melbourne, whose aforementioned anti-Irish diatribe in front of the Queen so outraged Lady Mulgrave during the Duchess of Kent's birthday celebrations at Buckingham Palace in August 1838. Confiding in her journal during this period, the Queen recorded Lord Melbourne's many cautionary references to Lady Mulgrave as a sly woman who 'certainly would like to have influence'.[141] There may have been some justification for his concerns, as a letter written by Lady Mulgrave to her husband in October 1837 demonstrates. 'It is of great importance,' she advised him, 'that you should have a character for sturdiness as I want the Queen to look to you [as an alternative Prime Minister] in case of any thing ever happening to Lord Melbourne'.[142] While there can be little doubt about Lady Mulgrave's consciousness of the political gains that might arise from a closer relationship with the Queen, there can equally be no question that more than a modicum of genuine altruism prompted her quest for patronage on behalf of Ireland's manufacturers and working poor. Plagued by her own recurring financial problems in the days before Christmas 1837, she had written to Lord Mulgrave in Dublin urging him to keep the numbers attending dinner at Dublin Castle to a minimum in order to save money.[143] It was, in her view, much more important that the deserving poor of Dublin's Mendicity Institution should see no reduction in their annual Christmas donation from the viceroy and vicereine:

> I suppose you will send the same as usual to the Mendicity for Christmas – an ox and some potatoes. It is pleasant to think that they get one good dinner in the year and I never want to shorten [reduce spending on] the charities.[144]

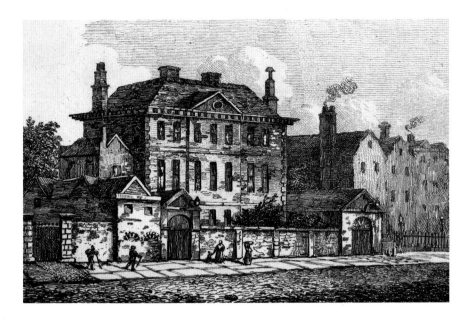

Fig. 05.15.

William Brocas

Moira House, Dublin

1811

Reproduced courtesy of the
National Library of Ireland.

The Mendicity Institution was founded in 1818 as a non-denominational charity for beggars and the homeless and was based, for much of the nineteenth century, at Moira House, Usher's Quay (Fig. 05.15).[145] As one of only two charitable institutions in Dublin in the 1820s that 'made a virtue of their religiously balanced governance', out of a total of '100 or so', its ethos was in keeping with Lady Mulgrave's non-partisan outlook.[146] Throughout her time as vicereine, Lady Mulgrave would remain a generous supporter of the Mendicity Institution in her own right, later donating quantities of new clothes including 'twelve women's petticoats, fourteen women's wrappers, one woollen shawl, five calico shifts, four striped calico shirts, five flannel waistcoats, and nine entire suits of baby clothes'.[147] Despite his misgivings about Lady Mulgrave's motives, Lord Melbourne saw fit to recommend to the Queen that she and her husband be raised to the titles of Marquess and Marchioness of Normanby in June 1838, as part of the coronation honours.[148] It may well have been a case of a politician keeping his friends close and his enemies closer but it was a fitting recognition of their successes and sacrifices in Ireland. At precisely the same time, the impact of Lady Mulgrave's artistic contribution to the Irish poplin industry was also acknowledged. At the third annual exhibition of the Royal Dublin Society, a brocaded poplin described as 'beautiful and novel', which had recently been designed by the vicereine, was awarded with a premium.[149] By the close of 1838, as the end of Lady Mulgrave's tenure as vicereine drew near, she was again submitting what was described as Queen Victoria's 'annual' order for Irish poplin to Atkinson and Co.[150] In less than four years, design, production and marketing practices in the Irish poplin industry had been modernized and expanded to the advantage of Dublin's industrious merchants as well as its poor weavers, and this was thanks, in no small part, to the vision and hard work of the newly ennobled Marchioness of Normanby. So too, had the interiors of Dublin Castle.

From Ballroom to Balcony:
Art, Architecture and Imagery at Dublin Castle

Lady Mulgrave's immediate impressions upon her arrival at Dublin Castle as vicereine in May 1835 had been positive. 'The Castle,' she wrote at the time, 'is much nicer than I expected.'[151] Anticipating, perhaps, an incommodious medieval bastion, she found instead a plain but elegant Georgian palace with a suite of tolerably good state rooms overlooking a ceremonial courtyard (see Fig. 04.06).[152] Tolerably good though the State Apartments were, there was apparently room for improvement.[153] By the end of 1835, the new viceregal couple were putting plans in place to recast these rooms in line with the fresh image they were shaping of the viceregal court as an impartial, integrated institution of the United Kingdom. Their assimilationist vision of a union of equal rights and opportunities was predicated on the notion of the Castle as the physical and theoretical Irish equivalent of the royal palaces of London, rather than as a provincial outpost. The material realization of this vision would involve the decorative enhancement and modernization of the State Apartments in a manner worthy of their London counterparts. The grandest of their interventions would be the transformation of the ballroom, St Patrick's Hall, through an ambitious decorative scheme that has remained largely forgotten until now and is creditable, in no small part, to Lady Mulgrave's personal taste, influence and connections.

The work began in St Patrick's Hall in November 1835. On 21 November, the Office of Public Works (OPW) wrote to Messrs Perry and Co., of Bond Street, London to request proposals for lighting the space.[154] This hitherto overlooked record provides a valuable insight into the existing lighting scheme in St Patrick's Hall at the time, as well as the Italianate decorative scheme that was about to be implemented in the space:

> It [St Patrick's Hall] has heretofore been lighted with 9 lustres containing together 184 candles, 2 chandeliers containing together 12 ditto, 2 figures under the gallery containing together 12 ditto, total number of candles 208 … also 5 4-light patent lamps, 4 3-light patent lamps and this light has been considered insufficient. The ceiling is painted with historical pieces, and is somewhat of a dark colour. The walls are about to be covered with paper in imitation of Sienna marble, varnished, and the pilasters on the sides and columns at each end are also intended to be painted in imitation of marble … The lamps are intended to be in ormolu, with probably parts of the work burnished.[155]

Similar letters were sent to two other chandelier makers, Thomas Edge of Great Peter Street, Westminster, and Higginbotham, Thomas and Co., of nearby 12 Wellington Quay, Dublin.[156] On 14 December, the lighting proposals received were submitted to Captain Phipps, the State Steward, for the inspection of the viceroy and vicereine.[157] Conscious of the couple's preference for Irish goods and

services, the OPW pointed out that patronizing Irish craftsmen did not always necessarily equate to buying Irish and that, in its view, Irish firms such as Higginbotham, Thomas and Co. simply could not compete with London houses in terms of quality:

> There is a very great difference in the prices of the London houses and some of those sent in by the Dublin tradesman, who is supplied with lamps altogether manufactured in <u>Birmingham</u>. The Board think it right to observe that in fitting up a room like St. Patrick's Hall with large lamps ... it is most desirable that they be of the best workmanship, which was their reason for procuring tenders from London houses, one of which (Perry's) is employed by the Commissioners of Works & c. at Buckingham Palace.[158]

What was good enough for Buckingham Palace was good enough for Dublin Castle and, despite viceregal nerves about their London base and an initial dislike of their proposals, Perry and Co. were awarded the prestigious commission on 30 December.[159] The date fixed for hanging the lamps was the first week in March 1836, as it was considered 'indisputably necessary' by the OPW to have the Hall ready for the use of 'His Excellency's Court' before the social season concluded.[160] The viceroy and vicereine were clearly not willing to wait until the following 'season' to make an impact with their new interior. Efforts now intensified to complete the Hall in time for a grand unveiling to guests on St Patrick's Day, 17 March 1836.[161]

On 3 March 1836, it was reported that no ball had been held at the Castle to mark the official birthday of Queen Adelaide, as St Patrick's Hall was 'undergoing refurbishment'.[162] Two days before the St Patrick's Day deadline, details of the Hall's new appearance were made public by several newspapers. Though extensive, the report published in *The Morning Register* is worth quoting at length for the detail it offers on the nature of the works:

> The heavy drapery which formerly shrouded the windows by which the hall is lighted, has been altogether removed, and swing shutters substituted, which are painted so as, when closed, to make the windowed side of the Hall exactly similar to the opposite side ... In the compartments formed by the ornamental pillars which surround the Hall, eight vignettes have been introduced with a happy effect. They are painted, we believe, from original drawings by the Hon. Captain Liddell, aide-de-camp to his Excellency and brother to the Countess [of] Mulgrave. They are graceful and spirited sketches, and consist of the following: – A view of the Viceregal Lodge; a view on the Lake of Killarney; the Giant's Causeway; view on the Rhine; the Hill of Howth; the Vale of Ovoca [Avoca]; and two more landscape compositions.[163]

The deep cove beneath the three monumental ceiling paintings begun by the Italian artist Vincenzo Waldrè, in 1788, had also received artistic attention:

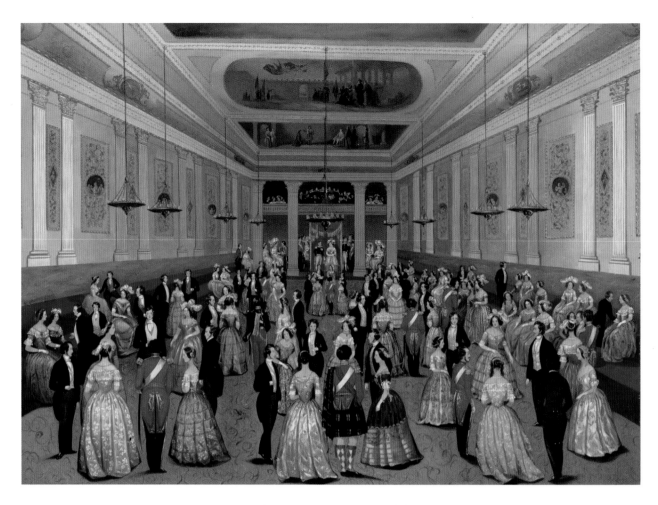

Fig. 05.16.

F.J. Davis

St Patrick's Hall, Dublin Castle

1836–57

The painting depicts the
Hall as it appeared following
redecoration in 1836 and before
subsequent renovations in 1857.

Private collection, image
courtesy of Sotheby's.

In the cones [coves] are painted the Four Seasons, and at either end of the
room the Muses are finely executed in *basso relievo*. The fine paintings on
the ceiling have been renovated and carefully varnished ... Eight magnificent
chandeliers, containing sixty lights, are suspended from the roof. They are
from the manufactory of Messrs. Perry and Co. of New Bond-street, London
... The gilding has been executed in the best manner by Mr. Murray, of Great
Britain-street, in this city, and the improvements have been conducted under
the immediate direction of Mr. Walker, who, we understand, is an Irishman
and has already superintended extensive alterations in several palaces on
the Continent and in England ...[164]

A second report, in *The Freeman's Journal*, confirmed that 'Mr. Walker'
himself had painted the eight new landscape vignettes drawn by Lady Mulgrave's
brother, Captain [George] Liddell.[165] The two additional vignettes not described in
the first report were identified as 'a view in Turkey' and 'a bridge in the county of
Wicklow'.[166] This second account also noted that the columns and pilasters were of
'painted white marble' with bases of 'painted antique red and verd [green] marble',
and with flutings and capitals of 'burnished gold'.[167]

According to both reports, the entire project had been supervised by the OPW architect Jacob Owen (1778–1870).[168] Records in the OPW account books show that Perry and Co. were paid £558 in March 1836 for their suite of chandeliers.[169] The account books also allow for the identification of 'Mr. Walker', who assisted Owen, as one John Walker.[170] Walker was paid the sum total of £150 for 'ornamental painting executed in St. Patrick's Hall' in February and March 1836.[171] The large sum paid to Walker suggests that he was responsible not only for the eight landscape vignettes on the main north and south walls of the room between the pilasters, but also for the additional painted elements of the decorative scheme that gave the impression of a lofty stone hall lined with rich Sienna marble. According to *The Freeman's Journal*, Walker had travelled 'much on the continent' and had 'applied the continental refinement of the arts to the decoration of many of the splendid halls and mansions of the British nobility'.[172] No other details of John Walker's career as an artist have yet emerged but it is possible that he may have been the same 'Mr. Walker' who was responsible for a major scheme of redecoration at the Belfast Theatre in 1835.[173]

Some impression of the sight that greeted Lord and Lady Mulgrave's guests as they arrived for the St Patrick's Day ball of 1836 is offered by an amateur oil

Fig. 05.17.

Unknown artist

Queen Victoria in St Patrick's Hall, Dublin Castle

1849

Published in *The Illustrated London News*, 11 August 1849.

Courtesy of the Office of Public Works, Dublin Castle.

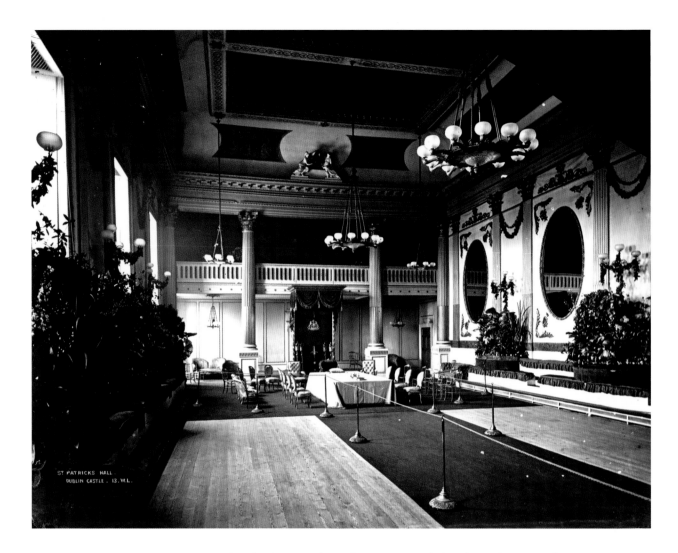

ST PATRICKS HALL.
DUBLIN CASTLE . 13. W.L.

Fig. 05.18.

Robert French (photographed by)

St Patrick's Hall, Dublin Castle

1857–84

The scenes visible in the ceiling
cove were painted by James
Mahony in 1857 and remained
on view until 1884.

Reproduced courtesy of the
National Library of Ireland.

sketch of St Patrick's Hall as it appeared after this Italianate makeover (Fig. 05.16).
Despite the stylized manner of its execution, the painting corresponds in almost
every respect to the descriptions of the room as a space with walls that imitated
yellow Sienna marble, with white columns and pilasters set on a painted green and
red marbleized base, and with decorative painted vignettes between the pilasters
and in the cove. The precise date of this painting, which is signed 'F.J. Davis', has
been the subject of some discussion.[174] With the identification of the previously
unknown decorative scheme it depicts, it is now possible to confirm that it was
painted no earlier than March 1836 when the Mulgraves' Sienna marble scheme was
completed, and no later than January 1857 when a whole new decorative overhaul
was introduced.[175] A print depicting Queen Victoria and Prince Albert in St Patrick's
Hall, during their visit of August 1849, shows that the Mulgraves' scheme was
still in place some thirteen years after its completion (Fig. 05.17). Later prints and
photographs record the subsequent interventions that swept much of this scheme
away in January 1857 when the room was given a decorative treatment featuring
white walls, oval mirrors and a painted ceiling cove (Fig. 05.18).[176] Overlooked until

(above)

Fig. 05.19.

Joseph Nash

*Stafford House: The Staircase
at the Ball, 16 June 1847*

1847

Royal Collection Trust/© Her
Majesty Queen Elizabeth II 2021.

Fig. 05.20.

The staircase at Mulgrave
Castle, North Yorkshire (detail).

Photograph by Scott Wicking,
reproduced courtesy of the
Marquis and Marchioness of
Normanby.

Five

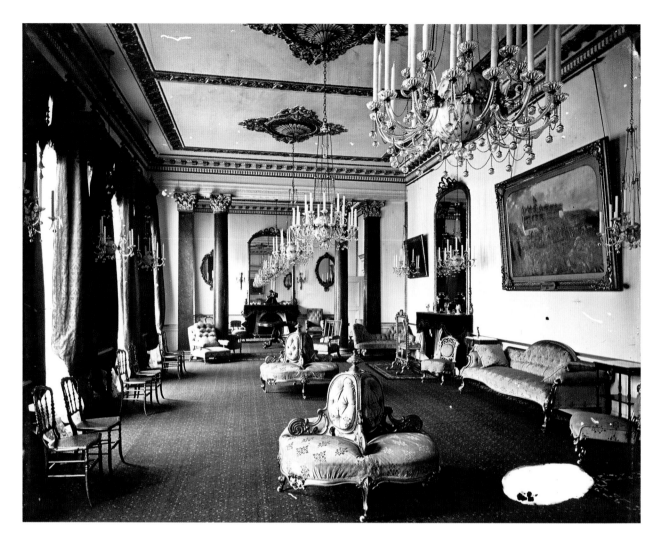

Fig. 05.21.

Robert French (photographed by)

State Drawing Room, Dublin
Castle

c.1867–71

Reproduced courtesy of the
National Library of Ireland.

now, the scenes painted in the cove in 1857, which replaced those executed by John
Walker during the Mulgrave viceroyalty, were the work of the Cork-born artist
James Mahony (c.1816–c.1859).[177] The subjects of Mahony's paintings ranged from
the 'Four Seasons' on the short east and west sides of the Hall to 'a procession of
the Order of St Patrick, a Wedding Procession, a Rural Merry-making, and St.
Patrick preaching to the Natives' on the longer north and south sides.[178] Executed
in a 'vigorous, sketchy manner', Mahony's paintings remained visible until the
Hall was again remodelled in 1884, but it is possible that they and elements of
the earlier Mulgrave scheme of the 1830s survived and remain entombed behind
later accretions.[179]

　　While there can be no doubting the central roles played by Jacob Owen and
John Walker in effecting the alterations in St Patrick's Hall in 1836, credit for the
character of its new appearance must also be reserved for Lady Mulgrave, whose
observations on contemporary London interiors proved influential. Drawing
on her experience of the taste for grand Sienna marble interiors in London, she
appears to have envisaged her ballroom at Dublin Castle as a fashionable Irish

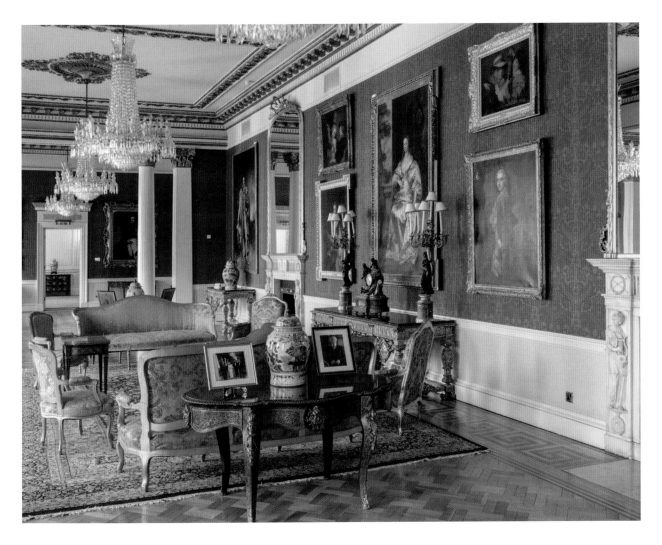

Fig. 05.22.

State Drawing Room, Dublin Castle

Photograph by Davison & Associates, courtesy of the Office of Public Works, Dublin Castle.

equivalent. The seeds of the idea were sown in July 1835 when a visit to the Duchess of Sutherland at Stafford House (now Lancaster House) in London prompted the writing of a rapturous report to her husband: 'I saw the Duchess of Sutherland in her gorgeous palace yesterday. Really it is more like a fairy palace than any thing I ever saw.'[180] At the heart of the house, which she went on to describe in detail, was a monumental imperial staircase with yellow scagliola walls that imitated Sienna marble (Fig. 05.19). There has, historically, been some doubt about the exact date of the Stafford House staircase hall and its 'Sienna marble' walls.[181] Based on a newspaper report of a concert that took place there in July 1835, it is now possible to confirm that the space and its vividly coloured walls were complete by then – exactly one week before Lady Mulgrave's visit. 'The concert took place,' it was noted in the report, 'in the grand staircase of the extensive mansion ... Its dimensions are superior to those of any other staircase in the metropolis, and in the splendour and magnificence of its decorations it stands unrivalled ... The walls of the staircase are of Scagliola, in imitation of Sienna marble ...'[182] Filled with admiration for the newly completed interiors she witnessed at Stafford House in the summer of 1835,

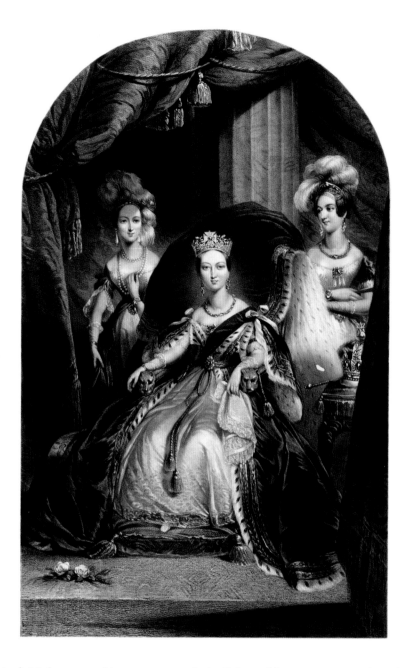

Lady Mulgrave would attempt to evoke its fashionable staircase not only in the redecoration of St Patrick's Hall a few months later, but also in her own staircase hall at Mulgrave Castle.[183] There, unlike at Dublin Castle, the scheme of yellow 'marble' on a green base survives intact to offer a still vivid impression of how these twin Anglo-Irish schemes may have looked when completed (Fig. 05.20).

It is not clear which of the 'Sienna marble' schemes at Dublin Castle and Mulgrave Castle came first but it seems possible that John Walker, who was credited with decorating many of the halls of the British nobility, may well have had a hand in both projects and even in the decoration of Stafford House.[184] His reported familiarity with contemporary British interiors made him a suit-

able conduit for Lady Mulgrave's vision of a viceregal palace that seems to have expressed a sense of parity and equality between Dublin and London through its form as much as its function in the late 1830s. Perhaps more importantly, his Irish nationality, which the Dublin newspapers were quick to highlight, and the views of the Wicklow and Antrim countryside he had painted, which both the viceroy and vicereine could boast of having visited in person, sent out an even more effective message of viceregal pride in Ireland's distinctive identity within this United Kingdom of equals. The message of the ballroom's painted ceiling, which, since the 1780s, had served as a paean to British rule in Ireland, was now ameliorated by artwork that spoke less of subordination and more of assimilation.[185]

Similar messages were reflected in the form, function and fabric of the improvements made to the rest of the State Apartments by the vicereine wherever possible. In January 1838, Lord and Lady Mulgrave sent a joint requisition to the OPW for the erection of a balcony on the exterior façade of the Presence Chamber (Throne Room).[186] Completed later that year, the balcony predated the famous example at Buckingham Palace and enabled the viceregal couple to extend the hitherto exclusive ceremonial pageantry of the Presence Chamber out into the public arena by appearing before the crowds that gathered in the Upper Castle Yard on high days and holidays. It would subsequently be used by successive viceroys and vicereines on occasions such as St Patrick's Day, and during the proclamation of new monarchs, before eventually being demolished in 1964.[187] Inside the Presence Chamber, one of Lady Mulgrave's own signature designs was used to create 'rich' new poplin hangings, which served to dignify the room's formal ceremonies and advertise the merits of the vicereine's fabric of choice.[188]

Towards the end of 1838, Lady Mulgrave also oversaw the decoration and furnishing of the Castle's new State Drawing Room, a spacious seven-bay room designed by Jacob Owen (Figs 05.21 & 05.22). Throughout this process, she insisted on articles of the highest quality and was unwilling to settle for compromise options that would taint the Castle with associations of inferiority. OPW records in the National Archives of Ireland show that the scagliola columns and pilasters of the room's columnar screen were the work of Messrs P. and T. McAnaspie of 37 Great Brunswick Street (now Pearse Street), Dublin.[189] They were paid a total of £101 for the work.[190] Specialist papier-maché enrichments for the ceiling signalled a more cutting-edge taste and were sourced from Charles Bielefeld of London, at a cost of £234.11.7.[191] By the beginning of August 1838, work on the room had progressed sufficiently for the vicereine to begin deciding on its decoration.[192] On 2 August, Lady Normanby, as she had recently become, wrote to her husband from Windsor Castle to convey her opinions on the wallpaper samples he had sent for the room from Dublin:

> I have got the paper patterns and I like none of them. I think them all
> common and vulgar. They are not manufactured in Ireland therefore why
> should I not choose one in London[?] Will you ask that[?] I know that the
> flocking ... and I believe the gilding is done in England ...[193]

Shortly afterwards, in a marked break with normal procedures, the OPW and its architect began communicating with the vicereine directly, rather than through her husband, about the furnishing of the room.[194] It remains the only example identified so far of direct, official communication between an arm of government and a vicereine in this period.[195] This irregular departure for the time suggests both the very high level of influence Lady Normanby had, by now, come to exert over matters architectural and decorative at Dublin Castle, and the extent to which she was now viewed by Irish officials as a decision-maker in her own right as vicereine. On 25 August, the OPW wrote to Lady Normanby to approve funds for the purchase of furniture and ornaments for the new State Drawing Room, and for the Viceregal Lodge:

> The Commissioners of Public Works present their compliments to the Marchioness of Normanby, and having received through Mr Owen, an expression of Her Excellency's wishes that additional armchairs and ornaments for chimney pieces & c. should be provided for the Park and Castle, the Commissioners take advantage of Her Excellency's kind offer to select such as may be suitable … and are enabled to appropriate … a sum of one hundred pounds, in addition to the sum of £50, voted in the Estimates, and already mentioned in Mr. Owen's note to the Marchioness of Normanby.[196]

From her base in London as Lady of the Bedchamber to the Queen, the vicereine set about sourcing furniture for the new State Drawing Room that would again help to reinforce her message of stylistic parity between Dublin Castle and the palaces of London. Bills furnished to the OPW reveal that she spent slightly more than the £150.00 allocated to her – £129.3.6 was paid to the cabinetmakers Town and Emanuel of New Bond Street for furniture purchased in August while a further £50.13.1 was settled on Messrs Taylor of Berners Street for 'upholsterer's goods' supplied in September.[197] As one of the earliest London cabinetmakers to deal extensively in old furniture, Town and Emanuel represented the burgeoning London taste for antique goods, and enjoyed royal patronage.[198] The purchase of furniture at their Bond Street premises, and the subsequent employment of Taylor's of nearby Berners Street to carry out upholstery work, suggests that Lady Normanby may have been among the antiquarian vanguard in her selection of old furniture that received a new lease of life before it was despatched from London to the State Drawing Room at Dublin Castle.

Although content to leave the selection of armchairs and ornaments for the room in the vicereine's hands, the OPW was unwilling to capitulate on the question of the wallpaper. At the end of August, Lady Normanby informed her husband that she had been visited at Windsor Castle by Jacob Owen and had 'told him to send cash' so that she could purchase the wallpaper in London herself.[199] Nonplussed, the OPW encouraged Owen 'to have paper of the particular pattern (or the nearest to it) approved by Her Excellency, manufactured in Dublin' on account of the fact that, as they put it, 'it is a branch of work which the trades-

men of Dublin understand well'.[200] Ultimately, Lady Normanby's argument that many so-called Irish wallpapers were not in fact *manufactured* in Ireland appears to have won the day, as an eventual payment to George Morant of New Bond Street, London for the wallpaper indicates.[201] For all of its recalcitrance over the wallpaper, it seems that the OPW had conveniently forgotten its own use of the very same argument just a couple of years earlier when it dismissed so-called Irish chandeliers mooted for St Patrick's Hall because they had been manufactured in Birmingham. Acting on her apparent belief that modern viceregal patriotism demanded the promotion of the best *of* Ireland but also the attainment of the best *for* Ireland, Lady Normanby aimed to support craftsmanship of a quality that reflected the equal importance of Dublin Castle, and by extension of Ireland, within the United Kingdom. According to this rubric, 'vulgar' wallpaper was no more suitable for Dublin Castle than it would be for Buckingham Palace, even if it *was* sourced in Ireland. Lady Normanby's new State Drawing Room at Dublin Castle was complete in time for the new 'season' of 1839. 'I expect,' she observed with satisfaction, 'the rooms will be very pretty this year at the Castle.'[202] She would not, however, have long to enjoy them.

On 4 October 1838, Queen Victoria noted in her journal that the Prime Minister, Lord Melbourne, had informed her that the viceroy was 'very tired of Ireland and very anxious to come away'.[203] The vicereine, however, did not share her husband's feelings of weariness. Earlier that year, she had remarked in a letter to him that she would be 'very sorry to leave Ireland'.[204] As 1838 neared its end, she was busy completing a new terrace and flower garden at the Viceregal Lodge, which she herself had designed with the assistance of the architect Decimus Burton.[205] The design of the parterre had presented her with yet another opportunity to express her support for Ireland in the form of two large beds arranged in the shape of ringed crosses.[206] At the same time, the publication of a contemporary mezzotint served as a reminder of her equally busy and influential position as one of the Queen's most senior female attendants at court in London (Fig. 05.23). But despite the high profile she now enjoyed, the forthcoming social season of 1839, during which she would be unveiling her new State Drawing Room at Dublin Castle, was to make less of an impact than she anticipated. The end, when it came, was sudden. On Monday, 11 February 1839, rumours began to circulate in the press that changes were afoot at Dublin Castle.[207] The following morning, Ireland awoke to the news that a new viceroy was to be appointed and that the Marquess and Marchioness of Normanby would be gone before the week was out.[208] The social season was suspended and luggage was swiftly packed. Lady Normanby's years as vicereine of Ireland were over.

Conclusion

Signs of Lady Normanby's legacy as vicereine were all around her as she made her departure from Dublin Castle on Saturday, 16 February 1839. They were to be felt in the close contact of the thousands of people of all creeds and classes who filed through the Castle's State Apartments to bid her farewell.[209] They were to

be seen in the Irish poplin hangings of the Castle's Presence Chamber and the painted Irish landscapes that adorned the walls of the ballroom, St Patrick's Hall. They were also to be heard in the public pledge, made that morning in that same ballroom, that her kindness to Ireland, its industries and its poor would 'never be effaced from the memory of a grateful people'.[210] Amid the dense crowds and promises of perpetual remembrance, Lady Normanby made her way out through the gates of Dublin Castle for the last time, down through Dame Street, and into history.

In time, much of that history would be eclipsed by events of such magnitude in Ireland that little space would remain on the record for the legacies of aristocratic English women like the Marchioness of Normanby. Crushed out of public consciousness by the effects of famine, rebellion and civil war, and further neglected on account of her gender, her legacy would eventually be effaced almost entirely from the memory of an increasingly indifferent people. As memories faded, the signs of that legacy, which had once been so vivid, also disappeared. The threads of the poplins designed by her unravelled and were disposed of, the weaving industry in Dublin went into terminal decline, and the State Apartments at Dublin Castle were transformed by fashion and fire. With each loss compounding the effects of the last, the signs of her existence slowly became confined to the dark and dusty interiors of archival storage boxes. While images of her husband abound in collections across Ireland and Britain, portraits of Lady Normanby are limited almost exclusively to her own former home and are often identifiable only through inscriptions on the reverse (see Cat. 22).[211]

Reflecting on the significance of original artefacts as physical testaments to history, David Lowenthal has observed that 'a past lacking tangible relics seems too tenuous to be credible'.[212] With the steady loss of so many tangible public signs of Lady Normanby's life and legacy, her past as vicereine seems all the less credible for being all the more tenuous. In attempting to retrieve a sense of that past based on the material that has survived, this essay has sought to finally place Lady Normanby's contribution to the social, political, economic and cultural life of Ireland on the historical record. It is a contribution that speaks for itself, regardless of the potential socio-political gains she may have enjoyed in making it. Her impartiality in hosting Catholic and Protestant alike at Dublin Castle, her visits to the most remote corners of Ireland to witness the realities of rural life, her use of her artistic skills and her position at court to improve the design, production and sales of Irish poplin (and by extension, the fortunes of the working poor), and her modernization of the viceregal court as an institution that celebrated Ireland's unique identity but also expressed a sense of its parity and equivalency within the United Kingdom are the principal hallmarks of that record. They are the same hallmarks that appear to have made her one of the most popular vicereines of the first half of the nineteenth century. Drawn together, they suggest an alternative, nascent reading of the nature of the British administration in Ireland, as viewed not only through the mainly political actions of its men but also through the wide-ranging cultural activities of its women.

Writing almost a decade after leaving Ireland, Lady Normanby acknowledged that while much had been achieved through the 'Justice to Ireland' policies of the 1830s, much remained to be done: 'The real truth is that in Ireland there are still real grievances to redress, and much as has been done, there is still much to do. I still think the Protestant Church a grievance ... I also think their representation a grievance ... I can never see why they should not have their own Parliament for local matters ...'[213] In expressing these views, she would prove to be a woman ahead of her time. The reasons for her progressive views on Ireland and her efforts on behalf of its people as vicereine remain unclear, but a combination of her professed sense of historical injustices in Ireland throughout the reigns of previous British monarchs, and an apparently strong social conscience and charitable streak, coupled with a healthy dash of ambition and a desire to exercise influence, all appear to have played their part. However, as the opening lines of this essay show, the precise reasons are ultimately obscured to us, at least in part, by her own belief that details of her private thoughts and motivations warranted less space in her journal than those of her husband's 'eventful life'.

Even in death this hierarchy endured. On a windswept hill in North Yorkshire, in a quiet parish church, a plain marble tablet has served as the principal public record of Lady Normanby's life since that life came to an end in 1882. Here, as elsewhere, it is a record overshadowed by that of her husband, whose public offices, achievements and honours are enumerated in a long list that leaves but little space for her epitaph. In one short and simple line, at the bottom of the tablet, she is honoured as a woman who was 'full of good works and almsdeeds which she did'.[214] In seeking, for the first time, to explore these works and deeds, it is hoped that this essay has served to expand that epitaph by finally acknowledging the life of Maria, Marchioness of Normanby, as a 'subject for history'.

The author wishes to express his sincere thanks to the Marquis and Marchioness of Normanby for providing access to the Mulgrave Castle Archives and for their kind hospitality. He is also extremely grateful to Claire Clark, whose tireless panning for gold among stacks of old papers has enabled valuable historical nuggets to come to the surface. The generous support provided by the Paul Mellon Centre for Studies in British Art, in the form of a grant that supported primary research for this essay, is also gratefully acknowledged.

Endnotes

1 Journal of Maria, Marchioness of Normanby, 18 January 1838 [misdated 1837], Mulgrave Castle Archives (Library), A4.

2 *Courier*, 18 August 1838.

3 *Morning Post*, 18 August 1838.

4 Ibid.

5 Letter to Constantine, Marquess of Normanby from Maria, Marchioness of Normanby, 18 August 1838, Mulgrave Castle Archives, NN/302.

6 See, for example, letter to Constantine, Earl of Mulgrave from Maria, Countess of Mulgrave, undated [August 1837], Mulgrave Castle Archives, NN/243; *Dublin Evening Post*, 31 October 1837, 27 November 1838.

7 *Whitby Gazette*, 28 October 1882.

8 Lady Normanby is described briefly in the entry on her husband in the *Oxford Dictionary of National Biography* as 'a powerful whig hostess who partly inspired the character of Berengaria, Lady Montfort, in Disraeli's novel *Endymion*'; see R. Davenport-Hines, 'Phipps, Constantine Henry, first Marquess of Normanby (1797–1863)', in H.C.G. Matthew and B. Harrison (eds), *Oxford Dictionary of National Biography* (Oxford: Oxford University Press, 2004), vol. 44, p. 176. She is mentioned, again briefly, as a designer of textile hangings for Dublin Castle, in M. Dunlevy, *Pomp and Poverty: A History of Silk in Ireland* (London: Yale University Press, 2011), p. 135 (she is also misidentified on p. 135 of this source as 'the Countess of Musgrave', in reference to her earlier title, the Countess of Mulgrave, which she held from 1831 to 1838). She is credited with the design of the south lawn at the Viceregal Lodge (now Áras an Uachtaráin), Dublin while serving as vicereine, in J.A. McCullen, *An Illustrated History of the Phoenix Park: Landscape and Management up to 1880* (Dublin: Office of Public Works, 2009), p. 9.

9 Quote from journal of Maria, Marchioness of Normanby, Mulgrave Castle Archives (Library), A4. The life and career of Lady Normanby's husband, Constantine Henry Phipps, has been documented and explored by several modern scholars. See, for example, Davenport-Hines, 'Phipps, Constantine Henry', pp. 176–7; P. Gray, 'A "People's Viceroyalty"? Popularity, Theatre and Executive Politics 1835–47', in P. Gray and O. Purdue (eds), *The Irish Lord Lieutenancy, c.1541–1922* (Dublin: University College Dublin Press, 2012), pp. 158–78; V. Crossman, 'Phipps, Constantine Henry', in J. McGuire and J. Quinn (eds), *Dictionary of Irish Biography* (Cambridge: Cambridge University Press, 2009), viewable online: https://dib.cambridge.org/viewReadPage.do?articleId=a7328&searchClicked=clicked&quickadvsearch=yes (accessed 8 October 2019).

10 G. Bloomfield, *Extracts of Letters from Maria, Marchioness of Normanby, The Hon. Frances Jane Liddell, The Hon. Anne Elizabeth, Lady Williamson, Jane Elizabeth, Viscountess Barrington, The Hon. Elizabeth Charlotte Villiers, Susan, Countess of Hardwicke, The Hon. Charlotte Amelia Trotter* (Hertford: Simson & Co., 1892), n.p. (preface to p. 1).

11 G.E. Cockayne (ed.), *Complete Peerage of England, Scotland, Ireland, Great Britain and the United Kingdom: Extant, Extinct or Dormant* (London: George Bell & Sons, 1895), vol. 6, p. 61.

12 Ibid.

13 See Davenport-Hines, 'Phipps, Constantine Henry', p. 176.

14 Ibid.

15 *Belfast News-Letter*, 15 May 1835.

16 Letter to Sophia, Dowager Countess of Mulgrave from Maria, Countess of Mulgrave, 17 May 1835, Mulgrave Castle Archives, H/814.

17 Ibid.

18 *Dublin Evening Post*, 12 May 1835.

19 Letter to Sophia, Dowager Countess of Mulgrave from Maria, Countess of Mulgrave, 17 May 1835, Mulgrave Castle Archives, H/814.

20 *Tralee Mercury*, 16 May 1835.

21 *Belfast News-Letter*, 15 May 1835.

22 Ibid.

23 *Dublin Evening Packet and Correspondent*, 19 May 1835.

24 See Gray, 'A "People's Viceroyalty"?', p. 160.

25 Letter to Sophia, Dowager Countess of Mulgrave from Maria, Countess of Mulgrave, 17 May 1835, Mulgrave Castle Archives, H/814.

26 P. Murphy, *Nineteenth-Century Irish Sculpture: Native Genius Reaffirmed* (London: Yale University Press, 2010), p. 228.

27 See Gray, 'A "People's Viceroyalty"?', p. 161.

28 C. O'Mahony, *The Viceroys of Ireland* (London: John Long, 1912), pp. 238–9.

29 See Gray, 'A "People's Viceroyalty"?', p. 159.

30 K. Theodore Hoppen, *Governing Hibernia: British Politicians and Ireland 1800–1921* (Oxford: Oxford University Press, 2016), p. 73.

31 Ibid., p. 74.

32 Ibid., p. 77.

33 See Davenport-Hines, 'Phipps, Constantine Henry', p. 176.

34 Ibid.

35 *Dublin Evening Post*, 12 May 1835.

36 Letter to Sophia, Dowager Countess of Mulgrave from Maria, Countess of Mulgrave, 17 May 1835, Mulgrave Castle Archives, H/814.

37 See memorial tablet to John Mulgrave, St Werburgh's Church, Dublin.

38 Ibid.

39 *Freeman's Journal*, 13 May 1835.

40 *Sixth Annual Report of the Female Refuge School at Fairfield, Manchester*, December 1838, Mulgrave Castle Archives, S/1010.

41 Ibid.

42 Ibid.

43 Ibid.

44 Ibid.

45 See U. Sill, *Encounters in Quest of Christian Womanhood: The Basel Mission in Pre- and Early Colonial Ghana* (Leiden: Brill, 2010), pp. 109–132.

46 Ibid.

47 See Bloomfield, *Extracts of Letters*, p. 20

48 Ibid., p. 5.

49 Ibid., p. 14.

50 Ibid., pp. 27–28.

51 Letter to Constantine, Earl of Mulgrave from Maria, Countess of Mulgrave, undated [November 1834], Mulgrave Castle Archives, NN/120.

52 See Jamaican sketchbooks of Maria, Countess of Mulgrave, Mulgrave Castle Archives (unnumbered).

53 Letter to Constantine, Earl of Mulgrave from Maria, Countess of Mulgrave, undated [*c.* February 1835], Mulgrave Castle Archives, NN/141.

54 Letter to Constantine, Earl of Mulgrave from Maria, Countess of Mulgrave, undated [April 1835], Mulgrave Castle Archives, NN/182.

55 Letter to Constantine, Earl of Mulgrave from Maria, Countess of Mulgrave, undated [August 1835], Mulgrave Castle Archives, NN/219.

56 Letter to Constantine, Earl of Mulgrave from Maria, Countess of Mulgrave, undated [April 1835], Mulgrave Castle Archives, NN/182.

57 See, for example, *Saunders's News-Letter*, 15 May 1835; *Warder and Dublin Weekly Mail*, 16 May 1835.

58 *Freeman's Journal*, 22 May 1835.

59 Letter to Sophia, Dowager Countess of Mulgrave from Charles B. Phipps, 25 May 1835, Mulgrave Castle Archives, H/814.

60 *Freeman's Journal*, 22 May 1835.

61 H. Heaney (ed.), *A Scottish Whig [in] The Irish Journals of Robert Gra[ham of] Fagorton* (Dublin: Four Courts P[ress, 199]9), p. 21.

62 See *Kerry [Evening Po]st*, 11 July 1835.

63 Fo[r comment]ary on this tour, see *Free[man's Journal]*, 18 July 1835; *Tralee Mercury*, 25 [July 1835; Kerry Evening Post], 29 August 1835; *Kerry Evening Post*, 15 August 1835; *Connaught Telegraph*, 26 August, 2 September 1835.

64 See, for example, *Leinster Express*, 15 August 1835.

65 Among the few early examples of an extended Irish tour by a vicereine was the visit of Mary Isabella, Duchess of Rutland to the south of Ireland in October and November 1785, for which, see Chapter Four in this volume. In the autumn of 1809, the then vicereine Charlotte, Duchess of Richmond also embarked on a tour of the south of Ireland with her husband, visiting counties including Limerick and Offaly; see P. McCarthy, *Life in the Country House in Georgian Ireland* (New Haven: Yale University Press, 2016), pp. 35–6.

66 Letter to Constantine, Earl of Mulgrave from Maria, Countess of Mulgrave, undated [April 1835], Mulgrave Castle Archives, NN/182.

67 Letter to Sophia, Dowager Countess of Mulgrave from Maria, Countess of Mulgrave, 28 September 1835, Mulgrave Castle Archives, H/814.

68 For commentary on this tour, see *Enniskillen Chronicle and Erne Packet*, 1 October, 8 October 1835; *Belfast News-Letter*, 2 October 1835; *Morning Register*, 3 October 1835; *Londonderry Sentinel*, 3 October 1835; *Belfast Commercial Chronicle*, 26 October 1835.

69 Letter to Sophia, Dowager Countess of Mulgrave from Maria, Countess of Mulgrave, 28 September 1835, Mulgrave Castle Archives, H/814.

70 Ibid.

71 *Morning Register*, 3 October 1835.

72 *Enniskillen Chronicle and Erne Packet*, 8 October 1835.

73 *Morning Register*, 3 October 1835.

74 *Londonderry Sentinel*, 3 October 1835.

75 See Gray, 'A "People's Viceroyalty"?', p. 165.

76 Letter to Sophia, Dowager Countess [of] Mulgrave from Maria, Countess of [Mulgra]ve, 8 October 1835, Mulgrave Cast[le Archiv]es, H/814.

77 *Waterford Mail*, [1835].

78 See Daven[port-Hines,] Phipps, Constantine Hen[ry'].

79 [Letter to] Constantine, Earl of Mulgrave [from Da]niel O'Connell, 19 August 1835, Mul[g]rave Castle Archives, M/597.

80 Journal of Maria, Marchioness of Normanby, 20 January 1838, Mulgrave Castle Archives (Library), A4.

81 Ibid.

82 See Davenport-Hines, 'Phipps, Constantine Henry', p. 177.

83 Letter to Sophia, Dowager Countess of Mulgrave from Maria, Countess of Mulgrave, 17 May 1835, Mulgrave Castle Archives, H/814.

84 S. Foster, '"An Honourable Station in Respect of Commerce, as well as Constitutional Liberty": Retailing, Consumption and Economic Nationalism in Dublin, 1720–85', in G. O'Brien and F. O'Kane (eds), *Georgian Dublin* (Dublin: Four Courts Press, 2008), p. 33.

85 Ibid.

86 R. Atkinson & Co., *Poplin: A Short History of its Manufacture and Introduction in Ireland* (Dublin: Forster & Co., *c.*1870), p. 4.

87 Ibid., p. 7.

88 Ibid.

89 See Dunlevy, *Pomp and Poverty*, p. 123.

90 Ibid., p. 118.

91 Ibid., p. 120.

92 *Warder and Dublin Weekly Mail*, 27 June 1835.

93 Ibid.

94 *Freeman's Journal*, 14 December 1835.

95 Ibid.

96 Ibid.

97 Letter to Sophia, Dowager Countess of Mulgrave from Maria, Countess of Mulgrave, 17 May 1835, Mulgrave Castle Archives, H/814.

98 *Freeman's Journal*, 14 December 1835.

99 *Belfast News-Letter*, 25 December 1835.

100 Letter to Maria, Countess of Mulgrave from Victoria, Duchess of Kent, 13 November 1835, Mulgrave Castle Archives, S/930.

101 There had been occasional attempts to encourage royal support for the Irish textile industry during previous viceroyalties, such as that of George, 1st Marquess of Buckingham. In 1788, Lord Buckingham had arranged for an order of linen to be commissioned from John Carleton an[d Co.] of Lisburn, County Antrim, for [the ho]usehold of King George III. While warmly received, such gestures were largely sporadic rather than sustained and so had only a limited effect on the fashionability and profitability of Irish textiles; see M. Campbell, '"Sketches of their Boundless Mind": The Marquess of Buckingham and the Presence Chamber at Dublin Castle, 1788–1838', in M. Campbell and W. Derham (eds), *Making Majesty: The Throne Room at Dublin Castle, A Cultural History* (Dublin: Irish Academic Press, 2017), pp. 64–5.

102 *Atlas*, 22 November 1835.

103 Letter to Constantine, Earl of Mulgrave from Maria, Countess of Mulgrave, undated [July 1835], Mulgrave Castle Archives, NN/202.

104 Ibid.

105 Letter to Constantine, Earl of Mulgrave from Maria, Countess of Mulgrave, undated [July or early August 1835], Mulgrave Castle Archives, NN/206/1.

106 Ibid.

107 *Belfast News-Letter*, 25 December 1835.

108 See Dunlevy, *Pomp and Poverty*, p. 133.

109 Ibid.

110 *Freeman's Journal*, 14 December 1835.

111 For an illustration of the sample see Dunlevy, *Pomp and Poverty*, p. 133.

112 See Atkinson & Co., *Poplin: A Short History*.

113 *Enniskillen Chronicle and Erne Packet*, 22 September 1836.

114 Ibid.

115 *Saunders's News-Letter*, 29 September 1836.

116 Ibid., 19 April 1837.

117 Ibid.

118 See, for example, *Dublin Mercantile Advertiser*, 17 April 1837 and *Galway Patriot*, 22 April 1837.

119 Journal of Queen Victoria, 8 July 1837, Royal Archives, Windsor Castle, RA VIC/MAIN/QVJ.

120 Ibid., 3 August 1837.

121 Letter to Queen Victoria from Maria, Countess of Mulgrave, undated [August 1837], Royal Archives, RA VIC/MAIN/S/15/2. The permission of Her Majesty Queen Elizabeth II for the use of this material is gratefully acknowledged.

122 *Morning Post*, 14 July 1837.

123 Letter to Constantine, Earl of Mulgrave from Maria, Countess of Mulgrave, undated [August 1837], Mulgrave Castle Archives, NN/243.

124 *Dublin Evening Post*, 4 June 1835.

125 See reproduction of the patent in R. Atkinson & Co., *Poplin: A Short History*, n.p.

126 See Dunlevy, *Pomp and Poverty*, p. 150.

127 *Saunders's News-Letter*, 18 September 1837.

128 Ibid.

129 Ibid.

130 *Freeman's Journal*, 18 September 1837.

131 *Dublin Evening Post*, 31 October 1837.

132 Letter to Constantine, Earl of Mulgrave from Maria, Countess of Mulgrave, 18 October 1837, Mulgrave Castle Archives, NN/249.

133 For an illustration of the sample see Dunlevy, *Pomp and Poverty*, p. 133.

134 Collection of Atkinson & Co., Newtownabbey, County Antrim.

135 Journal of Queen Victoria, 14 November 1837, Royal Archives, Windsor Castle, RA VIC/MAIN/QVJ.

136 Journal of Maria, Marchioness of Normanby, 18 January 1838 [misdated 1837], Mulgrave Castle Archives (Library), A4.

137 Letter to Constantine, Earl of Mulgrave from Maria, Countess of Mulgrave, 26 December 1837, Mulgrave Castle Archives, NN/270.

138 Letter to Maria, Countess of Mulgrave from Constantine, Earl of Mulgrave, 29 December 1837, Mulgrave Castle Archives, N/379.

139 Ibid.

140 *Morning Register*, 19 January 1838.

141 Journal of Queen Victoria, 22 January 1839, Royal Archives, Windsor Castle, RA VIC/MAIN/QVJ. See also, for example, Journal of Queen Victoria, 19 and 20 October 1838, Royal Archives, Windsor Castle, RA VIC/MAIN/QVJ.

142 Letter to Constantine, Earl of Mulgrave from Maria, Countess of Mulgrave, undated [October 1837], Mulgrave Castle Archives, NN/257. Lady Mulgrave's influence on the Queen would later become a critical factor in the so-called Bedchamber Crisis of May 1839, when the Conservative politician Sir Robert Peel refused to form a new government on account of Victoria's unwillingness to dismiss Lady Mulgrave and several other wives of leading Whig politicians from their roles as Ladies of the Bedchamber.

143 Letter to Constantine, Earl of Mulgrave from Maria, Countess of Mulgrave, 18 December 1837, Mulgrave Castle Archives, NN/263.

144 Ibid.

145 D. Dickson, *Dublin: The Making of a Capital City* (London: Profile Books, 2015), p. 315.

146 Ibid., p. 299.

147 *Morning Register*, 18 February 1839.

148 Journal of Queen Victoria, 4 June 1838, Royal Archives, Windsor Castle, RA VIC/MAIN/QVJ.

149 *Morning Register*, 9 June 1838.

150 *Dublin Evening Post*, 27 November 1838.

151 Letter to Sophia, Dowager Countess of Mulgrave from Maria, Countess of Mulgrave, 17 May 1835, Mulgrave Castle Archives, H/814.

152 By the late eighteenth century, the 'spaciousness' of this courtyard, the 'uniformity' of its buildings and the 'fine display of the north side [the Bedford Tower]' were said to give it 'an air of grandeur superior to what is observable in any of the courts of St. James's, the Royal Palace of London'; see J. Warburton, J. Whitelaw and R. Walsh, *History of the City of Dublin, from the Earliest Accounts to the Present Time* (London: printed for T. Cadell & W. Davies, 1818), vol. 1, p. 470. For the development of Dublin Castle and the State Apartments in the seventeenth and eighteenth centuries, see E. McParland, *Public Architecture in Ireland 1680–1760* (New Haven: Yale University Press, 2001), pp. 91–121; R. Loeber, 'The Rebuilding of Dublin Castle: Thirty Critical Years, 1661–1690', *Studies: An Irish Quarterly Review*, 69, 273 (Spring 1980), pp. 45–69; F. O'Dwyer, 'Dublin Castle and its State Apartments 1660–1922', *The Court Historian*, 2, 1 (1997), pp. 2–8.

153 Contemporary visitor perceptions of the State Apartments differed considerably in the years before the Mulgraves' arrival at Dublin Castle. Visiting in 1813, Rev. James Hall judged the ballroom, St Patrick's Hall, and the 'supper room' to be on 'a splendid scale' and noted 'varieties of elegant and valuable paintings'; J. Hall, *Tour through Ireland; Particularly the Interior and Least Known Parts* (London: printed for R.P. Moore, 1813), p. 12. Conversely, in the late-1820s, a discerning German visitor, Prince Hermann von Pückler-Muskau, was decidedly underwhelmed: 'I visited a number of "show places." First the Castle, where the vice-King resides, and whose miserable state-apartments with coarsely boarded floors do not offer anything very attractive'; H. von Pückler-Muskau, *Tour of England, Ireland, and France in the Years 1826, 1827, 1828, and 1829* (Philadelphia: Carey, Lea & Blanchard), 1833, p. 324.

154 Letter to Messrs Perry and Co. from Daniel Corneille, 21 November 1835, OPW letter book, National Archives of Ireland, OPW1/1/2/5.

155 Ibid.

156 Ibid.

157 Letter to the Hon. Captain Phipps from Henry R. Paine, 14 December 1835, OPW letter book, National Archives of Ireland, OPW1/1/2/5.

158 Ibid.

159 Letter to Messrs Perry and Co. from Henry R. Paine, 30 December 1835, OPW letter book, National Archives of Ireland, OPW1/1/2/5.

160 Letter to Messrs Perry and Co. from Henry R. Paine, 5 January 1836, OPW letter book, National Archives of Ireland, OPW1/1/2/5.

161 *Saunders's News-Letter*, 15 March 1836.

162 *Globe*, 3 March 1836.

163 *Morning Register*, 15 March 1836.

164 Ibid.

165 *Freeman's Journal*, 15 March 1836.

166 Ibid.

167 Ibid.

168 *Morning Register*, 15 March 1836; *Freeman's Journal*, 15 March 1836.

169 Record of payment to Geo. Perry & Co., 19 March 1836, OPW journal, National Archives of Ireland, OPW2/2/4/1

170 Records of payments to John Walker, 18 February 1836 and 19 March 1836, OPW journal, National Archives of Ireland, OPW2/2/4/1.

171 Ibid.

172 *Freeman's Journal*, 15 March 1836.

173 *Belfast News-letter*, 14 April 1835.

174 See *A Living Legacy: Irish Art from the Collection of Brian P. Burns* (London: Sotheby's, 2018), pp. 52–5.

175 *Dublin Daily Express*, 30 January 1857.

176 Ibid.

177 Ibid.

178 Ibid.

179 Ibid.

180 Letter to Constantine, Earl of Mulgrave from Maria, Countess of Mulgrave, 23 July 1835, Mulgrave Castle Archives, NN/199.

181 H. Colvin, 'The Architects of Stafford

House', *Architectural History*, 1 (1958), pp. 26–9.

182 *Morning Chronicle*, 16 July 1835.

183 Letter to Constantine, Earl of Mulgrave from Maria, Countess of Mulgrave, 23 July 1835, Mulgrave Castle Archives, NN/199.

184 *Freeman's Journal*, 15 March 1836.

185 The ceiling features three painted scenes that reflect the longstanding British presence in Ireland. It depicts 'St Patrick and Henry II as benign invaders' in panels that flank the large central painting dedicated to the reign of George III; see B. Rooney, 'Vincent Waldré: Sketch for the Ceiling of St Patrick's Hall in Dublin Castle', in B. Rooney (ed.), *Creating History: Stories of Ireland in Art* (Dublin: Irish Academic Press, 2016), p. 179.

186 Letter to Thomas Drummond from D. Corneille, 24 January 1838, OPW letter book, National Archives of Ireland, OPW1/1/2/6.

187 See W. Derham, '(Re)making Majesty: The Throne Room at Dublin Castle, 1911–2011', in Campbell and Derham (eds), *Making Majesty*, pp. 269, 295.

188 See Dunlevy, *Pomp and Poverty*, p. 135.

189 Letter to Messrs P. and T. McAnaspie from the Office of Public Works, 14 December 1838, OPW letter book, National Archives of Ireland, OPW1/1/2/6.

190 Records of payments to P. and T. McAnaspie, 25 October 1838 and 15 December 1838, OPW ledger, National Archives of Ireland, OPW2/2/5/1.

191 Letter to Charles Bielefeld from Henry R. Paine, 22 December 1838, OPW letter book, National Archives of Ireland, OPW1/1/2/6.

192 Letter to Constantine, Marquess of Normanby from Maria, Marchioness of Normanby, undated [2 August 1838], Mulgrave Castle Archives, NN/293.

193 Ibid.

194 See, for example, letter to Maria, Marchioness of Normanby from the Office of Public Works, 25 August 1838, OPW letter book, National Archives of Ireland, OPW1/1/2/6.

195 A review of OPW's official correspondence with the viceregal household in the 1820s and 1830s has yielded no other such examples of direct written contact with a vicereine at the time; see OPW letter books, National Archives of Ireland, 1826–41, OPW1/1/2/4, OPW1/1/2/5, OPW1/1/2/6.

196 Letter to Maria, Marchioness of Normanby from the Office of Public Works, 25 August 1838, OPW letter book, National Archives of Ireland, OPW1/1/2/6.

197 Letters to Messrs Town and Emanuel and Messrs Taylor from Henry R. Paine, 30 March 1839, OPW letter book, National Archives of Ireland, OPW1/1/2/6.

198 F. Collard, 'Town & Emanuel', *Furniture History*, 32 (1996), p. 81.

199 Letter to Constantine, Marquess of Normanby from Maria, Marchioness of Normanby, 29 August 1838, Mulgrave Castle Archives, NN/307.

200 Letter to Jacob Owen from Henry R. Paine, 3 September 1838, OPW letter book, National Archives of Ireland, OPW1/1/2/6.

201 Letter to Messrs G. Morant and Sons from Henry R. Paine, 7 November 1838, OPW letter book, National Archives of Ireland, OPW1/1/2/6. For a discussion of the circumstances surrounding the manufacture, import and export of wallpaper in Ireland in this period, see D. Skinner, *Wallpaper in Ireland 1700–1900* (Tralee: Churchill House Press, 2014), esp. pp. 159–69.

202 Letter to Constantine, Marquess of Normanby from Maria, Marchioness of Normanby, 29 August 1838, Mulgrave Castle Archives, NN/307.

203 Journal of Queen Victoria, 4 October 1838, Royal Archives, Windsor Castle, RA VIC/MAIN/QVJ.

204 Letter to Constantine, Earl of Mulgrave from Maria, Countess of Mulgrave, 6 January 1838, Mulgrave Castle Archives, NN/277.

205 Letter to Maria, Marchioness of Normanby from Constantine, Marquess of Normanby, 30 July 1838, Mulgrave Castle Archives, N/398. See also letter to Constantine, Marquess of Normanby from J.T. Burgoyne, 22 August 1838, Mulgrave Castle Archives, M/248.

206 See McCullen, *An Illustrated History*, p. 9.

207 *Pilot*, 11 February 1839.

208 *Morning Register*, 12 February 1839.

209 *Freeman's Journal*, 18 February 1839.

210 *Dublin Weekly Register*, 23 February 1839.

211 There are portraits of Constantine Henry Phipps, 1st Marquess of Normanby in institutions and collections including the National Gallery of Ireland, the National Library of Ireland, the National Portrait Gallery, the Royal Collection, the National Trust, National Galleries Scotland and the Royal Belfast Academical Institution. Images of Maria, Marchioness of Normanby can be found in the collection of the National Portrait Gallery and in the Royal Collection. No portrait or print of her has yet been traced in an Irish collection.

212 D. Lowenthal, *The Past is a Foreign Country* (Cambridge: Cambridge University Press, 1985), p. 247.

213 See Bloomfield, *Extracts of Letters*, pp. 51–2.

214 See memorial tablet to Constantine, Marquess of Normanby and Maria, Marchioness of Normanby, Parish Church of St Oswald, Lythe, Whitby, North Yorkshire.

Six

Lacing Together the Union

How Theresa, Marchioness of Londonderry's Unionist Endeavours were at the Heart of her Viceregal Tenure in Ireland, 1886–9

Neil Watt

In a publication exploring portraits of the vicereines of Ireland, it is perhaps appropriate to begin this essay on Theresa, Marchioness of Londonderry (1856–1919) by highlighting two contemporary representations of this particular vicereine, which appeared in printed and painted form. Writing in 1937, the Countess of Fingall sketched out her impressions of Lady Londonderry in her published memoir, *Seventy Years Young*, in which she remarked: 'Hers was a most dominant personality. She had the proudest face I have ever seen, with a short upper lip and a beautifully-shaped, determined chin.'[1] Having enjoyed a friendship with the Marchioness at close quarters, despite their political and religious differences, Lady Fingall managed, with some artistry, to capture the essence of the woman – a woman with an imposing presence in any social situation, a woman whom contemporaries 'looked up to with absolute confidence', a marchioness 'from top to toe, who played the part to perfection' (Fig. 06.01).[2] A similar impression of the self-assured Theresa Londonderry had been captured some years earlier, when Theresa had commissioned a half-length portrait of herself by John Singer Sargent, as a birthday gift for her husband, in 1909.[3] The completion of this portrait is evidence enough of her dominant and persuasive personality, given that only two years prior to her sitting, Sargent had closed his studio.[4] Sargent had become weary of the dominant personalities who sought to reveal their character through conversation in the hope that it would influence the image captured by him on canvas, remarking at the time: 'Painting a portrait would be quite amusing if one were not forced to talk while working … What a nuisance having to entertain the sitter and to look happy when one feels wretched.'[5] Although his portrait of her would take the form a modest half-length, family tradition holds that it was her favourite likeness of herself, for he had managed to capture a sense of her hauteur and presence (see Cat. 28). Like Lady Fingall's written description of Theresa, it is her proud, almost arrogant countenance that Sargent focusses all his attention upon: her elevated face illuminated against a backdrop of rich but monotone black costume. Both of these portrayals serve as fitting representations of the presence and personality of a woman who 'lived and ruled … like a very benevolent monarch', and who undoubtedly contributed to a 'very magnificent' viceroyalty during a shifting period in Ireland's history when the binding threads of unionism were beginning to unravel.[6]

In light of these contemporary portrayals, it is unfortunate that such a figure has been relegated to the shadows of mainstream Irish and British history, where she features but rarely in any of the relevant modern studies dealing with the aristocracy during her lifetime.[7] In the *Oxford Dictionary of National Biography* (*ODNB*) she remains elusive and is dealt with not in a dedicated entry of her own, but rather as part of the biography of her husband.[8] It is also noteworthy that the description of her in this entry begins with her apparent failed attempt at being a monogamous wife, with the biographer highlighting her alleged affair with the notorious womanizer Harry Cust.[9] In the *ODNB*, her sexual endeavours currently outrank her contributions as vicereine of Ireland, not to mention her later political and public achievements throughout the first two decades of the twentieth

century. In addition, her own attempt at writing her autobiography sadly remained unfinished, probably due to her sudden and untimely death in 1919 at the age of 62; it has languished in the archives ever since.[10] The typescript fragments that survive offer the most intimate account of her childhood, her experiences as a young married woman, and her clear preoccupation with politics from an early age. Her personal champion in the modern age has been Diane Urquhart, whose academic biography, *The Ladies of Londonderry: Women and Political Patronage*, includes what is, to date, the definitive biography of Theresa Londonderry, emphasizing her strong conservative unionism and her significant role in establishing what became the largest political association of women in Ireland's history – the Ulster Women's Unionist Council, of which Theresa served as president.[11] But, inevitably, Theresa's very active and dominant political role in Ulster unionism in the early twentieth century has somewhat overshadowed her initial work in the nineteenth century as a conservative unionist concerned not only with Ulster, but with the whole of Ireland as an integral part of the United Kingdom. Urquhart does argue that Theresa 'was a woman with real political convictions [and] a doughty defender of the legislative union between Britain and Ireland', but even here the emphasis inevitably drifts to her later political work, with only brief analysis of her earlier role as a leading Tory hostess and as vicereine of Ireland.[12] The aim of this essay, therefore, which draws heavily on her unpublished memoirs, is to explore the first half of Theresa's life, during which, as a committed unionist with remarkable political passion and awareness, she used her elevated social and political position to promote the British regime in Ireland.

Lady Theresa Susey Helen Chetwynd-Talbot was born on 6 June 1856, the eldest child of Charles, 19th Earl of Shrewsbury and Waterford, who simultaneously held the two oldest earldoms in England and Ireland.[13] Had she been born a male, she would likely have become the 20th Earl of Shrewsbury and Waterford, and this was something that she lamented; it has been observed that 'she would have vastly preferred to play a man's part'.[14] Nevertheless, she was a traditionalist at heart, and wore her ancestry as proudly as her brother, but within the parameters of a woman's existence.[15] Whilst English by birth, Theresa had a very keen interest in Ireland, and her mother, Anna Theresa (née Cockerell), had a strong Irish ancestry.[16] Theresa would later take great pride in recounting her maternal family's unconventional Dublin roots, in her unpublished memoir.[17] In addition, her father also had connections to Ireland, having succeeded to the hereditary title of Lord High Steward of Ireland in 1868, just a few days before Theresa's twelfth birthday.[18] Lord Shrewsbury was a committed conservative unionist and raised his family in this strong and patriotic tradition, with Theresa being no exception.[19] As his eldest child, Theresa was almost certainly destined to make a great match that would carry both social and political responsibilities and, accordingly, her father and mother allowed her to be exposed to a socio-political culture from her youth.[20] This exposure meant that she was immersed in politics from a very young age, during which time, the blurred lines between the private and the public spheres were already being made known to her.[21] She had a natural taste for the

socio-political mix encountered as part of a high-born existence, remarking that even as a child, the discussion of matters political and public with her parents was far preferable to the trivialities of playtime with her siblings: 'however delightful one's brothers and sisters I thought it very boring compared to being at home with an adored father and mother who made me their companion from the time I was four years old, and always talked sense to me and explained everything to me of a public and a private nature'.[22]

Politics would continue to pervade Theresa's childhood, with her father taking her to the funeral procession of the great statesman Lord Palmerston, who, because of his lifelong devotion to politics, his promotion of the Empire, and his political legacy within the Conservative as well as the Liberal Party, was given the honour of a state funeral in 1865.[23] It was made clear to Theresa from a young age that true greatness and public recognition came from a dedication to public duty, and her attendance at Palmerston's funeral left a lasting impression:

> During all this young period of my life, [my father] always interested me in celebrated people. I remember his taking me to see the procession at Lord Palmerston's funeral. I think I was about nine or ten. I remember standing on a platform opposite Cambridge House, and … he gave me a short sketch of what he was like and his politics and he always spoke of him as a thorough Englishman and sportsman.[24]

So invested was Theresa, as a young girl, in her father's political career that she wrote: 'one of my greatest early griefs was my father being beaten for the constituency of South Staffordshire'.[25] She shared, with huge sensitivity and awareness, this political defeat and its associated embarrassment for her father as a leading Conservative.[26] Throughout her childhood, her father and mother would host political levees at their Staffordshire family homes of Alton Towers and Ingestre, where she learned that the political wheels of governance often turned more freely within the realms of hospitality, and where even as a child, she was influencing the theatrical tone in which politics were being conducted: 'I remember once we had a political levee at Alton and some of the gentlemen dressed up as ladies. We were delighted but my father was very angry as he thought it might bring the political reception into disrepute.'[27] At other such political receptions held by her parents, Theresa records how she was singled out by the Prime Minister, Benjamin Disraeli (during his first term in office, in 1868), as a young woman with considerable ambition: 'Mr Disraeli came two or three times with his wife, and paid very flowery compliments to my mother and to us. I remember him saying once, "Theresa is ambitious" and though I was only thirteen at the time, he was not far wrong.'[28] A portrait of Theresa and her brother, Charles, which was painted at about this time, captures something of that ambition and strength of character, depicting her as a commanding presence next to the young boy.

It is clear from her unpublished memoirs that Theresa thrived in this socio-political environment and enjoyed engaging in political debate, whether that meant

listening to others or vocalizing her own opinions. It provided her with an open forum in which to practice the power of discussion and debate, which, in turn, allowed her to be more than just 'aware' of what was going on, but well able to analyse arguments and form opinions with which to fight her own cause and provoke responses in others.[29] As Urquhart has stated, 'Theresa loved to encounter opposition, so that she might crush it.'[30] Theresa's contemporary, Lady Fingall, recorded a similar impression:

> I have often wondered why the Londonderrys should have been so good to me, rebel and Papist as I was ... Anyhow their friendship was never failing and it made no difference to it that we often fought on politics and it was fun, I expect, at those parties at Mount Stewart ... to see me flair up in angry defence of my side.[31]

This keenness for political discussion and debate meant that Theresa became a skilled raconteur and debater and, in this way, she marked herself out as an informed opponent and influencer within the socio-political and domestic domain, where, at one time, 'she was supposed to rule England and statesmen used to quail before her'.[32]

Theresa certainly was ambitious, but she also seems to have been aware that in order for this ambition to find its realization within her own sphere, she needed to make an excellent match with a suitable husband, preferably one who could facilitate such an able woman by adorning her with the trappings of wealth and privilege.[33] Theresa's awareness of the significance of marriage as the essential basis for her own particular ambitions and material role in life has parallels with the more general experiences of other women of her class, as Amanda Vickery has observed: 'For most genteel women, the assumption of their most active material role coincided with marriage, when they became the mistress of a household. Thereby, the administration of a household, the management of servants, the guardianship of material culture and the organisation of family fell to her lot.'[34] For Theresa, the opportunity to assume such a role came in 1875 when she married Charles Vane-Tempest-Stewart (1852–1915), Viscount Castlereagh (later 6th Marquess of Londonderry). Charles was the eldest son of the 5th Marquess of Londonderry, whose father, the 3rd Marquess, had married Frances Anne Vane, who, as Marchioness of Londonderry, had become one of the great political hostesses of her generation.[35] Upon this solid bedrock, Theresa would be able to build her own career as the latest leading conservative society hostess to bear the Londonderry name.

It is noteworthy also that the Londonderry name was synonymous with Viscount Castlereagh (son of Robert, 1st Marquess of Londonderry), the Foreign Secretary who had found acclaim in both national and international politics in the early nineteenth century, and a man considered to be the architect of the Acts of Union between Britain and Ireland, in 1801.[36] This would have huge symbolic meaning for the Londonderrys, with Theresa and her husband, Charles, instilling the values of Lord Castlereagh in their son, who wrote:

(opposite)

Fig. 06.02.

Thomas Alfred Jones

*Charles Vane-Tempest-Stewart,
6th Marquess of Londonderry*

1889

Photograph by Davison &
Associates, courtesy of the Office
of Public Works, Dublin Castle.

It was not going too far to say that our House stood for the Union of Ireland and England ... That was to be the raison d'être of my going into the political world ... As I grew up my Mother used to actively press me to take an interest in politics ... My Mother talked to me too, about the great Lord Castlereagh, whose name ... I bore at the time.[37]

This same son would also state that his father, the 6th Marquess of Londonderry, whilst passionate about unionism, did not share Theresa's burning ardour for it.[38] Lord Londonderry had enjoyed a short-lived political career of his own as an MP for the Irish constituency of Down from 1878 before succeeding his father as Marquess in 1884 and sitting in the House of Lords.[39] In her personal memoir, Theresa comments on how he was 'passed over' for a truly significant cabinet or court position during Lord Salisbury's Conservative government, formed in 1886, largely because he had failed to show a fervent interest in politics before this time.[40] Theresa, keen to be seen as the supportive wife and partner, carefully outlines how able Lord Londonderry really was, arguing that had he been more forceful in his approach, he would have held the sort of high office he felt entitled to:

> I think Lord L would have liked one of the court appointments, such as Master of the Horse, and we were both disappointed. I must own that even at that time I flew higher, and would have liked him to have an under-secretaryship but when in the House of Commons, he had not taken much interest in politics, and having only just succeeded to the title, he was passed over. I may here mention that knowing his great capacity for political work, his earnest support of the Tory principles and his great position in the counties of Down and Durham, it would not be long before his merits would be recognised.[41]

Once again, Theresa admits to her own personal ambition for the enjoyment of public and political office in the expression 'I flew higher', while at the same time tacitly acknowledging, through her reference to their shared disappointment at his failure to advance further, that her influence would be derived from his success.

Lord Londonderry was described by Lady Fingall as a great gentleman.[42] 'He was not,' she added, 'very clever, but did the right thing by instinct, and after all, that is the best way to do it.'[43] The combination of his unionist views and his relatively limited interest in politics made him a good choice for the role of viceroy, the responsibilities of which were being 'restricted to viceregal ceremonial and charitable activities' by 1886, as the Chief Secretary became the primary political agent of the British administration in Ireland.[44] He was a solid choice of conservative figurehead for the role, when the challenges of radical change in Ireland were becoming manifest. In the face of growing calls for Home Rule and in the shadow of an agrarian crisis, he represented a sense of stability for the old order.[45] For Lord Salisbury, this viceroyalty was exactly what he desired in order to preserve the status quo, but at the same time, to offer a diplomatic concession to both the Irish people, and the Ulster unionists, by placing an Irishman at the pinnacle of

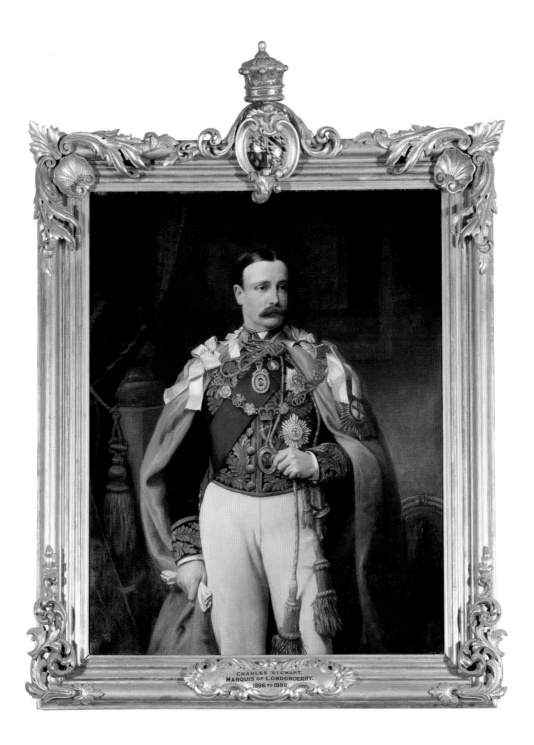

CHARLES STEWART.
MARQUIS of LONDONDERRY.
1886 to 1889.

Irish society, as Theresa noted:

> In order to please the Unionists of the 'Black North' as it is called, who were
> up in arms and said they had been sold to the Home Rulers, they suggested
> that Lord Londonderry should be asked to be Lord Lieutenant as the name
> of Castlereagh, who had been such a great figure in the Union, would reas-
> sure the Ulster party that the government intended to preserve the Union.[46]

This was one of the few occasions on which an Irishman held the post of viceroy.[47] Recording the speeches of the new viceroy, Irish newspapers with conservative and unionist sympathies rejoiced that the honour of representing the monarch in Ireland had been conferred on an Irishman.[48] The added bonus for the Conservative government was his familial connection to 'the name of Castlereagh', the maker of the Union, and with it, the implied affirmation of the government's commitment to preserving that Union. Ultimately, he was the right man for the job, not because he was outstanding in his own right, but, instead, because he was not. He was the embodiment of the Union, and of conservative and unionist principles, a 'safe rather than a brilliant Lord-Lieutenant', who was unlikely to frighten the horses (Fig. 06.02).[49] Instead, Lord Salisbury's unexpected secret weapon in the quest to highlight the benefits of the Union in Ireland would turn out to be Theresa Londonderry, who would support the work of her husband as viceroy by her own means and by 'shaping the agenda of his tenure'.[50]

As Martin Pugh has noted, 'Charles "was widely considered to owe his elevation as Irish Viceroy in 1886 to his formidable wife rather than to his own slight talents, though his readiness to spend freely in Dublin was probably the decisive factor."'[51] Lord Salisbury had known Theresa for a long time and was well aware of her ambitious character, as well as her ability to influence society by means of what has come to be called 'soft power'.[52] Diane Urquhart has noted that

> the specifics of her role [in securing the post of viceroy for her husband] are unrecorded, but she had known Salisbury since childhood and the existence of a familial connection on her side to the post [her great-grandfather, Charles, 2nd Earl Talbot (1777–1849) was viceroy from 1817 to 1821] ... may have increased her interpretation that her husband should have the position.[53]

It is worth noting the overlooked point that Theresa may also have been conscious that her Irish great-grandmother, Frances Thomasine, Countess Talbot (1782–1819), wife of Charles, 2nd Earl Talbot, had served as vicereine (Fig. 06.03). Lady Talbot had been actively serving in the role when she died suddenly, in December 1819, and despite the unofficial nature of her position, she had been afforded the honour of a day of official mourning at the Chapel Royal, Dublin Castle, where her remains lay in state on 7 January 1820.[54] An even closer blood relative, her maternal grandmother, Theresa (née Newcomen), Countess of Eglinton (d.1853) had briefly served as vicereine in 1852, as the wife of Archibald Montgomerie, 13th Earl of Eglinton, her second husband (Fig. 06.04).[55] In addition, there was a symbolic dimension to Theresa's suitability for the role of vicereine as the daughter of the hereditary Lord High Steward of Ireland – a position that symbolized Ireland's enduring connection with Britain. Her popularity and her Anglo-Irish credentials were often noted by newspapers during her time as vicereine, with *The Belfast News-Letter* pointing out the challenges her popularity and familiarity in Ireland posed for Irish nationalists:

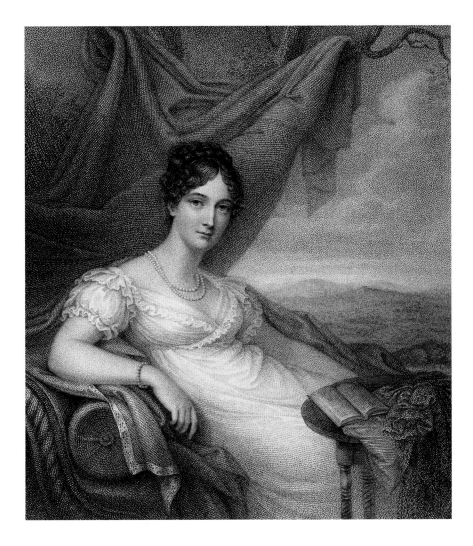

Fig. 06.03.

J.S. Agar, after C. Robertson

Frances Thomasine, Countess Talbot

1819

Reproduced courtesy of the National Library of Ireland.

She is a familiar figure in society, and is well known as one of the best of the family of Talbot … Dealing with Lady Londonderry, her first obvious difficulty was that not even Irish Nationalists could find it in their hearts to say disagreeable things about her, and, therefore, they adopted the insidious course of praising her at the expense of her husband. Thus our old friend the *Pall Mall* said on 29th July, 1886 – 'Lord Londonderry has absolutely no qualification for the post beyond his marriage with one of the prettiest and most popular ladies in society.'[56]

Despite her Englishness, Theresa's Irish ancestry and symbolic family ties to Ireland, as the daughter of the hereditary Lord High Steward, gave her a significant stake in the campaign to uphold the British regime in Ireland, a campaign she would soon seek to support through her own symbolic role as vicereine.

Patricia Jalland has made the important point that the social roles of upper-class women as political hostesses and mistresses of households were often critical to the success of their husbands' careers in this period, and that these roles

'became more demanding in the second half of the nineteenth century'.[57] Undoubtedly, one of Theresa's strongest qualifications for the role of vicereine was that she had already proven herself a capable mistress of the house, managing several large country houses in both England and Ireland, as well as the magnificent Londonderry House in Park Lane, where she had thrown herself into the redecoration of its public suites in order to make them even more splendid, so that she 'might put them to political purpose'.[58] Running and managing multiple and extensive households as a 'leading Tory hostess' was a key responsibility for her as the wife of the Marquess of Londonderry, and Theresa's confidence in decorating her interiors with political ends in mind was derived from her own very sound pedigree, and was bolstered by her husband's enormous wealth.[59] Here was the perfect marriage of pedigree and taste, coupled with the confidence to execute bold designs without needing to worry about the costs. While some may have thought the Londonderrys *nouveau riche*, brash or vulgar, nobody could level such insults at Theresa, whose lineage was one of the most impressive in the United Kingdom. Within the interiors she created, Theresa would draw key political characters to her, reigning supreme as a 'confessedly party woman' who was queen of her own Tory domain.[60] The dining rooms, drawing rooms and ballrooms of her houses were the spaces in which she was most powerful and where, most importantly, she could use everything at her disposal to wield an influence that 'softened the crudities' of politics.[61] Filling her interiors with rich textiles, furnishings and jewels, she created an imposing backdrop that lent weight and authority to her arguments in support of the Empire and the Union (Figs 06.05 & 06.06). A similarly grand backdrop to lavish entertaining, one filled with visual signifiers of the benefits of

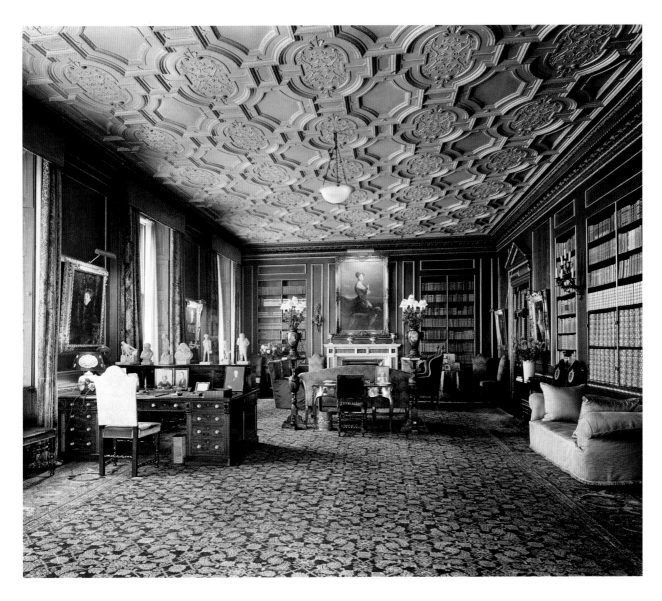

Ireland's union with Britain, would be a strong feature of the Londonderry vice-royalty at Dublin Castle.

Within her interiors, Theresa derived particular enjoyment from "'familiar conversation with the men who counted in the direction of the causes in which she believed – the Union with Ireland and the Unionist Party'".[62] At the same time, she was 'also frustrated that as a result of her sex she was condemned to play an ancillary political part'.[63] Despite her frustrations, Theresa remained a prominent figure in the political sphere at this time. Her passion for hearing political debate in the Houses of Parliament, her avid attention to electoral results and what they meant for party politics, and her familiarity with the changing occupants of positions of political power and influence, are all recorded with impressive detail in her unpublished memoirs.[64] This extremely active political engagement undoubtedly contributed to her success as a political hostess. Though relegated to the ladies'

Fig. 06.05.

A.E. Henson (photographed by)

Library, Londonderry House, London

1937

John Singer Sargent's portrait of Theresa, Marchioness of Londonderry is visible on the wall between the windows.

© Country Life.

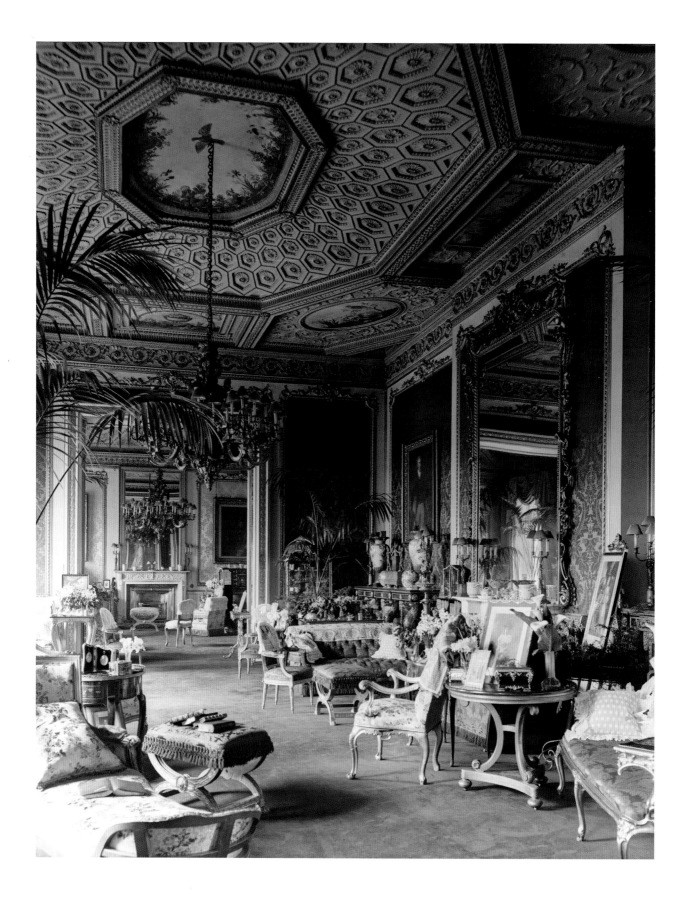

gallery, she was obsessed with the political transactions at Westminster, and was often present to ensure that she was fully informed on relevant political questions. On one occasion, 'in the midst of a commons Home Rule bill, when Theresa, resplendent in furs and pearls, strained to hear the debate from the ladies' gallery over Mrs McKenna and Mrs Churchill's conversation, so puffing herself out to her maximum she demanded, "silence badly dressed children!"'[65]

Whilst she was relegated to the gallery in Westminster on account of her sex, gender knew far fewer boundaries in the private spheres of townhouse and country house, where Theresa, because of her class and responsibilities as chatelaine, was able to reach the public and political figures of the day. Though private, these spaces were, nonetheless, political. As K.D. Reynolds has noted, 'To few circumstances can the concept of separate spheres have been more inappropriately applied than that of Victorian political society ... politics and policies were discussed in social and domestic settings, and social events took on political significance as a result of the close knit socially cohesive nature of the governing classes.'[66] As the Marchioness of Londonderry, and as an informed political hostess, Theresa could exert influence in a way she could not in the formal institutions of power. At grand parties where entertaining went hand in hand with power and politics, Theresa had an opportunity to break the boundaries of gender divisions, in a setting where she could speak freely with the men around her. In this environment, she could charm and manipulate, but also use her privileged position to talk robustly, albeit informally and unofficially, to people of importance, influencing them in favour of the careers of her husband and son. These events, when carefully managed, often led to opportunities, and it was at such a social gathering that Lord Londonderry was asked to be viceroy of Ireland under the watchful eye of his wife, who wrote:

> King Edward, then Prince of Wales, had a party for Goodwood that year, and I shall never forget Lord Salisbury coming to Lord Londonderry with the news the very day of the races ... I have always considered it much pleasanter to be one's self than to represent anyone else, but as I had always been most ambitious for Lord L, I was delighted on his account. He told me if I did not wish it, he would not go to Ireland, but I, of course, begged him to go.[67]

The Londonderrys' approach to the decoration of their own interiors appears to have been shaped by a desire to express social significance but also to satisfy their voracious appetite for material culture. This same approach was soon adopted in the State Apartments at Dublin Castle, which by the time of their viceroyalty in the late 1880s, were said to 'have had no money expended upon them' for several years, with the result that 'the hand of time was becoming unpleasantly visible'.[68] This was not entirely correct. In February 1885, the then viceroy and vicereine, the Earl and Countess Spencer (see Cat. 27), had completed a major scheme of remodelling and redecoration in the ballroom, St Patrick's Hall.[69] The adjoining spaces, however, which included the Portrait Gallery, Throne Room and State

(opposite)

Fig. 06.06.

Charles Latham (photographed by)

Drawing Room, Londonderry House, London

1902

© Country Life.

Six

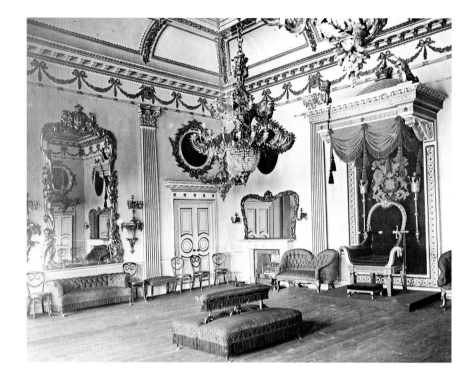

Drawing Room, had received relatively little attention since 1867, when the Duke and Duchess of Abercorn (see Cat. 25) had completed a comprehensive programme of redecoration.[70] Arriving in late September 1886 and experiencing their first social season at Dublin Castle in February and March of 1887, the Londonderrys had little choice, initially, but to carry on with their engagements despite the lacklustre condition of these interiors.[71] However, given how quickly they set about tackling this image problem, it seems that the largely tired appearance of the Dublin Castle interiors was not to the Londonderrys' taste, nor representative of the magnificent viceroyalty to which they aspired. Here lay an opportunity for Theresa to shape her image as vicereine. For visitors to Dublin Castle, her transformation of these highly symbolic regal spaces would dispel any fears that longstanding neglect of the interiors was indicative of dwindling British interest in preserving the Union, which, by now, was being threatened by demands for Home Rule. As the suite of rooms that served as Ireland's *de facto* royal palace, that housed the trappings of royal authority in Ireland, and that were the ceremonial centre of British rule in Ireland (Fig. 06.07), the State Apartments were a critical backdrop for the display of the Union's health and lustre, and it now fell to Theresa to restore their lost sheen.

As soon as her first social season had drawn to a close in 1887, Lady Londonderry was able to set about redecorating the State Apartments. The extensive works were carried out over several months and were not limited to the spaces themselves but also to the collection of artworks and furniture displayed within them. That collection included the series of portraits of each viceroy who had served under the Union since 1801, which, tellingly, were restored and had their frames re-gilded.[72] In January 1888, *The Irish Times* eagerly reported the results:

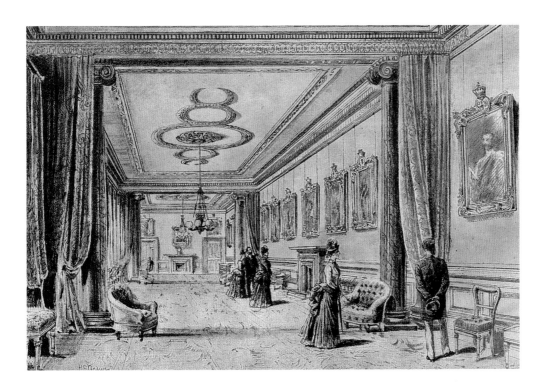

Fig. 06.08.

H.C. Brewer

Picture Gallery, Dublin Castle

1888

Published in *The Graphic*, 21 April 1888.

Courtesy of the Office of Public Works, Dublin Castle.

The entire suite of apartments have now been repainted by Messrs Dockrell and Sons, of South Great George's street. The portraits of preceding Viceroys have been restored by a well-known local artist, the frames and gilding work being executed by Messrs Sibthorpe and Son, of Molesworth street, in the style that might be expected from so eminent a firm. The various suites of furniture were forwarded to Messrs Thomas Fry and Co., who have re-covered any articles worth retaining in new silk poplin specially manufactured by them, in an Oriental design chosen by her Excellency the Marchioness of Londonderry, who has displayed excellent taste in selecting the colours, a rich crimson being chosen for the Throne room, and a delicate moss green for the drawing-rooms, both of these colours harmonizing admirably with the surrounding decorations. Several new couches, sofas, and luxurious easy chairs of modern design have also been selected by her Excellency, these being made by Messrs Thomas Fry and Co., the whole being, as stated, on view at their Sackville street establishment.[73]

A further report appeared in the same newspaper less than a week later, providing additional details of the scale and cost of the works undertaken in the Portrait Gallery and Throne Room:

The renovation here consists of ceiling enrichments, cornices, entablatures, and other beautiful designs. These have been re-gilt, and present a magnificent appearance, the ground work being white and so finely finished as to show at a glance the extreme care taken, and the skill displayed by those

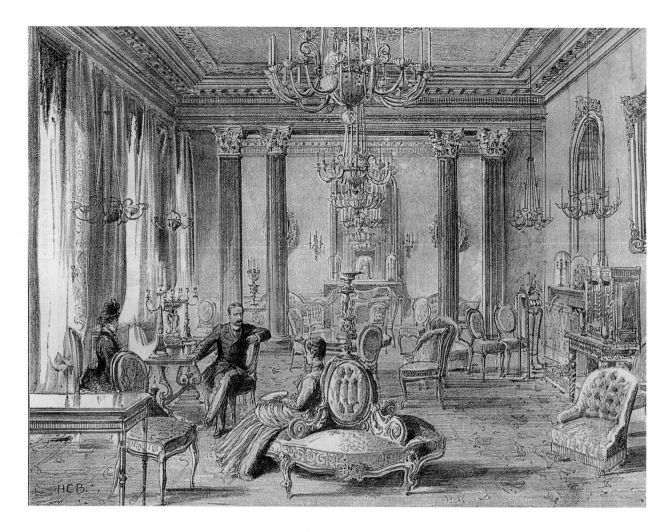

Fig. 06.09.

H.C. Brewer

State Drawing Room, Dublin Castle

1888

Published in *The Graphic*, 14 April 1888.

Courtesy of the Office of Public Works, Dublin Castle.

to whom the execution of the improvements was confided. The doors, windows, columns, & c., have been completed in a very superior class of white enamel and gold ... Some idea of the magnitude of the work may be found when it is stated that in the progress of the gilding over three thousand books of gold leaf were used.[74]

The list of Irish suppliers employed to carry out this work over many months suggests that Theresa was intentionally using her viceregal position to curry favour with the Irish people, by filling the Castle with Irish textiles, furniture and skilled craftspeople. It was also important that she was being seen to be investing in Dublin Castle, with the public's imagination being captured through the display of restored and newly commissioned furniture in the prominent shop windows of Messrs Thomas Fry and Co., of Sackville Street (now O'Connell Street). The public could now witness the literal magnificence of the Londonderry viceroyalty and aspire to emulate the vicereine's tastes. It is easy to forget that during their time living and working in Dublin during their viceroyalty, Theresa and her husband became residents of the city, and this was one way in which they could share part

of the viceregal collection with those who might otherwise never have been able to see it. The decision to place these material objects on show in a public retail outlet, for all to see, is likely to have been a popular move with Dubliners who supported the British connection, as it provided a chance for ordinary people to experience something of the grandeur of the Londonderry viceroyalty and, by extension, the British regime. For political allies and foes alike, this move publicly advertised the fact that some semblance of the Union's supposed lustre had now been restored by the vicereine at Dublin Castle, and that the British administration was apparently committed to maintaining it. A few months later, readers right across the United Kingdom could witness the renaissance at the Castle from the comfort of their own armchairs, when specially commissioned prints of the refurbished State Apartments appeared in *The Graphic*, alongside portraits of the viceroy and vicereine (Figs 06.08, 06.09, 06.10).

It is clear that Theresa knew the importance of material culture and exploited its potential in order to make allusions to prosperity and renaissance – ideas that were synonymous with the aims of Lord Salisbury's Conservative government, which voted very large sums of money for measures such as state-assisted land purchase in Ireland at this time.[75] As Theresa and Charles were representing the monarch, Queen Victoria, the fact that Dublin Castle was being refreshed and presented in a more regal fashion was important, as a means of setting a higher standard for the image of the British monarchy in Ireland at a crucial time. As Diane Urquhart has noted, 'under the Londonderry auspices, the Castle Drawing Rooms were soon depicted as a court, attracting fuller attendances than previously, a fact Victoria considered a sanction of both herself and her lieutenant during a tumultuous time as the first Home Rule bill and then its creator, Gladstone, met their defeat'.[76] Most importantly, for Theresa, the work showed her to be a committed and effective mistress of Dublin Castle and society hostess, a chatelaine who kept a good house, managed and decorated the Castle to the advantage of both the Irish people and the British monarchy, and provided excellent entertainments – all attributes of a magnificent vicereine.

Urquhart has estimated that Lord Londonderry spent '£32,675 over his salary' during his years as viceroy, which in today's money amounts, approximately, to more than £2 million.[77] Theresa's generous spending on material culture, which may well have contributed to this major cost overrun, was not restricted to interiors, and perhaps an even more significant and far-reaching outlet for her patronage as vicereine was fashion. Through her support for the Irish textile industry, she could be seen to be actively promoting Irish skill and example. The effects of this support were reported widely in newspapers such as *The Belfast News-Letter* as her tenure in the role progressed:

> She from the very first set herself to do her utmost to support and revive Irish industries ... She is fully occupied in developing schemes to promote the happiness of the people. The Dublin tradespeople are already cheered, for they have prospects of busy days in their city.[78]

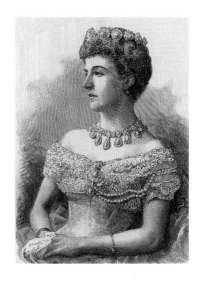

Fig. 06.10.

H.C. Brewer (attributed to)
The Marchioness of Londonderry
1888
Published in *The Graphic*, 14 April 1888.
Courtesy of the Office of Public Works, Dublin Castle.

Dublin artisans were not the only beneficiaries of Theresa's schemes, as notice of a competition organized by her in 1886 demonstrates:

> The prizes … offered by the Marchioness of Londonderry for designs for a flounce, and a narrow border to match it, to be worked in Carrickmacross appliqué lace, have been awarded to Miss Z.A. Inman, of Halstead, Essex. Upwards of thirty designs were submitted in competition: six were selected as being the more distinguished, and of these Miss Inman's was adjudged to be the best. The lace is being worked at the Bath and Shirley Lace School, Carrickmacross, county Monaghan, of which Mrs Martin is the superintendent.[79]

Her focus on the lacemaking industry in rural and regional counties and cities such as Monaghan and Limerick, rather than on the textile industries of Dublin, which had often received the lion's share of viceregal patronage, reflected a growing trend among women of Theresa's class in Ireland, as Janice Helland has observed:

> It was particularly important for Theresa as it was part of a philanthropic enterprise taken up by many high-ranking aristocratic women … in Ireland during the 1880s and it was perceived to be a charitable cause to bring employment and industry to rural populations. Exhibitions such as that at the Mansion House in 1883 could 'prove that design and quality could be produced in Ireland'.[80]

For Theresa, the 'happiness of the people' who profited from the opportunities she created in this sector ultimately increased the prospects of their happiness with the socio-political climate and, by extension, the Union with Britain that made those opportunities possible.[81] By doing so much to encourage the lace industry right across Ireland, she was sending out a message that it could thrive under the Union better than under a Home Rule parliament. At a time of social, political and agrarian unrest that sought to bring about independence and self-determination for Ireland away from such a union, this was a strategic message for Theresa to be promoting in her very public role as vicereine. Through this message, she was also helping to support the core objectives of the Conservative administration at that time, which was seeking to foster support for textiles produced across the United Kingdom, as Janice Helland has noted:

> By the 1880s 'buying British' had become a familiar cry among politicians, philanthropists and merchants as they attempted to encourage home production and thwart the ever-increasing demand for imported goods. The Marquess of Salisbury, for example, in a speech made in 1881 … insisted it was a matter of national interest that purchasers of textile fabric gave preference to British goods. He also acknowledged fashion as a 'great force' that could be wielded by 'all women in England' because it determined the destiny and influenced the wealth and poverty of large sections of the labour and industrious population.[82]

Fig. 06.11.

Sarah Purser

Charles Stewart, Viscount Castlereagh, later 7th Marquess of Londonderry (1878–1949), aged 10

1888

© National Trust/Bryan Rutledge.

As previously discussed, Theresa had identified closely with Ireland through her lineage and her title even before she assumed her responsibilities as vicereine, and this enabled her to add an authentically Irish dimension to a role that had been so dominated by women from Great Britain. The utilization of Irish textiles, especially lace, further enhanced her identification with Ireland, as she adorned herself in the handmade garments created by her fellow countrywomen, quite literally binding herself to the creations of the country. Through her efforts, the women of Ireland's cottage industries could be encouraged to see Theresa as a champion of their crafts and as a channel to the wider British market that the Union afforded access to, as *The Belfast News-Letter* reported, in January 1888:

> Even at the outset Lady Londonderry had given the cue for assisting Irish
> manufacture, for she wore Irish poplin and Carrickmacross lace on her State
> entry into Dublin, and she used her best influence from that time to help on

the native work, not only offering prizes for Carrickmacross lace, but also bringing this staple industry of Ireland so prominently under notice that the Government appointed Mrs. Power Lalor lace inspector of Ireland in November, 1886, to whose labours the exceedingly creditable show of Irish lace at the Manchester exhibition is due.[83]

A painting of Theresa's son Charles, Viscount Castlereagh (1878–1949) as a page to the Order of St Patrick was completed by the Irish artist Sarah Purser (1848–1943) at this time.[84] Exhibited publicly at the Royal Hibernian Academy in 1889, it served as something of an advertisement for Theresa's cultural causes during the viceroyalty.[85] The robes featured in the portrait are a combination of St Patrick's blue silk and Irish lace and, as such, reflect a certain familial pride, not only in the role of Lord Londonderry as viceroy and Grand Master of the Order, but equally in the efforts of Lady Londonderry as vicereine and promoter of Ireland's lacemaking industry (Fig. 06.11).

Of all Theresa's opportunities for the advertisement of Irish lace, perhaps the most effective were her own appearances as vicereine in the gilded interiors of Dublin Castle. By wearing Irish lace, which was so closely associated with rural society in Ireland, Theresa added a sense of glamour and celebrity to what had been a modest Irish cottage industry. Her first drawing room reception as vicereine, in 1887, was an indication of things to come:

> The effect of this early work of Lady Londonderry's was made apparent at her first Drawing Room, on 9th February, 1887, when – as the report goes – 'one of the chief things noted was the tremendous quantity of Irish lace that was worn, mostly Carrickmacross, and some beautiful Limerick flouncings; and also the vast array of Irish poplins, plain, satin-embossed, and some exquisitely wrought with gold and silver.'[86]

Contemporary commentators were quick to make the connection between the quantities of Irish lace worn at the vicereine's drawing rooms and the idea of loyalty to Crown and Union that Theresa was seeking to foster by popularizing it:

> *Lady's Pictorial's* Dublin correspondent insisted that she had 'never indeed, at any drawing room seen so much Irish lace work' and she concluded from this display that it would 'turn out a contradiction that loyalty in Ireland is dying out.' Loyalty, in this instance, meant loyalty to the English crown, a sentiment wholeheartedly endorsed by the Marchioness of Londonderry…[87]

Theresa's message was further reinforced by the coupling of Irish lace with her own personal insignia of the viceroyalty – her parure of diamonds, which included a dazzling tiara and a stomacher that cascaded down the frontage of her costumes. At this time, the quality of Irish lace was being likened to fine jewellery as an aspirational material commodity, with one publication at the time noting:

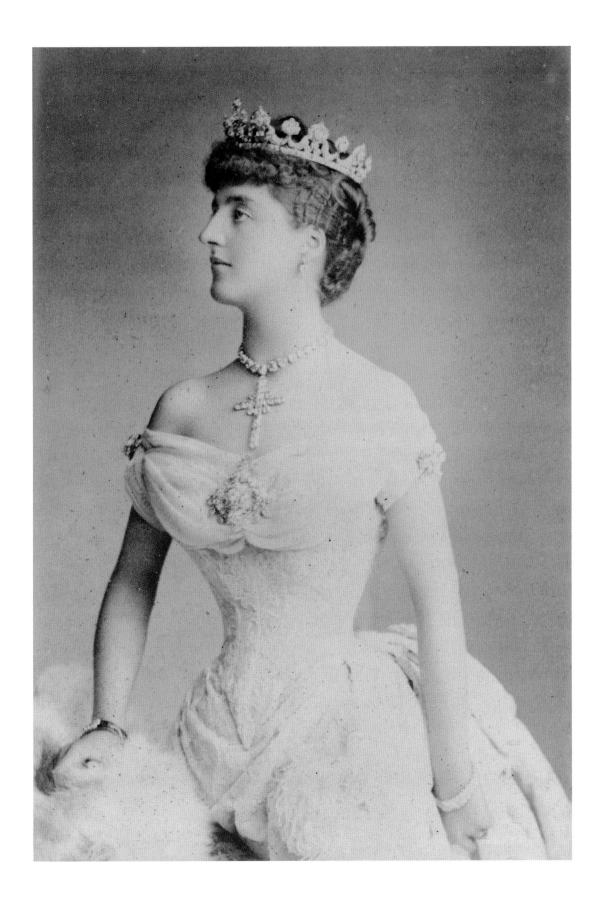

'Good lace, like good jewels, if carefully used, should last, and be handed down for generations.'[88] Together, the vicereine's lace and jewels became adornments of empire – the jewels being from India and the lace from Ireland – combined by her in perfect fashionable union.[89] The combined effect of lace and jewels was recorded in an official photographic portrait of her as vicereine, which was produced in Dublin, in 1886 (Fig. 06.12).

By wearing, purchasing and promoting Irish textiles, and taking these crafts to be exhibited and worn in Britain, thereby attempting to establish them as an integral part of the trappings of British society, Theresa was celebrating one of Ireland's unique and very skilled contributions to the industry of the United Kingdom. The British establishment was, in turn, sitting up and taking notice of this important Irish industry, as frequent reports of Theresa's efforts in British newspapers demonstrate.[90] In her unpublished memoirs, Theresa saw fit to record a description of her first viceregal costume, rather modestly stating: 'I do not know that it is of any political interest, but my dress was white with [Irish] point lace.'[91] The fact that her thoughts linked politics and material culture in this way would suggest that her intentions in wearing Irish lace were clear. As Helland has noted, 'it was proclaimed that "fashions devised from cottage crafts will be of infinitely more practical benefit to Irish peasants than HOME RULE"'.[92] By wearing these articles at the seat of power in Ireland, Theresa could send out no greater signal that those whose livelihoods depended on Ireland's rural economy should remain loyal to the Union.

Such was Theresa's affiliation with the Irish lace industry that it continued to feature heavily in the dress of both herself and her daughter, Lady Helen, in the years following the viceroyalty (Fig. 06.13). At her daughter's wedding, the display of lace was impressive, with Helland arguing that 'while lace would not have affected her already secure social status, to have not worn handmade Irish

lace at her wedding would have made a mockery of her mother's two decades of devotion to and support of the industry'.[93] It was an industry through which, as one newspaper account put it, 'Lady Londonderry set herself heart and soul to help the Irish as best she could.'[94]

During her tenure as vicereine of Ireland, Theresa, Marchioness of Londonderry played her role with great aplomb, contributing significantly to what has been remembered as a magnificent viceroyalty.[95] By birth, education and marriage, Theresa was well equipped to play this regal part, and she attempted to strengthen the bonds between Britain and Ireland by espousing causes that reflected her unionist politics, and by drawing those around her into a milieu of regal grandeur at Dublin Castle. She undoubtedly helped during her husband's viceroyalty to 'steady the buffers' of British rule in Ireland, and cleverly sought to popularize feelings of goodwill towards the Union in a land where calls for political separatism were growing louder. She achieved this through her energetic campaign for the support of Ireland's textile industries, one which must be seen as much more than a tokenistic effort to encourage an appreciation of Irish craftsmanship, but rather as an offensive that was deeply rooted in her unionist political agenda. Similarly, her restoration of the interiors of the State Apartments at Dublin Castle should be seen as much more than an attempt to create a personal 'Londonderry' style. Rather, they made a very public statement of the splendour of the British regime in Ireland, a splendour that could be forged by the skilled hands and creative minds of Irish artisans. Theresa has been described as someone who believed 'in causes and not in people'.[96] While this is true to the extent that her unflinching belief in her own political causes shaped so many of her actions, it was, fundamentally, her belief in herself and her ambition as an individual that best enabled her to further the cause of Ireland's union with Britain, as this portrait of her early years has shown. Theresa, as an upper-class woman, used her position as wife and consort to push boundaries and carve out a place in society that allowed her to play the leading part – never more so than in her role as vicereine. Theresa was a formidable and powerful woman whose strength of character shaped the reality around her: a woman who utilized a tangible private dominance and a visible public influence to help lace together a union that had begun to fray at the seams.

Dedicated to Lady Rose Lauritzen & Krissy Reid – two strong individuals who have touched my life at Mount Stewart and kept me from fraying at the seams.

Endnotes

1　E. Fingall, *Seventy Years Young: Memories of Elizabeth, Countess of Fingall* (Dublin: The Lilliput Press, 1991), p. 163.

2　D. Urquhart, *The Ladies of Londonderry: Women and Political Patronage* (London: I.B. Tauris, 2007), p. 79.

3　Ibid., p. 134.

4　S. Olson, *John Singer Sargent: His Portrait* (New York: St Martin's Press, 1986), p. 227.

5　Ibid.

6　See Fingall, *Seventy Years Young*, p. 163.

7　See, for instance, K.D. Reynolds, *Aristocratic Women and Political Society in Victorian Britain* (Oxford: Clarendon Press, 1998), p. 7; M. Pugh, *The Tories and the People, 1880–1935* (Oxford: Blackwell, 1985), p. 47. See also R.E. Finley-Bowman, 'An Ideal Unionist: The Political Career of Theresa, Marchioness of Londonderry, 1911–1919', *Journal of International Women's Studies*, 4, 3 (May 2003), pp. 15–29.

8　A. Jackson, 'Stewart, Charles Stewart Vane-Tempest-, sixth marquess of Londonderry (1852–1915)', in H.C.G. Matthew and B. Harrison (eds), *Oxford Dictionary of National Biography* (Oxford: Oxford University Press, 2004), viewable online: https://www.oxforddnb.com/view/10.1093/ref:odnb/9780198614128.001.0001/odnb-9780198614128-e-36626?rskey=zn-COBq&result=3 (accessed 14 February 2020).

9　Ibid. See also A. Jackson, *The Ulster Party: Irish Unionists in the House of Commons, 1884–1911* (Oxford: Oxford University Press, 1989).

10　See typescript copy of Lady Londonderry's memoirs, 'The Life of the Dowager Marchioness of Londonderry' (unpublished), 1915, H. Montgomery Hyde Papers, Public Record Office of Northern Ireland, D3084/C/B/3/1.

11　See Urquhart, *The Ladies of Londonderry*.

12　Ibid., p. 79.

13　G.E. Cockayne (ed.), *The Complete Peerage of England, Scotland, Ireland, Great Britain and the United Kingdom: Extant, Extinct or Dormant* (London: George Bell & Sons, 1910), vol. 4, p. 134.

14　See Urquhart, *The Ladies of Londonderry*, p. 79.

15　Typescript copy of Lady Londonderry's memoirs, 'The Life of the Dowager Marchioness of Londonderry' (unpublished), 1915, H. Montgomery Hyde Papers, Public Record Office of Northern Ireland, D3084/C/B/3/1.

16　G.E. Cockayne (ed.), *The Complete Peerage of England, Scotland, Ireland, Great Britain and the United Kingdom: Extant, Extinct or Dormant* (London: George Bell & Sons, 1896), vol. 7, p. 146.

17　Typescript copy of Lady Londonderry's memoirs, 'The Life of the Dowager Marchioness of Londonderry' (unpublished), 1915, H. Montgomery Hyde Papers, Public Record Office of Northern Ireland, D3084/C/B/3/1.

18　*Belfast Morning News*, 8 June 1868.

19　Typescript copy of Lady Londonderry's memoirs, 'The Life of the Dowager Marchioness of Londonderry' (unpublished), 1915, H. Montgomery Hyde Papers, Public Record Office of Northern Ireland, D3084/C/B/3/1.

20　Ibid.

21　Ibid.

22　Ibid.

23　For a contemporary account of the decision to confer this honour, see *[London Evening] Standard*, 24 October 1865.

24　Typescript copy of Lady Londonderry's memoirs, 'The Life of the Dowager Marchioness of Londonderry' (unpublished), 1915, H. Montgomery Hyde Papers, Public Record Office of Northern Ireland, D3084/C/B/3/1.

25　Ibid.

26　Ibid.

27　Ibid.

28　Ibid.

29　Ibid.

30　See Urquhart, *The Ladies of Londonderry*, p. 78.

31　See Fingall, *Seventy Years Young*, p. 163.

32　Ibid.

33　Typescript copy of Lady Londonderry's memoirs, 'The Life of the Dowager Marchioness of Londonderry' (unpublished), 1915, H. Montgomery Hyde Papers, Public Record Office of Northern Ireland, D3084/C/B/3/1.

34　A. Vickery, *The Gentleman's Daughter: Women's Lives in Georgian England* (London: Yale University Press, 1998), p. 8.

35　G.E. Cockayne (ed.), *The Complete Peerage of England, Scotland, Ireland, Great Britain and the United Kingdom: Extant, Extinct or Dormant* (London: George Bell & Sons, 1893), vol. 5, p. 133. For Frances Anne as a political hostess, see E. Vane-Tempest-Stewart, *Frances Anne: The Life and Times of Frances Anne, Marchioness of Londonderry, and her Husband, Charles, Third Marquess of Londonderry* (London: Macmillan, 1958).

36　For Castlereagh's role in shaping the Union, see J. Bew, *Castlereagh: Enlightenment, War and Tyranny* (London: Quercus, 2011), part 1, chps 17–18. See also M. Brown, P.M. Geoghegan and J. Kelly (eds), *The Irish Act of Union, 1800: Bicentennial Essays* (Dublin: Irish Academic Press, 2003).

37　See Urquhart, *The Ladies of Londonderry*, p. 79.

38　Ibid.

39　B. Hourican, 'Stewart, Charles Stewart Vane-Tempest', in J. McGuire and J. Quinn (eds), *Dictionary of Irish Biography* (Cambridge: Cambridge University Press, 2009), viewable online: https://dib.cambridge.org/viewReadPage.do?articleId=a8302&searchClicked=clicked&quickadvsearch=yes (accessed 17 February 2020).

40　Typescript copy of Lady Londonderry's memoirs, 'The Life of the Dowager Marchioness of Londonderry' (unpublished), 1915, H. Montgomery Hyde Papers, Public Record Office of Northern Ireland, D3084/C/B/3/1.

41 Ibid.

42 See Fingall, *Seventy Years Young*, p. 208.

43 Ibid.

44 J. Loughlin, 'The British Monarchy and the Irish Viceroyalty: Politics, Architecture and Place', in P. Gray and O. Purdue (eds), *The Irish Lord Lieutenancy, c.1541–1922* (Dublin: University College Dublin Press, 2012), p. 184.

45 Ibid.

46 Typescript copy of Lady Londonderry's memoirs, 'The Life of the Dowager Marchioness of Londonderry' (unpublished), 1915, H. Montgomery Hyde Papers, Public Record Office of Northern Ireland, D3084/C/B/3/1.

47 The handful of earlier Irish incumbents included Richard Talbot, 1st Earl of Tyrconnell (created Jacobite Duke of Tyrconnell in 1689), 1687–9, Richard, 1st Marquess Wellesley, 1821–8, 1833–4, and John, 4th Earl of Bessborough, 1846–7; see Gray and Purdue (eds), *The Irish Lord Lieutenancy*, appendix, pp. 233–7.

48 *Belfast News-Letter*, 20 September 1886.

49 C. O'Mahony, *The Viceroys of Ireland* (London: John Long, 1912) p. 298.

50 P. Gray and O. Purdue, 'Introduction: The Irish Lord Lieutenancy, c.1541–1922', in Gray and Purdue (eds), *The Irish Lord Lieutenancy*, p. 6.

51 Quoted in Urquhart, *The Ladies of Londonderry*, p. 45.

52 Typescript copy of Lady Londonderry's memoirs, 'The Life of the Dowager Marchioness of Londonderry' (unpublished), 1915, H. Montgomery Hyde Papers, Public Record Office of Northern Ireland, D3084/C/B/3/1.

53 See Urquhart, *The Ladies of Londonderry*, p. 80.

54 Countess Talbot was a paternal great-grandmother of Theresa and had grown up at Beauparc, County Meath. She died while serving as vicereine on 30 December 1819; see Cockayne, *The Complete Peerage*, vol. 7, pp. 362–3; *Saunders's News-Letter*, 31 December 1819. For the day of official mourning, see *Dublin Evening Post*, 8 January 1820.

55 G.E. Cockayne (ed.), *The Complete Peerage of England, Scotland, Ireland, Great Britain and the United Kingdom: Extant, Extinct or Dormant* (London: George Bell & Sons, 1890), vol. 3, p. 244.

56 *Belfast News-Letter*, 24 January 1888.

57 P. Jalland, *Women, Marriage and Politics 1860–1914* (Oxford: Clarendon Press, 1986), p. 189.

58 See Urquhart, *The Ladies of Londonderry*, p. 82.

59 See O'Mahony, *The Viceroys of Ireland*, p. 299.

60 Ibid., p. 301.

61 Ibid.

62 *Times*, 17 March 1919.

63 See Urquhart, *The Ladies of Londonderry*, p. 79.

64 Typescript copy of Lady Londonderry's memoirs, 'The Life of the Dowager Marchioness of Londonderry' (unpublished), 1915, H. Montgomery Hyde Papers, Public Record Office of Northern Ireland, D3084/C/B/3/1.

65 See Urquhart, *The Ladies of Londonderry*, p. 78.

66 See Reynolds, *Aristocratic Women*, p. 155.

67 Typescript copy of Lady Londonderry's memoirs, 'The Life of the Dowager Marchioness of Londonderry' (unpublished), 1915, H. Montgomery Hyde Papers, Public Record Office of Northern Ireland, D3084/C/B/3/1.

68 *Irish Times*, 25 January 1888.

69 Ibid., 10 February 1885.

70 Anon., 'Improvements at the Castle', *The Irish Builder*, 9, 171 (1 February 1867), p. 29.

71 *Queen*, 5 February 1887.

72 *Irish Times*, 25 January 1888.

73 Ibid.

74 Ibid., 31 January 1888.

75 K. Theodore Hoppen, *Governing Hibernia: British Politicians and Ireland 1800–1921* (Oxford: Oxford University Press, 2016), p 264.

76 See Urquhart, *The Ladies of Londonderry*, p. 80.

77 Ibid.

78 *Belfast News-Letter*, 24 January 1888.

79 *[London Evening] Standard*, 4 January 1887.

80 J. Helland, '"Caprices of Fashion": Handmade Lace in Ireland 1883–1907', *Textile History*, 39, 2 (2008), p. 195.

81 *Belfast News-Letter*, 24 January 1888.

82 See Helland, '"Caprices of Fashion"', p. 194.

83 *Belfast News-Letter*, 24 January 1888.

84 J. O'Grady, *The Life and Work of Sarah Purser* (Dublin: Four Courts Press, 1996), pp. 202–3.

85 Ibid.

86 *Belfast News-Letter*, 24 January 1888.

87 See Helland, '"Caprices of Fashion"', p. 197.

88 *The Lady*, 5 July 1888, quoted in Helland, '"Caprices of Fashion"', p. 204.

89 For the diamonds, see H. Montgomery Hyde, *The Londonderrys: A Family Portrait* (London: Hamish Hamilton, 1979), p. 14. The parure of diamonds, known as the 'Down Diamonds', was brought into the family by Mary Cowan, wife of Alexander Stewart, when they married in 1737. Mary's brother, Sir Robert Cowan had been Governor of Bombay, and as his heiress, Mary inherited his property which is said to have included the diamonds.

90 See, for example, *[London Evening] Standard*, 2 November 1886; *Nottingham Evening Post*, 4 January 1887; *Lakes Chronicle*, 27 January 1888.

91 Typescript copy of Lady Londonderry's memoirs, 'The Life of the Dowager Marchioness of Londonderry' (unpublished), 1915, H. Montgomery Hyde Papers, Public Record Office of Northern Ireland, D3084/C/B/3/1.

92 See Helland, '"Caprices of Fashion"', p. 202.

93 Ibid.

94 *Belfast News-Letter*, 24 January 1888.

95 See Fingall, *Seventy Years Young*, p. 209.

96 See Urquhart, *The Ladies of Londonderry*, p. 75.

Seven

'One of the Sincerest Democrats of her Caste'

Lady Ishbel Aberdeen's Crusade against Tuberculosis in Ireland

Éimear O'Connor

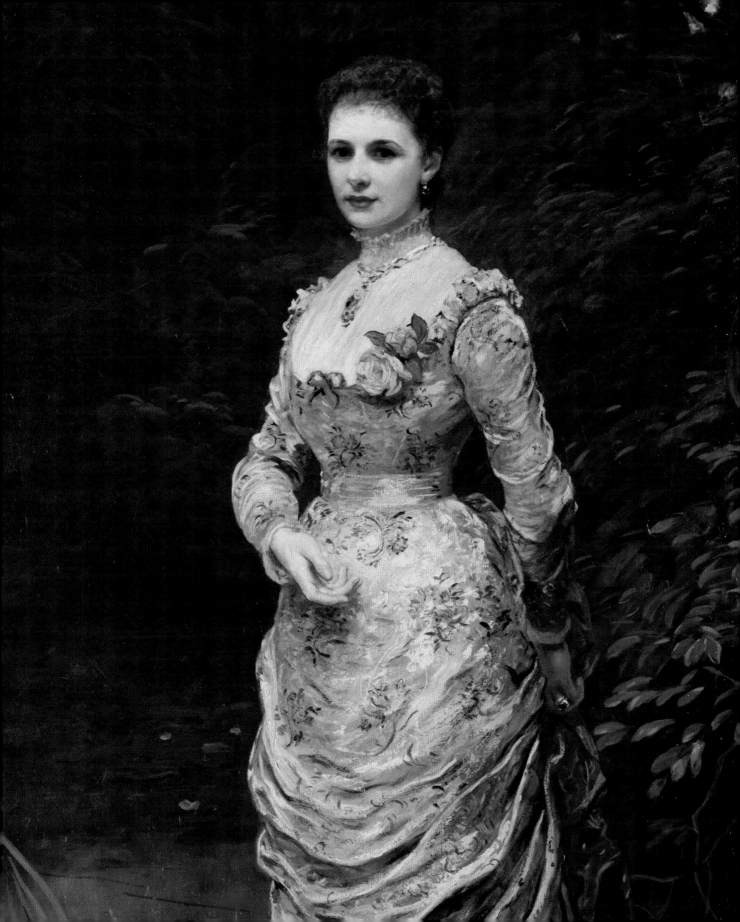

'You can do it if you will arm yourselves with faith and prayer ... and above
all, never be afraid.'[1]

Introduction

The quotation above aptly describes Lady Ishbel Aberdeen's attitude to life, and to
her enduring desire to contribute to society by helping those less fortunate than
herself. Born into a political family, Ishbel Hamilton-Gordon (née Marjoribanks),
Countess of Aberdeen (Fig. 07.01), later Marchioness of Aberdeen and Temair
(1857–1939), was a life-long supporter of the Liberal Party. Her father, Dudley
Coutts Marjoribanks, was a Liberal MP for Berwick-on-Tweed. Gladstone was
a friend of the family; Ishbel absorbed his attitude to politics analogous with a
belief in religious faith. From a young age she was very aware of the importance
of service to the community, and at the same time, she paid particular attention
to the 'morality and livelihoods' of working women.[2] Her approach to the plight
of working women, whether lace makers in Irish cottages, or those who found
themselves on the streets of London, is notable; it denotes her attitude to gender
balance, a stance that was to bring her to support the concept of full suffrage for
all women in later years. In the interim, Ishbel and her husband, John Campbell
Hamilton-Gordon (1847–1934), 7th Earl of Aberdeen, later 1st Marques of Aber-
deen and Temair, whom she married in 1877, were well-matched, and 'drawn
together' through their mutual religious belief in a life dedicated to the service of
God. It must be understood, in the context of the historical era, that 'fundamental
to their attitude was a paternal disposition' and a concomitant outlook on social
benevolence which accepted as 'a given' that society, as created by God, was natu-
rally hierarchical.[3] Therefore, 'it was the duty of the wealthy to protect, guide and
help the lower ranks, maintaining a firm moral superintendence'.[4] Thus, before
they arrived in Dublin in 1886, the couple had already involved themselves with
several social issues, including the National Home Reading Union, the Parents'
National Education Union, Canning Town Women's Settlement, and homes for
working girls.[5]

With their support of Home Rule well-known to political observers, Lord
Aberdeen was appointed by Gladstone to the role of viceroy of Ireland in 1886. Lady
Aberdeen was astute, clearly politicized in spite of her protestations to be other-
wise, and highly experienced at working with those who were far less privileged.[6]
Moreover, as an equal partner in her marriage, she was never of a mind to remain
in the background while her husband undertook his formal duties.[7] With Home
Rule in mind, the Aberdeens determined to bring about an economic revival in
Ireland, and for Ishbel, that was going to happen through her role as President of
the Irish Industries Association, inaugurated in May 1886, along with her support
of the Irish lace, poplin and art needlework embroidery industries. As it turned
out, the Aberdeens were in Dublin Castle for just under six months, during which
time they established themselves as trustworthy supporters of various causes
for the less fortunate in Ireland. Although they had to leave Dublin Castle when

Parliament was dissolved in July 1886, they assumed that they would be returned without haste. But, as it turned out, Lord Aberdeen had to wait until 1905 before being reappointed by Sir Henry Campbell-Bannerman; the couple arrived back in Dublin, and in different political circumstances, in February 1906.

In the interim, Lady Aberdeen did not lose contact with Ireland. Determined to advertise the place and its people as the anticipated beneficiaries of Home Rule, she established her 'Irish Village' at the Chicago World's Fair in 1893. She populated the village as a settlement – a home from home of sorts – replete with Irish labourers, all of whom were highly trained in lacemaking, woodwork, dairying and various other forms of craft and labour.[8] That same year, Lord Aberdeen was appointed as Governor General of Canada, and while in residence there, Lady Aberdeen continued her support of Irish home industries by being sure to be photographed in Irish-made dresses, replete with handmade lace and extraordinary embroidery, and by travelling to Ireland on a frequent basis to oversee meetings of the Irish Industries Association. As a consequence of her work with Irish home industries, and her experience of the living conditions of labourers around the country and in Dublin, Lady Aberdeen then turned her attention to one of the greatest health issues of the time: tuberculosis (TB). Since her death, and in the context of the rebuilding of the Irish nation in the post-Treaty era, her important role in this regard has been largely overlooked. It is as a result of access to archival material held by her family at the Haddo Estate in Aberdeenshire, and by the National Archives of Ireland, that Lady Aberdeen's significant involvement in the project to eradicate TB in Ireland is made known anew in this chapter.

The National Council of Women, 1893

Lady Aberdeen, always interested in supporting causes concerning women, took the opportunity, while in Canada, to encourage the establishment of a Canadian branch of the National Council of Women. The idea to do so emerged as a result of a major Women's Congress held during the World's Fair in Chicago in 1893, during which she was elected overall President of the organization. In her role as President, she was expected to encourage the formation of National Councils, and local Councils, so that 'local societies and institutions with which women [were] connected [could be] invited to affiliate'.[9] Her experience of working with the model of expansion used by the organization was to prove useful on her return to Dublin as vicereine in 1906. With regard to the formation of the National Council in Canada, and its work, which she found 'awe-inspiring', Lady Aberdeen noted:

> About 1,500 or more present. A very hearty meeting, the movement to start this Council had its origin at the Women's Congress at Chicago [in 1893]. Most countries were represented there by more or less officially appointed women, but no women had been appointed for Canada, and so it came about that only women sent by various Societies, and those nearly all in Ontario, were present. These met at the end of the Congress and determined to start a

Seven

195

National Council of Women for Canada, representing all phases of women's work, on the same lines as the National Council for the United States which has been working during these past five years ... The National Council was duly brought into existence by resolution and I have accepted the Presidency, being already President of the International Council.[10]

More importantly, her commitment to the causes of women, her enthusiasm, and the importance to her of 'all sections of thought and work' is palpable:

It is wonderful to feel and see the intense desire and readiness of the women from some such movement as this and it is awe-inspiring to find this work just prepared all ready to my hand – a work to which no one can take exception as it is intended to combine all sections of thought and work, secular philanthropic, and religious.[11]

It was this fervour and commitment to 'secular, philanthropic, and religious' work that she brought to Dublin in 1886, and again, in 1906.

Return to Dublin

While in Canada, Lady Aberdeen maintained her connection with Ireland, and often travelled to Dublin to attend meetings of the Irish Industries Association. She was aware of, and somewhat, although not entirely, sensitive to the political and cultural changes that had taken place in Ireland since 1886. She knew that she had to be careful about the 'controversial nature' of anything she might become involved with on her official return to Dublin Castle in 1906. With this care in mind, as early as 1905, she was in correspondence with the author Stephen Gwynn (1864–1950), then living in Raheny, in north County Dublin.[12] Evidence of the extent of their friendship and correspondence is brief but fascinating when considered in the political context of the time. Gwynn was a Protestant, a nationalist, and a member of the Gaelic League, and as such, his correspondence with Lady Aberdeen suggests that she was sympathetic to the nationalist cause. Clearly responding to a query about who or what she should support as vicereine, Gwynn wrote:

In the matter of art, there is the same lack of objects. Still you have plenty to do. Hugh Lane will be wanting help for his gallery of modern art and you can be of great service there – for he is preaching in the wilderness. In the way of painters, there is old Mr Hone who has heaps of money and no ambition and his house is full of the finest landscapes that anyone could see – but go and look at them beside the work of the Barbizon men with whom he studied. The pictures he gave Lane for the Gallery were about the best things in the room. But I needn't tell you about art. You will hear all about Ms Purser and her Tower of Glass and Miss Gleeson with her Dun Emer. I commend to you, my cousin, Dermod O'Brien, who really can paint, and deserves more luck than

he is getting. If he were a recipitous person, instead of being a landlord with a big place and a small income, we should all be touting to get him commissions. Of course, you know the work of old Mr Yeats and of young Orpen.

Gwynn continued thus:

> It would be well worth your while to read regularly the League's paper ... and also a little weekly called The Irish Peasant. They will tell you a great deal about the ideas at work in this country ... I hope that you will weigh this aspect of the League – a body existing to educate the nation actually providing teaching in its own classes, and beyond that, colleges where the state teachers can go and learn how to teach Irish. There are two of these colleges now, and there will soon be a third (here in Dublin) and probably a fourth (in Ulster). The League itself, you can only help indirectly, I think. But if you approve of it ... Dean Bernard is probably the ablest man in the Irish church today and he has been induced, I hear, to consent that a service in Irish shall be held at St Patrick's [Cathedral, Dublin] on St Patrick's Day. Tell him you are glad to hear it.[13]

According to another letter from Gwynn, dated February 1906, the month that the Aberdeens returned to Dublin, and which reveals his familial connections, not only had she taken some of his advice, but he could now offer her a method by which to introduce the Gaelic League into Castle life:

> I am very glad you congratulated Dean Bernard on his resolution. You know that Mr Hannay, the rector of Westport in Mayo, is author of those prodigiously clever books <u>The Seething Pot </u>and <u>Hyacinth</u>. He is a member of the executive of the Gaelic League and, of many clergymen in Ireland who are asking how the Church of Ireland should justify her title, the only one who has the courage of convictions – or opinions. I detest a great deal in 'Hyacinth', but it is a wonderful and sympathetic presentment, from outside, of the average Protestant attitude towards Irish nationality and the duty of a citizen. Needless to say, the book and his connection with the Gaelic movement bar him effectively from promotion in the church. Would you not be able to have him asked to preach – or the like of that – that is assuming you think what is likeable in the books outweigh what one may dislike. But if you want to encourage talent, there are a few men in Ireland who have shown so much ...
>
> You cannot do better about the Irish tableaux than write to Mrs Milligan Fox. They were arranged by her sister, Miss Alice Milligan – to whom, I fear, the Castle would be anathema, as she is a great little Fenian. But Mrs Fox was in touch with the whole, and could probably direct anything of the kind. The Miss O'Brien who took part was probably Barry O'Brien's daughter. My cousin Nelly O'Brien lives here at 132 Stephen's Green, and I think you should

Fig. 07.02.

Dermod O'Brien

*John Campbell Hamilton-Gordon
(1847–1904), 7th Earl of Aberdeen,
later 1st Marquess of Aberdeen
and Temair*

c.1912

Courtesy of the Office of Public
Works, Dublin Castle.

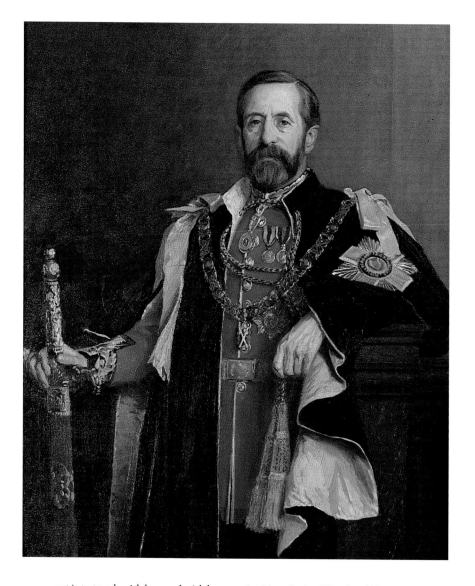

get into touch with her, and with her cousin, Mary Spring Rice, Lord Montea-
gles [sic] daughter. Both have been presented [at the viceregal court], I expect.
They are both working hard for the Gaelic League. A thing which through
them you might accomplish would be to stir up in whatever few representa-
tives of the old Irish houses still retain a place as part of the hereditary nobility,
something of the spirit which has (I understand) never left the Scotch heads
of the clans – that is, a feeling for the old customs and language. The present
Inchiquin (who is, of course, head of the O'Briens) has, I believe, a strong feel-
ing for Ireland and is certainly popular in Clare. His brother was A.D.C. [Aide
de Camp] a few months ago – I do not know if he is still in Dublin …

I hardly know these relatives of mine at all and I do not know if the Cahir-
moyle O'Briens (to whom my cousin Nelly belongs) and their Spring Rice
connections are in touch with them either to any great extent. But I fancy

they would be acceptable to any stimulus of racial pride. Everybody in Ireland values a connection with the 'old stock' to support whatever belongs to the past glory of Ireland …[14]

Gwynn's encouragement and advice gives a background for the many balls, featuring Irish lace, Irish dancing and Irish tableaux performances that took place in Dublin Castle under the watchful eye of Lady Aberdeen. A portrait of Lord Aberdeen by Gwynn's cousin, Dermod O'Brien (1865–1945), which was exhibited at the Royal Hibernian Academy in 1912 and remains in the Dublin Castle collection, is further evidence of his influence (Fig. 07.02).[15] Lady Aberdeen's interest in the Gaelic language, and in whatever form of nationalism she could support, also offers a context for the dress she wore at a Pageant of Irish Industries, held in St Patrick's Hall, Dublin Castle, in 1909. She arrived in splendour, 'wearing a most stately and becoming gown of pale saffron Irish poplin … the bodice draped with most beautiful Clonmacnoise lace, fastened with gold Celtic ornaments and diamonds; the graceful sleeves were the same lace'.[16] Attached to the gown was her official court train, made by Mrs Sims of Dublin, and embroidered by the Royal Irish School of Art Needlework during her previous period as vicereine in the Castle in 1886. Most significant, however, was the embroidered detail, presumably by the Royal Irish School of Art Needlework, that had been added to the front of the dress. Featuring 'raised gold embroidery on a white poplin ground', the emblem displayed was, in fact, the Irish national trademark, upon which was inscribed, in the Irish language, the words *Déanta in Éirinn*, meaning 'made in Ireland' (Fig. 07.03).[17] With the cause of Irish industries already close to her heart, on her formal arrival back at Dublin Castle in 1906, Lady Aberdeen soon found another major cause for concern, about which she decided to do something to help. The cause was TB – a disease that ignored class and creed, and was widespread throughout Ireland.

Tuberculosis and the Formation of the Women's National Health Association of Ireland

Soon after their return to Ireland, Lord and Lady Aberdeen were approached by the 'National Association for the Prevention of Tuberculosis (NAPT)'.[18] The organizers asked Lady Aberdeen, known for her particular commitment to women's causes, to 'take part in its programme', but the programme itself was said to have been 'largely ineffectual because of its elitist character'.[19] The death rate from the various forms of TB in Ireland was steadily increasing, in spite of the work of the NAPT, founded in 1899, which provided information and lectures on the 'value of sensible precautions'.[20] By 1906, there were already provisions in place to hospitalize patients away from the rest of the population, in an attempt to cure those patients, and to bring the number of cases of infection down. From Lady Aberdeen's point of view, it is not surprising that she chose TB as a major

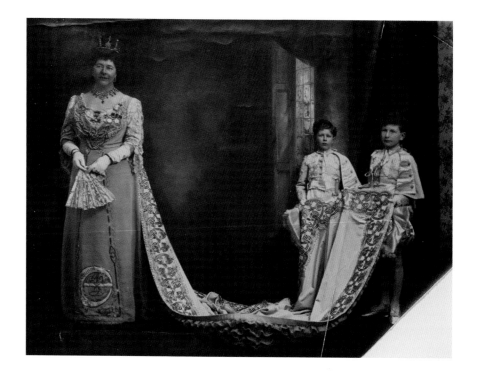

cause for her help and attention. The disease ravaged the households around the country that she was trying to support through the Irish Industries Association, and more specifically, she could see the effects of bad housing and illness on the streets that she had to pass through to get from the Viceregal Lodge in the Phoenix Park to Dublin Castle.

In response to the distress caused by poverty and illness, Lady Aberdeen, already well-grounded with the skills necessary for organizational success, founded an organization that she named the Women's National Health Association (WNHA). The first meeting of the provisional committee of the organization was held in the Viceregal Lodge in the Phoenix Park on 12 April 1906, with those present being: Lady Aberdeen in the chair, the Dowager Marchioness of Dufferin and Ava; the Countess of Mayo; Miss Rosa M. Barrett; Mrs Matheson; Mrs Foran; Mrs A.M. Sullivan and Mrs Rushton.[21] Akin to the working method of the International Council of Women, it was agreed that the work of the WNHA would be carried out by local branches affiliated to the Central Council. The Constitution of the organization, which was ratified at the meeting, stated that all branches of the WNHA were to include 'all classes, creeds and politics, to make it thoroughly understood that [the organization was] entirely non-sectarian and non-political'.[22] It may well be that Lady Aberdeen encouraged the non-sectarian and non-political focus as a result of her friendship with Horace Plunkett, whose Irish Agricultural Organisation Society co-operative movement worked on the same principles. Fundamental to the concept of the WNHA, again mirroring the example of the operational model of the International Council of Women, was that it would initiate and encourage contact with each and every organization around the country

that was working within the realm of health and housing so as to offer lectures, advice and information.

One of the first issues that the WNHA decided to confront was TB and its effects in Ireland. At the request of the inaugural committee, Lady Aberdeen, as President, was deputed to send the following resolution to the Chief Secretary for Ireland, Augustine Birrell:

> The Committee of the Women's Health Association of Ireland venture respectfully to draw the attention of His Majesty's Government to the enormous death-rate in Ireland from tubercular diseases, and to suggest that special measures should be adopted for the protection of the community from the increasing ravages of a disease from which nearly 18,000 people die annually, and from which it is estimated that over 10,000 people suffer. The measures which the Women's National Health Association of Ireland venture to suggest are:
>
> 1. The immediate introduction of Legislation giving powers to County Councils to erect sanatoria and calmetter dispensaries.
>
> 2. The making of Tuberculosis a notifiable disease.[23]

The address given for the WNHA at the time was the Viceregal Lodge, Dublin, then the home of the viceroy and vicereine. As President of the organization, Lady Aberdeen, with the imprimatur of her husband, offered to undertake all correspondence on behalf of the WNHA using her address at the Viceregal Lodge.[24] In retrospect, the decision to do so was a mistake, both within the context of the ever-strengthening nationalist movement in Ireland, and in terms of support for Lady Aberdeen from among those who might otherwise have befriended her. In other words, Lady Aberdeen was making enemies within and without her camp.

The WNHA was inaugurated by Lord Aberdeen at a public meeting on 13 March 1907, and the first meeting of the Provisional Committee, which was held on 12 April 1907, got to work straight away.[25] Concerned to reach every part of the countryside, the first touring 'wagon', called 'Éire', complete with lecture slides and pamphlets, was introduced to the public concurrent with a formal 'Tuberculosis Exhibition along the lines of similar undertakings in the United States and on the continent', at the Irish International Exhibition held in Herbert Park, Dublin, in 1907.[26] The minutes of the second meeting of the organization, which was held in November 1907 in the Home Industries Section of the Irish International Exhibition in Herbert Park, reveal a focus on hygiene, specifically within the national school system. With regard to TB, it was proposed at that meeting that the WNHA should approach 'ten clinical hospitals in Dublin' with a request that they establish a fortnightly TB hospital, and that the WNHA would provide two nurses to visit TB patients 'in their own homes in accordance with the hospi-

tals above named'.[27] As it turned out, the display held in association with the Irish International Exhibition and the subsequent travelling wagons were so successful that in the following year, 1908, 'the WNHA won joint first prize of $1000 with the C.O.S. [Charity Organization Society] of New York, as the two voluntary societies who had done the most effective work against tuberculosis' (Fig. 07.04).[28]

Tuberculosis Prevention Bill, 1908 and the National Health Insurance Act, 1911

By 1908, Lady Aberdeen, through the auspices of Lord Aberdeen, had persuaded the Chief Secretary for Ireland, Augustine Birrell, to support the Tuberculosis Prevention (Ireland) Bill, which was going through the House of Commons for the second time that year.[29] Certain elements of the Bill were a cause of concern for some members of the House. Joseph Nannetti, MP for the constituency of Dublin College Green, for example, did not intend to oppose the Bill, but he felt duty-bound to point out the issues, and his speech to the House was recorded thus:

> In respect of one or two points connected with the Bill there had been a good deal of comment. Its provisions applied to every person who was troubled with tuberculosis, and when the medical officer of a district found that a person was suffering from the disease, he had to report that person immediately, which meant an expenditure of 2s. 6d. per patient for the local authority. The question of providing sanatoria for these unfortunate people also came in, and there was no contradicting the fact that these establishments

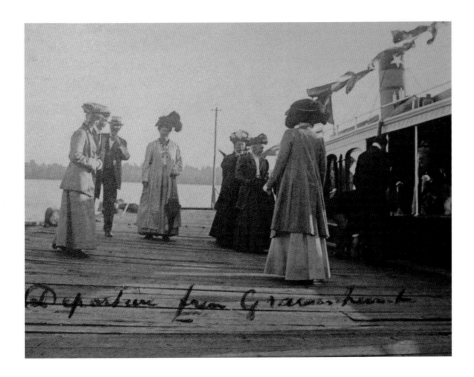

Fig. 07.05.

Unknown photographer

Lady Aberdeen's departure
from Muskoka Sanatorium,
Gravenhurst, Canada

1909

Courtesy of the Gordon
Family Archive, Haddo Estate,
photograph © Éimear O'Connor.

must cost a great deal of money. He imagined that if the Bill passed, every working man who might be afflicted with this disease would, as it were, be singled out, and would be marked as an affected person. In many ways that might injure him, and more especially it might be the cause of his being unable to find employment. Other men, naturally, would not like to work in a place with a man who would be liable to spread infection, and under the circumstances he thought they should give the measure fair consideration in Committee in order to ensure that the least possible amount of harm should be done. Personally, he was in favour of doing everything that was possible to remove the danger of the spread of infection, but so many difficulties might be created and hardships caused that he thought they should be very careful how they went to work ... it was necessary that certain precautions should be taken and that those interested in Ireland should have an opportunity of considering the Bill in Committee with a view to inserting Amendments that would have the effect of minimising the worst results anticipated from the measure.[30]

Birrell was concerned that the Bill, which was going through procedures in December 1908, might not pass. Clearly frustrated, he wrote to Lady Aberdeen:

> But if the Tuberculosis Bill is killed, let it be made plain who are the murderers – for it sometimes happens they lose courage when forced into the open country. In no event will your labours be in vain. After all to awaken the country is the first and chief thing to do. I grow more and more a Sinn Feiner![31]

Fig. 07.06.

Unknown photographer

Meeting in the grounds of Ely
House, Dublin

Undated

Courtesy of the Gordon
Family Archive, Haddo Estate,
photograph © Éimear O'Connor.

In spite of Birrell's concerns, the Bill was passed, although it was not until the advent of the National Health Insurance Act, 1911, that specific funds were made available for the treatment of TB in Ireland.[32] It was that fund which would help to establish the WNHA as the organization at the forefront of TB care in Ireland.

In the meantime, in 1909, Lady Aberdeen returned to Canada, this time to Ontario, to visit the Muskoka Tuberculosis Sanatorium in Gravenhurst to see for herself how the facilities there benefitted those who were suffering from the disease. Built in 1897 as Canada's first TB hospital, on a site chosen for its fresh air, it was remodelled in 1902. Muskoka Tuberculosis Sanatorium utilized the same system of displays, pamphlets and travelling exhibitions of information as the WNHA, to help outlying communities develop better hygiene in the home, in a bid to eradicate the disease.[33] More importantly, Lady Aberdeen would have seen the purpose-built, glass-fronted pavilions, with open-air balconies, used as wards for patients suffering from the disease (Fig. 07.05).

That same year, 1909, Lady Aberdeen revealed her plan for a new set of postage stamps, the sale of which was intended to help the cause of the eradication of TB in Ireland. As it happened, the stamp idea did not come to fruition, but a letter to Lord Aberdeen from Dublin-based distiller, Mr Power, is worth quoting for the evidence it contains of the attitude to Lady Aberdeen in some quarters at this particular time. It is of note that Lady Aberdeen's brother had recently died, a point that is raised below to suggest that she should be in mourning rather than being publicly involved in 'the cause of tuberculosis extermination':

Since my return from Italy I have mixed much with Dublin people – especially the middle classes – and I was deeply alarmed to hear things said about her Excellency and her labours in the cause of tuberculosis extermination in our country. I must earnestly appeal to you to prevent her starting this new idea about a stamp collection for Christmas ... (this stamp idea was tried at the late Exhibition and again recently by the Sinn Fein party and proved in each case a failure! It is not understood in Dublin and there would not be the least bit of enthusiasm to make it a success.) My sincere advice for her Excellency would be to avail of her brother's recent and sad death and not to force 'tuberculosis' any more upon the shop keepers, the hotel people and of course every conservative in the country – those who are ... 'galled' by the provisions of the Budget Bill are all outspoken in their hostility towards her Excellency's proceedings and very unpleasant things are being said ... And I can assure you it is unwise that any further volume of literature should emanate from the Vice-Regal Lodge under the franc of 'Free postage'. I can assure you further that even the medical profession are resenting ...[34]

The very idea that Lord Aberdeen would try to prevent his wife from doing what she thought was right was anathema to him. Their shared belief in working for the betterment of society was the foundation of their marriage. But the political landscape in Ireland was changing far more rapidly than Lord and Lady Aberdeen might have anticipated. In spite of her various successes, and her acceptance by the poor of Dublin and further afield, Lady Aberdeen's activities were not popular among certain nationalists either. Arthur Griffith, for example, used his newspaper, *Sinn Féin*, to undermine Lord Aberdeen's political acumen by continually insinuating that she was, in fact, in charge in Dublin Castle. For many at the time, Lady Aberdeen's public profile and political influence 'eclipsed' that of her husband, so much so that in May 1914, Griffith came right out and wrote that it was 'her ladyship ... not the babbling creature who wears the title' who was 'the real governor-general of Ireland'.[35]

A Place to Work – 8 and 9 Ely Place

It was becoming clear that the WNHA needed a base that was not connected with either the Viceregal Lodge, or indeed, with Dublin Castle. In 1894, Lord and Lady Aberdeen had taken out a sixty-year lease on number 8 Ely Place, otherwise known as Ely House, for Lady Aberdeen to use as a base while in Dublin.[36] Therein lay the solution; the couple used the upstairs apartments as their home away from the Viceregal Lodge, and so sometime in late 1911, the ground floor rooms were given over as offices to the WNHA (Fig. 07.06). That same year, the Aberdeens took out a 42.5-year lease on number 7 Ely Place, which was situated beside number 8.[37] The couple retained accommodation in Ely House, and later in number 7, until the late

Fig. 07.07.

Unknown photographer

The grounds at Peamount
Sanatorium

Undated

Courtesy of the Gordon
Family Archive, Haddo Estate,
photograph © Éimear O'Connor.

1930s. In the interim, within the two houses ran every spin-off of the WNHA including the Civics Institute, the Mother and Baby Club Committee, which established clubs all around Dublin's inner city, all with a focus on household and baby hygiene, and the Playground Committee, which established the Ormond Market Boys Camp and other playgrounds on empty building sites around Dublin so that children could get enough fresh air. During the War years, there was a clothing depot for those in need, in one of the houses, while number 8 played host to first-aid training classes for the Irish Red Cross, which was brought to Ireland by Lady Aberdeen in 1914. Perhaps Lady Aberdeen took the advice not to send literature from the Viceregal Lodge; but her work and that of the WNHA was voluntary, and was fully supported by Lord Aberdeen, who allowed the organization to post material using the stamping facilities at Dublin Castle. So it was that in 1912, the WNHA included an information leaflet about the National Insurance Act (1911) with letters that were going out around Ireland from Dublin Castle. The action did not go down well in London; the Chief Secretary was formally asked whether he was aware that:

> … envelopes bearing the Royal Arms and franked by the Government have been dispatched to the members of the National Health Association and others, from Dublin Castle, these envelopes containing, amongst other matters, a pamphlet known as the Little Red Book, explaining in a popular way, and from a Liberal standpoint, the main benefits of the National Insurance Act; and will he explain why there has been this expenditure of public money on stationery and postage.[38]

Yet it was the passing of the National Insurance Act that necessitated the provision of sanatoria around the country, which in turn gave Lady Aberdeen and the WNHA the opportunity to establish a hospital that is still in operation today (Fig. 07.07).

The WNHA and the Society of United Irishwomen – A Misunderstanding

Founded by Anita Lett and Ellice Pilkington in 1911, the Society of United Irishwomen was inspired by the co-operative movement, and by the work of Horace Plunkett.[39] Plunkett and Lady Aberdeen were long-time friends, and indeed, she appears to have been influenced by his ideas about co-operation. The aims of the Society of United Irishwomen were not, in fact, dissimilar to those of the WNHA, in that it worked with women to encourage them to establish home industries, to maintain a hygienic home, to provide healthy food for their families, and to take

an active interest in public and intellectual life. Thus, the membership could prove advantageous to the WNHA, which wanted to establish a network of affiliated organizations throughout the country. Hardly surprisingly, given their association with Horace Plunkett and the ideals of the Irish Agricultural Organisation Society, the group held their meetings in Plunkett House on Merrion Square in Dublin. But no sooner had the Society been established than a misunderstanding arose as to its purpose, and rumour abounded regarding its apparent desire to be 'antagonistic' towards the WNHA. The situation was potentially dangerous for the public standing of the WNHA; it required an exercise in diplomacy to discourage the gossip, and importantly, to keep the WNHA away from any negative publicity. Plunkett and Lady Aberdeen clearly met to discuss the situation, which led to a public meeting at which both spoke about the differences between the two organizations, and how one could help the other. Plunkett wrote to Lady Aberdeen the following day; his letter reveals the subtext of the issues that had been causing problems:

My dear Lady Aberdeen

I thank you cordially for your kind letter and still more for your speech. You have done a great deal to clear up a serious misunderstanding. Above all you have ensured co-operation between two bodies of Irish women, each of which is capable of doing splendid work for Ireland. Much hangs upon the right relations between them being maintained. You say you wish we could have talked over the whole matter before any public reference had been made to the relations between the two organisations. To be quite frank, I did not like to trouble you again with my views. Before I knew anything about the United Irishwomen you told me that you felt aggrieved at my having promoted their organisation without first consulting you. I explained that my participation in the matter was limited to giving them the hospitality of The Plunkett House for their meetings; but I promised to make full enquiry and see whether there was any danger of the conflict you anticipated between the United Irishwomen and the WNHA. To this enquiry, which I made very fully, I owed my first knowledge of the aims and objectives of the new Association. I at once recognised that they were reviving an old project of the IAOS [Irish Agricultural Organisation Society]. I ought to have known all this when you mentioned the matter to me; but the fact is I was in rather poor health last year and was guilty of many sins of omission in my work.

Before I left for the United States, I wrote to you saying that I had satisfied myself that the United Irishwomen could not possibly interfere with your work, but on the contrary, must be helpful to it. I also indicated, if I remember right, the special reasons why they must remain a distinct and separate organisation. To this letter I got no reply but on my return from America I was shocked to find that several leading people in the WNHA were repeating

the fiction about United Irishwomen not only overlapping, but actually being antagonistic to the Health Association. For instance, when I mentioned to Mr Fletcher that I had heard this extravagant rumour, he told me that he himself had believed it to be true. Nothing could show more clearly that extent to which harms had been done, and the urgent need of dealing with the matter in the most public way. It is only thus that you can counteract gossip.

I cannot help feeling that your speech of yesterday would have been deprived of half its beneficial effect if you had not been able to make it perfectly clear that both you and I spoke publicly our own minds, and not each other's after a private agreement as to how public opinion was to be handled.[40]

The meeting appears to have satisfied everyone concerned in both organizations, although whether gossip continued on the ground is difficult to ascertain. At a strategic level, it was vital that the matter was sorted out because Lady Aberdeen and the WNHA had a plan for the treatment of TB in Ireland; the organization could not afford to be caught up in a quagmire of controversy.

Supply and Demand: The WNHA and the Foundation of Peamount Hospital

The National Insurance Act required that hospitals for the treatment of TB should be provided all around Ireland. Many years later, in 1939, Lady Aberdeen wrote:

The advisory committee appointed by the Government to recommend the steps that must be taken to make that Act effective explained in their report that, as far as Ireland was concerned, there was no possibility of providing the number of beds made requisite by a certain date by [the Chancellor of the Exchequer] Mr Lloyd George's promise, unless a voluntary association, like the Women's National Health Association, would undertake to provide emergency accommodation, receiving a grant for the purpose. With this offer before us, we did not need twice telling, and the end of it was that we received a grant of £25,000, with which were established two sanatoria – one at Peamount, about eleven miles from Dublin, and the other at lovely Rossclare, near Enniskillen.[41]

It has been more or less forgotten that it was Lady Aberdeen and her WNHA that first established Peamount Hospital. The grant allowed the WNHA to purchase a house and surrounding farmland at Peamount, on the outskirts of Dublin, as well as to establish a smaller sanatorium at Rossclare on Lough Erne, in County Fermanagh. Wooden structures with open balconies, akin to those at Gravenhurst, in Canada, were built as pavilion wards around the main house at Peamount, and at Rossclare, and a matron and full staff were employed by the WNHA to look after the patients.

However, although Peamount Hospital was established in late 1912, it did not, or rather it could not accept patients for a time, specifically because there were difficulties over access to water on the site. The only water well was on the farm next door, and thus far the owner had not granted access to it. However, according to one observer, Miss C.M. Brennan, Matron at Peamount, in October 1912, it was Lady Aberdeen who resolved the issue. Miss Brennan wrote to Lord Aberdeen:

Your Excellency, Dear Lord Aberdeen

Please pardon me writing to you, but I want to plead guilty for delaying Lady Aberdeen here last evening. The reason I do so is that her one wrong was that she had not written to you and therefore I want you to forgive me for my shame in keeping her here, and disappointing you so much not receiving her letter. We are still the same and the LGB are as nasty as they can be. It was to have reply to one of their many questions about the water that Lady Aberdeen went herself to the house of the woman that has the well on her land. But she succeeded, as please God, she will, in spite of all the opposition. It is only another proof of her determination to win and no consideration of herself. Anybody else would let another do it for them and the people were so pleased with her unceremonious visit that there was not a question of refusal to let us use the water until we have our own supply.

It is such a pity that we cannot have patients and the weather is beautiful. It is delightful here. It is so warm and the lovely tints in the trees, we could be so happy trying to do something for the poor suffer[er]s and we know that nothing could make Lady Aberdeen happier than to see this fulfilled. This delay, that means so much, is the annoying part of the whole thing ...

I remain, your Excellency's obedient servant, C.M. Brennan [signed].[42]

Redoubtable as ever, Lady Aberdeen solved the temporary water issue, but as the letter suggests, there was opposition to the hospital, and to its founder. Such was the opposition to Lady Aberdeen that she was labelled 'Lady Microbe' by nationalists such as Arthur Griffith for whom the viceroyalty, no matter what its incumbents did to support Ireland's poor or sick, represented the 'fount of all that is slimy in our national life'.[43]

In spite of problems with water, and opposition to Lady Aberdeen herself, Peamount Hospital opened to patients on 27 October 1912.[44] No sooner was the hospital taking patients than it began to run into added difficulties, principally for two reasons: the first was that rather than build their own local hospitals, councils around the country began to ask for beds for their patients at Peamount Hospital. The second was that while Peamount did its best to accommodate all patients, it received only £1 per head from local councils for their care.[45] The hospital was run on voluntary funding, and there was not enough money to care for the buildings,

never mind the patients. That said, Lady Aberdeen's work on behalf of TB patients in Ireland did not go unnoticed, or unappreciated, by some. In May 1914, David Lloyd George, then serving as Chancellor of the Exchequer, wrote to Lord Aberdeen:

> My dear Aberdeen
>
> I am so sorry I was engaged when you called on Thursday evening and that it was not possible for me to have some talk with you ... I know how much we are indebted to Lady Aberdeen for all her good work in connexion with the working of the Insurance Act in Ireland and particularly as regards sanatorium benefit. I should be very glad if you would let her know how much the grand work she has done is being appreciated on this side of the Channel ...
>
> Ever yours sincerely, D. Lloyd George.[46]

Yet the hospital remained in financial straits, and it was not until 1917 that the government consented to raising the level of expenditure per head to 30 shillings (£1.10), which eventually rose to 42 shillings (£2.20) per adult by 1930. But that was not enough, especially as the buildings themselves had to be maintained.[47] At its height, the number of beds in Peamount had risen to 260, while the small facility at Rossclare had 50 beds.

As it turned out, Lord Aberdeen was relieved of his post as viceroy of Ireland in 1915, hastened, it has been suggested, by his wife's 'meddling' in the health and affairs of the poor (Fig. 07.08).[48] But, and in spite of opposition from nationalists, their departure failed to dissuade the couple from their various endeavours for the country. From a practical perspective, so as to fulfil their obligations to government, funds had to be found to provide for the accommodation and treatment of patients with TB in Peamount Hospital. To that end, Lord and Lady Aberdeen went to America on a fundraising mission for two years between 1916 and 1918. Following on, perhaps, from previous experience of the benefits of populating her 'Irish Village' in Chicago in 1893 with 'real' Irish people, the Aberdeens were accompanied throughout their tour of America by 'real Irish colleens, under the direction of Miss Louise Agnese', who were used to market the advantages of funding Peamount by advertising their youth and vitality. The dancers appeared first at the National Allied Bazaar in Boston, in December 1916:

> Six beautiful and talented young colleens brought over by Lady Aberdeen to make a tour through the country for the benefit of the Child Welfare Work of the Women's National Health Association of Ireland. They have arrived just in time to make their first appearance in this country at the Pavilion. They dance real Irish dances and sing real Irish songs with great charm, and one of them plays the old Irish harp.[49]

Between subscriptions from close friends in Britain, and their intensive tour of America, the couple raised £40,000 towards the upkeep of the hospital.[50] Ultimately, however, while the money raised took Peamount through the 1920s, the financial situation was not sustainable.

Peamount Industries: The Irish Papworth

According to a memorandum written by Lady Aberdeen in 1930, the WNHA had always hoped that Peamount Hospital would be taken over by the Government, 'a central committee' or a 'local council such as Dublin County Council'. But thus far, that had not happened, and the financial situation was becoming more precarious.[51] A solution had to be found to ease costs, and to provide much needed employment for TB patients, and those in recovery. By that stage, Lady Aberdeen had been in communication with a doctor by the name of Sir Pendrill Varrier-Jones, then well-known for his treatment of TB patients at Papworth in England. Indeed, during the late 1920s, several esteemed members of the Irish medical profession visited Papworth on behalf of the committee of the WNHA and Peamount. One of the main issues was that those with TB, or recovering from it, could not find employment once they left hospital, so they were depressed and lacking in motivation and self-esteem. As a result, they often became ill again, and ended up back in hospital, thereby unwittingly creating pressure on the system. In response, Varrier-Jones espoused the 'industrial settlement' model, whereby former TB patients

were gainfully employed at Papworth's purpose-built 'settlement' consisting of houses and small factories. The scheme at Papworth was outlined as follows:

> On the one hand, it reaches out towards an intelligent after-care movement, and on the other it is wide enough to provide hospital accommodation for a patient resident in a cottage who has a serious breakdown ... It comprises hygienic housing conditions, abundant light and air, an efficient nursing staff available from the central institution ... a garden ... and workshops, the property of the colony, where the work is strictly regulated according to the patient's health and strength ...[52]

Former patients lived on site, and were paid for their work in the factory units, which in turn, helped them to develop skills and self-esteem. By 1929, Jones's 'organising genius' had ensured that Papworth 'had become a centre of hope and happiness for people who had very little prospects of becoming self-sufficient citizens again'.[53]

So it was that the central committee of the WNHA, under the guidance of Lady Aberdeen, formulated a plan to build an 'Irish Papworth' in the grounds of Peamount Hospital. The announcement of the venture, to be called 'Peamount Industries', was made by Lady Aberdeen, in May 1930. By that stage, Varrier-Jones had agreed to act in an 'honorary' capacity to oversee the successful establishment of the project, while the general manager of the venture was a former male patient at Peamount Hospital who had been trained at Papworth.[54] Some of the money used to establish the initial new buildings to form the industrial settlement at Peamount had been donated by Lord and Lady Aberdeen from a bequest left to them by a woman called Mrs Anne Sharpe. Lady Aberdeen felt sure that using the bequest in this manner would have received approval from Mrs Sharpe, who had 'left the legacy for the benefit of the Dublin poor'.[55] The first workshops for male patients – which made greenhouses, hen houses, garden sheds and other wooden buildings – were built by three patients at the beginning of 1930 with a capital sum of £230. That year, the turnover amounted to over £3,500, and the following year the buildings were doubled to accommodate over forty men.[56]

Peamount Industries proved highly successful. By 1937, the male patients had built several workshops, machine shops, a hostel, a glove factory for women patients and an open-air school that housed over eighty child patients.[57] Dr Alice Barry, who was the medical overseer at Peamount Hospital, was very much in support of the Industries, because they brought about a 'change of atmosphere' among the 350 patients in the hospital, 'in spite of the fact that many of them would never be able to undertake any of the work themselves'.[58] While the male hostel was 'doing well', there was no female hostel on site, and there was a long list of women, all former patients, waiting for accommodation. The hospital itself was also badly in need of a new, up-to-date, x-ray machine.[59] By 1938, however, the hospital was celebrating the installation of its new x-ray machine, and Peamount Industries was doing well.

The Aberdeens continually maintained their interest in Ireland throughout the 1920s and 1930s. To Lady Aberdeen's great sorrow, her husband died, aged 86, in 1934, but she continued to travel to Ireland at least once a year thereafter, to chair meetings of the WNHA and to visit the various projects that the organization was involved with. In 1936, for example, she visited Dublin for the occasion of the annual meeting of the National Council of Women, which was held at 5 Leinster Street South in the city. She was still the President of the International Council of Women, and remained so until 1939. At that stage, the National Council of Women in Ireland was concerned with 'the position of women in the Civil Service, the employment of married women, and the position of women in industry'. So too, part of the programme for future local work was 'proper school meals for children, and the securing of a women's police force'.[60] Showing something of her feisty, feminist personality, when a male journalist asked her, during the visit, how 'conditions for women could be improved', apparently 'her blue eyes flashed beneath her white muslin cap' before she replied 'on just the same lines as for men'.[61]

Lady Aberdeen visited Dublin in June 1938, on the occasion of the twenty-fifth annual folk-dance festival, organized by the WNHA and held in the grounds of the Earl of Iveagh's house near Earlsfort Terrace in the city (now the Iveagh Gardens).[62] While at the festival, she watched 'displays of tactical marching, drill displays, Scottish, Irish and Folk dance, a Young Mothers display, maypole dances etc'.[63] The groups were made up of children and young adults from various clubs associated with the WNHA, including Hill Street Playground, Peamount, the St Laurence O'Toole Club, Cabra Playground, St Monica's Club, St Patrick's Club, St Brigid's Club and St Dominic's Social Club. Junior groups included the Gordon Club, wearing tartan and so-named after the Gordon family, Whitefriar Street Girls, wearing pink and green, and Whitefriar Street Boys, wearing gold and blue. There was one infant group, from Whitefriar Street girls' school.[64]

While in Dublin, Lady Aberdeen took the opportunity to visit Peamount Hospital and Industries on 11 June 1938. When she got out of the car, she was greeted by ninety boys and girls, all in the best 'bibs and tuckers' before attending a reception along with 200 guests. Dr Alice Barry was still working at the hospital, and the matron was a Mrs Stokes. The glove factory was doing well, and many visitors purchased gloves on the day. The woodwork factory was dealing with orders for hen coops, fruit cabinets, garden seats and tables. Male patients were playing clock golf and croquet behind the main building, and 'further back the children were in the big verandas enjoying the afternoon milk'.[65] The occasion was the inauguration of the newly built x-ray room, and the associated equipment, at which the Lord Mayor, Alfie Byrne, was invited to speak. He congratulated Lady Aberdeen and the Peamount Committee of the WNHA for their achievements, before inspecting the new x-ray room. While in the room, somebody took an x-ray of the Lord Mayor's right hand, and, 'amidst much laughter, presented it to him' as 'the hand that shakes Dublin'.[66] According to the *Irish Times* of the day, several

Fig. 07.09.

Unknown photographer

Lady Aberdeen watching the girls at work in the glove factory, Peamount Industries

1938

Courtesy of the Gordon Family Archive, Haddo Estate, photograph © Éimear O'Connor.

Fig. 07.10.

Unknown photographer

Lady Aberdeen with her beloved dogs

c.1914

Courtesy of the Gordon Family Archive, Haddo Estate, photograph © Éimear O'Connor.

new buildings had recently been added to the Peamount Industries settlement, including 'a new library, a laundry extension, and the office in the special charge of the Peamount Industries, which include glove making, carpentry and a new x-ray department'.[67] Her vision complete, Lady Aberdeen did not see Peamount Hospital again (Fig. 07.09).

Conclusion

Ishbel Hamilton-Gordon, Marchioness of Aberdeen and Temair, died on 18 April 1939. By that stage, the political regime in Ireland had changed entirely, and her legacy to the poor of Ireland in general, and of Dublin in particular, fell into decline. But her time in Ireland had seen a major re-invigoration of Irish home industries; she introduced the Red Cross to Ireland, and it was she who was responsible for the establishment of a Red Cross hospital in the State Apartments at Dublin Castle, in 1914 – the one to which James Connolly was brought after he was shot in 1916. She was a nationalist-leaning vicereine, although not a nationalist, with a life-long belief in gender balance and equality, who did her utmost to inculcate as much 'Irishness' as she could into Dublin Castle without getting into trouble, while often becoming an obvious target for nationalist journalists. Her life-long attitude to gender balance and suffrage is best explained in her own words, written in 1889:

> I, for one, claim that women have an equal claim with men as citizens to the franchise and to the expression of an opinion as to how they shall be governed. I think that we women who have leisure and means have our full share of influence and that it matters very little to us if we have the vote or

not. But it is not so with the working women and it is they who suffer most from any defective legislation, they and their children and their homes; and they have no means of making their voice heard. The most intelligent of them feel this keenly, and I frankly own that it is this consideration that has made me feel that I must join the ranks of those who contend that it is only justice to treat men and women as human beings with equal rights and claims, and then let nature work out her own laws in assigning to each those functions which each can best fulfil in advancing the welfare of the state. I detest these 'women's questions', pitting men and women against each other as if their interests and their duties could be apart. I shrink from them all and long for the time when the law will recognise no sex. You will see therefore, that I will only become keen on the question when the time comes for something like manhood suffrage to be granted. And so, I give plenty of time to cry and to preach 'educate, educate, educate' in preparation for that time![68]

It was through Lady Aberdeen's hard work, and that of the WNHA, that Peamount Hospital was founded, followed by Peamount Industries. In other words, she committed to, and worked hard towards, the eradication of TB in Ireland. As the disease declined throughout the country, the hospital was put to other uses, and in spite of major changes, it remains today. Rossclare House in County Fermanagh, which had been converted and extended for use as the hospital there, also survives, but there is little evidence to suggest that Lady Aberdeen remained involved with it after leaving Ireland.[69] Now, in this moment of the decade of commemorations, it is time to reconsider Lady Ishbel Aberdeen (Fig. 07.10), and her contribution to Ireland, as another (her)story; one that may prove difficult to accept, given her role as vicereine and, therefore, her association with the colonial past, but one that deserves acceptance all the same. Recalling the quotation which began this chapter, Lady Aberdeen, in spite of many challenges, was never 'afraid' to do what she thought it was right to do. Finally, a statement published about her in 1891 is a fitting tribute to her commitment to serving others in the only way she knew how:

> She has charm of voice, and a fine presence; she shows genuine, unmistakable feeling; she is far from being deficient in humour, and she is conscientious … She talks politics soberly and in a business-like fashion. Perhaps she is, in reality, one of the sincerest democrats of her caste …[70]

The author would like to sincerely acknowledge the late Alexander Gordon, 7th Marquess of Aberdeen and Temair (1955–2020), and thank everyone at Haddo Estate, Tarves, Aberdeenshire, Scotland; the Trustees of Peamount Hospital; the staff of the National Archives of Ireland; Myles Campbell.

Endnotes

1 Letter to Ishbel, Marchioness of Aberdeen and Temair from William Ewart Gladstone, written during the last few months of his life, and quoted by her in a speech she gave supporting a vote of thanks to speakers at the Liberal Assembly, Buxton, Friday 28 May 1937, Gordon Family Archive, Haddo Estate, file 22/2/26.

2 É. O'Connor, '(Ad)dressing Home Rule: Irish Home Industries, the Throne Room and Lady Aberdeen's Modern Modes of Display', in M. Campbell and W. Derham (eds), *Making Majesty: The Throne Room at Dublin Castle, A Cultural History* (Dublin: Irish Academic Press, 2017), p. 240.

3 Ibid.

4 See O'Connor, '(Ad)dressing Home Rule', p. 240, quoted from n. 21, p. 261, L. Cluckie, *The Rise and Fall of Art Needlework: Its Socio-economic and Cultural Aspects* (Bury St Edmunds: Arena Books, 2008), pp. 59–60.

5 See O'Connor, '(Ad)dressing Home Rule', p. 241, quoted from n. 24, p. 261, Lord and Lady Aberdeen, *"We Twa": Reminiscences of Lord and Lady Aberdeen* (London: W. Collins Sons & Co. Ltd, 1925), vol. 1, p. 197.

6 See O'Connor, '(Ad)dressing Home Rule', p. 241.

7 Ibid.

8 Ibid., pp. 237–63, for further information on Lady Aberdeen's modern modes of display in support of Irish industries and Home Rule, and on the 'Irish Village' in the Chicago World's Fair, 1893.

9 See Lord and Lady Aberdeen, *"We Twa"*, vol. 2, p. 99.

10 Journal of Ishbel, Countess of Aberdeen, 1893–4, 27 October 1893, Gordon Family Archive, Haddo Estate, Box 10/2. According to Lady Aberdeen's journal, the first formal committee meeting of the Women's National Council of Canada was held on 28 October 1893 – during which they went over the constitution and rules.

11 Ibid.

12 Stephen Lucius Gwynn (1864–1950), author, poet and Protestant Nationalist politician. He represented Galway City as a member of the Irish Parliamentary Party from 1906 to 1918. He was a cousin of artist Dermod O'Brien (1865–1945).

13 Letter to Ishbel, Countess of Aberdeen from Stephen Gwynn, [month unclear] 1905, Gordon Family Archive, Haddo Estate, file 1/24/Stephen Gwynn.

14 Letter to Ishbel, Countess of Aberdeen from Stephen Gwynn, 18 February 1906, Gordon Family Archive, Haddo Estate, file 1/24/Stephen Gwynn.

15 R. Kennedy, *Dublin Castle Art* (Dublin: Office of Public Works, 1999), pp. 76–7.

16 *Irish Independent*, 16 March 1909; quoted from É. O'Connor, '(Ad)dressing Home Rule', pp. 254–5.

17 Ibid.

18 C.S. Breathnach and J.B. Moynihan, 'The Frustration of Lady Aberdeen in her Crusade against Tuberculosis in Ireland', *Ulster Medical Journal*, 81, 1 (2012), p. 39. Regarding the approach made by the NAPT to Lady Aberdeen in 1906, the authors quote from The Marquis and Marchioness of Aberdeen and Temair, *More Cracks with 'We Twa'* (London: Methuen & Co. Ltd, 1929), p. 155.

19 Ibid.

20 See Breathnach and Moynihan, 'The Frustration of Lady Aberdeen', p. 39.

21 Minutes of the first meeting of the WNHA, Peamount Hospital Archives, National Archives of Ireland, PRIV/WNHA/1/17. Access to Peamount Hospital Archives with kind permission of the Trustees of Peamount Hospital, held in trust by the National Archives of Ireland. The Women's National Health Association of Ireland was formally incorporated in 1912, after the passing of the Health Insurance Act, 1911.

22 Minutes of the first meeting of the WNHA, Peamount Hospital Archives, National Archives of Ireland, PRIV/WNHA/1/1.

23 Minutes of the first meeting of the WNHA, Peamount Hospital Archives, National Archives of Ireland, PRIV/WNHA/1/17.

24 Ibid.

25 Ibid.

26 The Countess of Aberdeen, *The Work of the WNHA*, c.1930, Gordon Family Archive, Haddo Estate, file 22/2/26, p. 4.

27 Minutes of the second meeting of the WNHA, Peamount Hospital Archives, National Archives of Ireland, PRIV/WNHA/1/17.

28 See Aberdeen, *The Work of the WNHA*, p. 6. See also https://socialwelfare.library.vcu.edu/social-work/charity-organization-society-of-new-york-city/ (accessed 20 September 2019).

29 See House of Commons debate on the second reading of the Tuberculosis Prevention (Ireland) Bill, 15 July 1908, viewable online: https://api.parliament.uk/historic-hansard/commons/1908/jul/15/tuberculosis-prevention-ireland-bill (accessed 20 September 2019).

30 https://api.parliament.uk/historic-hansard/commons/1908/jul/15/tuberculosis-prevention-ireland-bill ibid (accessed 20 September 2019).

31 Letter to Ishbel, Countess of Aberdeen from Augustine Birrell, 14 December 1908, Gordon Family Archive, Haddo Estate, file 1/42/3/7.

32 See, for example, Dáil Éireann debate on the Tuberculosis (Establishment of Sanatoria) Bill, 1945 – Second Stage, 31 January 1945, viewable online: https://www.oireachtas.ie/en/debates/debate/dail/1945-01-31/26/ (accessed 20 September 2019).

33 See guide to tuberculosis records in the Archives of Ontario, viewable online: http://www.archives.gov.on.ca/en/explore/online/health_records/tuberculosis.aspx (accessed 3

November 2019). For the Muskoka Sanatorium, see A. Baston, *Curing Tuberculosis in Muskoka: Canada's First Sanatoria* (Toronto: Old Stone Books Ltd, 2013).

34 Letter to John, Earl of Aberdeen from Mr Power, 26 October 1909, Gordon Family Archive, Haddo Estate, Box 1/5.

35 M. Duncan, 'An Irishman's Diary', *Irish Times*, 3 March 2015, viewable online: https://www.irishtimes.com/culture/heritage/an-irishman-s-diary-on-lady-aberdeen-1.2123413 (accessed 1 October 2019).

36 See deed record for 8 Ely Place, Registry of Deeds, Dublin, 1911/19/176. The grantor was Thomas Hughes Kelly who was based in New York.

37 See deed record for 7 Ely Place, Registry of Deeds, Dublin, 1911/54/159. The grantors were the Callwell sisters, Amy Louisa Charlotte; Gertrude Emma; May Alberta; Helen Lindsay Mary and Ida Eleanor, all of whom were based in England.

38 Copy of letter to the Chief Secretary from Mr Chambers, 4 March 1912, Gordon Family Archive, Haddo Estate, Box 1/5.

39 In 1935, the Society of United Irishwomen changed its name to the Irish Countrywomen's Association.

40 Letter to Ishbel, Countess of Aberdeen from Horace Plunkett, 30 March 1911, Horace Plunkett Letters, Gordon Family Archive, Haddo Estate, Box 1/5.

41 Ishbel, Marchioness of Aberdeen and Temair GBE, 'Peamount, The Irish Papworth', in T.S.L. Burrell (ed.), Reprint no. 284 from *The British Journal of Tuberculosis* (July 1939), Gordon Family Archive, Haddo Estate, file 22/2/26.

42 Letter to John, Earl of Aberdeen from C.M. Brennan [Matron at Peamount], October 1912, Gordon Family Archive, Haddo Estate, Box 1/5.

43 See Durkan, 'An Irishman's Diary'.

44 See F. Carruthers, 'The organisational work of Lady Ishbel Aberdeen, Marchioness of Aberdeen and Temair (1857–1939)' (unpublished PhD thesis, National University of Ireland Maynooth, 2001), p. 233.

45 Memo regarding the future of Peamount and of the Women's National Health Association of Ireland, 10 May 1930, Gordon Family Archive, Haddo Estate, file 1/25/5.

46 Letter to His Excellency, the Earl of Aberdeen from David Lloyd George (from an address at Treasury Chambers, Whitehall, London), 8 May 1914, Gordon Family Archive, Haddo Estate, file 55/1/5/2.

47 Memo regarding the future of Peamount and of the Women's National Health Association of Ireland, 10 May 1930, Gordon Family Archive, Haddo Estate, file 1/25/5.

48 See, for example, Durkan, 'An Irishman's Diary'.

49 Events and Happenings, book of newspaper clippings, unfiled, p. 41, Gordon Family Archive, Haddo Estate.

50 Ishbel, Marchioness of Aberdeen and Temair GBE, 'Peamount, The Irish Papworth', in T.S.L. Burrell (ed.), reprint no. 284 from *The British Journal of Tuberculosis* (July 1939), Gordon Family Archive, Haddo Estate, file 22/2/26.

51 Memo regarding the future of Peamount and of the Women's National Health Association of Ireland, 10 May 1930, Gordon Family Archive, Haddo Estate, file 1/25/5.

52 'Outline of the Scheme', in Sir G. Woodhead and P.C. Varrier-Jones, *Industrial Colonies and Village Settlements for the Consumptive* (Cambridge: The University Press, 1920), pp. 64–5.

53 Memo regarding the future of Peamount and of the Women's National Health Association of Ireland, 10 May 1930, Gordon Family Archive, Haddo Estate, file 1/25/5.

54 Ibid.

55 Memo for the WNHA Executive from Lady Aberdeen, 9 Ely Place, Dublin, 29 April 1930, Gordon Family Archive, Haddo House, file 1/24/5.

56 Ishbel, Marchioness of Aberdeen and Temair GBE, 'Peamount, The Irish Papworth', in T.S.L. Burrell (ed.), reprint no. 284 from *The British Journal of Tuberculosis* (July 1939), Gordon Family Archive, Haddo Estate, file 22/2/26.

57 Ibid.

58 Ibid.

59 Ibid.

60 *Irish Times*, 26 March 1936, unpaginated, press cuttings book, Gordon Family Archive, Haddo Estate.

61 Ibid.

62 *Irish Independent*, 13 June 1938.

63 Press cuttings, June 1938, unpaginated, press cuttings book, Gordon Family Archive, Haddo Estate.

64 Ibid.

65 *Irish Independent*, 11 June 1938, in press cuttings, unpaginated, press cuttings book, Gordon Family Archive, Haddo Estate.

66 Ibid.

67 *Irish Times*, 11 June 1938, in press cuttings, unpaginated, press cuttings book, Gordon Family Archive, Haddo Estate.

68 Copy of letter to Mr [John] Morley, Chief Secretary [for Ireland] from Ishbel, Countess of Aberdeen, 20 May 1889, Gordon Family Archive, Haddo Estate, Box 1/5.

69 For Rossclare House, see A. Rowan, *North West Ulster: The Counties of Londonderry, Donegal, Fermanagh, and Tyrone* (Harmondsworth: Penguin, 1979), p. 329.

70 *Northern Daily News*, 20 November 1891, news cuttings, May 1889 to November 1891, p. 153, Gordon Family Archive, Haddo Estate.

Catalogue

1

Manner of Sir Peter Lely (1618–1680)
Frances Jennings, afterwards Duchess of Tyrconnel
*c.*1680
Oil on canvas, 127.7 x 102.5 cm
National Trust for Scotland, Fyvie Castle, Aberdeenshire

Vicereine of Ireland 1687–9

Writing in 1913, the first and thus far only biographer of Frances Jennings, Duchess of Tyrconnell (*c.*1649–1731) noted that few surviving portraits of this prominent Jacobite woman did justice to the 'glowing accounts of her charms'.[1] For several contemporaries, those charms were chiefly physical; she was said to have had the 'fairest and brightest complexion that ever was seen' and hair 'of a most beauteous flaxen'.[2] For others, Frances's 'spirit and strength of mind' were equally admirable.[3] Of the known portraits of Frances, this work strikes perhaps the best balance in its attempt to capture the physical and mental attributes that made her name in the 1660s and that later marked her conduct as vicereine of Ireland in the 1680s.[4] Frances Jennings enjoyed a rapid ascent at court in London. In 1664, she became Maid of Honour to Anne Hyde, first wife of the future King James II.[5] Following a spell in France during which she was widowed, Frances married the Irishman Richard Talbot (later Earl of Tyrconnell), in 1681.[6] The symbolism of this portrait suggests that it was painted at about this time, perhaps as an indication of her betrothal to Talbot.

Resting her hand on a spaniel (a pictorial allusion to loyalty), gazing directly at the viewer and wearing a string of pearls in her famous flaxen hair, Frances is portrayed as a committed, confident and elegant woman of high social rank. These qualities, coupled with her strength of mind, would all be in evidence during her husband's term as Lord Deputy of Ireland from 1687 to 1689. Frances's loyalty to the Catholic King James II shaped many of her public actions as vicereine of Ireland at a time of rising Protestant discontent. In 1687–8 she helped to establish an order of Benedictine nuns in the prominent location of Great Ship Street, adjacent to Dublin Castle.[7] On 27 September 1689, she led a procession to Christ Church Cathedral to preside over its seizure from Protestant hands and reconsecration for Catholic worship.[8] As the inscription on this portrait indicates, Frances and her husband were elevated to the dukedom of Tyrconnell as a mark of the King's favour, but his imminent defeat at Battle of the Boyne would soon spell the end of Frances's time as vicereine and of the Catholic order at Dublin Castle.

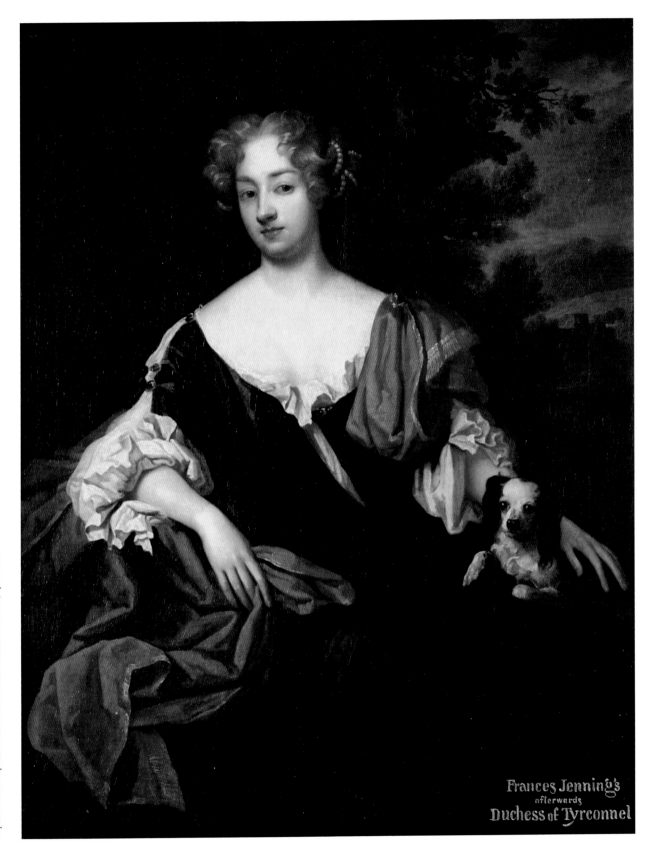

Frances Jenning's
afterwards
Duchess of Tyrconnel

2

Francis Sandford (1630–1694)
The History of the Coronation of the Most High, Most Mighty, and Most Excellent Monarch, James II
c.1687
Printed book, 42.3 x 29.2 x 3.4 cm
Office of Public Works, Emo Court, County Laois

The coronation of King James II and Queen Mary took place at Westminster Abbey on 23 April 1685. This book was produced by the Irish-born herald Francis Sandford in response to the King's order that 'the whole Ceremony, with all its Circumstances, should be Printed and Illustrated with Sculpture'.[9] Among those who appear in its illustrations is Frances, Countess of Tyrconnell (afterwards Jacobite Duchess of Tyrconnell), who would later serve as vicereine of Ireland from 1687 to 1689 (see Cat. 01). Frances participated in the coronation as an attendant to the Queen under her Irish title, Countess of Bantry.[10] As a contemporary visual record of her central position at court, this book illustrates the close relationship with the new Catholic monarchs that would define much of Frances's conduct as vicereine in Dublin.

Frances's experience of life at court and of the etiquette associated with occasions such as the coronation proved to be advantageous in Ireland where, it was said, her tenure as vicereine 'truly' bore the hallmarks of a 'reign'.[11] Her patronage of Catholic religious houses sent out a strong message of loyalty to the increasingly beleaguered James II, who had

appointed Frances's husband as Lord Deputy to support the Roman Catholic interest in Ireland.[12] The appointment had been greeted with dismay by Irish Protestants.[13]

Frances's displays of loyalty, piety and courtly deportment as vicereine appear to have sustained those around her even in the most hopeless of circumstances, as an account of her actions following the Battle of the Boyne demonstrates: 'When the King and her husband arrived [at Dublin Castle] as fugitives from the lost battle, on which her fortunes and her hopes had depended … she, hearing of their plight, assembled all her household in state, dressed herself richly, and received the fugitive King … with all the splendour of court etiquette. Advancing to the head of the grand staircase with all her attendants, she kneeled on one knee, congratulated him on his safety, and invited him to a banquet …'[14] Even in defeat, Frances was judged to have 'held her state as Vice-queen with much grace and magnificence …'[15]

3

Michael Dahl (1659–1743)
Lady Mary Somerset, Duchess of Ormond
c.1695–6
Oil on canvas, 263.5 x 146.5 cm
National Trust, Petworth House, West Sussex

Vicereine of Ireland 1703–7, 1710–13
(absent from Ireland after 1705)

This portrait of Mary, Duchess of Ormond (1665–1733) by Michael Dahl is thought to have been painted just a few years before she served as vicereine of Ireland.[16] As the daughter of Henry Somerset, 1st Duke of Beaufort and from 1685, the wife of Ireland's only duke, James Butler, 2nd Duke of Ormond, Mary was one of the celebrities of her time.[17] As such, she was one of seven famous 'beauties' selected by Charles Seymour, 6th Duke of Somerset to 'sett [sit] to Mr Dahl for their pictures which he then had painted'.[18] The completed pictures, including this one, subsequently became 'the ornament of one of his fine rooms at Petworth'.[19]

In 1702, Mary's celebrity increased when she became Lady of the Bedchamber to Queen Anne. A year later, she accompanied her husband to Dublin as vicereine, arriving on 4 June 1703.[20] Mary's influence as a fashionable society beauty quickly extended to forms of artistic production well beyond the sphere of portraiture, and she used this influence for the practical benefit of Dublin's artisans. According to one contemporary, Mary 'made the Welfare of the Wollen [sic] Manufactuer [sic], and the Weavers and Stuff Shops

her greatest Concern; insomuch that her Grace wore a new [Irish] Stuff Suit every *Monday*'.[21] In doing so, she helped to set an early patriotic example that was emulated 'by all the Nobility and Gentry, so that no Lady appeared at Court [in Dublin Castle] in any other Dress'.[22]

Mary's influence also heralded a new style of viceregal entertainment at Dublin Castle.[23] The formal assemblies held in the Council Chamber were now complemented by convivial gatherings in her newly decorated drawing room.[24] According to an inventory of 1705, this opulent room was hung with fashionable engravings after Poussin, Vouet and Annibale Carracci, all of which were purchased in Ireland.[25] During her husband's frequent absences, Mary became 'the focus of the viceregal court'.[26] Despite the weight of this social burden, she coped admirably, partly because of her ability to move more freely with the men at court than in previous decades, when men and women had eaten and socialized separately.[27] Although Mary left Ireland prematurely in 1705 and did not return for her husband's second viceroyalty from 1710 to 1713, her tenure had nonetheless seen 'noticeable development in the position of vicereine'.[28]

21

Unknown maker
Foundation Stone of the Dublin City Workhouse
1704
Stone, 35 x 55 x 25 cm
Dublin City Council

On 12 October 1704, the vicereine of Ireland, Mary, Duchess of Ormond (see Cat. 03), laid this foundation stone for the building of Ireland's first workhouse, on the site of the present-day St James's Hospital, Dublin.[29] Far from representing a routine ceremonial duty, this action symbolized the culmination of Mary's tireless personal campaign as vicereine to raise funds for the workhouse and to secure an act of parliament allowing for it to be erected. 'Her Grace,' noted a contemporary observer, was pleased 'to promote this design, not only by a Liberal Contribution, but by a singular and unwearied Application in procuring the Act for Erecting of the Work-House, and in getting Subscriptions from several of the Nobility, and other Persons of Quality in this Kingdom.'[30] Offering much more than 'a famous name' that lent dignity to the turning of the first sod, Mary was, in fact, 'effectively leading the entire venture'.[31] In total, she raised the large sum of £902.0.2 for the institution, which equates to approximately €115,000 today.[32]

In 1730, the workhouse became an orphanage known as the Foundling Hospital.[33] On 16 April 1829, it was visited by the then serving vicereine, Charlotte Florentia, Duchess of

Northumberland (see Cat. 19), who recorded a favourable impression in her diary: 'Went to the Foundling Hospital … to see the children walk in to dinner in the great hall 550 girls & near 400 boys, the former are fed upon potatoes & milk the latter on beef cabbage & potatoes – Nothing could be more clean & orderly than their appearance. The hospital is a very extensive building & the various apartments are as airy and clean as possible … The Govt. give yearly 31,000£ towards the support of this Charity.'[34] Conscious of the achievements of one of her predecessors as vicereine, Charlotte acknowledged Mary's pioneering efforts of more than a century earlier: 'The hospital was erected in the year 1704 & the Duchess of Ormond laid the first stone, her husband being the L[or]d. L[ieutenan]t. – Her arms appear on the building.'[35] High mortality rates, which had apparently been hidden from Charlotte on this stage-managed visit, later contributed to the closure of the institution, but the 'benevolent idea' that inspired its foundation in 1704 endures in the form of this foundation stone, which still bears Mary's name.[36]

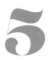

James Maubert (1666–1746)
Henrietta, Duchess of Bolton (1682–1730) as a Shepherdess
1721
Oil on canvas, 120 x 148 cm
National Gallery of Ireland

Vicereine of Ireland 1717–20

Henrietta, Duchess of Bolton (1682–1730) served as vice-reine of Ireland from 1717 to 1720. Painted in 1721, just one year after her departure from Ireland, this portrait's abundant symbolism and proximity in date to her tenure in the role offers a valuable contemporary record of her attributes that helps to compensate for the 'frustratingly sparse' evidence of her time as vicereine.[37]

Resting her head on her right arm and gazing pensively from the picture plane, Henrietta adopts the popular pictorial pose of *melancholia*. It has been suggested that her reflective state may be attributable to the fact that the picture was painted the year her husband died – 1721.[38] This cannot, however, be the case, as Henrietta's husband Charles, 2nd Duke of Bolton died not in 1721 but in 1722.[39] Instead, allusions to loyalty, royalty, stewardship and fidelity in the form of a spaniel, a floral crown, a lamb and a pair of courting doves respectively, coupled with the emphasis on her contemplative nature, suggest an intention to capture Henrietta's own qualities, lineage and commanding presence rather than to define her in relation to the presence or absence of her husband.

The lack of evidence of Henrietta's social activities as vicereine may suggest a similarly remote existence in Dublin to that hinted at in this portrait. As Lady of the Bedchamber to Caroline, Princess of Wales from 1714 to 1717, Henrietta was among 'the many intelligent female readers who flourished in her household and at court'.[40] As the illegitimate granddaughter of King Charles II (to which her floral crown may refer), Henrietta reportedly attempted to 'make believe she was one of the Royal family'.[41] These influences and behaviours at court in London suggest an earnest, bookish, quasi-regal demeanour that may have hindered Henrietta's sociability in Ireland.[42] The naming of Dublin's fashionable Henrietta Street in her honour, following her departure, does suggest a certain degree of popularity.[43] However, the prevailing impression of her tenure corresponds largely with this portrayal of her as the introspective inhabitant of a distant, decorative space.

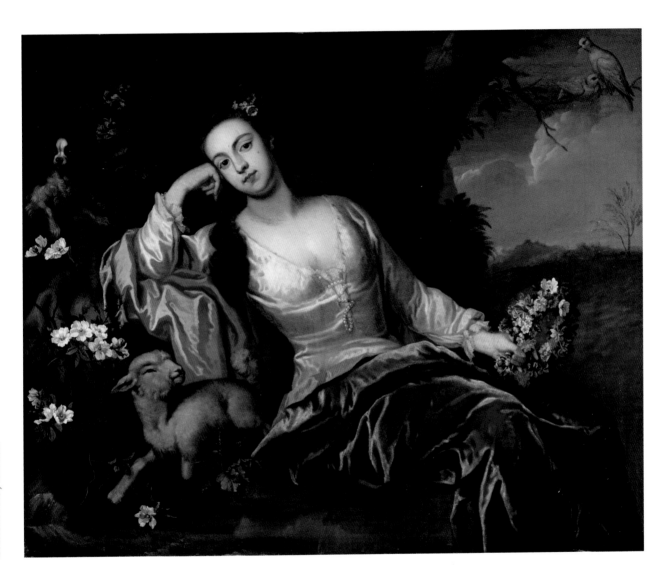

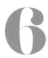

6

Sir Godfrey Kneller (1646–1723)
Frances Worsley, Baroness Carteret (1694–1743)
1715
Oil on canvas, 154 x 129 cm
National Trust, Ham House, Surrey

Vicereine of Ireland 1724–30

Painted in 1715, this portrait of Frances Worsley, Baroness Carteret (1694–1743) by Sir Godfrey Kneller features the 'paler, more pastel-like' colouring and 'softer', more rococo handling that characterizes the artist's portraits from about 1710, and contrasts with the more old-fashioned baroque character of his earlier work.[44] Capturing Frances in this fashionable light, it anticipated the similarly modern image she would soon project as vicereine of Ireland in the period from 1724 to 1730, during which she ushered in 'an intense social programme and sense of routine not previously seen at Dublin Castle'.[45]

Frances's social programme included several novelties, among which was the first regular series of drawing room receptions to be held by a vicereine.[46] Following the example set by Caroline, Princess of Wales, Frances 'drew inspiration from the royal court and held 'two drawing rooms a week, in a princely manner".[47] Although she had never held a court position, Frances was a sufficiently regular attendee at the Princess's drawing rooms in London to observe this modern royal model in action. An account of one such visit when Frances was serving as vicereine demonstrates that she was also on personal speaking terms with the Princess, and it was noted that during their conversation about dress, the Princess 'admired my Lady Carteret's [dress] extremely'.[48] Equipped with this personal experience, Frances was able to set a new and lasting social template for her successors at Dublin Castle. From this point onwards, regular scheduled drawing rooms, presided over by the vicereine, became firm fixtures of the Dublin court calendar.

By 1729, Frances's drawing rooms had come to occupy an apparently vital position in the social life of Ireland's Ascendancy women, as the comments of one young attendee demonstrate: 'Lady Carteret has disappointed the ladies mightily for the chicken pox confined her [a] month and last week her ladyship miscarried so that we young folks are threatened with the terrible apprehension of having no more drawing room this winter.'[49] Frances's novel social routine had helped to give the viceregal court and, by extension, the Hanoverian monarchy it represented (and emulated), a fresh edge and new social currency in Ireland. She was hailed by Jonathan Swift as 'the best queen we have known in Ireland these many years'.[50] The age of the vicereine as a social agent and image-maker in her own right had dawned.

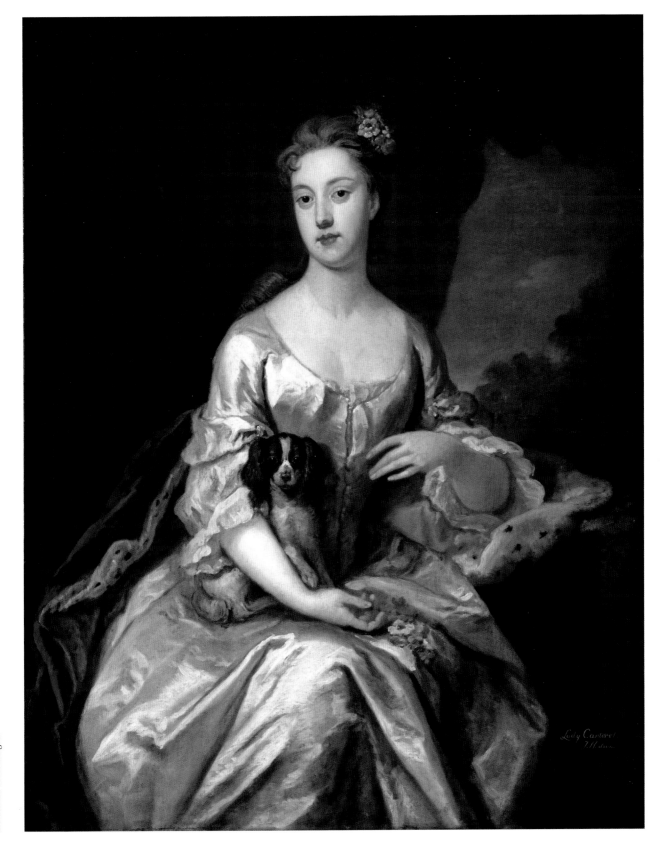

7

Mary Barber (*c.*1685–1755)
Poems on Several Occasions
1735
Printed book, 20.5 x 13 cm
Library of Trinity College Dublin

Throughout the late 1720s, the court of Caroline, Princess of Wales, in London, provided a template for the social activities of the then vicereine of Ireland, Frances, Baroness Carteret (see Cat. 06).[51] For the Princess, 'a burgeoning culture of print-world publicity' meant 'performing visible government' in various 'modern ways' and thereby attracting the increasing attention of writers, petitioners and the press.[52] For Frances, comparable public acts and appearances in Dublin, among them visits to musical, theatrical and scientific performances, as well as excursions to fashionable resorts such as Castletown House, County Kildare, raised the profile of the vicereine in a similar way.[53] One result was that the practice of using the vicereine as the subject or dedicatee of a literary work now likewise 'took off' as it had for the Princess of Wales.[54]

This poem addressed to Frances as vicereine is one of several examples of the practice. It was penned by Mary Barber in 1725 as a petition on behalf of the struggling 'widow Gordon', whose poverty was causing 'unutterable woe'.[55] The poem helped to establish Lady Carteret in popular print as a focus of potential assistance for the poor and in doing so, served to elevate the position of vicereine in the public consciousness. Although it represented her as a woman of only limited powers who might be appealed to as 'the Wretch's last resort', new evidence of the poem's wider publication in newspapers in October 1725, long before it was printed in this volume a number of years later, indicates that it brought the influential role of the vicereine as a patroness to even greater public attention.[56] The result of Barber's rhetorical device of giving a voice to the voiceless widow was that the vicereine helped to raise 'a considerable Sum ... for her Relief'.[57] Despite Lady Carteret's later observation that it was 'easy enough to get subscriptions but not quite so easy to get the money paid' when promoting her charitable causes as vicereine, it might have been less easy still to get those same subscriptions without the publicity generated by ventures such as this, which did much to promote the vicereine's philanthropic role to a wider public readership.[58]

The Widow Gordon's *Petition* *:

To the Right Hon. the Lady Carteret.

WEARY'D with long Attendance on the
[Court,
 You, Madam, are the Wretch's laſt Reſort.
Eternal King! if here in vain I cry,
Where ſhall the Fatherleſs and Widow fly?

How bleſt are they, who ſleep among the Dead,
Nor hear their Childrens piercing Cries for Bread!

WHEN your lov'd Off-ſpring gives your Soul
[Delight,
Reflect how mine are irkſome to my Sight:
O think, how muſt a wretched Mother grieve,
Who hears the Want ſhe never can relieve!

* *Written for an Officer's Widow.*

AN

8

Circle of Sir Godfrey Kneller (1646–1723)
Elizabeth Sackville, Duchess of Dorset (1686–1768)
*c.*1720
Oil on canvas, 124.5 x 100 cm
Private collection

Vicereine of Ireland 1730–7, 1750–5

The brilliance with which Frances, Baroness Carteret (see Cat. 06) discharged her social duties as vicereine of Ireland from 1724 to 1730 is apparent as much from the length of the shadow cast by her departure, as from the length of time it took for her successor, Elizabeth Sackville, Duchess of Dorset (1686–1768), to emerge from that shadow.[59] Writing in 1731, shortly after Elizabeth's arrival in Dublin as vicereine, Mrs Delany was quick to identify the contrast: 'Lady Carteret used to have balls once a week, but they brought so great a crowd that the Duchess, who is of a quiet spirit, will avoid them.'[60] Bishop Robert Clayton likewise found Elizabeth 'very civil and polite, but very silent in public …'[61] Much like this candid, unassuming portrait of her, which was painted several years earlier and eschewed traditional ducal signifiers such as ermine robes and a coronet, these accounts offered little indication that the initially shy duchess would eventually succeed in making the position of vicereine 'comparable to that of a queen'.[62]

What Elizabeth lacked in sociability she made up for in style. Her major advantage over her predecessor was her vast experience of court life as a maid of honour to Queen Anne and, from 1714, as Lady of the Bedchamber and latterly Mistress of the Robes to Caroline, Princess of Wales (later Queen Caroline).[63] Elizabeth's use of a group of ladies-in-waiting as a formal escort party at balls, her organization of card games, such as basset, for the ladies, and her appearance at twice-weekly drawing rooms all mirrored her experiences with Queen Caroline and 'made the establishment at Dublin Castle more similar than ever to its London counterpart'.[64] For Mrs Delany, her experiences at the Duchess's court were 'just the same as at St. James's [Palace]'.[65] During her lengthy tenure as vicereine from 1730 to 1737 and again from 1750 to 1755, Elizabeth brought a quiet, regal dignity to the role and by the 1750s, her manner was still considered 'very graceful and princely'.[66] It was this 'princely' demeanour that had finally enabled her to step out of her predecessor's shadow and in doing so, to rival even the popularity of the Queen. Writing in 1733, Lady Anne Conolly confirmed this transformation when she confessed to her father, 'I own I like Queen Dorset much better than Queen Caroline.'[67]

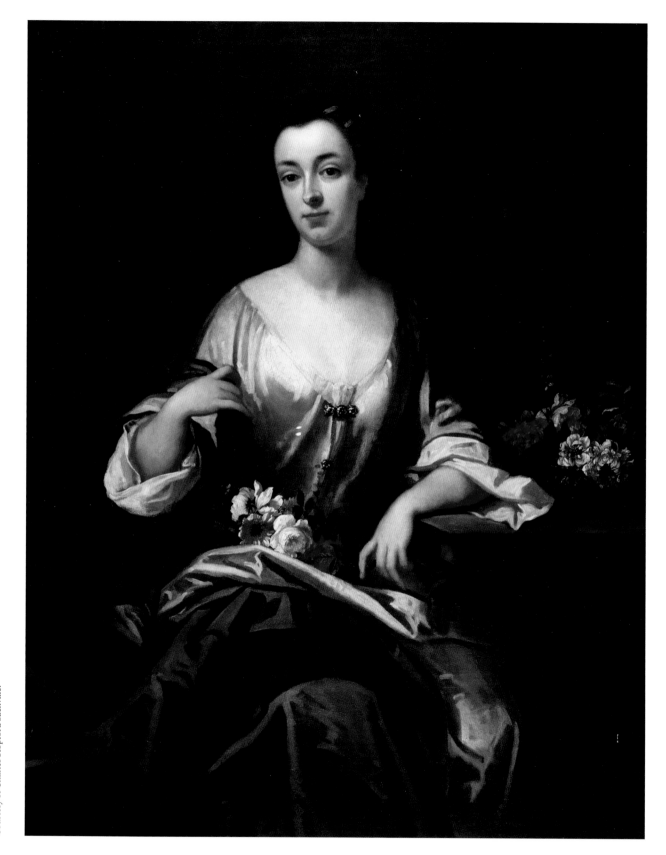

Charles Jervas (*c.*1675–1739)
Catherine Cavendish, Duchess of Devonshire (1700–1777)
*c.*1720
Oil on canvas, 124.5 x 100 cm
Chatsworth House, Derbyshire

Vicereine of Ireland 1737–45

Piety and morality are the qualities alluded to in this somewhat austere portrait of one of Ireland's lesser-known vicereines of the eighteenth century, Catherine Cavendish, Duchess of Devonshire (1700–1777). Depicted in the guise of St Catherine of Alexandria, she holds a palm frond symbolizing martyrdom. Her martyred namesake's attribute, the wooden wheel, appears in the background. The daughter of a merchant, Catherine found herself at the head of one of Britain's leading families when she married the aspiring Whig politician William Cavendish, Marquess of Hartington (later 3rd Duke of Devonshire) of Chatsworth House, on 27 March 1718.[68] This portrait by Charles Jervas, who was 'a favourite among Whig circles', is believed to have been painted to mark the occasion.[69]

Despite the length of Catherine's tenure as vicereine from 1737 to 1745, her periodic absences, responsibilities as a mother of seven children and apparent religiosity, which is reflected in this portrait, meant that she did not distinguish herself socially. Arriving in Dublin in 1737, she was accompanied by all seven of her children from the outset, which may help to account for her low profile.[70] Her time at the Castle was relatively limited and she made frequent trips back to England. In July 1743, for instance, she was preparing to travel to London to purchase clothes for the forthcoming wedding of her daughter, Elizabeth.[71] Notwithstanding her onerous maternal responsibilities, she did occasionally find time to fulfil social obligations as vicereine, such as an engagement to spend Christmas 1739 with Katherine Conolly at Castletown House, County Kildare.[72]

According to Horace Walpole, Catherine demonstrated a marked aversion to hosting non-religious gatherings. When she did organize them, they were apparently characterized by a restraint that could scarcely have satisfied expectations of her as vicereine. 'The Duchess of Devonshire,' quipped Walpole in 1752, 'has had her secular assembly, which she keeps once in fifty years: she was more delightfully vulgar at it than you can imagine; complained of the wet night, and how the men would dirty the rooms with their shoes; called out to the Duke, "Good God! my lord, don't cut the ham, nobody will eat any!"'[73] Portraying Catherine in a similarly ascetic light, Jervas's portrait serves as a useful reminder that the public responsibilities of a vicereine were not always easily reconciled with her private moral values.

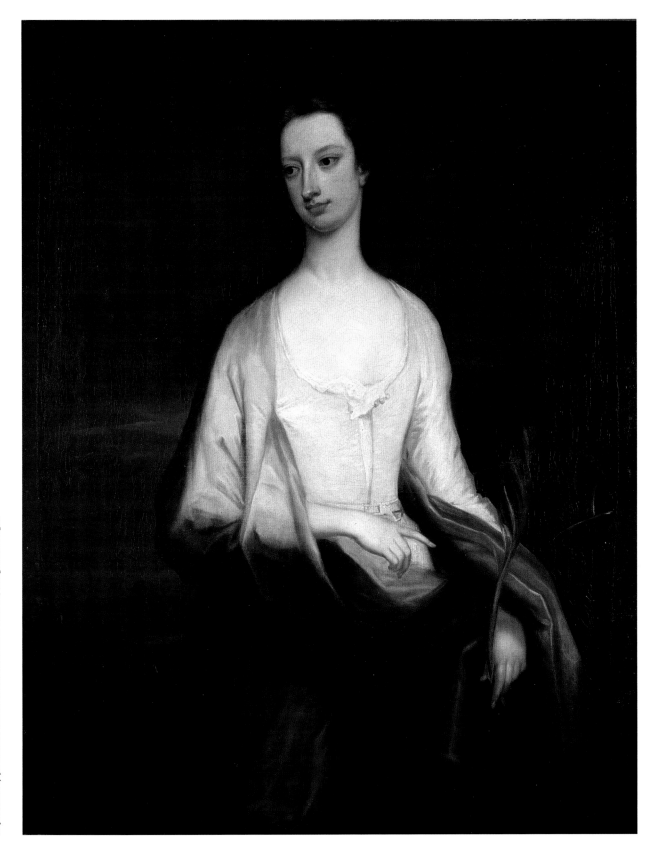

10

Thomas Gainsborough (1727–1788)
Caroline Hobart, Countess of Buckinghamshire (c.1755–1817)
1784
Oil on canvas, 233 x 145 cm
National Trust, Blickling Hall, Norfolk

Vicereine of Ireland 1776–80

Caroline, Countess of Buckinghamshire (c.1755–1817) was vicereine of Ireland from 1776 to 1780. This portrait of her by Gainsborough was completed in 1784 as a companion picture to his matching full-length depiction of her husband, John Hobart, 2nd Earl of Buckinghamshire, as viceroy.[74] As such, it serves as an unofficial retrospective portrayal of Caroline as vicereine. Notwithstanding the positive reviews it received in 1784, it has been observed that the picture's suppressed colour makes it subordinate to the colourful portrait of her husband.[75] In this regard, it contrasts markedly with the picture painted of Caroline in Irish newspaper accounts of the 1770s, which suggest a public image every bit as vivid as that of the viceroy.

The Buckinghamshire viceroyalty coincided with a period of severe economic strain in Ireland, which was widely attributed to oppressive British restrictions on Irish trade.[76] In response, a major 'free trade' campaign to boycott English goods in favour of Irish ones was mounted.[77] By the summer of 1779, women who had initially supported the 'buy Irish' initiatives for charitable reasons, found themselves at the centre of an increasingly political and anti-English campaign.[78] For Caroline, this campaign created a dilemma. As the wife of the British representative in Ireland, she had a duty to uphold Britain's interests and resist the free trade campaign, but as the daughter of William James Conolly of Castletown House, where her brother and sister-in-law Tom and Lady Louisa Conolly still lived, there was a strong patriotic imperative for her to support it.[79] Caroline's Irish loyalties won out and in May 1779, she declared her intention to appear at a charity ball dressed exclusively in Irish textiles, a gesture which, in the circumstances, appeared to indicate tacit support for the campaign.[80] Later that month, it was reported that she had gone even further by signalling her 'approbation' for the sale of 'free trade' ribbons for women's clothing.[81] These ribbons reportedly featured emotive imagery of an 'untuned' Irish harp and a 'Manufacturer looking up to Heaven for Relief'.[82] They also bore the 'free trade' campaign motto 'We Will Support It.'[83] Having come close to undermining the very crown she represented by setting 'so laudable an Example', the vicereine had shown her true colours as a woman of Irish origins; colours that, unlike those in this portrait, made her far from subordinate to her husband in Irish eyes.[84]

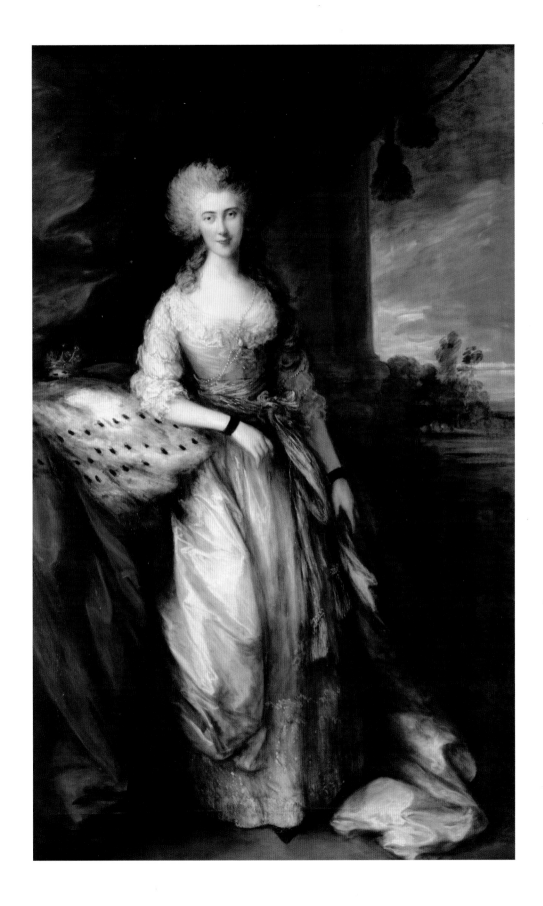

11

George Romney (1734–1802)
Dorothy Bentinck, Duchess of Portland (1750–1794)
*c.*1772
Oil on canvas, 77 x 63 cm
Chatsworth House, Derbyshire

Vicereine of Ireland 1782

It has been observed that during her very brief tenure as vicereine of Ireland from April to August 1782, Dorothy, Duchess of Portland 'liked to shake off formalities when socializing privately and dispense with accompanying ushers and pages'.[85] This relatively relaxed, informal representation of her by George Romney, with its shallow picture plane, reduced colour palette, diffident expression and lack of ducal trappings, is consistent with her apparently easy and straightforward manner. This unassuming demeanour may help to explain her preference for an artist known for his 'instinctively literal observation of his sitters' rather than for flashy swagger portraits.[86]

Romney's literal treatment of his subject did not appeal to Dorothy's husband, William Cavendish-Bentinck, 3rd Duke of Portland, as a letter from Dorothy among his surviving papers makes clear. Written in 1772, when this portrait is likely to have been painted, Dorothy's letter expressed her disappointment over her husband's response to Romney's portrayals of her, in which he felt she appeared to 'squint'.[87] 'I am sorry,' she wrote, 'to hear Romney's pictures of me appear so ill to you: you certainly shall not be troubled with the sight of them if you do not like it …'[88] As a young vicereine in her early thirties, Dorothy also appears to have deferred to her older husband by largely following his lead in matters of patronage. In June 1782, it was reported that together with her husband, she had endeavoured to relieve 'distressed artisans, weavers, & c.' by wearing Dublin-made attire.[89]

Social responsibilities likewise appear to have been shared, as on 8 August 1782, when the Portlands organized a fireworks display and performance of wind instruments at Dublin's 'elegantly illuminated' Ranelagh Gardens.[90] The brevity of their viceroyalty precluded the possibility of Dorothy developing a more active social and cultural role for herself as vicereine. When the idea of her husband's re-appointment was mooted thereafter, it was stated that 'Her Grace is far from being averse to the idea of the Duke's re-visiting Ireland …'[91] It was not to be, however, and Dorothy died in 1794 at 43 years of age.[92] Much like her grandmother, Catherine, Duchess of Devonshire (see Cat. 09), who was vicereine more than three decades earlier, her limited time in Ireland resulted in a profile as modest in print as that captured in paint.[93]

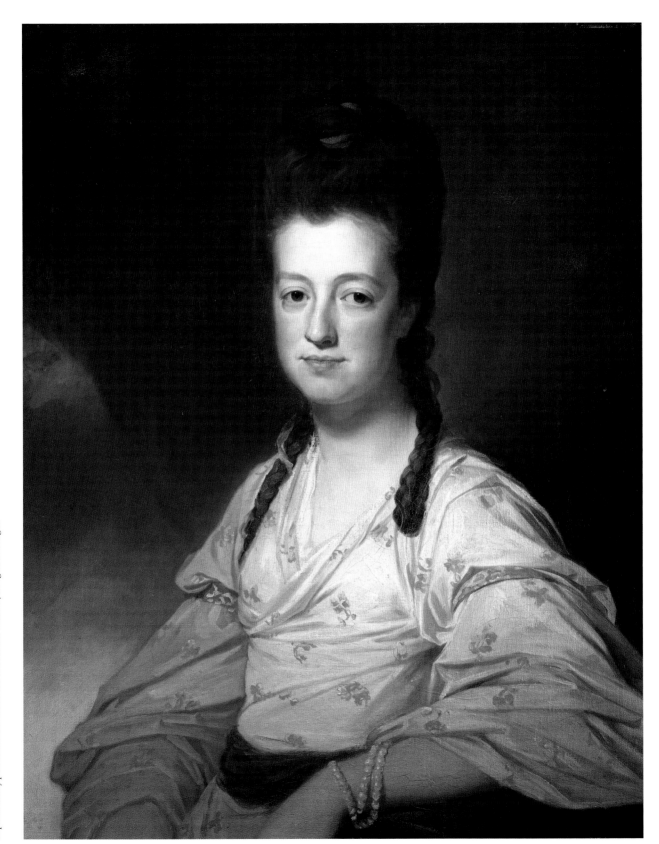

12

Horace Hone (1754–1825)
Mary, Marchioness of Buckingham (1758–1812)
1783
Watercolour on ivory, 5.6 x 4.6 cm
Fitzwilliam Museum, Cambridge

Vicereine of Ireland 1782–3, 1787–9

In 1782, the miniature painter Horace Hone made the journey from London to Dublin, the city of his father's youth, where, before long, he built a fashionable practice on the strength of his connection with the viceregal court.[94] That connection had come about as the result of Hone's close contact with the serving vicereine, Mary, Countess Temple (later Marchioness of Buckingham), who had invited him to the city in a bid to advance his career.[95] Painted before Mary left Dublin as vicereine the following year, this delicate miniature by Hone serves as a tribute to one of the numerous acts of patronage initiated by Mary during her tenure in the role from 1782 to 1783 and again from 1787 to 1789.[96]

Mary's patronage was by no means limited to the fine arts and when a deputation of silk weavers arrived at Dublin Castle to present her with a petition in December 1782, she likewise pledged her support: 'I shall always be happy to give every encouragement and protection to the labour and to the produce of a kingdom, with which I am connected by so many ties …'[97] As the daughter of an Irishman, Mary's ties to the country were strong and by the end of that month, she had reportedly donated 'several large Sums of Money' to cover the debts of upwards of sixty struggling tradesmen in Dublin, allowing them to be released from their creditors and 'earn Bread for their … desolate families'.[98] The Lord Mayor of Dublin marked the gesture with a bonfire and illuminations.[99]

Mary's support extended to commissioning, wearing and insisting on the use of Irish fabrics at Dublin Castle. In January 1783, protocols for the celebration of Queen Charlotte's birthday at the Castle were revised at her request, to ensure that those attending would dress solely in Irish fabrics.[100] Setting the standard, she commissioned an Irish dress of 'extraordinary richness' for herself and an Irish suit of the most 'elegant wrought Gold Velvet' for her father.[101] It was reported that attendees duly followed 'in the splendour of their dresses the patriotic example of the … Vice Queen'.[102] By the end of her first term as vicereine, Mary was said to deserve 'every national compliment' for supporting the arts and industry in Ireland, and enjoyed tributes every bit as flattering as that paid by Hone in this intimate portrait.[103]

13

Sir Joshua Reynolds (1723–1792)
Palette with Colours set by Sir Joshua Reynolds, P.R.A. for Mary, Marchioness of Buckingham
1784–92
Oil colours on timber palette, 48.5 x 57.5 x 4 cm
Royal Academy of Arts, London

In September 1782, it was reported that the new 'Vice Queen of Ireland', Mary, Countess Temple (later Marchioness of Buckingham) was 'passionately fond of painting and antiquities' and was 'supposed to be the most … accomplished woman in Europe'.[104] Notwithstanding the grandiosity of this claim, evidence of her artistic passions did soon emerge in Dublin, in the form of support for artists such as Horace Hone and for the Irish silk industry (see Cat. 12).[105] Further evidence of these passions survives in the form of this artist's palette, which once belonged to Mary.

According to an original note written by the picture restorer Thomas York and attached to it, this palette was prepared for Mary by Sir Joshua Reynolds as part of a training exercise. The note states that under the personal 'instructions of Sir Joshua' at Stowe House, where she lived, Mary used this palette of colours to produce a copy of Reynolds's celebrated painting *Sarah Siddons as the Tragic Muse*.[106] York's more detailed note on the reverse records that he received the palette from the clerk of works at Stowe House, Mr C. Jones, following the clearance of the room used by Mary as her 'study in the arts'. It also states that Mr Humphreys, the groom of the chambers at Stowe, 'knew Sir Joshua and remembers the pallet being set by that Gentleman'.[107]

Shortly after Mary's death in 1812, it was noted that 'Her ladyship possessed considerable taste and skill in works of genius, manifested in her drawings and paintings, many of which decorate the superb mansion at Stowe'.[108] Among these paintings was Mary's portrait of Sarah Siddons, which remained at Stowe until it was auctioned in 1848.[109] The painting was described in the catalogue of the 1848 sale as 'a copy on a large scale painted by Mary Marchioness of Buckingham, herself a pupil of Sir Joshua Reynolds, after the original of her great instructor'.[110] Although the whereabouts of this work by Mary and of many other paintings in her collection remain unknown, this palette endures as an illuminating indicator of the personal artistic interests and experiences that shaped her energetic approach to cultural patronage as vicereine of Ireland.

Robert Smirke (1753–1845)
Mary Isabella Manners, Duchess of Rutland (1756–1831)
1823
Oil on canvas, 272 x 174 cm
Belvoir Castle, Leicestershire

Vicereine of Ireland 1784–7

Almost two decades after her tenure as vicereine from 1784 to 1787, impressions of Mary Isabella Manners, Duchess of Rutland as 'Fashion's superlative Queen' remained vivid in Ireland.[111] This portrait of Mary Isabella conveys a similarly strong impression of the stylish silhouette that won her many admirers, including Charles Manners, 4th Duke of Rutland, whom she married in 1775.[112] The original by Sir Joshua Reynolds was painted in 1780 but was later destroyed in a fire at the Rutlands' seat, Belvoir Castle, in 1816.[113] The account books at Belvoir Castle show that this version, which is described in the relevant entry as a 'copy of Sir Joshua Reynolds' Portrait of Dss Dowager [Mary Isabella]', was painted by Robert Smirke in 1823, when he was paid £53.8.6 for it.[114] It was based on an earlier copy he had already made before the fire, in 1799, which survives at Mary Isabella's ancestral home, Badminton House.[115]

The account books at Belvoir show that even larger sums were spent on shaping Mary Isabella's image through fashion. For her viceregal wardrobe, a range of avant-garde accoutrements were supplied by 'E. Beauvais' in 1784 and 1785. These included 'a panashe of figaro feathers' for a 'super blond cap with poppy colour flowers', trimming for 'a suit of Cloathes richly embroidered with Velvett gold spangles chains of gold & beads', and '3 large feathers' of the kind depicted on her headdress in this portrait.[116] During her time in Ireland, Mary Isabella used her mode of dress to help give 'a powerful impulse to industry'.[117] In response to her lavish and 'constant' patronage, Dublin's Corporation of Sheermen and Dyers voted to award her the freedom of their guild.[118] Her influential support also extended to advertising Irish fabrics by wearing them in the presence of the royal family. At a drawing room in St James's Palace, in January 1785, she wore a dress of white Irish poplin with spangles, the style of which was as 'novel' as the vicereine's effort to promote it at court.[119] Through her all-night parties and all-consuming patronage, Mary Isabella created an image of herself as vicereine that was every bit as fashionable as that projected in this portrait.[120]

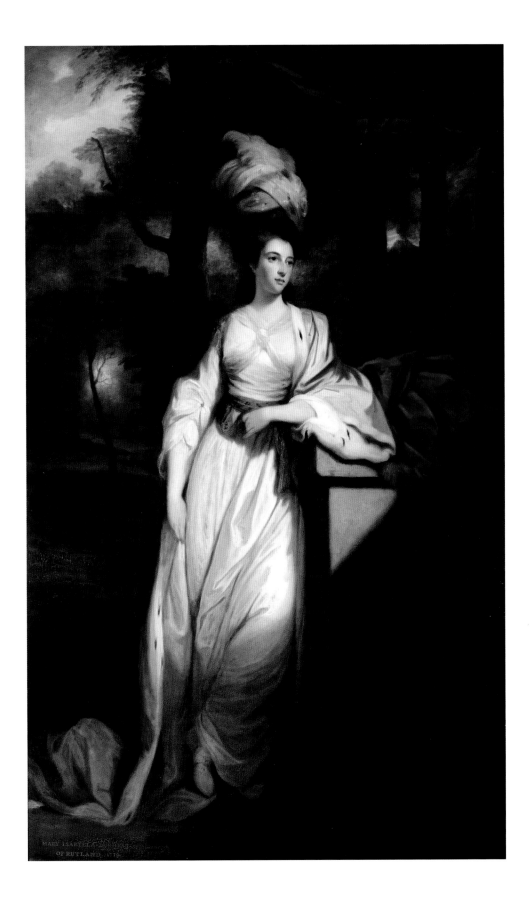

15

Joseph Constantine Stadler (*fl.*1780–1812)
The Rutland Fountain, Merrion Square, Dublin
*c.*1792
Etching and aquatint with watercolour on paper, 55.8 x 70.5 cm
National Library of Ireland

In the grand squares and thoroughfares of late-eighteenth-century Dublin, commemorative sculptures of women were few and far between. Serving almost exclusively as models for religious and ideal works, women seldom managed to secure the sort of lasting public tributes in bronze or stone that were bestowed upon male monarchs and military commanders.[121] In 1792, the former vicereine of Ireland, Mary Isabella, Duchess of Rutland (see Cat. 14), became a notable exception when the Rutland Fountain was completed on the west side of Merrion Square.[122] Although developed as a memorial to her deceased husband, Charles, 4th Duke of Rutland, who died prematurely while serving as viceroy in 1787, this chaste Neoclassical structure nonetheless accorded Mary Isabella a position of equal prominence in the form of a matching figurative roundel that complemented a medallion depicting the Duke.[123] In a further tribute, this aquatint and watercolour etching of the new fountain was dedicated to Mary Isabella by the politician Sir John Blaquiere, who inscribed it as 'her devoted servant'.

Bearing the tribute 'pulcherimma illa' ('she is beautiful'), the roundel depicting Mary Isabella on the Rutland Fountain reflects the influence of more than her physical charms. During the early days of her husband's fragile administration in Ireland, Mary Isabella had worked extremely hard to support him by abandoning the partisan approach to official entertaining adopted by some of her predecessors and hosting vast crowds of guests from across the political spectrum at all-night parties in Dublin Castle.[124] The politician Sir Jonah Barrington was impressed by the 'voluptuous brilliancy' of the regime.[125] Henry Grattan formed a similar impression, noting a list of political 'votaries and admirers' who were won over by Mary Isabella.[126] Chief among these men was Sir John Blaquiere, whose loyalty she cultivated even further through courtesy calls such as that made on 6 March 1786 when, as receipts at Belvoir Castle show, she travelled in style by sedan chair to his home.[127] As the 'moving spirit' behind the Rutland Fountain and this associated print, Blaquiere helped to ensure that Mary Isabella's political flattery paid off.[128] At his behest, she was rewarded with these two memorials in stone and aquatint, which, although comparatively modest, have proved much more enduring than the monuments to monarchs and military men that once graced the Dublin streetscape.

To her Grace Mary Isabella Dutchess of RUTLAND this PLATE is most humbly inscribed by her devoted Servant J. Blaquiere

This fountain for the use of the Poor of the City of Dublin, was Erected in honor of the Duke of Rutland, the late & much lamented Lord Lieutenant of Ireland it stands in Mercer ____ ____ ____ feet, in a recess in the centre, is a Sea Goddess reclining on an Urn, & discharging its water in a large Shell of rough Masonry, which is under it, from whence it flows over Rocks below above this in high relief __ ____ tablet is represented the good Samaritan, & the well known Story of the Marquis of Granby presenting to a Wounded Soldier the water which had been brought for his own refreshment In compartments __ ____ other side are medallions of the noble Duke & the present beautiful Dutchess. On the right wing is represented Agrippina weeping over the Ashes of Germanicus, & on the left Ireland bewailing the loss of her guarded ____ protector. An English & Latin inscription are on each side, one reminding the Passenger of the Virtues & premature Death of the friend & protector of the Poor who had he lived would have Erected this Fountain __ ____ their use at his own expence And the other expressive of the feelings of those who carried the work into execution

16

Sir Joshua Reynolds (1723–1792)

Frances Molesworth, later Marchioness Camden

1777

Oil on canvas, 141.6 x 114.3 cm

The Huntington Library, Art Museum, and Botanical Gardens, California

Vicereine of Ireland 1795–8

This portrait of Frances Molesworth (c.1760–1829) by Sir Joshua Reynolds captured her at a time in her life when, in the words of Mrs Delany, she was 'pretty, quiet, and young'.[129] Eight years and three rejected marriage proposals later, Frances married John Jeffreys Pratt (afterwards Earl Camden), in 1785, before later accompanying him to Ireland to serve as vicereine in the troubled years from 1795 to 1798.[130] As the last woman to serve in the role before the outbreak of the 1798 Rebellion, Frances carried out her duties in the shadow of mounting political and religious tensions, winning plaudits for her 'humanity and benevolence of heart'.[131]

It has been claimed, incorrectly, that on account of her husband's unpopular policy of 'extreme repression' towards Irish Catholics, Frances 'soon returned to the safety of England' after arriving in Dublin.[132] It would have been easy for her to have done so but in spite of her husband's increasingly 'hard-line approach', Frances, in fact, remained in Ireland throughout this period and proved herself to be an active and charitable vicereine.[133] Correspondence with Lady Louisa Conolly of Castletown House records her attempts to bridge divides with her husband's rivals by reaching out to their wives. Taking the initiative, she wrote to express the hope that political differences, ostensibly over Catholic rights and Irish autonomy, would not prevent Lady Louisa from meeting her.[134] 'Politics,' wrote Lady Louisa in response, 'does not in the least diminish the personal respect and regard I entertain for … Your Ladyship.'[135]

Frances also used her influence as vicereine to support cultural and charitable causes. In April 1796, her name headed a list of patrons who had supported William Heron in his release of new vocal music.[136] Heron's music included 'the Pathetic Tale of "The Black-birds," set partly to Music and partly for Recitation'.[137] Particularly notable among her acts of charity, at a time when religious tensions were running high, was the donation of £10 to the Catholic Charity Schools at Arran Quay, Dublin, at Christmas 1795.[138] In the face of the growing threat of rebellion against British rule, Frances's attempts to bridge the religious and political divide in Ireland suggest a woman of strength, influence and independent mind who, as vicereine, cast off the innocent image portrayed here by Reynolds.

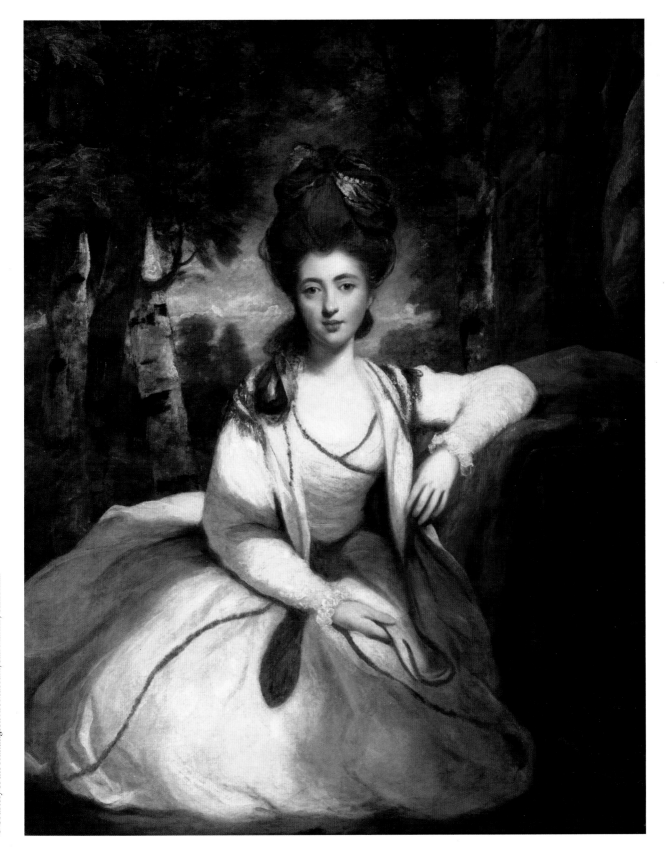

17

Elizabeth, Countess of Hardwicke (1763–1858)
The Court of Oberon, or the Three Wishes
1831
Printed book, 29 x 22.5 cm
Library of Trinity College Dublin

At midday on 1 January 1801, the hoisting of the Union flag over the Bedford Tower at Dublin Castle marked the formal birth of the United Kingdom of Great Britain and Ireland.[139] Arriving at the Castle six months later as the first vicereine of the Union period, Elizabeth Yorke, Countess of Hardwicke, found herself in what she called a 'new world' inhabited by large numbers of struggling people.[140] 'I was much struck,' she wrote shortly after arriving, 'with the appearance of sickness and depression among them.'[141] Sensing change, she quickly identified the need to find new relevance for the viceregal court at a time when its continued existence was in doubt, and resolved to 'shew the trades-people that the union does not do away [with] the Court'.[142] Motivated by the impulses of charity and utility, Elizabeth embarked on a series of novel ventures that would culminate in the publication of this play some thirty years later.

Among those ventures was the promotion of Irish calico as a fashionable alternative to wallpaper. Designing a pattern of 'Vine Leaf and Spray on a rose-pink ground', Elizabeth commissioned a large order for the Viceregal Lodge from one Mr Clarke of Palmerstown.[143] Clarke reportedly received 'extensive orders for this pattern' thereafter.[144] Emulating earlier vicereines by appearing in Irish dress, Elizabeth also pioneered a more lasting form of support for the textile industry by establishing the Charitable Repository in Dublin.[145] This outlet 'for female industry' was modelled on the Manchester Repository and flourished under her successors.[146] Visiting it twenty-four years later, another vicereine explained its function and enduring value: 'All persons who, from reduced circumstances are in distress may sell the product of their industry without disclosing their names – I was told that the widow of an officer makes 300£ a year in this manner, & the work shewn to me was beautifully executed.'[147] Although her tenure as vicereine came to an end in 1805, Elizabeth's support for Ireland's poor continued. In 1831, she published and illustrated *The Court of Oberon* in support of a bazaar for the 'distressed Irish'.[148] Featuring engravings by the Irish artist John Samuel Templeton (*fl.*1830–57) and themes of aristocratic paternalism, it was dedicated to Princess Victoria (later Queen Victoria) and represented the climax of Elizabeth's longstanding support for Ireland.[149]

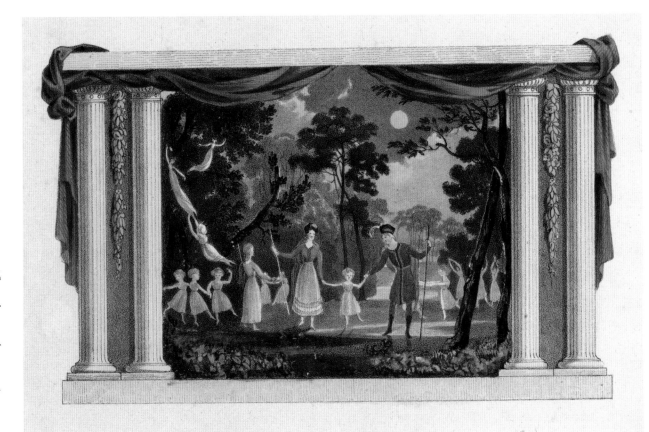

COURT OF OBERON, ACT I.

Drawn on Stone by J.S. TEMPLETON, from a Drawing by the COUNTESS OF HARDWICKE.

Printed by Engelmann & Co.

18

Unknown artist
Charlotte Lennox, Duchess of Richmond (1768–1842)
c.1807
Oil on canvas, 56 x 48 cm
Goodwood House, West Sussex

Vicereine of Ireland 1807–13

In July 1807, an engraving of this portrait of Charlotte, Duchess of Richmond, or a version of it, was published in the fashionable periodical *La Belle Assemblée*.[150] In October, a second engraving of the image appeared as the frontispiece to the Irish periodical *Walker's Hibernian Magazine*.[151] It was through this portrayal of her in simple, modest dress, with a sincere, direct gaze towards the viewer, that the image of Charlotte as vicereine of Ireland was first disseminated.

Throughout Charlotte's tenure from 1807 to 1813, that image was expanded through frequent reports of her activities. Most notable among these was her progressive use of Dublin Castle for charitable purposes rather than solely for exclusive aristocratic entertainment. In July 1808, she staged a ball and exploited the occasion to host a charitable lottery in the Castle grounds, along with a fair at which Dublin artisans sold 'selections of their most valuable Irish manufactures'.[152] The lottery raised 'between one and two hundred guineas' for Dublin's Charitable Repository, which had been established by former vicereine Elizabeth, Countess of Hardwicke (see Cat. 17).[153] 'Thus,' noted *The Morning Post*, 'our amiable Vice-Queen,

sought to combine pleasure with profit to the Citizens of Dublin'.[154] In the same month, she organized a similar fair at the Viceregal Lodge.[155]

Charlotte's patriotic example was also manifest in the instruments she played as well as in the iconography of the clothes she wore and the spaces she decorated. In 1809, she commissioned a pedal harp from John Egan of Dublin.[156] For her daughter's christening the following year, she engaged the Dublin painter Charles Jones to decorate the floor of St Patrick's Hall at Dublin Castle with wreaths of shamrocks and the motto 'Prosperity to Ireland'.[157] By October 1810, she was reportedly working with 'Mr. Clarke of Palmerstown' to commission dresses of 'Irish Cambrick Muslin' featuring shamrocks and 'devices emblematical of the country'.[158] In recognition of her efforts, she was publicly saluted by the Lord Mayor of Dublin as the 'patroness of Irish manufacturers'.[159] In rendering 'pleasure subservient to objects of humanity', Charlotte cultivated a benign image as vicereine that largely accorded with the modest, unpretentious portrait that had been published to mark the commencement of her tenure in 1807.[160]

19

Martin Cregan (1788–1870)
Charlotte Florentia Percy, Duchess of Northumberland (1787–1866)
1831
Oil on canvas, 175 x 114 cm
Syon House, London

Vicereine of Ireland 1829–30

'It represents her Grace, who is the very personification of an English lady, more like a Donnybrook duchess, or a lady's maid dressed up in the cast-off finery of her mistress.'[161] Such was the scathing review of this portrait of Charlotte Florentia, Duchess of Northumberland by Martin Cregan when it was exhibited at the Royal Hibernian Academy in 1831. According to an entry in her diary, Charlotte first noticed Cregan's portraits, which she considered 'really well executed', shortly after her arrival in Dublin as vicereine of Ireland in 1829.[162] The commission for this portrait followed and on 6 December 1830, she recorded her 'last sitting with Mr. Cregan'.[163] Contemporary criticism of the portrait focussed on the disagreeable tension between the showiness of Charlotte's robes and ostentatious plumed hat, and the contrasting modesty and graciousness of her character. It was, however, a tension that Cregan was arguably not unwarranted in highlighting.

For Charlotte, as vicereine, impressive displays mattered. At a Dublin Castle dinner in 1829, she ensured that her gold plate was 'left on the table' in order to arouse the 'satisfaction of the curious'.[164] A week later, she was delighted with the 'brilliant effect' of her two services of plate, which 'seemed to surprise as well as please'.[165] In March 1829, she was gratified that guests at her first drawing room were 'much better dressed than I expected'.[166] On another occasion, however, Irish ignorance of sartorial protocols at a fancy ball disappointed: 'Unfortunately in this country they cannot comprehend that a fancy is not a masked ball'.[167] Even grand Irish houses such as Carton were judged to be 'without any display'.[168] At the same time, Charlotte also recognized that finery could be a barrier. When she dispensed with it altogether on her visits to charitable institutions such as the Female Orphan School, her reputation as a sympathetic advocate for the poor soared.[169] In March 1829, she demonstrated a strong sense of social responsibility when she objected to attending service at the Chapel Royal, Dublin Castle 'in State'.[170] The trappings and panoply of viceregal display, she argued, undermined the solemnity of church services in a way that was 'quite disgusting', setting an unsavoury example of excess.[171] At once ostentatious and unassuming, Charlotte's style, like Cregan's portrait, highlights the often dichotomous image of the vicereine as a simultaneously majestic yet modest figure.

20

Henry Kirchhoffer (*c.*1781–1860)
Coast Scene, with Smugglers
1829
Oil on canvas, 52 x 63 cm
Office of Public Works, Dublin Castle

This atmospheric depiction of the twilight intrigues of smugglers has long been a part of the collection of paintings associated with Dublin Castle and the viceregal court.[172] Signed by the Irish artist Henry Kirchhoffer and dated 1829, it depicts the port of Martello in Corsica.[173] Of hitherto unknown provenance, it can now be identified as an acquisition made for the Castle's collection by Charlotte Florentia, Duchess of Northumberland, in 1829, while she was vicereine of Ireland. As such, it is a rare surviving example of a vicereine's tangible support for the arts during her time in the role.

In her diary entry for 9 May 1829, Charlotte recorded the visit to the annual Royal Hibernian Academy exhibition that prompted the acquisition of this work: 'We went to the private view of the Exhibition ... 2 or 3 landscapes good – on the whole much better than we had expected ...'[174] According to reports, Kirchhoffer's painting was among the two or three landscapes that had caught Charlotte's eye. 'This is a very interesting picture,' noted *The Morning Register,* 'and has many of the touches of nature ... The wild sublimity of the coast, and the dangerous profession of the

smuggler are very accurately portrayed. This is one of the pictures which, we understand, attracted the particular notice of her Grace the Duchess of Northumberland.'[175] Charlotte evidently shared the enthusiasms of the critics, and the painting's subsequent entry into the collection of artworks associated with the viceregal court can now be cited as one of several 'distinguishing proofs of patronage' associated with her visit to the exhibition.[176]

This visit was one of many such cultural excursions. Another noted by Charlotte in her diary was a trip to the exhibition of Old Master paintings organized by the Royal Irish Institution in 1829, where she 'found some very good paintings in the collection – a Claude, Salvator, Cuyp, Teniers & c & c'.[177] There was also a tour of the building 'dedicated to sculpture' at the Royal Dublin Society, where students sketched casts of 'the Laocoon – the Apollo & c & c'.[178] Charlotte's artistic enthusiasms as vicereine found another practical outlet when she commissioned Martin Cregan to paint her portrait in 1830 (see Cat. 19). Depicting the vicereine with an artist's paintbox, it signalled the same artistic interests that had prompted her to acquire Kirchhoffer's coastal scene for the collection at Dublin Castle.

21

West and Son Jewellers
The Hibernia / Northumberland Vase
1830
Silver, gold, bog oak, glass and semi-precious stones,
62.5 x 25.5 x 17.5 cm
Alnwick Castle, Northumberland

On Friday 3 December 1830, Charlotte Florentia, Duchess of Northumberland (see Cat. 19) said her final farewells as vicereine of Ireland. Recounting the circumstances in her diary, she noted: 'We received those who called to take leave of us on our departure and a most trying farewell it proved. I was informed a token of the regard of the ladies of our society was to be presented to me by the Duchess of Leinster ... we leave a country ... where we have been so happy ...'[179] The token of regard she referred to was this highly symbolic vase, which was later forwarded to her in England. Commissioned by a group of sixty-five women in and around Dublin, it was accompanied by a testimonial thanking Charlotte for her 'deep interest' in the welfare of the city of Dublin, her 'numerous charitable donations' and her 'liberal encouragement' of Irish manufacturers.[180]

Through its materials, authorship and symbolism, the vase serves as a romantic expression of the Irish skill and example in which Charlotte took such a 'deep interest' as vicereine. In a contemporary note accompanying it, emphasis was placed on the significance of its Irish authorship: 'N.B: This ornament has been executed under the immediate inspec-tion of Messrs West & Son, at their Establishment in Capel St. by Irish artists.'[181] Festooned with emblematic shamrocks and forget-me-nots, it features an Irish wolfhound seated upon an 'Irish mantle', and an enthroned figure of Hibernia playing the harp.[182] Above Hibernia's throne, a phoenix emerges from a canopy, heralding national rebirth. The entire eclectic ensemble is supported by a carved bog oak base in the form of an Irish elk's head, which bears the dedi-cation 'Hibernia Grata / Ireland is grateful.'

This gratitude was not, apparently, misplaced. Chief among Charlotte's charitable acts as vicereine was her assistance in forming and leading the Irish Ladies' Patri-otic Association for the purchase of Irish fabrics.[183] This undertaking helped to sow the seeds of a revival in the fortunes of Irish weavers in the 1830s.[184] It earned Char-lotte widespread praise, even among her husband's politi-cal opponents. At a dinner in honour of Daniel O'Connell in January 1830, the assembled company, though hostile to the viceroy, were united in the sentiment that his wife was 'doing infinite good'.[185] This vase survives today as a testament to the popularity of that sentiment.

22

Sir George Hayter (1792–1871)
Maria Phipps, Marchioness of Normanby (1798–1882)
Begun 1827, completed 1840
Oil on panel, 54.5 x 45.4 cm
Collection of the Marquis and Marchioness of Normanby

Vicereine of Ireland 1835–9

Six days after her arrival in Ireland as vicereine, in May 1835, Maria, Countess of Mulgrave (later Marchioness of Normanby) wrote to inform her mother-in-law of her early impact: 'I hear I have lifted up the hearts of the people in the liberties by ordering … some poplin gowns and I pray you if you can get me commissions for poplins do as the more I can buy the better for the poor people here.'[186] Convinced that Ireland had, as she phrased it, been 'put down' by successive British governments 'at the point of the bayonet', Maria was determined to recast the image of the viceroyalty in a more benign and inclusive light.[187] In shaping this new image, she would ultimately forge an equally novel relationship with the reigning monarch, which would lead to the completion of this portrait.

Throughout 1835, Maria sought to enhance the appeal of Irish poplin as an alternative to silk by designing patterns that attracted the influential royal patronage of the Duchess of Kent.[188] Sales were reportedly 'unprecedented'.[189] With the accession of the Duchess's young daughter as Queen Victoria in 1837, Maria moved quickly to win further royal patronage by joining the Queen's service as

Lady of the Bedchamber.[190] Her papers show that through this position, she was able to secure even larger orders for Irish poplin from the new monarch, as well as three coveted royal warrants for Irish poplin weavers.[191]

It was during her time in the Queen's service that Maria came into contact with Sir George Hayter, who had begun to paint this portrait of her in Florence in 1827.[192] 'I look forward to sitting to him as a great bore,' Maria had complained in 1827, 'and I am afraid he is so fond of … gorgeous colours … which are things I hate.'[193] By 1838, as vicereine and Lady of the Bedchamber to the Queen, who considered Hayter to be 'out and out the *best* Portrait painter', Maria was obliged to sit for him again for his painting of the Queen's coronation.[194] 'The ebauche,' she wrote of his initial efforts, 'is beastly but I daresay he will work it up right.'[195] The result, in addition to the coronation picture, was the completion of this previously abandoned portrait of Maria, which owed its redemption to the mollifying effects of time and the influential royal patronage that Maria so eagerly pursued as vicereine.[196]

23

William Tompson (*fl.*1810s) and unknown maker
Travelling Box of Maria Phipps, Marchioness of Normanby
c.1838
Rosewood with brass mounts and velvet-lined interior,
16.5 x 40 x 29 cm
Collection of the Marquis and Marchioness of Normanby

Frequent travel was a reality of life for many vicereines of Ireland. As they toured Ireland for weeks at a time and occasionally returned to Britain to visit children and family members, many relied on travelling boxes such as this to help them keep in touch with correspondents, store valuables and maintain their appearance. This example belonged to Maria, Countess of Mulgrave (later Marchioness of Normanby), who was vicereine from 1835 to 1839 (see Cat. 22). Emblazoned with her monogram 'MN' and her marchioness's coronet, it contains various bottles and receptacles for perfume, powder and ink, as well as implements for personal grooming and a tray for writing paper. Its patented Tompson lock ensured the security of the contents while the box was in transit or sitting on a temporary dressing table, as did a small lockable drawer for the safekeeping of Maria's jewellery.

In the wake of Catholic Emancipation, Maria believed strongly in the need to increase the visibility of the viceregal court by engaging with the underprivileged many rather than the privileged few. 'The days are gone by,' she warned her husband, 'when great dinners, balls and fêtes made a government popular in Ireland.'[197] This meant undertaking demanding provincial tours and making a particular effort to engage warmly with the Catholic majority, as she did on an extensive tour of Ulster in 1835, where her 'kindliness' was welcomed.[198] Despite the protests of what she called 'violent Orangemen' in Derry, who were opposed to these inclusive gestures, Maria noted with pleasure the 'great astonishment' of the people of the north Donegal coast when they witnessed the first viceregal visit to their county for more than three decades.[199] In 1837, Maria's travels as vicereine took her to London when she began serving simultaneously as Lady of the Bedchamber to the young Queen Victoria.[200] In taking on these combined viceregal and royal duties, Maria recognized the opportunity to encourage the monarch's support for the people of Ireland, who, she lamented, 'have never received justice from any English sovereign before'.[201] Her demanding journeys paid off in the form of large orders for Irish fabrics from the Queen, which Maria transmitted in person from London to Dublin.[202] Amid all the upheavals, this multi-purpose box helped to sustain her peripatetic lifestyle as one of the most active vicereines of her generation.

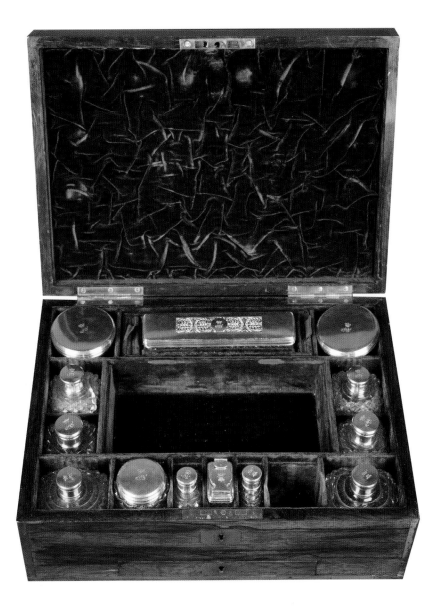

24

After Sir Thomas Lawrence (1769–1830)
Lady Henrietta Cole, Lady Grantham, later Countess de Grey (1784–1848)
*c.*1815
Oil on canvas, 54 x 46.4 cm
National Trust, Florence Court, County Fermanagh

Vicereine of Ireland 1841–4

This portrait of Henrietta Frances, Countess de Grey is among the handful of depictions of former vicereines on public display on the island of Ireland.[203] It usually hangs in the drawing room at Florence Court, County Fermanagh where, as the youngest daughter of William Willoughby Cole, 1st Earl of Enniskillen, Henrietta was born and raised.[204] In August 1842, Florence Court became the focus of festivities to mark Henrietta's return to her native Fermanagh after an absence of many years.[205] It prompted an outpouring of civic pride in her new-found status as vicereine of Ireland.[206] Responding to an official address delivered in the hall at Florence Court, Henrietta emphasized her sense of responsibility as an Irish-born vicereine: 'I pray that I may never prove unworthy of my race … That our country, and Fermanagh in particular, may through the Almighty's protection, prosper … is the ardent prayer of … your grateful, and affectionate friend and countrywoman.'[207]

Henrietta's Irish identity represented a distinct advantage for her as vicereine from 1841 to 1844, but it also gave rise to particular pressures. Among these were the heightened expectations of the Dublin poplin weavers, who petitioned Henrietta to mark her return to her native country by supporting them more vigorously.[208] In her response dated 15 December 1841, Henrietta stated that she was 'fully aware of the value of the Poplin Manufacture' and had 'already … contributed to its welfare'.[209] The issuing of a viceregal warrant in Henrietta's name that very same day, which appointed Richard Atkinson and Co. 'poplin manufacturers to Her Excellency', suggests a somewhat reactionary approach to these pressures, but her patriotic efforts soon intensified.[210] It has been observed that Henrietta boosted employment in Ireland by suggesting a range of public works funded from the royal estates.[211] She also appointed, among numerous official suppliers, John M. Barnardo as her furrier, Jane Russell as her dressmaker, James Forrest as her silk mercer, Mrs J. Oldham as her corset maker, Messrs M'Cullagh as her music sellers and a Mrs Johnston as her milliner.[212] Despite the limitations of what she referred to as 'her control' as vicereine, this unprecedented number of appointments suggests Henrietta's success, however limited, in helping to stimulate the national prosperity she referred to in her address at Florence Court, where her portrait still hangs as a reminder of her efforts.[213]

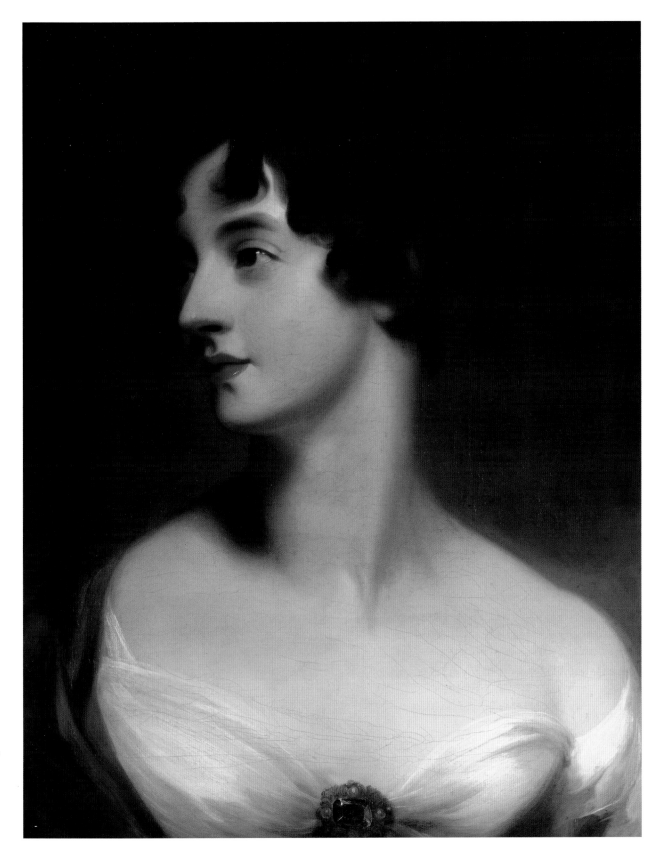

25

Sir Edwin Landseer (1802–1873)
Louisa Hamilton, Duchess of Abercorn (1812–1905)
1835
Oil on board, 33.5 x 22.5 cm
Barons Court, County Tyrone

Vicereine of Ireland 1866–8, 1874–6

In 1866, Louisa, Marchioness of Abercorn (later Duchess of Abercorn) followed in the footsteps of her mother Georgina, Duchess of Bedford (1781–1853) when she became vicereine of Ireland. Bearing a striking resemblance to her mother, who was vicereine from 1806 to 1807, she also followed her example by sitting regularly to Sir Edwin Landseer, who painted this portrait of Louisa in about 1835.[214] The musical interests captured in this depiction became manifest during Louisa's tenure as vicereine from 1866 to 1868 and again from 1874 to 1876, when she served as patroness of the Dublin Amateur Philharmonic Society.[215] Her official viceregal appointments were numerous and included Mr and Mrs Garbois as her dance teachers, George Lucas as her hairdresser and perfumer, Mrs Manning as her dressmaker and John Stewart as her dyer and ostrich-feather dresser.[216] The lavishness of her patronage was consistent with the view that during her time as vicereine, Louisa was 'a true *grande dame*, and ever comported herself as such'.[217]

This largesse was also consistent with expectations that the lavish spending of Louisa's husband James Hamilton, 1st Duke of Abercorn, would help to restore some of the ebbing prestige associated with the office of viceroy.[218] In seeking to meet these expectations, Louisa and her husband immediately instigated the most comprehensive programme of redecoration witnessed at Dublin Castle since the 1830s. They entrusted the upholstery work to Messrs Fry and Son, the decorating to John Battersby and the production of carpets to Millar and Beatty.[219] Interiors such as Louisa's boudoir, which was decorated in the 'Louis Seize' style with white and gold furniture and panels of blue satin, provided a more regal backdrop to court life and to occasions such as the visit of the Prince and Princess of Wales in 1868.[220] Amid the pageantry of the royal visit, which was planned to boost morale after the Fenian rebellion of 1867, it was noted that Louisa, despite her 'strong strain of Evangelical religion', behaved in a warm, unostentatious manner towards the Roman Catholic Archbishop of Dublin, Cardinal Cullen.[221] In the same way that her mother had been 'a charming consort' as vicereine but had known 'just how to make a political statement without saying a word', Louisa likewise employed a mix of 'extreme simplicity' and 'great dignity' that made her, both in this portrait and in her conduct as vicereine, 'the image of her Mama'.[222]

26

James Ronca (1826–1910)
Badge of the Order of Victoria and Albert (Third Class)
1879–80
Shell cameo in silver-gilt frame set with diamonds,
half-pearls and rubies, 5.3 x 3.4 x 0.7 cm
Royal Collection Trust

On 19 April 1880, Queen Victoria wrote to the outgoing vicereine of Ireland, Frances Anne, Duchess of Marlborough (1822–1899) with news of an impending honour: 'I, as everyone is, am filled with admiration at the indefatigable zeal and devotion with which you have so successfully laboured to relieve the distress in Ireland ... I am therefore anxious ... to confer on you ... the Victoria and Albert Order.'[223] On 5 May, the Queen received Frances at Windsor Castle to confer this prestigious honour in person.[224] It has been observed that on account of its date, this badge is 'probably' the one presented to Frances on that occasion, but that it may equally be a version given to the Duchess of Buccleuch the previous year.[225] Confirmation that the Duchess of Buccleuch's badge remains in the collection of her descendants would now appear to verify the provenance of this badge as the example presented to Frances.[226]

The 'zeal' referred to by the Queen was first demonstrated by Frances as vicereine in December 1879, when a mounting agricultural crisis had threatened to cause widespread hunger in Ireland.[227] Fearing a national tragedy on the scale of the Great Famine of the 1840s, Fran-

ces swiftly announced the creation of a fund to prevent 'extreme misery and suffering among the poor', especially in Kerry, Galway, Sligo, Roscommon, Donegal and Cork.[228] In a letter published in *The Times* on 18 December, she highlighted the 'extreme urgency' of the situation and advocated solidarity.[229] 'I appeal,' she wrote, 'to English benevolence.'[230] Funds duly poured in from London (over £10,000), but also from as far away as Hong Kong (over £4,000), Penang (£1,600) and the Falkland Islands (£142).[231] Throughout the winter of 1879–80, Frances chaired a weekly committee at Dublin Castle, distributing these funds to the most needy, irrespective of creed or class, and guarding as she had promised, 'against proselytism'.[232] In total, the Duchess of Marlborough's Relief Fund raised the enormous sum of £132,000, equivalent to approximately €9,647,606 today.[233] It was an extraordinary achievement for the vicereine. In a farewell address delivered in the Throne Room at Dublin Castle on 28 April 1880, Frances was assured that she would 'long be remembered' in Ireland for her efforts 'to mitigate the horrors of famine'.[234] This badge is a reminder of those efforts.

27

Sir John Leslie (1822–1916)
Charlotte Spencer, Countess Spencer (1835–1903)
1860
Oil on canvas, 239 x 147 cm
Althorp House, Northamptonshire

Vicereine of Ireland 1868–74, 1882–5

Charlotte, Countess Spencer was vicereine of Ireland from 1868 to 1874 and again from 1882 to 1885.[235] In this portrait by the Irish artist Sir John Leslie, a selection of worldly trappings are deployed as symbols of Charlotte's varied interests, many of which she pursued during her time in the role.[236] As the husband of Charlotte's cousin, Leslie was well placed to observe these interests.[237] Capturing Charlotte in a rich interior as she holds up a case of family miniatures, Leslie's portrayal emphasizes her domestic and material concerns but it also points to her life outside the home. Though she clutches the miniatures, Charlotte does not focus her attention upon them, gazing instead beyond the picture plane towards the viewer. This knowing, outward gaze, together with the representation of outside landscape and exotic furnishings, all hint at a life beyond the domestic sphere and an engagement with the wider world.

Charlotte's flair for interior decoration found expression in 1885 when she oversaw a major programme of renovations in St Patrick's Hall at Dublin Castle, as vicereine. It included the introduction of a new white and gold colour scheme as well as a new floor, ceiling cove and four large mirrors, all of which remain in place.[238] 'The alterations,' it was reported, 'have been carried out in strict accordance with the wishes and views of Lady Spencer.'[239] Her interests extended, however, beyond the lofty apartments of the Castle, and she maintained an avid interest in politics.[240] Despite the unpopularity of her progressive political views with Queen Victoria, Charlotte was a firm supporter of Gladstone's plans for Irish Home Rule.[241] While serving as vicereine, she published a treatise on poverty, which, she explained, aimed to empower the poor to 'strive against' those causes of poverty that were 'in their own power to diminish or to remove'.[242] The twin causes of Irish self-determination and self-sufficiency exercised Charlotte both during and after her time at Dublin Castle. In 1887, two years after she had left Ireland, she organized a bazaar in support of the enterprising Donegal Industrial Fund.[243] Held in the gilded interiors of her London townhouse, Spencer House, this public-spirited effort combined the various domestic and private but also political and public interests that had motivated Charlotte as vicereine.[244]

John Singer Sargent (1856–1925)
Theresa Susey Helen Talbot, Marchioness of Londonderry (1856–1919)
1909
Oil on canvas, 94 x 68 cm
National Trust, Mount Stewart, County Down,
Courtesy of the Trustees of the Londonderry Settlement

Vicereine of Ireland 1886–9

'Hers was a most dominant personality. She had the proudest face I have ever seen, with a … beautifully-shaped, determined chin … She had an all-powerful position both in politics and society.'[245] This vivid contemporary portrait of Theresa, Marchioness of Londonderry evokes in print the same powerful presence captured in paint by John Singer Sargent in 1909. Formidable in black furs and feathers, Theresa emerges from the shadows of Sargent's canvas in the same commanding way that she 'emerged as a political force' in the 1880s when she became vicereine of Ireland.[246]

From 1886 to 1889, Theresa presided over a 'very magnificent' viceroyalty at Dublin Castle.[247] Adamantly opposed to Home Rule and 'staunchly Unionist', she saw viceregal magnificence and munificence as channels for highlighting the benefits of British rule in Ireland.[248] In the winter of 1887–8, Theresa's costly redecoration of the Castle's State Apartments provided months of employment for a team of craftsmen led by the Dublin firms of Dockrell, Fry and Sibthorpe.[249] Reports that over 3,000 books of gold leaf had been exhausted sent out a message that money was no object when it came to supporting Irish industry and,

by extension, burnishing the credentials of the Union.[250] In Sackville Street, the premises of Thomas Fry provided Theresa with a shop window for the display of the Castle's improved furniture collection. Upholstered in Irish poplin of 'Oriental design', to the vicereine's specification, it advertised the benefits of her grand stimulus to local industry.[251]

For Theresa, local industry also meant cottage industry. In provincial cities and towns such as Limerick and Monaghan, lace makers benefitted from the kind of viceregal patronage rarely bestowed upon artisans outside Dublin. In January 1887, it was announced that Miss Z.A. Inman had won a design competition organized by Theresa in conjunction with London's South Kensington Design School.[252] Though the victor was English, the winning design for a lace flounce was to be worked in County Monaghan.[253] Theresa's support for the lace industry continued throughout and beyond her time as vicereine and five years later, in 1894, she became president of the London committee of the Irish Industries Association.[254] The ensuing efforts to popularize Irish fashions in Britain would, it was claimed, be 'of infinitely more practical benefit to Irish peasants than HOME RULE'.[255] Their political imperatives were consistent with the values and qualities that would later inspire Sargent's arresting portrait of the Marchioness.

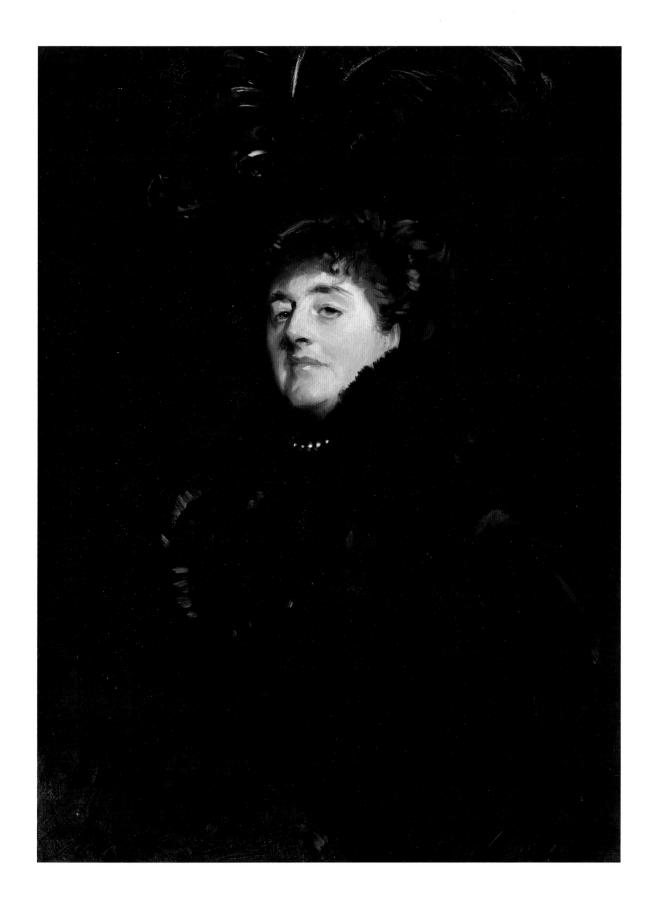

29

Unknown maker
Invitation to Countess Cadogan's Irish Textile Exhibition
1897
Printed card, 12 x 18 cm
National Library of Ireland

With this invitation card, one 'Miss Fitzgerald' found herself among the 'brilliant fashionable gathering' assembled at Dublin's Royal University on 19 August 1897 to witness the opening of Countess Cadogan's Irish Textile Exhibition.[256] Organized by the serving vicereine of Ireland, Beatrix, Countess Cadogan (1844–1907), the exhibition was one of the major cultural events of the year.[257] Its aim, according to Beatrix, was 'to bring under the notice of the visitors from England and elsewhere the excellence and the beauty of the work at present done in Ireland, and the perfection to which it has been brought'.[258] Earlier that year, Beatrix had organized a smaller display of Irish textiles at her London townhouse. Against a backdrop of lofty rooms and through the presence of a saleswoman from the London department store Fenwick's of Bond Street, she had attempted to boost the fashionable image of textiles sourced from even the most humble of origins in rural Ireland.[259] Building on these efforts, she now sought to link cottage industries across Ireland with influential buyers, retailers and patrons on a much grander scale.

As the Recorder of the City of Dublin observed at the launch of Beatrix's exhibition, cottage industries were foremost in her mind as she developed the project: 'The cottage industries carried on for the most part in remote rural districts, in which not only beautiful work is executed, but through the employment of the young people emigration is stayed … were in Her Excellency's mind a subject of special solicitude.'[260] Beatrix's call for exhibitors had been answered by numerous institutions such as the Crawford Municipal School of Art, as well as convents and regional artisans including Garde and Co. of Castlemartin, County Cork, Clayton and Co. of Navan, County Meath, Neil McLooney of Killybegs, County Donegal, and Richardson and Son of Belfast.[261] The exhibits of the latter, it was reported, were purchased in their entirety for re-sale at Dublin's most prestigious department store, Switzer's.[262] This agreeable outcome was but one example of the success of Beatrix's efforts to enhance the status of Irish textiles in the eyes of those with buying power and influence.[263] Another was the presence of the Duke of York (the future King George V) who, as this invitation indicates, formally opened the vicereine's landmark exhibition.

Her Excellency The Countess Cadogan's
Irish Textile Exhibition.

The Secretary and Manager
is directed by the Executive Committee to invite

Miss FitzGerald

to be present at the Opening Ceremony by

H. R. H. The Duke of York, K.G.

at the Royal University, Earlsfort Terrace,
on Thursday, 19th August, at 3.30 p.m.

R.S.V.P.

Morning Dress.

This Card to be presented at the Door.

30

Alphonse Jongers (1872–1945)
Ishbel, Marchioness of Aberdeen and Temair (1857–1939)
1897
Oil on canvas, 46 x 36.3 cm
National Trust for Scotland, Haddo House, Aberdeenshire

_____ Vicereine of Ireland 1886, 1905–15

In February 1886, John Campbell Gordon, 7th Earl of Aberdeen (afterwards 1st Marquess of Aberdeen and Temair) was invited to become viceroy of Ireland by the British Prime Minister, William Ewart Gladstone. His response provided a telling indication of the central role he envisaged for his wife, Ishbel, as vicereine: 'Very well; I accept; and I'll tell you, sir, why I do so with some confidence; it is because of the help I shall get from Lady Aberdeen'.[264] Though initially serving as vicereine for only six months, from February to August 1886, Ishbel more than fulfilled the confidence placed in her. She later returned to the role from 1905 to 1915. The highlight of her early efforts as vicereine was the inauguration of the Irish Industries Association, of which she was president, in May 1886. Marked by a garden party at the Viceregal Lodge, at which all guests wore Irish-made garments, the event 'heralded her first, highly intentioned, public relations exercise'.[265] Dressed in Atkinson's Irish poplin and wearing Irish leather shoes, Balbriggan stockings and a copy of the Tara brooch made by the Dublin jewellers Messrs Waterhouse, she was 'a living, head-to-toe announcement for Irish home industries'.[266]

As vicereine, Ishbel cultivated a benevolent image 'as a sort of national mother'.[267] Fusing a paternalistic approach to cultural patronage, especially of Ireland's textile industry, with support for her 'cherished' cause of Irish Home Rule, she wore and championed Irish materials, patterns and emblems that represented a future in which the Irish people could both help and govern themselves.[268] Her highly energetic activation of the role of vicereine helped to recast the viceroyalty in the image of a modern welfare monarchy, albeit a politicized one, that was in touch with the economic and political realities and aspirations of the many rather than the few. Whereas some, though by no means all, previous vicereines had operated at a remove, Ishbel, as her daughter put it, 'changed all that and at once struck the newer, informal, practical tone that we now associate with royalty and its representatives'.[269] Painted in Canada while Lord Aberdeen was serving as Governor General there from 1893 to 1898, this intimate portrait of Ishbel, with its modern composition and loose brushwork, strikes that same informal tone.

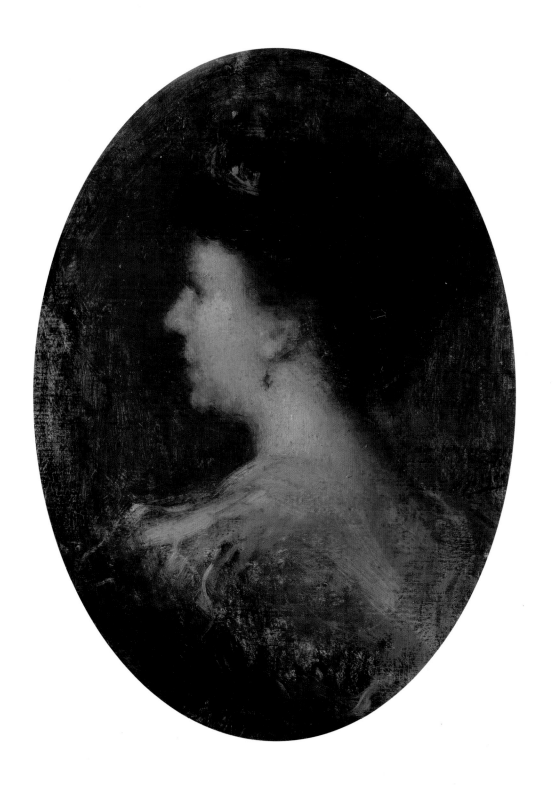

31

Unknown maker

Slainte: The Journal of the Women's National Health Association of Ireland

*c.*1909

Printed broadsheet, 60 x 54 cm

National Library of Ireland

During her second period as vicereine of Ireland from 1905 to 1915, Ishbel, Countess of Aberdeen (later Marchioness of Aberdeen and Temair) embarked on a proactive campaign to build on the social reforms she had initiated during her brief tenure in the role in 1886 (see Cat. 30). In addition to renewing her support for Irish industry, she now turned her attention to a growing public health crisis precipitated by overcrowding in urban tenements and the rise of tuberculosis (TB).[270] Seeking to alleviate these problems by tackling them at the source, Ishbel launched the Women's National Health Association of Ireland (WNHA) in 1907 and served as the editor of its journal, *Slainte* [Sláinte] (*Health*) from 1909 to 1915.[271] Through its use of the ringed cross, Celtic knot work and the Irish language, this design for the cover of the journal reflected Ishbel's vision, as an ardent supporter of social reform and Irish Home Rule, of an Ireland that could improve and represent itself as a distinct nation, socially, politically and culturally.

With the ongoing TB epidemic in mind, Ishbel and the WNHA identified women as key agents in the campaign to bring about improvements. Accordingly, they outlined, in the first volume of *Slainte*, their intention 'to spread the knowledge of what may be done in every home to guard against disease, and to eradicate it when it appears'.[272] In seeking to do so, they organized caravans that travelled across Ireland and raised awareness of the causes of TB and the solutions to it. At Peamount in Dublin and Ross-clare in County Fermanagh, Ishbel and the WNHA also established sanatoria for the treatment of TB patients, having raised the large sum of £25,000 for the purpose.[273] In what was perhaps the ultimate demonstration of the vicereine's public-spirited attitude, another hospital, this time for the treatment of soldiers returning from the First World War, opened at her behest in the gilded interiors of the State Apartments at Dublin Castle on 27 January 1915.[274] Despite the scale of Ishbel's efforts, nationalist dissatisfaction with her 'suffocatingly maternalist *ancien regime*' grew in tandem with mounting agitation against British rule.[275] 'It seems impossible,' Ishbel had complained years earlier, 'for anyone here to comprehend that one can really care about the Irish people …'.[276] By 1915, on the eve of open rebellion against the administration she represented, it seemed more impossible than ever.

32

Sir John Lavery (1856–1941)
The Lady in White, Viscountess Wimborne
1939
Oil on canvas, 201 x 101.6 cm
Private collection

Vicereine of Ireland 1915–18

From its vantage point on Carlisle Pier at Kingstown (now Dún Laoghaire) on 14 April 1915, a primitive video camera captured the moment when Alice Churchill Guest (1880–1948), Baroness Wimborne (later Viscountess Wimborne) and her husband disembarked the *R.M.S. Munster* to commence their State entry into Dublin as the new vicereine and viceroy of Ireland.[277] Carrying a bouquet presented to her by Mrs O'Brien, the wife of the chairman of Kingstown council, Alice can be seen smiling and nodding appreciatively to the hat-waving crowds in the short piece of footage recorded at three o'clock that afternoon.[278] Dressed in a cloak described as 'emerald green' in colour, she moves up the platform with the same poise captured by Sir John Lavery in this alluring portrait of her painted some years later.[279] With a bravura display of confident brushstrokes, the octogenarian Lavery created a remarkable portrait that, despite the passing years, showed neither a diminution of his powers nor a decline in the former vicereine's 'commanding' self-assurance.[280]

Though the moving images that captured Alice's arrival at Kingstown were decidedly modern, her conduct as vicereine was traditional. Accustomed to living in the greatest Edwardian plush style, Alice was 'a lady in the grand manner' who, during her time in Dublin, was known as 'Queen Alice'.[281] In public and in private, she and her husband 'assumed all the attitudes and affectations of a regal couple'.[282] At the Viceregal Lodge, dinner was served on gold plate by a retinue of powdered, colourfully liveried footmen in a manner worthy of the grandest viceroyalties of previous centuries.[283] Revelling in the pomp and circumstance of viceregal life, Alice 'played her queenly role to perfection', adopting what one visitor described as 'a heaven-born manner'.[284] But by now, this quasi-regal choreography seemed increasingly out of step with the modern world. With the First World War raging on the Continent, the State Apartments at Dublin Castle serving as a Red Cross hospital (see Cat. 31), and Irish impatience for self-government reaching fever pitch, the viceroyalty was 'rapidly sinking into irrelevance'.[285] Unlike Lavery's enduringly powerful portrayal of her, Alice's remote and grandiose image as vicereine failed to fully command the attention it might otherwise have garnered. In a country on the brink of revolution, the days of the viceregal court were numbered.

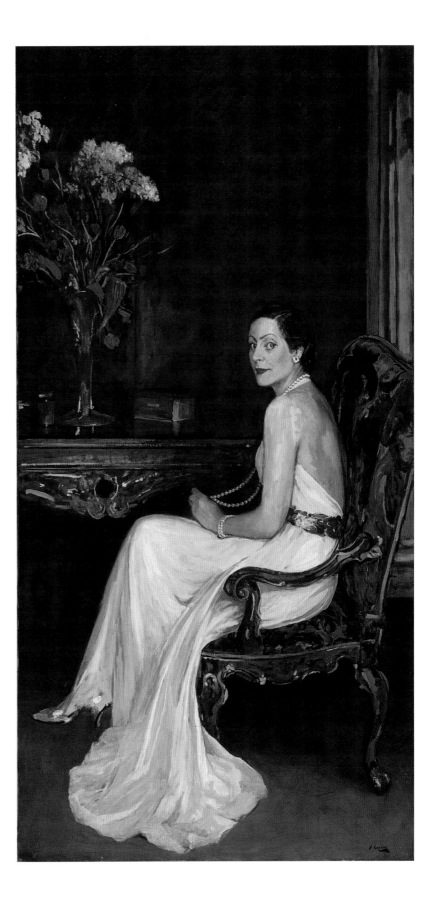

33

Alice, Baroness Wimborne, afterwards Viscountess
Wimborne (1880–1948)
*Letter from Lady Alice Wimborne to her mother, Baroness Ebury,
giving an account of the Easter Rising in Dublin, and its aftermath*
1916
Manuscript, 20 x 16 cm
National Library of Ireland

On 2 May 1916, the vicereine of Ireland, Alice, Baroness
Wimborne (see Cat. 32) sat down in the Viceregal Lodge,
Dublin to write this letter. Though the grand rooms
around her retained their customary regal appearance,
the city beyond them was now almost unrecognizable.
Eight days earlier, on Monday 24 April, the Easter Rising
had broken out in the centre of Dublin, resulting in death
and destruction that had made headlines around the
world. Addressed to Alice's mother, this letter provided
an account of the rebellion from her unique perspective
as a woman who, as she put it, 'saw all' from within the
British administration during Easter week.[286]

News of the rebellion had reached Alice in an alarming
manner: 'Monday came, I was washing my hands for lunch-
eon when I was rung up & told to stay in my bedroom, Sein
Faners [Sinn Féiners] had attacked the castle & might come
here … There were ten men on the guard to defend this huge
place … we were absolutely defenceless…'[287] Resisting her
husband's calls for her to escape to the safety of the coun-
tryside, Alice declared that she would 'sooner die' than leave
the Viceregal Lodge.[288] Unfazed by the dangers, she became

engrossed in the strategizing: 'Was there more behind
this than met the eye? W[oul]d the populace sympathise?
W[oul]d the Irish troops fire on their countrymen? Was
Germany trying to raid Ireland from the south coast?'[289]
Outlining these questions in her letter, she demonstrated
the political intelligence which, according to a close friend,
was often hidden from view beneath her 'exquisite shell'.[290]

Politically perceptive though she was, Alice could scarcely
have realized, as she signed and sealed this letter, that the
events she had just recounted represented the beginning
of the end of British rule in Ireland. 'It has all calmed down
now,' she had written, 'but it's been a terrible time. One
more awful tragedy in this beloved land – it makes my
heart ache.'[291] There would be more tragedy to come. That
very same day, the authorities condemned the first leaders
of the Easter Rising to death, setting in motion a chain of
events that would culminate in the birth of the Irish Free
State less than six years later. After centuries of pomp,
patronage and politics, the end was nigh for the viceregal
court. Alice's successor, Mary, Viscountess FitzAlan (1859–
1938) would be the last vicereine of Ireland.[292]

MS. 49,809/2

May 2nd,

VICE REGAL LODGE
DUBLIN

My darling mummie. It was such
a joy to get y' letter darling my
first from the outside world for
nearly 9 days. It has all calmed down
now but its been a terrible time.
One more awful tragedy in this
beloved land – it makes my heart ache
I am so sorry you were anxious
feared you w'd be brooding. The
country as you do the position
of the Vice Regal etc – I got a
wire through to you as soon as
I cd a letter. Did you get it

Endnotes

1 P. Sergeant, *Little Jennings and Fighting Dick Talbot* (London: Hutchinson & Co., 1913), vol. 1, p. 160.

2 A. Hamilton, *Memoirs of the Count de Grammont: Containing the History of the English Court under Charles II* (London: Swan Sonnenschein & Co., 1911), p. 254.

3 Mrs [A.B.] Jameson, *The Beauties of the Court of King Charles the Second* (London: Richard Bentley, 1833), p. 218.

4 A half-length portrait of apparently similar date is in the collection at Althorp, Northamptonshire. The treatment of the head is similar but the dog and landscape background are absent and a peeress's ermine robe is included; for an illustration see Chapter Two in this volume.

5 See Sergeant, *Little Jennings*, pp. 158–9.

6 Ibid., p. 280.

7 P. Nolan, *The Irish Dames of Ypres: Being a History of the Royal Irish Abbey of Ypres founded A.D. 1665 and Still Flourishing and Some Account of Irish Jacobitism with a Portrait of James II and Stuart Letters Hitherto Unpublished* (Dublin: Browne & Nolan, 1908), p. 150.

8 *Calendar of the Manuscripts of the Marquess of Ormonde. K.P. preserved at Kilkenny Castle* (London: Historical Manuscripts Commission, 1920), vol. 8, p. 372.

9 F. Sandford, *The History of the Coronation of the Most High, Most Mighty, and Most Excellent Monarch, James II* (London: In the Savoy, printed by Thomas Newcomb, 1687), n.p. (preface).

10 Ibid., p. 78.

11 See Jameson, *The Beauties of the Court*, p. 218.

12 Ibid., p. 216.

13 J. McGuire, 'Talbot, Richard', in J. McGuire and J. Quinn (eds), *Dictionary of Irish Biography* (Cambridge: Cambridge University Press, 2009), viewable online: https://dib.cambridge.org/viewReadPage.do?articleId=a8460&search-Clicked=clicked&quickadvsearch=yes (accessed 11 March 2020).

14 See Jameson, *The Beauties of the Court*, p. 218.

15 Ibid., pp. 217–18.

16 This portrait was reduced in size from a full-length to a three-quarter-length when a plan was devised in the late 1820s at Petworth to fold the unwanted part of the canvas over a shorter stretcher; see C. Rowell, '"Reigning Toasts": Portraits of Beauties by van Dyck and Dahl at Petworth', *Apollo*, 157, 494 (2003), p. 45. These interventions were reversed in 2019 when conservation work restored the portrait to its original form; see T. Barber (ed.), *British Baroque: Power and Illusion* (London: Tate Gallery Publishing, 2020), pp. 121–3. Dahl is known to have painted at least two further portraits of the Duchess, one of which is at Mary's ancestral home, Badminton House, Gloucestershire, while the other has been recorded as part of a private collection in Ireland; see J. Fenlon, *The Ormonde Picture Collection* (Kilkenny: Dúchas, 2001), p. 75.

17 R. Wilson, 'The Vicereines of Ireland and the Transformation of the Dublin Court, c.1703–1737', *The Court Historian*, 19, 1 (June 2014), p. 39.

18 See Rowell, 'Reigning Toasts', p. 44.

19 Ibid.

20 *The Life of James, Late Duke of Ormonde* (London: printed for M. Cooper, 1747), p. 292.

21 *Faithful Memoirs of the Life and Actions of James Butler, Late Duke of Ormonde, & c.* (London: printed for W. Shropshire, 1732), p. 30.

22 Ibid.

23 T. Barnard, *Making the Grand Figure: Lives and Possessions in Ireland, 1641–1770* (London: Yale University Press, 2004), p. 93.

24 Ibid.

25 Inventory of Dublin Castle, 1705, Ormond Family Papers, National Library of Ireland, MS 2524.

26 See Wilson, 'The Vicereines of Ireland', p. 10.

27 Ibid., p. 11.

28 Ibid.

29 D. Coakley and M. Coakley, *The History and Heritage of St James's Hospital, Dublin* (Dublin: Four Courts Press, 2018), p. 13. For the design and development of the building, see E. McParland, *Public Architecture in Ireland 1680–1760* (New Haven: Yale University Press, 2001), pp. 75–7.

30 J. Ware, *The Antiquities and History of Ireland* (Dublin: printed for E. Dobson & M. Gunne, 1705), p. 196.

31 R. Wilson, *Elite Women in Ascendancy Ireland, 1690–1745: Imitation and Innovation* (Woodbridge: The Boydell Press, 2015), p. 147.

32 Ibid. For currency conversions, see 'The National Archives Currency Converter, 1270–2017', viewable online: http://www.nationalarchives.gov.uk/currency-converter/ (accessed 26 February 2020).

33 J. Warburton, J. Whitelaw and R. Walsh, *History of the City of Dublin, from the Earliest Accounts to the Present Time* (London: printed for T. Cadell & W. Davies, 1818), vol. 1, p. 579.

34 Diary of the Duchess of Northumberland, 16 April 1829, Papers of Charlotte Florentia, Duchess of Northumberland (1787–1866), Flintshire Record Office, D-BP/D/1/4.

35 Ibid.

36 W.D. Wodsworth, *A Brief History of the Ancient Foundling Hospital of Dublin, from the Year 1702* (Dublin: printed by Alexander Thom, 1876), pp. iv, 2.

37 See Wilson, 'The Vicereines of Ireland', p. 15.

38 N. Figgis and B. Rooney, *Irish Paintings in the National Gallery of Ireland, Volume 1* (Dublin: National Gallery of Ireland, 2001), p. 361.

39 For the Duke of Bolton's death in January 1722, see *Newcastle Courant*, 27 January 1722, *Caledonian Mercury*, 30 January 1722. See also M. Kilburn, 'Paulet [Powlett], Charles, second duke of Bolton', in H.C.G. Matthew and B. Harrison (eds), *Oxford Dictionary of National Biography*

(Oxford: Oxford University Press, 2004), viewable online: https://www.oxforddnb.com/view/10.1093/ref:odnb/9780198614128.001.0001/odnb-9780198614128-e-21614?rskey=rtCdt9&result=2 (accessed 18 March 2020).

40 C. Campbell Orr, 'Conversations, Knowledge, and Influence', in J. Marschner (ed.), *Enlightened Princesses: Caroline, Augusta, Charlotte, and the Shaping of the Modern World* (New Haven: Yale University Press, 2017), p. 280.

41 *Diary of Mary Countess Cowper, Lady of the Bedchamber to the Princess of Wales, 1714–1720* (London: printed for John Murray, 1864), p. 80.

42 Henrietta was no stranger to Dublin before becoming vicereine, having married the Duke there in 1697 and having given birth to her son there in 1698; see T.C. Banks, *The Dormant and Extinct Baronage of England* (London: A. Seguin, 1837), vol. 4, p. 440. Despite her familiarity with the city, she does not seem to have created as much of an impact on the record of its social and cultural life as some of her predecessors when she returned as vicereine; see Wilson, 'The Vicereines of Ireland', pp. 7–15.

43 See A.P.W. Malcomson, *Nathaniel Clements, 1705–77: Politics, Fashion and Architecture in Mid-Eighteenth-Century Ireland* (Dublin: Four Courts Press, 2015), pp. 11–16.

44 J. Douglas Stewart, *Sir Godfrey Kneller and the English Baroque Portrait* (Oxford: Clarendon Press, 1983), p. 63; see also p. 97 (cat. 139).

45 See Wilson, 'The Vicereines of Ireland', p. 21. Frances, Baroness Carteret was the wife of John Carteret, 2nd Baron Carteret (afterwards 2nd Earl Granville), who served as Lord Lieutenant of Ireland from 1724 to 1730.

46 See Wilson, 'The Vicereines of Ireland', p. 21.

47 Ibid.

48 See M. Dennison, *The First Iron Lady: A Life of Caroline of Ansbach* (London: William Collins, 2017), p. 274. See also C. Campbell Orr, *Mrs Delany: A Life* (New Haven: Yale University Press, 2019), pp. 59–60.

49 See Wilson, *Elite Women*, p. 112.

50 See Wilson, 'The Vicereines of Ireland', p. 22.

51 Ibid., p. 21.

52 J. Roach, 'Public and Private Stages', in Marschner (ed.), *Enlightened Princesses*, p. 164.

53 See Wilson, 'The Vicereines of Ireland', p. 21; see Barnard, *Making the Grand Figure*, p. 17.

54 See Wilson, 'The Vicereines of Ireland', p. 21.

55 *Poems on Several Occasions* (London: printed for C. Rivington, 1735), p. 3.

56 The poem appeared in various newspapers in October 1725; see, for instance, *Stamford*

Mercury, 14 October 1725, *Caledonian Mercury*, 18 October 1725.

57 E. O'Flaherty, 'Patrons, peers and subscribers: The publication of Mary Barber's *Poems on Several Occasions* (London, 1734)' (unpublished PhD thesis, National University of Ireland Galway, 2013), pp. 18, 52.

58 See Barnard, *Making the Grand Figure*, p. 11.

59 Elizabeth, Duchess of Dorset was the wife of Lionel Cranfield Sackville, 1st Duke of Dorset, who served as Lord Lieutenant of Ireland from 1730 to 1737 and again from 1750 to 1755.

60 Lady Llanover (ed.), *The Autobiography and Correspondence of Mary Granville, Mrs Delany* (London: Richard Bentley, 1861), vol. 1, p. 290.

61 See Wilson, 'The Vicereines of Ireland', p. 24.

62 Ibid., p. 26.

63 G.E. Cockayne (ed.), *Complete Peerage of England, Scotland, Ireland, Great Britain and the United Kingdom: Extant, Extinct or Dormant* (London: George Bell & Sons, 1890), vol. 3, p. 152; see Dennison, *The First Iron Lady*, pp. 111–12.

64 See Wilson, 'The Vicereines of Ireland', pp. 26–7.

65 See Lady Llanover, *The Autobiography and Correspondence*, vol. 1, p. 290.

66 Ibid., vol. 3, p. 51.

67 See Wilson, 'The Vicereines of Ireland', p. 28.

68 See Cockayne, *Complete Peerage*, vol. 3, pp. 116–17.

69 C. Pegum, 'Jervas, Charles (c.1675–1739)', in N. Figgis (ed.), *Art and Architecture of Ireland: Volume II, Painting 1600–1900* (New Haven: Yale University Press, 2014), p. 324.

70 J. Robins, *Champagne & Silver Buckles: The Viceregal Court at Dublin Castle 1700–1922* (Dublin: The Lilliput Press, 2001), p. 24.

71 Letter to Mr Wilmot from William, Viscount Duncannon, 27 July 1743, Wilmot Papers, Public Record Office of Northern Ireland, T3019/481.

72 See Wilson, *Elite Women*, p. 109.

73 J. Wright (ed.), *The Letters of Horace Walpole, Earl of Orford: Including Numerous Letters Now First Published from the Original Manuscripts* (London: Richard Bentley, 1840), vol. 2, p. 290.

74 H. Belsey, *Thomas Gainsborough: The Portraits, Fancy Pictures and Copies after Old Masters* (New Haven: Yale University Press, 2019), vol. 1, pp. 121, 125.

75 Ibid., p. 125.

76 P. Higgins, 'Consumption, Gender, and the Politics of "Free Trade" in Eighteenth-Century

Ireland', *Eighteenth-Century Studies*, 41, 1 (2007), p. 88.

77 Ibid.

78 M. O'Dowd, *A History of Women in Ireland, 1500–1800* (London: Routledge, 2014), p. 58.

79 G. E. Cockayne (ed.), *Complete Peerage of England, Scotland, Ireland, Great Britain and the United Kingdom: Extant, Extinct or Dormant* (London: George Bell & Sons, 1889), vol. 1, p. 71.

80 *Dublin Evening Post*, 8 May 1779.

81 Ibid., 25 May 1779.

82 Ibid.

83 Ibid.

84 *Dublin Evening Post*, 8 May 1779.

85 See Robins, *Champagne & Silver Buckles*, p. 45.

86 A. Kidson, *George Romney: A Complete Catalogue of his Paintings* (New Haven: Yale University Press, 2015), vol. 2, p. 14.

87 Letter to William, Duke of Portland from Dorothy, Duchess of Portland, 4 December 1772, Papers of William Henry C. Cavendish-Bentinck, 3rd Duke of Portland (1738–1809), Nottingham University Library, Pw F 10636.

88 See Kidson, *George Romney*, p. 469.

89 *Saunders's News-Letter*, 21 June 1782.

90 Ibid., 7 August 1782.

91 Letter to William Brabazon Ponsonby from Thomas Lewis O'Beirne, 10 July 1783 [misdated 1793], Grey/Ponsonby Papers, Public Record Office of Northern Ireland, T3393/18.

92 G. E. Cockayne (ed.), *Complete Peerage of England, Scotland, Ireland, Great Britain and the United Kingdom: Extant, Extinct or Dormant* (London: George Bell & Sons, 1895), vol. 6, p. 274.

93 Ibid.

94 N. Butler, 'Hone, Horace (1754–1825)', in Figgis (ed.), *Art and Architecture of* Ireland, p. 307.

95 W.G. Strickland, *A Dictionary of Irish Artists* (Shannon: Irish University Press, 1969), pp. 508–9.

96 Mary was the wife of George Nugent-Temple-Grenville, 3rd Earl Temple (later 1st Marquess of Buckingham) of Stowe House, Buckinghamshire, for whom see R.W. Davis, 'Grenville, George Nugent-Temple-, first marquess of Buckingham (1753–1813)', in Matthew and Harrison (eds), *Oxford Dictionary of National Biography*, vol. 23, pp. 727–30.

97 *Dublin Evening Post*, 17 December 1782.

98 *Northampton Mercury*, 30 December 1782. Mary was the daughter of Robert, Viscount Clare (later 1st Earl Nugent) of Carlanstown, County Westmeath; G.E. Cockayne (ed.), *Complete Peerage of England, Scotland, Ireland, Great Britain and the United*

Kingdom: Extant, Extinct or Dormant (London: George Bell & Sons, 1889), vol. 2, p. 60.

99 *Northampton Mercury*, 30 December 1782.

100 *Hibernian Journal: or, Chronicle of Liberty*, 8 January 1783.

101 *Dublin Evening Post*, 20 February 1783; *Hibernian Journal: or, Chronicle of Liberty*, 8 January 1783.

102 *Dublin Evening Post*, 20 February 1783.

103 Ibid. For the most extensive of these tributes, see Anon., 'Character of the Right Honourable Countess Temple (With a Beautiful Likeness of her Ladyship)', *The Hibernian Magazine: or, Compendium of Entertaining Knowledge*, April 1783, pp. 169–70.

104 *Kentish Chronicle*, 21 September 1782.

105 Ibid.

106 The original work by Reynolds was completed in 1784 and is in the collection of the Huntington Art Museum, San Marino, California. A later version dated 1789 is in the collection of the Dulwich Picture Gallery.

107 A further note bearing the signature of Thomas Wright of Upton Hall, Nottinghamshire, also on the reverse of the palette, confirms his receipt of it from Thomas York as 'a present'. The note is dated 1842. The palette was later presented to the Royal Academy by Sir Francis Grant (1803–1878), who was President of the Academy from 1866 to 1878.

108 E. Brydges, *Collins's Peerage of England* (London: printed for F.C. & J. Rivington, 1812), vol. 2, p. 615.

109 H. Rumsey Forster, *The Stowe Catalogue, Priced and Annotated* (London: David Bogue, 1848), p. 153. The painting was recorded in an ante-room at Stowe in 1832; see *Stowe. A Description of the House and Gardens of the Most Noble Richard Grenville Nugent Chandos Temple, Duke of Buckingham and Chandos* (Buckingham: printed by R. Chandler, 1832), p. 47.

110 See Rumsey Forster, *The Stowe Catalogue*, p. 153.

111 *Belfast Commercial Chronicle*, 16 April 1806.

112 D. Rutland and E. Ellis, *Resolution: Two Brothers, a Nation in Crisis, a World at War* (London: Head of Zeus, 2017), p. 98.

113 A. Graves and W.V. Cronin, *A History of the Works of Sir Joshua Reynolds P.R.A.* (London: published for the proprietors of Henry Graves and Co., 1899), vol. 2, pp. 851–2.

114 Record of payment to Mr [Robert] Smirke from John, Duke of Rutland, 19 June 1823, Account 291, Belvoir Castle Muniments. Cited by kind permission of His Grace the 11th Duke of Rutland.

115 See Graves and Cronin, *A History of the Works*, vol. 2, pp. 853–4.

116 Records of payments to E. Beauvais from Mary Isabella, Duchess of Rutland, November 1784 to February 1785, Belvoir Castle Muniments. Cited by kind permission of His Grace the 11th Duke of Rutland.

117 J. Barrington, *Historic Memoirs of Ireland; Comprising Secret Records of the National Convention, the Rebellion, and the Union; with Delineations of the Principal Characters Connected with these Transactions* (London: published for Henry Colburn, 1835), vol. 2, p. 216.

118 *Hibernian Journal: or, Chronicle of Liberty*, 8 December 1784.

119 *Chelmsford Chronicle*, 21 January 1785.

120 For Mary Isabella's all-night parties at Dublin Castle, see *Belfast Mercury; or Freeman's Chronicle*, 25 May 1784; see also Chapter Four in this volume.

121 P. Murphy, *Nineteenth-Century Irish Sculpture: Native Genius Reaffirmed* (New Haven: Yale University Press, 2010), p. 3.

122 C. Casey, *Dublin: The City Within the Grand and Royal Canals and the Circular Road with the Phoenix Park* (New Haven: Yale University Press, 2005), p. 590.

123 For the wider context surrounding this response to the death of the Duke of Rutland, see R. Wilson, '"Our late most excellent viceroy": Irish Responses to the Death of the Duke of Rutland in 1787', *Journal for Eighteenth-Century Studies*, 42, 1 (Spring 2019), pp. 67–83.

124 See, for example, *Hibernian Journal: or, Chronicle of Liberty*, 12 May 1784.

125 See Barrington, *Historic Memoirs of Ireland*, vol. 2, p. 216.

126 H. Grattan, *Memoirs of the Life and Times of the Rt. Hon. Henry Grattan* (London: Henry Colburn, 1841), vol. 3, p. 278.

127 Chairman's bill paid by Thomas Norris to White and Sheridan on behalf of the Duchess of Rutland, 8 March 1786, Belvoir Castle Muniments. Cited by kind permission of His Grace the 11th Duke of Rutland.

128 T. Drew, 'The Stolen Fountain and Rutland Monument of Merrion-Square, Dublin', *Journal of the Royal Society of Antiquaries of Ireland*, 7, 2 (June 1897), p. 180.

129 Lady Llanover (ed.), *The Autobiography and Correspondence of Mary Granville, Mrs Delany* (London: Richard Bentley, 1862), ser. 2, vol. 2, p. 342. Frances sat for the portrait in 1777, and it was paid for in 1779 and 1780; see Graves and Cronin, *A History of the Works*, vol. 2, pp. 652–3.

130 See Cockayne, *Complete Peerage*, vol. 2, p. 124.

131 *Dublin Evening Post*, 7 March 1797.

132 See Robins, *Champagne & Silver Buckles*, p. 81.

133 G. O'Brien, 'Revolution, Rebellion and the Viceroyalty 1789–99', in P. Gray and O. Purdue (eds), *The Irish Lord Lieutenant, c.1541–1922* (Dublin: University College Dublin Press, 2012), p. 123.

134 Letter to Lady Louisa Conolly from Frances, Countess Camden, 6 June 1795, Conolly-Napier Papers, National Library of Ireland, MS 34,922 (22).

135 Letter to Frances, Countess Camden from Lady Louisa Conolly, 7 June 1795, Conolly-Napier Papers, National Library of Ireland, MS 34,922 (23).

136 *Dublin Evening Post*, 16 April 1796.

137 Ibid.

138 *Saunders's News-Letter*, 23 December 1795.

139 *London Courier and Evening Gazette*, 5 January 1801.

140 Letter to Agneta Yorke from Elizabeth, Countess of Hardwicke, 24 July 1801, Yorke Family Papers, Cambridgeshire Archives, 408/F1/16. Elizabeth, Countess of Hardwicke was the wife of Philip Yorke, 3rd Earl of Hardwicke, who served as Lord Lieutenant of Ireland from 1801 to 1805.

141 Ibid.

142 Ibid.

143 *Saunders's News-Letter*, 17 February 1802.

144 Ibid.

145 For reports of Elizabeth's appearances in Irish dress, see *Walker's Hibernian Magazine: or, Compendium of Entertaining Knowledge*, November 1801, p. 703; *London Courier and Evening Gazette*, 19 January 1802; *Morning Post*, 23 March 1802; *Saunders's News-Letter*, 14 November 1804. For the establishment of the Charitable Repository, see *Manchester Mercury*, 26 March 1805.

146 *Manchester Mercury*, 26 March 1805.

147 Diary of the Duchess of Northumberland, 14 April 1829, Papers of Charlotte Florentia, Duchess of Northumberland (1787–1866), Flintshire Record Office, D-BP/D/1/4.

148 Elizabeth, Countess of Hardwicke, *The Court of Oberon, or the Three Wishes* (London: W. Nicol, 1831), n.p. (preface).

149 For a discussion of the play's development and themes, see J. Hawley, 'Elizabeth and Keppel Craven and the Domestic Drama', in L. Engel and E.M. McGirr (eds), *Stage Mothers: Women, Work, and the Theater, 1660–1830* (Lewisburg: Bucknell University Press, 2014), p. 202.

150 The engraving was described as 'An elegant portrait of the Duchess of Richmond,

from a Picture in the possession of her mother, the Duchess of Gordon'; see *La Belle Assemblée, or, Bell's Court and Fashionable Magazine*, July 1807. Charlotte, Duchess of Richmond was the wife of Charles Lennox, 4th Duke of Richmond, who served as Lord Lieutenant of Ireland from 1807 to 1813.

151 See *Walker's Hibernian Magazine: or, Compendium of Entertaining Knowledge*, October 1807.

152 *Morning Post*, 30 July 1808.

153 Ibid.

154 Ibid.

155 *Morning Post*, 27 July 1808.

156 N. Hurrel, *The Egan Irish Harps: Tradition, Patrons and Players* (Dublin: Four Courts Press, 2019), pp. 217–18; see also *Belfast Commercial Chronicle*, 21 October 1809.

157 *Kentish Chronicle*, 23 January 1810.

158 *Saunders's News-Letter*, 10 October 1810.

159 *Morning Post*, 11 November 1809.

160 Ibid., 27 July 1808.

161 *Morning Register*, 18 May 1831. The same report appeared in *Pilot*, 18 May 1831.

162 Diary of the Duchess of Northumberland, 9 May 1829, Papers of Charlotte Florentia, Duchess of Northumberland (1787–1866), Flintshire Record Office, D-BP/D/I/4. Charlotte Florentia, Duchess of Northumberland was the wife of Hugh Percy, 3rd Duke of Northumberland, who served as Lord Lieutenant of Ireland from 1829 to 1830. For Cregan, see B. Rooney, 'Cregan, Martin (1788–1870)', in Figgis (ed.), *Art and Architecture of Ireland*: pp. 218–20; A. Crookshank and the Knight of Glin, *Ireland's Painters, 1600–1940* (New Haven: Yale University Press, 2002), pp. 182–3.

163 Diary of the Duchess of Northumberland, 6 December 1830, Papers of Charlotte Florentia, Duchess of Northumberland (1787–1866), Flintshire Record Office, D-BP/D/I/5.

164 Diary of the Duchess of Northumberland, 19 March 1829, Papers of Charlotte Florentia, Duchess of Northumberland (1787–1866), Flintshire Record Office, D-BP/D/I/4.

165 Ibid., 26 March 1829.

166 Ibid., 12 March 1829.

167 Ibid., 1 May 1829.

168 Diary of the Duchess of Northumberland, 12 July 1830, Papers of Charlotte Florentia, Duchess of Northumberland (1787–1866), Flintshire Record Office, D-BP/D/I/5.

169 Entries in Charlotte's diary show that she was a frequent visitor to charitable institutions in Dublin and was interested in the details of the living conditions and fortunes of the poor. Among the institutions she visited in one month alone, in April 1829, were the Dorset Charitable Institution (13 April), the Charitable Repository (14 April), the Foundling Hospital (16 April), the Female Orphan School (27 April) and the Magdalen Asylum (30 April). For positive responses to her charitable endeavours, see, for example, *Morning Post*, 20 January 1830; *Pilot*, 29 January 1830.

170 Diary of the Duchess of Northumberland, 29 March 1829, Papers of Charlotte Florentia, Duchess of Northumberland (1787–1866), Flintshire Record Office, D-BP/D/I/4.

171 Ibid., 22 March 1829.

172 See R. Kennedy, *Dublin Castle Art* (Dublin: Office of Public Works, 1999), p. 76.

173 Ibid. For Kirchhoffer, see N. Figgis, 'Kirchhoffer, Henry (c.1781–1860)', in Figgis (ed.), *Art and Architecture of Ireland,* pp. 334–5.

174 Diary of the Duchess of Northumberland, 9 May 1829, Papers of Charlotte Florentia, Duchess of Northumberland (1787–1866), Flintshire Record Office, D-BP/D/I/4.

175 *Morning Register*, 15 May 1829.

176 Ibid.

177 Diary of the Duchess of Northumberland, 18 May 1829, Papers of Charlotte Florentia, Duchess of Northumberland (1787–1866), Flintshire Record Office, D-BP/D/I/4. The Royal Irish Institution was founded in 1813, in Dublin, to promote the arts in Ireland. In 1829, it exhibited ninety-eight works in the Old Master loan exhibition visited by Charlotte, at its new purpose-built gallery in College Street. It was disbanded in 1832. I am grateful to Raymond Bolger and also to Dr Philip McEvansoneya for this information. See also J. Turpin, 'Dublin Art Institutions', in Figgis (ed.), *Art and Architecture of Ireland*, p. 29.

178 Diary of the Duchess of Northumberland, 20 May 1829, Papers of Charlotte Florentia, Duchess of Northumberland (1787–1866), Flintshire Record Office, D-BP/D/I/4.

179 Diary of the Duchess of Northumberland, 3 December 1830, Papers of Charlotte Florentia, Duchess of Northumberland (1787–1866), Flintshire Record Office, D-BP/D/I/5.

180 Testimonial of thanks to Charlotte Florentia, Duchess of Northumberland, 4 December 1830, Papers of Charlotte Florentia, Duchess of Northumberland, Alnwick Castle Archives, Acc 526/2A. The committee of women was headed by Charlotte Augusta, Duchess of Leinster; see List of ladies who have the honour of presenting 'the Tribute of Esteem and Respect' to Her Grace the Duchess of Northumberland, Papers of Charlotte Florentia, Duchess of Northumberland, Alnwick Castle Archives, Acc 526/3A. Cited by kind permission of His Grace the 12th Duke of Northumberland.

181 Description of the testimonial for presentation to Her Grace the Duchess of Northumberland, Papers of Charlotte Florentia, Duchess of Northumberland, Alnwick Castle Archives, Acc 526/4A. Cited by kind permission of His Grace the 12th Duke of Northumberland.

182 Ibid.

183 *Dublin Evening Post*, 16 January 1830.

184 For the expansion of the Irish poplin weaving industry in the 1830s, see Chapter Five in this volume.

185 *Pilot*, 29 January 1830.

186 Letter to Sophia, Dowager Countess of Mulgrave from Maria, Countess of Mulgrave, 17 May 1835, Mulgrave Castle Archives, H/814. Maria, Countess of Mulgrave was the wife of Constantine Henry Phipps, 2nd Earl of Mulgrave (later 1st Marquess of Normanby), who served as Lord Lieutenant of Ireland from 1835 to 1839.

187 Letter to Constantine, Earl of Mulgrave from Maria, Countess of Mulgrave, undated [August 1835], Mulgrave Castle Archives, NN/219.

188 See letter to Maria, Countess of Mulgrave from Victoria, Duchess of Kent, 13 November 1835, Mulgrave Castle Archives, S/930; see also *Warder and Dublin Weekly Mail*, 27 June 1835; *Freeman's Journal*, 14 December 1835.

189 See *Enniskillen Chronicle and Erne Packet*, 22 September 1836; *Drogheda Argus*, 24 September 1836; *Saunders's News-Letter*, 29 September 1836.

190 Letter to Queen Victoria from Maria, Countess of Mulgrave, undated [August 1837], Royal Archives, RA VIC/MAIN/S/15/2. The permission of Her Majesty Queen Elizabeth II for the use of this material is gratefully acknowledged.

191 Letter to Constantine, Earl of Mulgrave from Maria, Countess of Mulgrave, undated [August 1837], Mulgrave Castle Archives, NN/243. See also *Dublin Evening Post*, 31 October 1837.

192 The portrait bears the following inscription on the reverse of the support: 'The Most Noble The Marchioness of Normanby. The Head painted by George Hayter M.A.S.L. at Florence 1827 and finished in London 1840, by him.' Maria recorded her first encounter with Hayter for some years while serving as Lady of the Bedchamber to the Queen in October 1837: 'I was a great deal with the Queen yesterday as she sent for me

when she was sitting for her Picture and I saw Hayter again – just as conceited as ever'; letter to Constantine, Earl of Mulgrave from Maria, Countess of Mulgrave, undated [October 1837], Mulgrave Castle Archives, NN/247.

193 Letter to Constantine, Viscount Normanby from Maria, Viscountess Normanby, 8 March [1827], Mulgrave Castle Archives, NN/33.

194 B. Coffey Bryant, 'Hayter, Sir George (1792–1871)', in Matthew and Harrison (eds), *Oxford Dictionary of National Biography*, vol. 26, p. 72.

195 Letter to Constantine, Marquess of Normanby from Maria, Marchioness of Normanby, undated [late August 1838], Mulgrave Castle Archives, NN/308.

196 Despite Maria's earlier dislike of Hayter and his 'gorgeous colours', the Queen's appointment of him as her 'Painter of History and Portrait' in 1837, and her apparent delight with his work at this time, seems to have prompted a reassessment. In August 1838, Maria wrote to her husband in praise of Hayter's recent portrait of the Queen for the City of London: 'Hayter has made a very beautiful picture of her for the City. I wish the Queen would send a copy of it to Dublin, it really is a very fine picture and extremely like'; letter to Constantine, Marquess of Normanby from Maria, Marchioness of Normanby, undated [August 1838], Mulgrave Castle Archives, NN/299. See also B. Bryant, 'Hayter, Sir George', in J. Turner (ed.), *The Dictionary of Art* (London: Macmillan, 1996), vol. 14, p. 270.

197 Letter to Constantine, Earl of Mulgrave from Maria, Countess of Mulgrave, undated [April 1835], Mulgrave Castle Archives, NN/182.

198 *Enniskillen Chronicle and Erne Packet*, 8 October 1835.

199 Letter to Sophia, Dowager Countess of Mulgrave from Maria, Countess of Mulgrave, 28 September 1835, Mulgrave Castle Archives, H/814.

200 Letter to Queen Victoria from Maria, Countess of Mulgrave, undated [August 1837], Royal Archives, RA VIC/MAIN/S/15/2. The permission of Her Majesty Queen Elizabeth II for the use of this material is gratefully acknowledged.

201 Letter to Constantine, Marquess of Normanby from Maria, Marchioness of Normanby, 18 August 1838, Mulgrave Castle Archives, NN/302.

202 See, for example, *Dublin Evening Post*, 31 October 1837, 27 November 1838; letter to Constantine, Earl of Mulgrave from Maria, Countess of Mulgrave, 18 October 1837, Mulgrave Castle Archives, NN/249.

203 Henrietta Frances, Countess de Grey was the wife of Thomas, 2nd Earl de Grey, who served as Lord Lieutenant of Ireland from 1841 to 1844.

204 C. Read, 'De Grey, Henrietta Frances', in J. McGuire and J. Quinn (eds), *Dictionary of Irish Biography* (Cambridge: Cambridge University Press, 2009), viewable online: https://dib.cambridge.org/viewReadPage.do?articleId=a9548&searchClicked=clicked&quickadvsearch=yes (accessed 31 March 2020).

205 *Dublin Evening Mail*, 31 August 1842.

206 Ibid.

207 *Enniskillen Chronicle and Erne Packet*, 1 September 1842.

208 *Morning Register*, 20 December 1841.

209 Ibid. In 1843, Henrietta issued a further response to a memorial from the carpet weavers of Ireland; see letter to W. Sheridan from Henry R. Paine, 15 March 1843, OPW letter book, National Archives of Ireland, OPW1/1/2/7.

210 For a copy of this warrant, see R. Atkinson & Co., *Poplin: A Short History of its Manufacture and Introduction in Ireland* (Dublin: Forster & Co., c.1870), n.p.

211 See Read, 'De Grey, Henrietta Frances'.

212 For these respective appointments, see *Dublin Evening Mail*, 21 February 1842; *Dublin Evening Packet and Correspondent*, 8 December 1842; *Saunders's News-Letter*, 6 May 1843; *Limerick Chronicle*, 5 March 1842; *Dublin Evening Packet and Correspondent*, 7 April 1842; *Warder and Dublin Weekly Mail*, 5 November 1842. Henrietta also commissioned a tabinet featuring 'broad satin stripes' for the Viceregal Lodge, which was made available for general sale; see M. Dunlevy, *Pomp and Poverty: A History of Silk in Ireland* (London: Yale University Press, 2011), p. 135.

213 *Morning Register*, 20 December 1841.

214 R. Trethewey, *Mistress of the Arts: The Passionate Life of Georgina, Duchess of Bedford* (London: Review, 2002), pp. 131, 196; W. Roulston, *Abercorn: The Hamiltons of Barons Court* (Belfast: Ulster Historical Foundation, 2014), pp. 131–4.

215 *Saunders's News-Letter*, 16 May 1867.

216 For these respective appointments, see *Dublin Daily Express*, 8 October 1866; *Dublin Evening Post*, 18 December 1866; *Saunders's News-Letter*, 16 October 1866; *Freeman's Journal*, 4 April 1868.

217 *Recollections of Dublin Castle & of Dublin Society* (New York: Brentano's, 1902), p. 46.

218 See Roulston, *Abercorn*, p. 152.

219 *Irish Times and Daily Advertiser*, 12 January 1867. See also Anon., 'Improvements at the Castle', *The Irish Builder*, 9, 171 (February 1867), p. 29.

220 *Irish Times and Daily Advertiser*, 12 January 1867.

221 See Roulston, *Abercorn*, pp. 134, 157.

222 See Trethewey, *Mistress of the Arts*, pp. 90, 229, 131.

223 M.E. Forster, *Churchill's Grandmama: Frances, 7th Duchess of Marlborough* (Stroud: The History Press, 2010), p. 139. Frances Anne, Duchess of Marlborough was the wife of John Spencer-Churchill, 7th Duke of Marlborough, who served as Lord Lieutenant of Ireland from 1876 to 1880.

224 *Belfast Morning News*, 5 May 1880.

225 K. Aschengreen Piacenti and J. Boardman, *Ancient and Modern Gems and Jewels in the Collection of Her Majesty the Queen* (London: Royal Collection Trust, 2008), p. 249.

226 Communication from Crispin Powell, Archivist, Buccleuch Collection, 7 June 2019. Frances's badge is no longer in the collection at Blenheim Palace. Insignia were usually returned to the royal collection upon the death of the holder, which may explain the presence of this badge in the Royal Collection today.

227 See R.V. Comerford, 'The Land War and the Politics of Distress, 1877–82', in W.E. Vaughan (ed.), *A New History of Ireland VI: Ireland under the Union, II, 1870–1921* (Oxford: Oxford University Press, 2012), pp. 36–7.

228 *Times*, 18 December 1879.

229 Ibid.

230 Ibid.

231 See Forster, *Churchill's Grandmama*, pp. 135–6.

232 *Times*, 18 December 1879.

233 See Forster, *Churchill's Grandmama*, p. 135. For currency conversions, see 'The National Archives Currency Converter, 1270–2017', viewable online: http://www.nationalarchives.gov.uk/currency-converter/ (accessed 22 April 2020).

234 *Irish Times*, 29 April 1880.

235 Charlotte, Countess Spencer was the wife of John Poyntz Spencer, 5th Earl Spencer, who served as Lord Lieutenant of Ireland from 1868 to 1874 and from 1882 to 1885.

236 The portrait is signed 'J. Leslie ft. 1860'. It was 'considerably repainted' by Sir John Leslie's son, Colonel John Leslie, in 1904; K.J. Garlick, 'A Catalogue of Pictures at Althorp', *The Volume of the Walpole Society*, 45 (1974–6), pp. 54–5.

237 Charlotte and Lady Constance Leslie maintained a long and close correspondence; see letters from Charlotte Spencer (née Seymour), Countess Spencer, to Constance Leslie, Leslie Papers, National Library of Ireland, MS 49,495/1214. In September 1883, Charlotte and her husband stayed

with the Leslies at their Irish home, Glaslough House (now Castle Leslie), County Monaghan while serving as vicereine and viceroy; *Derry Journal*, 28 September 1883. For Sir John Leslie, see M. Campbell, 'Leslie, John (1822–1916)', in Figgis (ed.), *Art and Architecture of Ireland*, pp. 345–6; T. Snoddy, *Dictionary of Irish Artists: 20th Century* (Dublin: Wolfhound Press, 1996), pp. 265–6. See also M. Campbell, 'Ahead of the Class: Sir John Leslie, HRHA, 1822–1916' (unpublished M.Phil dissertation, Trinity College Dublin, 2009).

238 *Irish Times*, 10 February 1885.

239 Ibid.

240 F. Seymour, *Charlotte, Countess Spencer: A Memoir* (Northampton: W. Mark, 1907), p. 6.

241 Ibid., p. 65.

242 The Countess Spencer (ed.), *East and West* (London: Longmans, Green, and Co., 1871), p. 3.

243 *Northern Whig*, 25 May 1887.

244 Ibid.

245 E. Fingall, *Seventy Years Young: Memories of Elizabeth, Countess of Fingall* (Dublin: The Lilliput Press, 1991), p. 163.

246 D. Urquhart, *The Ladies of Londonderry: Women and Political Patronage* (London: I.B. Tauris, 2007), p. 78.

247 See Fingall, *Seventy Years Young*, p. 163.

248 J. Helland, 'Translating Textiles: "Private Palaces" and the Celtic Fringe, 1890–1910', in A. Myzelev and J. Potvin (eds), *Fashion, Interior Design and the Contours of Modern Identity* (London: Routledge, 2016), p. 94.

249 *Irish Times*, 31 January 1888.

250 Ibid.

251 *Irish Times*, 25 January 1888.

252 *[London Evening] Standard*, 4 January 1887.

253 Ibid.

254 See Helland, 'Translating Textiles', p. 95.

255 Ibid., p. 99.

256 *Irish Times*, 20 August 1897.

257 Beatrix, Countess Cadogan was the wife of George Henry Cadogan, 5th Earl Cadogan, who served as Lord Lieutenant of Ireland from 1895 to 1902.

258 Anon., 'The Irish Textile Exhibition', *The Englishwoman's Review (New Series)*, 235 (15 October 1897), p. 260.

259 See Helland, 'Translating Textiles', p. 97.

260 *Irish Times*, 20 August 1897.

261 *Freeman's Journal*, 10 August 1897; *Dublin Daily Express*, 18 August 1897.

262 *Dublin Daily Express*, 18 August 1897.

263 Reporting on the outcomes of the exhibition, *The Freeman's Journal* judged it to have been a success, particularly in commercial terms: 'though it remained open for only nine days over twenty thousand persons visited the Exhibition ... The commercial results of the Exhibition are declared to be excellent. Orders that will give employment for many months were received, and the foreigner was also reached'; *Freeman's Journal*, 21 December 1897.

264 The Marquess and Marchioness of Aberdeen and Temair, *"We Twa": Reminiscences of Lord and Lady Aberdeen* (London: W. Collins & Co. Ltd, 1925), vol. 1, p. 248.

265 É. O'Connor, '(Ad)dressing Home Rule: Irish Home Industries, the Throne Room and Lady Aberdeen's Modern Modes of Display', in M. Campbell and W. Derham (eds), *Making Majesty: The Throne Room at Dublin Castle, A Cultural History* (Dublin: Irish Academic Press, 2017), p. 241.

266 Ibid., pp. 241–2.

267 P. Maume, 'Lady Microbe and the Kailyard Viceroy: The Aberdeen Viceroyalty, Welfare Monarchy, and the Politics of Philanthropy', in Gray and Purdue (eds), *The Irish Lord Lieutenancy*, p. 200.

268 Ibid., p. 205.

269 M. Pentland, *A Bonnie Fechter: The Life of Ishbel Marjoribanks, Marchioness of Aberdeen & Temair, G.B.E., LL.D., J.P., 1857 to 1939* (London: B.T. Batsford Ltd, 1952), p. 57.

270 See Maume, 'Lady Microbe', pp. 208–11.

271 F. Carruthers, 'The organisational work of Lady Ishbel Aberdeen, Marchioness of Aberdeen and Temair (1857–1939)' (unpublished PhD thesis, National University of Ireland Maynooth, 2001), pp. v, 114.

272 Ibid., p. 125.

273 Ibid., p. 226.

274 See O'Connor, '(Ad)dressing Home Rule', p. 257.

275 P. Maume, 'Gordon (Marjoribanks), Dame Ishbel Maria', in J. McGuire and J. Quinn (eds), *Dictionary of Irish Biography* (Cambridge: Cambridge University Press, 2009), viewable online: https://dib.cambridge.org/viewReadPage.do?articleId=a3527&searchClicked=clicked&quickadvsearch=yes (accessed 29 April 2020).

276 See Pentland, *A Bonnie Fechter*, p. 65.

277 See British Pathé footage, 'Ireland's New Viceroy', viewable online: https://www.britishpathe.com/video/irelands-new-viceroy (accessed 30 April 2020). Alice, Baroness Wimborne was the wife of Ivor Churchill Guest, 2nd Baron Wimborne (later 1st Viscount Wimborne), who served as Lord Lieutenant of Ireland from 1915 to 1918.

278 *Irish Independent*, 15 April 1915.

279 Ibid.

280 K. McConkey, *Sir John Lavery: A Painter and his World* (Edinburgh: Atelier Books, 2010), p. 201.

281 J. Brown, *Lutyens and the Edwardians: An English Architect and his Clients* (London: Penguin Books, 1997), p. 244.

282 See Robins, *Champagne & Silver Buckles*, p. 162.

283 Ibid.

284 Ibid.

285 K. Jeffery, 'Vizekönigerdämmerung: Lords French and FitzAlan at the Lodge, 1918–22', in Gray and Purdue (eds), *The Irish Lord Lieutenancy*, p. 215.

286 Letter to Emilie, Baroness Ebury from Alice, Baroness Wimborne, 2 May 1916, letters from Lady Alice Wimborne to her mother, Baroness Ebury, giving an account of the Easter Rising in Dublin, and its aftermath, 1916, National Library of Ireland, MS 49,809/1.

287 Ibid.

288 Ibid.

289 Ibid.

290 O. Sitwell, *Laughter in the Next Room* (London: Macmillan & Co., 1949), pp. 212–13.

291 Letter to Emilie, Baroness Ebury from Alice, Baroness Wimborne, 2 May 1916, letters from Lady Alice Wimborne to her mother, Baroness Ebury, giving an account of the Easter Rising in Dublin, and its aftermath, 1916, National Library of Ireland, MS 49,809/1.

292 Alice's husband, Ivor, Baron Wimborne, was succeeded as Lord Lieutenant of Ireland by John Denton Pinkstone French, 1st Viscount French (afterwards 1st Earl of Ypres), who served in the position from May 1918 to April 1921. Due to the mounting dangers, French's wife, Eleanore, did not accompany him to Dublin, and so there was no vicereine of Ireland in this period. French was, in turn, succeeded by Edmund Bernard Fitzalan Howard, 1st Viscount FitzAlan, in April 1921, whose wife, Mary, Viscountess FitzAlan, served as vicereine until 1922.

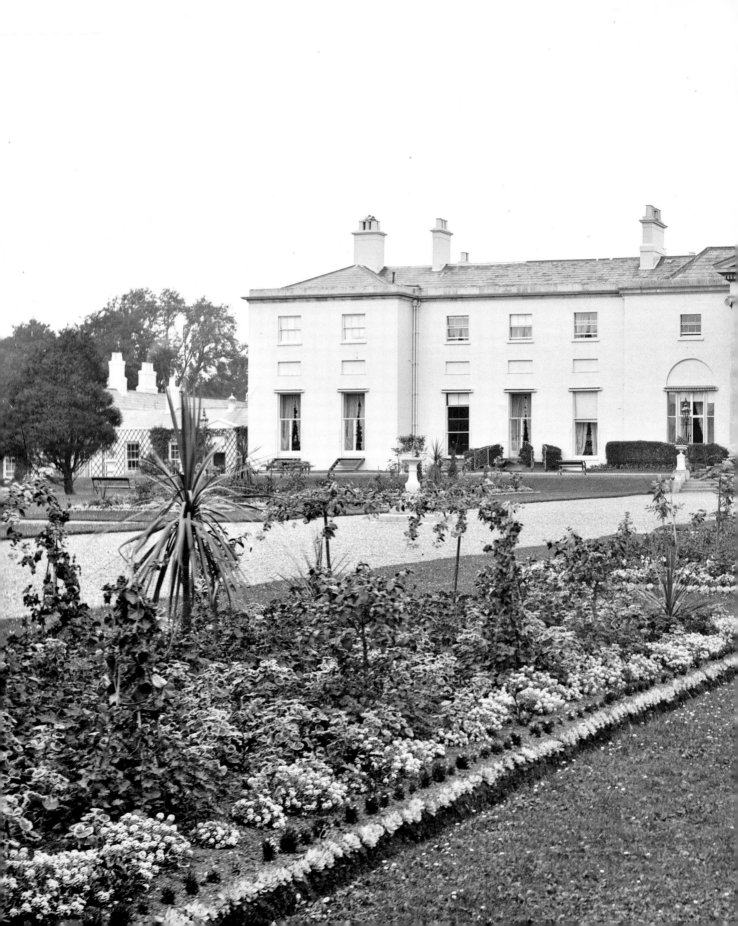

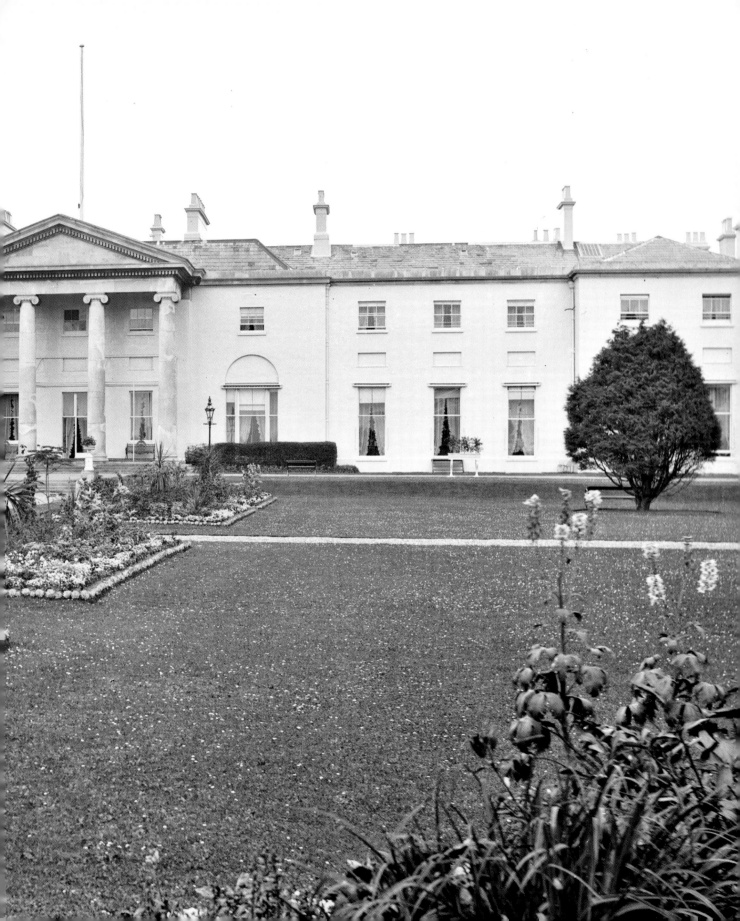

Select Bibliography

Archival Sources

Alnwick Castle Archives
Papers of Charlotte Florentia, Duchess of Northumberland, Acc 526

Archives du Ministère des Affaires Étrangères
Correspondence Politique Angleterre, vol. 118, f. 23–4

Bank of England Archive
Accountant's Department, Stock Ledgers, AC27/6451, f. 239

Belvoir Castle Muniments
Bills and payments of Charles, 4th Duke of Rutland, 1786–7
Letters to Charles, 4th Duke of Rutland from Joseph Hill, 1785–7
Household accounts of Charles, Duke of Rutland, for year ending 27 February 1785

Bodleian Library
Carte Papers, MS 243, fols 12–13, 18, 22, 24–6

British Library
Blenheim Papers, Add MS 61453, ff. 54–54v
Lansdowne Manuscripts, MS 1163

Cambridgeshire Archives
Yorke Family Papers, 408/F1

Centre for Buckinghamshire Studies
Miscellaneous deeds, accounts and other papers relating to the Stowe estate, D/104

Douai Abbey Archive
Registers of the English Benedictine Nuns of Pontoise, T.IV.1.f.17; T.IV.1.f.88

Flintshire Record Office
Papers of Charlotte Florentia, Duchess of Northumberland, D-BP/D

Gordon Family Archive, Haddo Estate
Papers of Ishbel, Marchioness of Aberdeen and Temair, File 1; File 22
Correspondence of John, Earl of Aberdeen, Box 1/5
Journal of Ishbel, Countess of Aberdeen, Box 10/2

Huntington Library
Stowe Papers, STG Boxes 34, 47, 48

Kent History and Library Centre
Stanhope of Chevening Manuscripts, U1590/S2

Mulgrave Castle Archives
Journal of Maria, Marchioness of Normanby, Library, A4
Letters addressed to Maria, Marchioness of Normanby, Box S
Letters and Papers of Constantine, Earl of Mulgrave, as Lord Lieutenant of Ireland, Box M
Letters from Constantine, Marquess of Normanby to his wife, Box N
Letters from Maria, Marchioness of Normanby to her husband, Box NN
Papers of Sophia, Countess of Mulgrave and her daughters, Box H

National Archives [of the United Kingdom]
Records of the High Court of Delegates, DEL 1/442
Will Registers of the Prerogative Court of Canterbury, PROB 11/1171.

National Archives of Ireland
OPW Journal, OPW2/2/4/1
OPW Ledger, OPW2/2/5/1
OPW Letter Books, OPW1/1/2/1–OPW1/1/2/8
OPW Minute Books, OPW1/1/1/1–OPW1/1/1/11
Peamount Hospital Archives, PRIV/WNHA
Registered Papers of the Office of Chief Secretary of Ireland, CSO/RP/1823

National Library of Ireland
Conolly-Napier Papers, MS 34,922
House of Lords Irish Appeal Cases, LO LB 627
Inchiquin Papers, MS 45,721,1–2
Leslie Papers, MS 49,495/1214
Letters to Richard, Earl of Tyrconnel, and other documents, MS 37

Ormond Papers, MS 2503; MS 2524
Westport Estate Papers, MS 40,898/1

Nottingham University Library
Papers of William Henry C. Cavendish-Bentinck, 3rd Duke of Portland, Pw F

OPW-Maynooth University Archive and Research Centre, Castle-town House
Conolly Archive, PP/CON

Public Record Office of Northern Ireland
Donoughmore Papers, T3459/C/2
Granard Papers, T3765
Grey/Ponsonby Papers, T3393
H. Montgomery Hyde Papers, D3084/C/B
Massereene-Foster Papers, D562
Shannon Papers, D2707/A/2

Royal Archives, Windsor Castle
Journal of Queen Victoria, RA VIC/MAIN/QVJ
Letters to Queen Victoria, RA VIC/MAIN/S

Royal Bank of Scotland Archives
Customer Account Ledgers, CH/194/14, ff. 175, 327

Sheffield City Archives
Wentworth Woodhouse Muniments, WWM/P/16/3

Theses

Campbell, M., 'Ahead of the class: Sir John Leslie, HRHA, 1822–1916', M.Phil dissertation, Trinity College Dublin, 2009.
Carruthers, F., 'The organisational work of Lady Ishbel Aberdeen, Marchioness of Aberdeen and Temair (1857–1939)', PhD thesis, National University of Ireland Maynooth, 2001.
Lyons, E., 'Morristown Lattin: A case study of the Lattin and Mansfield families in County Kildare, c.1600–1860', PhD thesis, University College Dublin, 2011.
Morris, J.E., 'An elite female philanthropist in late eighteenth-century England: Mary, Marchioness of Buckingham and the refugees of the French Revolution', PhD thesis, University of Leicester, 2020.
O'Flaherty, E., 'Patrons, peers and subscribers: The publication of Mary Barber's *Poems on Several Occasions* (London, 1734)', PhD thesis, National University of Ireland Galway, 2013.
Watkinson, C., 'Engaging nuns: Exiled English convents and the politics of exclusion, 1590–1829', PhD Thesis, University of Westminster, 2016.

Eighteenth and Nineteenth-Century Irish and British Newspapers

Belfast Commercial Chronicle
Belfast Mercury; or Freeman's Chronicle

Belfast News-Letter
Caledonian Mercury
Connaught Telegraph
Dublin Daily Express
Dublin Evening Packet and Correspondent
Dublin Evening Post
Dublin Mercantile Advertiser
Enniskillen Chronicle and Erne Packet
Freeman's Journal
Galway Patriot
Hibernian Journal: or, Chronicle of Liberty
Irish Times
Kentish Chronicle
Kerry Evening Post
London Courier and Evening Gazette
London Evening Standard
Londonderry Sentinel
Manchester Mercury
Morning Post
Morning Register
Newcastle Courant
Northern Daily News
Saunders's News-Letter
Times
Tralee Mercury
Volunteer's Journal or Irish Herald
Warder and Dublin Weekly Mail
Waterford Mail
Whitby Gazette
World, or Fashionable Intelligencer

Books, Journal Articles and Essays in Edited Volumes

Aberdeen, Lord and Lady, *"We Twa": Reminiscences of Lord and Lady Aberdeen* (London: W. Collins Sons & Co. Ltd, 1925).
Anon., 'Biographical Sketches of Illustrious Ladies. The Most Noble the Marchioness of Buckingham', *La Belle Assemblée*, January 1812.
——, 'Character of the Right Honourable Countess Temple (With a Beautiful Likeness of her Ladyship)', *The Hibernian Magazine: or, Compendium of Entertaining Knowledge*, April 1783, pp. 169–70.
——, *Faithful Memoirs of the Life and Actions of James Butler, Late Duke of Ormonde, & c.* (London: printed for W. Shropshire, 1732).
——, 'Improvements at the Castle', *The Irish Builder*, 9, 171 (1 February 1867), p. 29.
——, 'Original Subscribers to the Public Assembly Rooms', in *A List of the Proprietors of Licenses for Private Sedan Chairs, at 25th March, 1788, Alphabetically Ranged, with their Respective Residences, Published as Required by Law* (Dublin: n.p., 1788).
——, 'Portrait Gallery at Dublin Castle', *The Gentleman's Magazine* (December 1843), p. 643.
——, *Stowe. A Description of the Magnificent House and Gardens of the Right Honourable George Grenville Nugent Temple, Earl Temple, Viscount and Baron Cobham ...* (Buckingham: printed by B. Seeley, 1780).
——, 'The Irish Textile Exhibition', *The Englishwoman's Review* (New Series), 235 (15 October 1897), pp. 259–61.

---, *The Life of James, Late Duke of Ormonde* (London: printed for M. Cooper, 1747).

Aschengreen Piacenti, K. and Boardman, J., *Ancient and Modern Gems and Jewels in the Collection of Her Majesty the Queen* (London: Royal Collection Trust, 2008).

Aspinall, A. (ed.), *The Later Correspondence of George III* (Cambridge: Cambridge University Press, 1962), vol. I.

Atkinson, R. & Co., *Poplin: A Short History of its Manufacture and Introduction in Ireland* (Dublin: Forster & Co., c.1870).

Barber, M., *Poems on Several Occasions* (London: printed for C. Rivington, 1735).

Barber, T., (ed.), *British Baroque: Power and Illusion* (London: Tate Gallery Publishing, 2020).

Barnard, T., *Making the Grand Figure: Lives and Possessions in Ireland, 1641–1770* (London: Yale University Press, 2004).

Barnard, T. and Fenlon, J. (eds), *The Dukes of Ormonde, 1610–1745* (Woodbridge: Boydell Press, 2000).

Barrington, J., *Historic Memoirs of Ireland; Comprising Secret Records of the National Convention, the Rebellion, and the Union; with Delineations of the Principal Characters Connected with these Transactions* (London: published for Henry Colburn, 1835), 2 vols.

Beckett, J.V., *The Rise and Fall of the Grenvilles: Dukes of Buckingham and Chandos, 1710 to 1921* (Manchester: Manchester University Press, 1994).

Belsey, H., *Thomas Gainsborough: The Portraits, Fancy Pictures and Copies after Old Masters* (New Haven: Yale University Press, 2019), 2 vols.

Berry, H.F., *A History of the Royal Dublin Society* (London: Longmans, Green, and Co., 1915).

Bew, J., *Castlereagh: Enlightenment, War and Tyranny* (London: Quercus, 2011).

Bloomfield, G., *Extracts of Letters from Maria, Marchioness of Normanby, The Hon. Frances Jane Liddell, The Hon. Anne Elizabeth, Lady Williamson, Jane Elizabeth, Viscountess Barrington, The Hon. Elizabeth Charlotte Villiers, Susan, Countess of Hardwicke, The Hon. Charlotte Amelia Trotter* (Hertford: Simson & Co., 1892).

Breathnach, C., 'Lady Dudley's District Nursing Scheme and the Congested Districts Board, 1903–1923', in M.H. Preston and M. Ó hÓgartaigh (eds), *Gender and Medicine in Ireland, 1700–1950* (New York: Syracuse University Press, 2012), pp. 138–53.

Brown, J., *Lutyens and the Edwardians: An English Architect and his Clients* (London: Penguin Books, 1997).

Brown, M., Geoghegan, P.M. and Kelly, J. (eds), *The Irish Act of Union, 1800: Bicentennial Essays* (Dublin: Irish Academic Press, 2003).

Bryant, B., 'Hayter, Sir George', in J. Turner (ed.), *The Dictionary of Art* (London: Macmillan, 1996), vol. 14, p. 270.

Campbell, M., '"Sketches of their Boundless Mind": The Marquess of Buckingham and the Presence Chamber at Dublin Castle, 1788–1838', in Campbell and Derham (eds), *Making Majesty*, pp. 47–93.

Campbell, M. and Derham, W. (eds), *Making Majesty: The Throne Room at Dublin Castle, A Cultural History* (Dublin: Irish Academic Press, 2017).

---, *The Chapel Royal, Dublin Castle: An Architectural History* (Dublin: Office of Public Works, 2015).

Campbell Orr, C., 'Conversations, Knowledge, and Influence', in Marschner (ed.), *Enlightened Princesses*, pp. 279–303.

---, *Mrs Delany: A Life* (New Haven: Yale University Press, 2019).

Campbell Ross, I. (ed.), *Public Virtue, Public Love: The Early Years of the Dublin Lying-In Hospital, the Rotunda* (Dublin: The O'Brien Press, 1986).

Cannon, J., *The Fox–North Coalition: Crisis of the Constitution, 1782–4* (Cambridge: Cambridge University Press, 1969).

Carpenter, A., 'A Collection of Verse presented to James Butler, First Duke of Ormonde', *The Yale University Library Gazette*, 75 (October 2000), pp. 64–70.

Casey, C., *Dublin: The City Within the Grand and Royal Canals and the Circular Road with the Phoenix Park* (New Haven: Yale University Press, 2005).

Chalus, E.H., 'Manners [née Somerset], Mary Isabella, duchess of Rutland (1756–1831)', in Matthew and Harrison (eds), *Oxford Dictionary of National Biography*, vol. 36, pp. 472–4.

Childs, J., *The Williamite Wars in Ireland, 1688–1691* (London: Hambledon Continuum, 2007).

Clark, A. (ed.), *Gleanings from an Old Portfolio: Containing Some Correspondence Between Lady Louisa Stuart and her Sister Caroline, Countess of Portarlington, and Other Friends and Relations* (Edinburgh: printed for David Douglas, 1895–8), 3 vols.

Cluckie, L., *The Rise and Fall of Art Needlework: Its Socio-economic and Cultural Aspects* (Bury St Edmunds: Arena Books, 2008).

Coakley, D. and Coakley, M., *The History and Heritage of St James's Hospital, Dublin* (Dublin: Four Courts Press, 2018).

Cockayne, G.E., (ed.), *Complete Peerage of England, Scotland, Ireland, Great Britain and the United Kingdom: Extant, Extinct or Dormant* (London: George Bell & Sons, 1887–99), 8 vols.

Collard, F., 'Town & Emanuel', *Furniture History*, 32 (1996), pp. 81–9.

Colvin, H., 'The Architects of Stafford House', *Architectural History*, 1 (1958), pp. 17–30.

Comerford, R.V., 'The Land War and the Politics of Distress, 1877–82', in W.E. Vaughan (ed.), *A New History of Ireland VI: Ireland under the Union, II, 1870–1921* (Oxford: Oxford University Press, 2012), pp. 26–52.

Connolly, S.J., *Divided Kingdom: Ireland 1630–1800* (Oxford: Oxford University Press, 2008).

Crookshank, A. and the Knight of Glin, *Ireland's Painters, 1600–1940* (New Haven: Yale University Press, 2002).

Davis, H. (ed.), *The Prose Works of Jonathan Swift, Vol. XII: Irish Tracts 1728–1733* (Oxford: Oxford University Press, 1955).

Dennison, M., *The First Iron Lady: A Life of Caroline of Ansbach* (London: William Collins, 2017).

Dickens, C., 'The Castle of Dublin', *All the Year Round*, 15, 370 (26 May 1866), pp. 462–6.

Dickson, D., *Dublin: The Making of a Capital City* (London: Profile Books, 2015).

---, (ed.), *The Gorgeous Mask: Dublin 1700–1850* (Dublin: Trinity History Workshop, 1987).

Doderer-Winkler, M., *Magnificent Entertainments: Temporary Architecture for Georgian Festivals* (New Haven: Yale University Press, 2013).

Douglas Stewart, J., *Sir Godfrey Kneller and the English Baroque Portrait* (Oxford: Clarendon Press, 1983).

Dunlevy, M., *Pomp and Poverty: A History of Silk in Ireland* (London: Yale University Press, 2011).

Fenlon, J., *The Ormonde Picture Collection* (Kilkenny: Dúchas, 2001).

Figgis, N, (ed.), *Art and Architecture of Ireland: Volume II, Painting 1600–1900* (New Haven and London: Yale University Press, 2014).

Figgis, N., and Rooney, B., *Irish Paintings in the National Gallery of Ireland, Volume 1* (Dublin: National Gallery of Ireland, 2001).

Fingall, E., *Seventy Years Young: Memories of Elizabeth, Countess of Fingall* (Dublin: The Lilliput Press, 1991).

Finley-Bowman, R.E., 'An Ideal Unionist: The Political Career of Theresa, Marchioness of Londonderry, 1911–1919', *Journal of International Women's Studies*, 4, 3 (May 2003), pp. 15–29.

FitzGerald, B. (ed.), *Correspondence of Emily, Duchess of Leinster (1731–1814)* (Dublin: Irish Manuscripts Commission, 1949–57), 3 vols.

Foreman, A., *Georgiana, Duchess of Devonshire* (London: Harper Collins, 1999).

Forster, M.E., *Churchill's Grandmama: Frances, 7th Duchess of Marlborough* (Stroud: The History Press, 2010).

Foster, S., '"An Honourable Station in Respect of Commerce, as well as Constitutional Liberty": Retailing, Consumption and Economic Nationalism in Dublin, 1720–85', in O'Brien and O'Kane (eds), *Georgian Dublin*, pp. 30–44.

Garlick, K.J., 'A Catalogue of Pictures at Althorp', *The Volume of the Walpole Society*, 45 (1974–6), pp. 1–128.

Gilbert, J.T., *History of the Viceroys of Ireland; With Notices of the Castle of Dublin and its Chief Occupants in Former Times* (Dublin: James Duffy, 1865).

Graves, A. and Cronin, W.V., *A History of the Works of Sir Joshua Reynolds P.R.A.* (London: published for the proprietors of Henry Graves and Co., 1899–1901), 4 vols.

Gray, P. and Purdue, O. (eds), *The Irish Lord Lieutenancy, c.1541–1922* (Dublin: University College Dublin Press, 2012).

Hall, J., *Tour through Ireland; Particularly the Interior and Least Known Parts* (London: printed for R.P. Moore, 1813).

Hayes, A. and Urquhart, D. (eds), *The Irish Women's History Reader* (London: Routledge, 2001).

Heaney, H. (ed.), *A Scottish Whig in Ireland: The Irish Journals of Robert Graham of Redgorton* (Dublin: Four Courts Press, 1999).

Helland, J., 'Translating Textiles: "Private Palaces" and the Celtic Fringe, 1890–1910', in A. Myzelev and J. Potvin (eds), *Fashion, Interior Design and the Contours of Modern Identity* (London: Routledge, 2016), pp. 85–104.

Herman, N., 'Henry Grattan, the Regency Crisis and the Emergence of a Whig Party in Ireland, 1788–9', *Irish Historical Studies*, 32, 128 (November 2001), pp. 478–97.

Higgins, P., *A Nation of Politicians: Gender, Patriotism, and Political Culture in Late Eighteenth-Century Ireland* (Madison: University of Wisconsin Press, 2010).

–––, 'Consumption, Gender, and the Politics of "Free Trade" in Eighteenth-Century Ireland', *Eighteenth-Century Studies*, 41, 1 (Autumn 2007), pp, 87–105.

Hill, J., 'The Building of the Chapel Royal, 1807–14', in Campbell and Derham (eds), *The Chapel Royal, Dublin Castle*, pp. 39–53.

Historical Manuscripts Commission, *Calendar of the Manuscripts of the Marquess of Ormonde. K.P. preserved at Kilkenny Castle* (London: Historical Manuscripts Commission, 1920), vol. 8.

–––, *The Manuscripts and Correspondence of James, First Earl of Charlemont* (London: Historical Manuscripts Commission, 1891), vol. 1.

–––, *The Manuscripts of His Grace the Duke of Rutland, K.G. preserved at Belvoir Castle* (London: Historical Manuscripts Commission, 1894), vol. 3.

–––, *The Manuscripts of J.B. Fortescue, Esq., preserved at Dropmore* (London: Historical Manuscripts Commission, 1892), vol. 1.

–––, *The Manuscripts of the Duke of Beaufort, K.G., the Earl of Donoughmore, and Others* (London: Historical Manuscripts Commission, 1891).

–––, *The Manuscripts of the Earl of Carlisle, preserved at Castle Howard* (London: Historical Manuscripts Commission, 1897).

Hoppen, K.T., *Governing Hibernia: British Politicians and Ireland 1800–1921* (Oxford: Oxford University Press, 2016).

Hurrel, N., *The Egan Irish Harps: Tradition, Patrons and Players* (Dublin: Four Courts Press, 2019).

Jacobsen, H., 'Magnificent Display: European Ambassadorial Visitors', in D. Kisluk-Grosheide and B. Rondot (eds), *Visitors to Versailles* (New York: The Metropolitan Museum of Art, 2018), pp. 94–107.

Jameson, Mrs [A.B.], *The Beauties of the Court of King Charles the Second* (London: Richard Bentley, 1833).

Jupp, P., 'Earl Temple's Viceroyalty and the Question of Renunciation, 1782–83', *Irish Historical Studies*, 17, 68 (September 1971), pp. 499–520.

Kelly, J., *Prelude to Union: Anglo-Irish Politics in the 1780s* (Cork: Cork University Press, 1992).

–––, 'Residential and Non-Residential Lords Lieutenant – The Viceroyalty 1703–1790', in Gray and Purdue (eds), *The Irish Lord Lieutenant*, pp. 66–96.

Kidson, A., *George Romney: A Complete Catalogue of his Paintings* (New Haven: Yale University Press, 2015), 3 vols.

Kirkpatrick, T.P.C., and Jellett, H., *The Book of the Rotunda Hospital: An Illustrated History of the Dublin Lying-In Hospital from its Foundation in 1745 to the Present Time* (London: Adlard & Son, Bartholomew Press, 1913).

Lenihan, P., *The Last Cavalier: Richard Talbot (1631–91)* (Dublin: University College Dublin Press, 2014).

Lewis, J.S., '1784 and All That', in A. Vickery (ed.), *Women, Privilege, and Power: British Politics, 1750 to the Present* (Stanford: Stanford University Press, 2001), pp. 89–122.

–––, *Sacred to Female Patriotism: Gender, Class, and Politics in Late Georgian Britain* (New York: Routledge, 2003).

Llanover, Lady (ed.), *The Autobiography and Correspondence of Mary Granville, Mrs Delany* (London: Richard Bentley, 1861), 3 vols.

Loeber, R., 'The Rebuilding of Dublin Castle: Thirty Critical Years, 1661–1690', *Studies: An Irish Quarterly Review*, 69, 273 (Spring 1980), pp. 45–69.

Loughlin, J., *The British Monarchy and Ireland: 1800 to the Present* (Cambridge: Cambridge University Press, 2007).

–––, 'The British Monarchy and the Irish Viceroyalty: Politics, Architecture and Place', in Gray and Purdue (eds), *The Irish Lord Lieutenant*, pp. 179–98.

Lynn, J.A., *The Wars of Louis XIV, 1667–1714* (London: Routledge, 2013).

MacCurtain, M. and O'Dowd, M. (eds), *Women in Early Modern Ireland* (Edinburgh: Edinburgh University Press, 1991).

Malcomson, A.P.W., *Nathaniel Clements, 1705–77: Politics, Fashion and Architecture in Mid-Eighteenth-Century Ireland* (Dublin: Four Courts Press, 2015).

Marschner, J. (ed.), *Enlightened Princesses: Caroline, Augusta, Charlotte, and the Shaping of the Modern World* (New Haven: Yale University Press, 2017).

Matthew, H.C.G. and Harrison, B. (eds), *Oxford Dictionary of National Biography* (Oxford: Oxford University Press, 2004), 60 vols.

Maume, P., 'Lady Microbe and the Kailyard Viceroy: The Aberdeen Viceroyalty, Welfare Monarchy, and the Politics of Philanthropy', in Gray and Purdue (eds), *The Irish Lord Lieutenancy*, pp. 199–214.

Maxwell, C., *Dublin under the Georges, 1714–1830* (London: Faber and Faber, 1956).

McCarthy, P., *Life in the Country House in Georgian Ireland* (New Haven: Yale University Press, 2016).

McConkey, K., *Sir John Lavery: A Painter and his World* (Edinburgh: Atelier Books, 2010).

McCormack, D., *The Stuart Restoration and the English in Ireland* (Woodbridge: Boydell Press, 2016).

McCullen, J.A., *An Illustrated History of the Phoenix Park: Landscape and Management up to 1880* (Dublin: Office of Public Works, 2009).

McDowell, R.B., 'The Court of Dublin Castle', in R.B. McDowell, *Historical Essays 1938–2001* (Dublin: The Lilliput Press, 2003), pp. 1–52.

McGuire, J., 'James II and Ireland, 1685–1690', in W.A. Maguire (ed.), *Kings in Conflict: The Revolutionary War in Ireland and its Aftermath, 1689–1750* (Belfast: The Blackstaff Press, 1990), pp. 45–57.

---, 'Why was Ormond Dismissed in 1669?', *Irish Historical Studies*, 18, 71 (March 1973), pp. 295–312.

McGuire, J. and Quinn, J. (eds), *Dictionary of Irish Biography* (Cambridge: Cambridge University Press, 2009), 9 vols.

McParland, E., *Public Architecture in Ireland 1680–1760* (New Haven: Yale University Press, 2001).

Meaney, G., O'Dowd, M. and Whelan, B. *Reading the Irish Woman: Studies in Cultural Encounters and Exchange, 1714–1960* (Liverpool: Liverpool University Press, 2013).

Miller, J., 'The Earl of Tyrconnel and James II's Irish Policy, 1685–1688', *Historical Journal*, 20, 4 (December 1977), pp. 803–23.

Moore, G., *A Drama in Muslin* (Buckinghamshire: Colin Smythe Limited, 2010).

Morash, C., *A History of Irish Theatre, 1601–2000* (Cambridge: Cambridge University Press, 2002).

Murphy, P., *Nineteenth-Century Irish Sculpture: Native Genius Reaffirmed* (London: Yale University Press, 2010).

Nolan, P., *The Irish Dames of Ypres: Being a History of the Royal Irish Abbey of Ypres founded A.D. 1665 and Still Flourishing and Some Account of Irish Jacobitism with a Portrait of James II and Stuart Letters Hitherto Unpublished* (Dublin: Browne & Nolan, 1908).

Nugent, C., *Memoir of Robert, Earl Nugent: With Letters, Poems and Appendices* (London: W. Heinemann, 1898).

O'Brien, G. and O'Kane, F. (eds), *Georgian Dublin* (Dublin: Four Courts Press, 2008).

O'Connor, É., '(Ad)dressing Home Rule: Irish Home Industries, the Throne Room and Lady Aberdeen's Modern Modes of Display', in Campbell and Derham (eds), *Making Majesty*, pp. 237–63.

O'Dowd, M., *A History of Women in Ireland, 1500–1800* (London: Routledge, 2014).

O'Dwyer, F., 'Dublin Castle and its State Apartments 1660–1922', *The Court Historian*, 2, 1 (1997), pp. 2–8.

---, 'Making Connections in Georgian Ireland', *Bulletin of the Irish Georgian Society*, 38 (1996–7), pp. 6–23.

Ohlmeyer, J. and Zwicker, S., 'John Dryden, the House of Ormond, and the Politics of Anglo-Irish Patronage', *The Historical Journal*, 49, 3 (September 2006), pp. 677–706.

Olson, S., *John Singer Sargent: His Portrait* (New York: St Martin's Press, 1986).

O'Mahony, C., *The Viceroys of Ireland* (London: John Long, 1912).

Pelly, P. and Tod, A. (eds), *The Highland Lady in Dublin 1851–1856* (Dublin: New Island, 2005).

Pentland, M., *A Bonnie Fechter: The Life of Ishbel Marjoribanks, Marchioness of Aberdeen & Temair, G.B.E., LL.D., J.P., 1857 to 1939* (London: B.T. Batsford Ltd, 1952).

Pigott, C., *The Female Jockey Club, or a Sketch of the Manners of the Age* (London: printed for D.I. Eaton, 1794).

Pückler-Muskau, H. von, *Tour of England, Ireland, and France in the Years 1826, 1827, 1828, and 1829* (Philadelphia: Carey, Lea & Blanchard), 1833.

Raughter, R., 'A Natural Tenderness: The Ideal and Reality of Eighteenth-Century Female Philanthropy', in M.G. Valiulis and M. O'Dowd (eds), *Women & Irish History: Essays in Honour of Margaret MacCurtain* (Dublin: Wolfhound Press, 1997), pp. 71–88.

Reynolds, K.D., *Aristocratic Women and Political Society in Victorian Britain* (Oxford: Clarendon Press, 1998).

Robins, J., *Champagne & Silver Buckles: The Viceregal Court at Dublin Castle 1700–1922* (Dublin: The Lilliput Press, 2001).

Robinson, N., 'Caricature and the Regency Crisis: An Irish Perspective', *Eighteenth-Century Ireland*, 1 (1986), pp. 157–76.

Ross, C. (ed.), *Correspondence of Charles, First Marquis Cornwallis* (London: John Murray, 1859), 3 vols.

Roulston, W., *Abercorn: The Hamiltons of Barons Court* (Belfast: Ulster Historical Foundation, 2014).

Rowan, A., *North West Ulster: The Counties of Londonderry, Donegal, Fermanagh, and Tyrone* (Harmondsworth: Penguin, 1979).

Rowell, C., '"Reigning Toasts": Portraits of Beauties by van Dyck and Dahl at Petworth', *Apollo*, 157, 494 (2003), pp. 39–47.

Rumsey Forster, H., *The Stowe Catalogue, Priced and Annotated* (London: David Bogue, 1848).

Rutland, D., and Ellis, E., *Resolution: Two Brothers, a Nation in Crisis, a World at War* (London: Head of Zeus, 2017).

Sandford, F., *The History of the Coronation of the Most High, Most Mighty, and Most Excellent Monarch, James II* (London: In the Savoy, printed by Thomas Newcomb, 1687).

Sergeant, P., *Little Jennings and Fighting Dick Talbot* (London: Hutchinson & Co., 1913), 2 vols.

Seymour, F., *Charlotte, Countess Spencer: A Memoir* (Northampton: W. Mark, 1907).

Sheldon, E.K., *Thomas Sheridan of Smock Alley: Recording his Life as Actor and Theater Manager in both Dublin and London, and including a Smock-Alley Calendar for the Years of his Management* (Princeton: Princeton University Press, 1967).

Skinner, D., *Wallpaper in Ireland 1700–1900* (Tralee: Churchill House Press, 2014).

Smyth, J., *The Men of No Property: Irish Radicals and Popular Politics in the Late Eighteenth Century* (London: Macmillan Press, 1998 reprint).

Snoddy, T., *Dictionary of Irish Artists: 20th Century* (Dublin: Wolfhound Press, 1996).

Sonnelitter, K., *Charity Movements in Eighteenth-Century Ireland: Philanthropy and Improvement* (Woodbridge: The Boydell Press, 2016).

Spencer, The Countess (ed.), *East and West* (London: Longmans, Green, and Co., 1871).

Story, G.W., *A True and Impartial History of the Most Material Occurrences in the Kingdom of Ireland during the Last Two Years* (London: printed for Ric. Chiswel, 1691).

Strickland, W.G., *A Dictionary of Irish Artists* (Shannon: Irish University Press, 1969).

Szechi, D., *The Jacobites: Britain and Europe, 1688–1788* (Manchester: Manchester University Press, 1994).

Thackeray, W.M., *The Irish Sketch Book of 1842* (New York: Charles Scribner's Sons, 1911).

Thomas, P. (ed.), *The Collected Works of Katherine Philips, the Matchless Orinda, Volume II: The Letters* (London: Stump Cross Books, 1992).

Tooley, S.A., 'Women in Great Social Positions: The Vicereine of Ireland', in *Every Woman's Encyclopaedia* (London: s.n., 1910), vol. 1, pp. 216–19.

Trethewey, R., *Mistress of the Arts: The Passionate Life of Georgina, Duchess of Bedford* (London: Review, 2002).

Turner, M.J., *Pitt the Younger: A Life* (London: Hambledon & London, 2003).

Turpin, J., *A School of Art in Dublin since the Eighteenth Century* (Dublin: Gill & Macmillan, 1995).

–––, 'Dublin Art Institutions', in Figgis (ed.), *Art and Architecture of Ireland*, pp. 28–31.

Urquhart, D., *The Ladies of Londonderry: Women and Political Patronage* (London: I.B. Tauris, 2007).

Urquhart, D. and Hayes, A. (eds), *Irish Women's History* (Dublin: Irish Academic Press, 2004).

Valdrè, U., Lynch, B. and Lynch, C., *Vincenzo Valdrè, Faenza 1740–Dublino 1814* (Faenza: Tipografia Valgimigli, 2014).

Vickery, A., *The Gentleman's Daughter: Women's Lives in Georgian England* (London: Yale University Press, 1998).

Warburton, J., Whitelaw, J. and Walsh, R., *History of the City of Dublin, from the Earliest Accounts to the Present Time* (London: printed for T. Cadell & W. Davies, 1818), 2 vols.

Ware, J., *The Antiquities and History of Ireland* (Dublin: printed for E. Dobson & M. Gunne, 1705).

Williams, B., 'The Dominican Annals of Dublin', in S. Duffy (ed.), *Medieval Dublin II* (Dublin: Four Courts Press, 2001), pp. 142–68.

Wilson, R., *Elite Women in Ascendancy Ireland, 1690–1745: Imitation and Innovation* (Woodbridge: The Boydell Press, 2015).

–––, '"Our late most excellent viceroy": Irish Responses to the Death of the Duke of Rutland in 1787', *Journal for Eighteenth-Century Studies*, 42, 1 (Spring 2019), pp. 67–83.

–––, 'The Vicereines of Ireland and the Transformation of the Dublin Court, c.1703–1737', *The Court Historian*, 19, 1 (June 2014), pp. 3–28.

Wodsworth, W.D., *A Brief History of the Ancient Foundling Hospital of Dublin, from the Year 1702* (Dublin: printed by Alexander Thom, 1876).

Wright, J. (ed.), *The Letters of Horace Walpole, Earl of Orford: Including Numerous Letters Now First Published from the Original Manuscripts* (London: Richard Bentley, 1840), 6 vols.

Index